GALILEO AND THE 'INVENTION' OF OPERA

CONTRIBUTIONS TO PHENOMENOLOGY

IN COOPERATION WITH
THE CENTER FOR ADVANCED RESEARCH IN PHENOMENOLOGY

Volume 29

Editor:

John Drummond, Mount Saint Mary's College

Editorial Board:

Elizabeth A. Behnke
David Carr, Emory University
Stephen Crowell, Rice University
Lester Embree, Florida Atlantic University
J. Claude Evans, Washington University
José Huertas-Jourda, Wilfrid Laurier University
Joseph J. Kockelmans, The Pennsylvania State University
William R. McKenna, Miami University
Algis Mickunas, Ohio University
J. N. Mohanty, Temple University
Tom Nenon, The University of Memphis
Thomas M. Seebohm, Johannes Gutenberg-Universität, Mainz
Elisabeth Ströker, Philosophisches Seminarium der Universität Köln
Richard M. Zaner, Vanderbilt University

Scope

The purpose of this series is to foster the development of phenomenological philosophy through creative research. Contemporary issues in philosophy, other disciplines and in culture generally, offer opportunities for the application of phenomenological methods that call for creative responses. Although the work of several generations of thinkers has provided phenomenology with many results with which to approach these challenges, a truly successful response to them will require building on this work with new analyses and methodological innovations.

GALILEO AND THE 'INVENTION' OF OPERA

A STUDY IN THE PHENOMENOLOGY OF CONSCIOUSNESS

by

FRED KERSTEN

Emeritus Professor University of Wisconsin-Green Bay, U.S.A.

Springer-Science+Business Media, B.V.

A C.I.P. Catalogue record for this book is available from the Library of Congress.

ISBN 978-90-481-4847-9 ISBN 978-94-015-8931-4 (eBook)
DOI 10.1007/978-94-015-8931-4

Printed on acid-free paper

All Rights Reserved
© 1997 Springer Science+Business Media Dordrecht
Originally published by Kluwer Academic Publishers in 1997.
Softcover reprint of the hardcover 1st edition 1997

No part of the material protected by this copyright notice may be reproduced or
utilized in any form or by any means, electronic or mechanical,
including photocopying, recording or by any information storage and
retrieval system, without written permission from the copyright owner.

To the "Butterfly Lady"

TABLE OF CONTENTS

Dedication	v
Preface	ix
Acknowledgments	xv
Illustrations	xvii

CHAPTER ONE. Intimations of the Gap 1
 Bridging the Gap, 3; The Operatic Gap, 5; Preliminary
Stocktaking of the Gap, 9; The Gap Taken forGranted, 11;
The Eccentricity of Ordinary Life, 14; Bridging the Gap
at the Limit of Eccentricity, 17.

CHAPTER TWO. The Gap Represented 21
 The Near and the Far, 22; When Push Comes to Shove, 26;
The Beauty of the Push, 28; The Representation of the Gap, 30;
Representation by Way of Mimesis, 33; Some Characteristics of
Mimetic Resemblance, 35; From Mimesis to Analogy, 37; Representation
by Way of Analogy, 40; The End of the Classical Formulation of
Consciousness, 42.

CHAPTER THREE. The Gap at the Center 45
 Stocking Up on the Stock of Knowledge at Hand, 47; Holding
the Center, 49; Indicational Appresentation, 51; The Reciprocity of
Perspectives, 52; Specious Objects in the Specious Present, 54;
"Medii Cupperdine Victae," 56; What is "Right" Appresented by
What Seems "Right," 58; Mirror and Scenery, 61; The Mirror and
Eternity, 62; The Window and the Veil, 64; Here and There, 67; The
View from the Window, 69; Notes from the Center, 73; Portent of the
Gap at the Center, 76.

CHAPTER FOUR. Room at the Center. 79
 Getting Around the Bend, 83; The Chorus Invisible and
the Harmony of the Spheres, 86; Muscles and Bones, 90; The
Baroque Formulation of Consciousness, 94; "Catharsis" and
"Mimesis," 96; The Principle of Compossibility, 101; The Sun
and the Window, 104; The Compossibility of Sensory
Evidence, 108; The Milieu of Social Action, 111; The View from
the Window of the Room with a Window, 113; Note, 116.

CHAPTER FIVE. The Room and the Universe. 119
 The Lion and the Library, 121; The Rhetoric of the Room,
125; The Gentle Kiss and the Bite, 129; Narcissus, Fortuna, Hermes, 133;
At the Virgin's Feet, 135;The Mimetic Epoché, 140; The Fable of the

World, 143; The Imaginary Space of the Room, 147; Galileo's Fitting Room, 149.

CHAPTER SIX. Life at the Gap. 155
From Architectonics to Kinematics, 157; Motion Spaced Out, 161; Mathematical Realism and The Rendering of Reality, 163; Axiomatization, Idealization, Mathematization, 166; The Harmonies of the Room-Milieu, 167; Harmony and Motion, 170;The Room-Milieu of Arcadia, 173; The Compossibility of the Formula of Motion and the Ostinato Bass, 178; Life at the Gap: Verisimilitude and Truth, 184.

CHAPTER SEVEN. Baroque Twins: Science and Opera. The *Fin Lieto* of 187
the Baroque Formulation of Consciousness.
The Gentle Kiss and Bite (Joy and Malice), 188; Circles and Ellipses. Push and Shove: Correlates in the Life-World, 191;The Last Gasp of the Gap, 195; Tonic and Relative, p. 202; The Gap as "The Hermeneutical Doughnut," 204; Work and Performance. The Thingness of Things, p. 209.

CHAPTER EIGHT. The Enclave of the Eccentricity of Ordinary life. 215
The Classical Wolf at the Baroque Door, 217; Effeminacy and Hedonism, 222; The "Real" Unextrapolated, 227; The Last Stand of the Baroque Formulation of Consciousness: Rossini, 230.

CHAPTER NINE. The Domain of Phenomenological Clarification. 235
Predications of Reality and Existential Predications, 237; Some Moments Basic to the Phenomenology of the Formulations of Consciousness, 239; The Multiple Realities of the Enclave of Daily Life, 240; Presentive and Non-presentive Orders of Reality, 243; The Enclave of Daily Life and the Mimetic Epoché, 243; The Mimetic Epoché and the Phenomenological Epoché, 247; Compossibility and the "Fable of the World," 250; The End of the Road Across the Street. "Minding the Gap," 253.

Bibliography 257
Index 267

Preface

Some years ago, stranded in a large metropolitan airport, I passed my time by inspecting the wares of the many shops stocked to increase the bulk of one's carry-on baggage. In one of the shop windows I saw a sweatshirt with the word "Baroque (adj.)" in big black letters on the front. In the next line underneath in smaller letters was the definition: "When you are out of Monet." Below those letters was an empty picture frame. On impulse I purchased the shirt which still hangs in the back of the closet, unworn. It was worth the (exhorbitant) price, though, because it put me in mind of the fact that not only does the word, "Baroque," noun or adjective, still have a saleable meaning in ordinary experience, but it also bears the weight of its own carry-on baggage. Of course after the nineteenth century "Baroque" acquired a neutralized meaning in art-historical and social-scientific circles, as a period in history coming after the Renaissance. A good example is expressed in the title of a recent book, *Music & Spectacle in Baroque Rome. Barberini Patronage under Urban VIII.*[1] But the meaning of the ridiculous, the pedantic, even the empty-headed is also present in the sweatshirt-definition as well. Even in its presence in everyday life in the late twentieth century, "Baroque" still travels with the derogatory meanings invested in the word by eighteenth-century critics but also, in delightful contrast to Monet, with its richness, theatricality and monumentality along with its mannerist associations of exaggeration and eye- and ear-boggling complexity.[2]

That sweatshirt also made me realize that the use of the word, "Baroque," in the present book lives up to its sweatshirt attributions. At the same time it forced upon me the necessity of finding a way to get around the diversity of stylistic, social, philosophical, and scientific connotations of the word in order to locate a center of meaning which unifies and enables such diversity in the first place. Noble as that intention may have been when first I entertained it, I soon found a dark side to the presence of the Baroque in ordinary experience. When I first began to write this book it was also my intention to be sparing in footnotes despite the ambiguity of the word, "Baroque"—perhaps only half-dozen to a chapter. At the same time I also became aware of the very noticeable reluctance of many friends and colleagues to discuss the topic or even the Baroque, be the connotations of the word what they may. It became, in fact, quite embarrassing both academically and socially, which is why the sweatshirt still hangs unworn in the closet. For I had been made aware that the "trouble" with the Baroque was that it was the *fons et origo*

[1] By Frederick Hammond, Yale University Press, 1994.
[2] For the meanings of the term, "Baroque," see José-Luis Alonso-Misol, "En Torno al Concepto de Barroco," pp. 321-347; and Erwin Panofsky, "What is Baroque?" (1935), pp. 19f., 201f

of all the modernist evils which have befallen us, no doubt including some yet to come. Whether this is so, I do not know.

What I do know, however, is that the die were cast and in continuing to write this book I found I had few to talk to except the authors of books, painters of paintings and composers of music in and about the fifteenth through the nineteenth centuries. They, of course, required footnotes. The footnotes, then, represent the many (often late-night) conversations with, in a majority of cases, my predecessors rather than my contemporaries when stranded in airports large and small, or hiding in the basement from friends and relatives, or enduring mind-dulling faculty meetings or lecturing to peer- and career-paralyzed adolescents. Moreover, in this book I make no pretense to interpretations of art and science in or out of the Baroque any better or any less partial than either my contemporaries or predecessors. Nor do I claim to have made new discoveries of hitherto unknown materials hidden until now in the Vatican library or elsewhere, or deconstructed afresh lives, ideas and opinions. Because it is my belief that works of art and science are unique and untranslatable, my treatment of them is thematic, selective rather than exhaustive with respect to their presence in daily life where they subsist in all their plenitude and ambiguity. Although in many respects this book is scholarly, even scientific and historical, at times technical in method and content, more than anything else it is a labor of love. There is, of course, no reason why I or anyone else has to like all of what they love.

Galileo and the Invention of Opera begins and ends with the presence of the Baroque in ordinary experience, and seeks to unravel and account for that presence in very specific ways. The title expresses my belief[3] that, rather than simply the commonplace of historical juxtaposition, the coincidental emergence of opera and modern science[4] is more like the birth of twins who, as that most baroque of Baroque writers, Paracelsus said, "resemble one another completely without its being possible for anyone to say which of them brought its similitude to the other."[5] Opera and modern science are Baroque twins associated with two almost exact contemporaries, Galileo Galilei (1564-1642) and Claudio Monteverdi (1567-1643), whose writings, ideas and compositions, like those other not quite identical Baroque twins of somewhat later date, Bernini's Santa Maria di Montesanto (1662) and Fontana's Santa Maria dei Miracoli (1677), uniquely embody and thereby provide a compass to the many-sided complexity of Baroque thought and experience. The word, "invention" of the title expresses

[3] A first attempt to explore this belief was made many years ago in "Baroque Twins: Science and Opera," 1984, pp. 402-422.

[4] It may well be that opera and modern science, in some form or other, were "invented" elsewhere at other times. Why they were or were not is is beyond the scope of this book to consider. See H. Floris Cohen, *The Scientific Revolution. A Historiographical Inquiry*, Chapter 6, "The Nonemergence of Early Modern Science outside Western Europe."

[5] Paracelsus, *Liber Paramirum* (1562); cited by Michel Foucault, *The Order of Things. An Archeology of the Human Sciences*, p. 20.

an operative rather than descriptive concept of the coincidence of the emergence of opera and modern science; "Galileo" and "Monteverdi" are names, among others, for sets of ideas attributed, with good reason, to historical persons but which nevertheless transcend their attribution (below, p. 253).

That said, then by "invention" and twinned similtude of opera and modern science I mean something both more and less than a "common ground" (Cassirer), be it "a priori" (Panofsky) or "a posteriori" (Hauser), or "parallel ideas" or an "eternal golden braid" (Hofstadter) tying them together. If, just for the moment, questions of historical genesis are set aside (but by no means ignored), and if reflections psychological, metaphysical and musicological are stuffed away in a bottom drawer for later reference, then the belief I wish to explore is that opera and modern science, *rather than finished products of the Renaissance and Baroque, are instead tasks to be accomplished in common, thereby sharing an (ideal) possibility or "essence"* (as Edmund Husserl would say). And this entails my further belief that it is this overt but frequently covert task and shared possibility or essence, in themselves neither operatic nor scientific, which have given shape, meaning, at times even substance to our ordinary beliefs about science, opera, more broadly, art. In turn, the task and shared possibility have informed the ways in which we have access to and explain the "reality" of our world to ourselves from sweatshirts in airport malls to virtual reality.

But if there is any question at all bearing upon how we have access to and explain our world and "reality" to ourselves whether as mathematical manifold or as the human condition, it is, to paraphrase Aron Gurwitsch, always *implied by a quite specific formulation of consciousness included in modern theories and ideas and which serves as their point of departure.*[6] The ideas of opera, art and modern science explored in this book are no exception when considered as a common task sharing an essence or ideal possibility giving shape and meaning to our ordinary beliefs. Accordingly a chief task of this book will be to solicit some of those quite specific formulations of consciousness. And if the ideas of our world and the "real" are to be anything more than a mere assemblage of whatever grounds bestowing greater or lesser plausibility on our beliefs, and if we are to undercut the diversity of stylistic, social and art-historical connotations of the word, "Baroque," then a *phenomenology of consciousness* is required to secure the experiential data of ordinary experience that allow for them and their legitimation in the first place. Thus the subtitle of this book: "A Study in the Phenomenology of Consciousness."

In this respect this book may also be said to be an implicit, but at times explicit, application of a Husserlian phenomenological method to a set of problems of historical, musicological, literary and philosophical research focusing on mutually interactive connections between opera and science,

[6] Aron Gurwitsch, *Human Encounters in the Social World,* Part I. For the technical meaning of "formulation of consciousness," see below, pp. 94f., 103.

painting, architecture and sculpture from the fifteenth through the eighteenth centuries (well, a tad of the nineteenth century as well). There are several reasons for this choice of phenomenological method to develop a quite specific "Baroque formulation of consciousness."[7]

The first, and most likely obvious, reason is that the phenomenology of consciousness introduced by Husserl continues and advances the great empirical tradition begun by Galileo and others in the late sixteenth and early seventeenth centuries. A second, and doubtless less obvious, reason is that Husserl's phenomenological method can be employed at the same time to shed light on difficulties and even contradictions which have haunted both contemporary and traditional concepts and ideas of consciousness as much in science as in philosophy, music and painting. Notwithstanding, this book makes no pretense of being a phenomenology of science, or of philosophy or of painting or even of music.[8] After all, such "phenomenologies" would then be but one among many other kinds of theories in history. *The task*, instead, *of a phenomenology of the formulations of consciousness is to discriminate just what is granted to everyday life and theories about it at a certain time, but always only within the domain of phenomenological clarification.* This task, however, has the further consequence that the formulation of consciousness operative in the thinking and work of certain painters, musicians, philosophers, scientists, poets and playwrights in the Renaissance and Baroque will be understood, finally, as exemplifying empirical

[7] For the specifics of the *Husserlian* method employed here, see Fred Kersten, *Phenomenological Method: Theory and Practice*, §§7-12, 35, 100. The present book, in addition, complements my earlier attempts to understand the requirement of the phenomenology of consciousness in scientific theories; see Fred Kersten, "The Constancy Hypothesis in the Social Sciences," pp. 521-564. I have discussed the nature of the inclusion of the phenomenology of consciousness as well in *Phenomenological Method: Theory and Practice*, pp. 121ff. In the former study, discussion is restricted to social-scientific theories, in the latter to natural-scientific theories of space and time.

[8] The only full-fledged "phenomenology of music" of which I am aware is Gustav Güldenstern, "Beiträge zu einer Phänomenologie der Musik," first published in *Schweizerische Musikzeitung und Sängerblatt* (1931), derived from his *Theories der Tonart* of 1928. Mention may also be made of Alfred Schutz, "Fragments on the Phenomenology of Music," pp. 5-72; see also his *Life Forms and Meaning Structure*, jp. 180-208. Unfortunately, these fragments of Schutz are too incomplete to provide more than a generous hint at what might count as a phenomenology of music. In contrast, Schutz's published essays on music—"Mozart and the Philosophers" and "Making Music Together," reprinted in Alfred Schutz, *Collected Papers*, Volume II—are more properly to be regarded as chapters in the "phenomenology of the social." For an overview of literature pertaining to the phenomenology of music, see Edward Lippman, *A History of Musical Aesthetics*, Chapter 14. The situation is perhaps more fortunate in the case of the phenomenology of science. See Edmund Husserl, *Die Krisis der Europäischen Wissenschaften und die transzendentale Phänomenologie*, §§9-10; see also Aron Gurwitsch, *Phenomenology and the Theory of Science*, Chapters 2 and 6; Patrick A. Heelan, "Husserl's Phenomenology of Science," pp. 387-427. It would seem, however, that a "phenomenology of philosophy" has yet to be written (in contrast to a "phenomenological philosophy").

cases of a first attempt to elaborate that formulation as a shared, ideal possibility or essence but established on a different and perhaps sounder basis. A complementary task is to inquire, then, whether that first, actual formulation is the only possible one or whether there are any other formulations possible on the same or similar basis. Both tasks are central to this book.

In this respect this book may be considered as a study of the "origins" of specific, actual and possible formulations of consciousness revealed in Renaissance and Baroque music (especially opera) and science. The phenomenology of consciousness will serve, accordingly, as a necessary (but not sufficient) requirement for fixing the grounds and motivations, more narrowly, for the coincidental emergence of the Baroque twins, opera and modern science.[9] This is not to say that approaches other than the phenomenological have not been drawn upon: from the purely musicological (Bukofzer) to the structuralist (Damish), from the deconstructuralist (Tomlinson) to the hermeneutical (Dahlhaus), from the historiographical (Cohen) to the aesthetic (Kivy, Goehr) and to whichever other approaches will help point us to the specific, Baroque formulation of consciousness.

Besides the complaint of reopening the Pandora's Box of "modernist evils" and impeding the progress of postmodernism, there is the complaint that I have omitted discussion of Mozart. I can only reply that I was unable to discover a formulation of consciousness for Mozart. There is, to be sure, a formulation of consciousness for J. S. Bach,[10] but then I had already put my money on Monteverdi and Rossini which preserve the operatic parameters required by this book. In the case of the complaint about my continued and perhaps overzealous use of the word, *real,* in quotation marks, usually characteristic of phenomenologists and manufacturers of message-laden sweatshirts, I was put in mind of Virginia Woolf's essay, "A Sketch of the Past." Unfinished at her death by suicide, in her essay she ponders the question whether we should simply call, as convenient, the real real, or whether it should be plain "real" or even 'real.' The question bothered her, as it does me and others, and she thought that one day she might state the question more exactly and then "worry out" an answer. Because, too, for quite different reasons, I still have not found the time to worry out an answer, I have stuck to the double quotation marks throughout.

Fred Kersten
31 December, 1996

[9] And a "phenomenology of consciousness," whether considered in the case of science or of music (or whatever) is to be sharply distinguished from a "psychology of consciousness;" in this connection, see Aron Gurwitsch, "The Phenomenological and the Psychological Approach to Consciousness," pp. 89f., 96ff., and Güldenstern, "Beiträge," pp. 4ff.; see also below, pp. 92, 100f., 179f.
[10] See Douglas Hofstadter, *Gödel, Escher, Bach: An Eternal Golden Braid. A Metaphorical Fugue on Minds and Machines in the Spirit of Lewis Carroll* (1979).

Acknowledgments

For providing funds to obtain many of the research materials used in this book, I wish to acknowledge my thanks to Chancellor Edward W. Weidener and the Frankenthal Foundation of the University of Wisconsin-Green Bay. For their encouraging support in writing this book over the years I wish to express my sincere appreciation to many friends and colleagues, especially Pina Moneta, Lester Embree, Irwin Sonenfield, Carlos Vela Bueno, Elizabeth Behnke and Vivian Foss. I wish to thank John J. Drummond, editor of Contributions to Phenomenology, and two anonymous reviewers whose frank and helpful suggestions I have tried my best to incorporate into the text. Special thanks go to Maja S.M. de Keijzer of Kluwer Academic Publishing for her very special help. I am deeply indebted to my sons, Andrew and Stephen, for their help and encouragement in preparing this book, locating difficult to find books, repairing as best they could my aberrant 9th-grade mathematics, and patience in resolving my many problems in word-processing. To my wife, Karen, I am especially grateful for creating a place to write and a life to live with it.

Here, too, I must also acknowledge, not the presence, but the absence of a reader to whom I am deeply indebted: Maurice Natanson (1925-1996). To preserve his presence in his absence, I have given him the last word in this book.

For permission to reprint copyrighted material, I gratefully acknowledge the following publishers, authors, translators and artists:

Photo of Bernini's Santa Maria di Montesanto and Fontana's Santa Maria dei Miracoli in the Piazza del Popolo, Rome, courtesy of "The Butterfly Lady."

Drawing by C. Barsotti; © 1992 The New Yorker Magazine, Inc.; and drawing by Bruce Eric Kaplan; © 1992 The New Yorker Magazine, Inc.

W. W. Norton & Company, New York, drawing of José Ortega y Gasset attributed to Hermann Weyl, in José Ortega y Gasset, *The Idea of Principle in Leibniz and the Evolution of Deductive Theory,* translated by Mildred Adams. New York: W. W. Norton & Company, 1971.

Dover Publications, Inc., New York, reproduction of woodcut by Albrecht Dürer, no. 338, Albrecht Dürer, *The Complete Woodcuts of Albrecht Dürer,* edited by Dr. Willi Kurth. New York: Dover Publications, Inc., 1963.

UMI Research Press, Ann Arbor, musical diagram from Barbara Russano Hanning, *Of Poetry and Music's Power. Humanism and the Creation of Opera.* Ann Arbor: UMI Press, 1980.

Illustrations

Santa Maria di Montesanto/Santa Maria dei Miracoli	Title Page
"Perspective" by Barsotti	83
Caccini, *La Dafne*	98
Dürer, "The Room"	114
Jean-Baptiste Wenyx, Portrait of Descartes	145
Galileo, *Dialogue*, Frontispiece	159
Herman Weyl, Diagram	207
"I'm Tired of Being Treated Like An Object," by BEK	255

Chapter One

Intimations of the Gap

Once I overheard a conversation in a local biker-bar between several of the regulars and a biker-sociologist, or better, a sociologist cum biker. The question was whether, in point of fact (a locution gleaned from PBS docudramas), the scientist refers to the same reality of the social world that appears to your average biker, or your average anyone else, or whether there is more than one reality and if so, whether they are coinciding or separated by a gap and unrelated to each other, or even whether one is an appearance of the other. It was clear that by "average" was understood anyone who had the good fortune not to have a Phd in one or another of the social or natural sciences. The question, moreover, was posed in such a way that, as is generally the case in biker-bars, a yes or no answer was required (the ultimate fate of the Scholastic *sic et non*). Because there seemed to be neither a yes or a no, the issue was settled in the only way fashionable in a dehumanized, industrialized community: tire irons and chains. Social reality, *as it appears to your average biker*, prevailed, and the biker-sociologist was carried off in a squishing plastic sack to the dumpster across the street.

This story is not introduced as hyperbole. It has its origin in a strange situation beginning in the Baroque with the invention of science and opera. It is only the tip of a Baroque iceberg. As such, and at the beginning, it serves to confine our initial approach to the coincidence of the invention of science and opera to a certain vantage point: the experience in ordinary life of a "gap" between itself and its "representation" in scientific thinking as well as in music and art in general. It is that "gap" and its sundry intimations which are at issue in being allowed for and accepted by ordinary, everyday experience by reason of its own self-interpretation. Still, this is not obvious or at least no more so than the meaning of the nature of modern science or art or opera in particular. At the very beginning it is important to say something about ordinary experience and the "gap" between it and its "representation" in science and art.

Ordinary, everyday experience, after all, is anchored in the social world biographically and autobiographically. Some years ago when cleaning out the attic I stumbled over a box of books. One of the heavier books that fell out and struck my foot was a textbook of physics, and physics, as everyone knows, is a science, for many even "the" science. The temptation was too great to resist: I closed my eyes, then opened the book at random; opening my eyes to the page that fell open I read that light consists of a certain number of vibrations per second of particles in an electro-magnetic field. That text may be dated, but I did find it instructive and, so it would seem, useful. Seeking comic relief from attic-cleaning, armed with this information I set off for my favorite haberdashery and demanded to be shown a suit the color of which consisted of particles vibrating 1/360.27 times per second in an electro-magnetic field. At first the clerk laughed the laughter of clerks humoring their custom. But when I insisted and showed him my book he became hostile. I then asserted that it was the latest fashion, as any fool knows. At the word "fool" there arrived on the scene a large man with

razor-styled hair and a manicure: the manager. As I became more insistent (that is to say, shrill), other customers in the store stared and and began to smirk, especially when the manager disappeared and the police arrived with my parole officer. A struggle ensued when I was escorted to the door.

Clearly I had encountered a "gap" between what I read in my textbook about color and light and a situation in ordinary life which called for a judgment about color and fashion. In my textbook, it would seem, chromatic properties do not exist, at least in any way familiar to me. Reading on, my physics book informed me that there are two different schools of thought about light and color. According to one, light is undulatory; according to the other, light is corpuscular (what a muscular word!). Yet there is nothing whatever in my ordinary clothes-buying experience that facilitates deciding between these schools of thought, let alone understanding them in a way so as to buy a suit of clothes. While in jail awaiting sentencing it occurred to me that such a textbook cannot be very good anyway (it was inscribed by my Darwinist grandfather), and no doubt it was time to throw it out. Before I did, however, I also learned that for about four hundred years the earth has been said to rotate in an elliptical orbit around the sun, and this is known by virtue of certain computations. I could not recall experiencing anything of that motion in daily life. Membership in the Flat-Earth Society carries with it an adjunct membership in the Flat-Earth-At-Rest Society. Indeed, what would it be like were I to experience the earth in motion? While in jail (30 days, no early release) a charming literary friend sent me a book to read, Rainer Maria Rilke's *Notebooks of Malte Laurids Brigge*. For the first time I became acquainted with Nikolai Kusmitch.[1]

With Nikolai Kusmitch my encounter with the gap became more terrifying than violent. To Nikolai Kusmitch, one day, "something singular happened. He suddenly felt a breath on his face; it blew past his ears; he felt it on his hands. He opened his eyes wide. ...And as he sat there in the dark room with wide-opened eyes, he began to realize that what he now sensed was actual time, passing by." As if that were not enough, Nikolai Kusmitch "recognized them concretely, these tiny seconds, all equally rapid, one like the other, but swift, but swift." I found this sufficiently disturbing to cause me to trade my wristwatch for cigarettes. There was worse to come, however; "his surprises were not yet at an end. Beneath his feet as well there was something like a movement, not one movement only, but several, curiously interoscillating. He went stiff with terror: could that be the earth? Certainly, it was the earth. And the earth moved, after all. That had been spoken of in school; it had been passed over rather rapidly and later was readily hushed up; it was not held fitting to speak of it. But now that he had once become sensitive, he was able to feel this too ..."

The result of feeling the earth move had a decidedly debilitating effect on Nikolai Kusmitch, as it would on anyone, so that "he avoided even the street cars. He staggered about in his room as if he were on deck and had to hold on right and left. Unluckily something occurred to him, about the oblique position of the earth's axis. No, he could not stand all these movements. He felt wretched. Lie down and keep quiet, he had once read somewhere. And since that time

[1] Rainer Maria Rilke, *The Notebooks of Malte Laurids Brigge*, pp. 151f.

Nikolai Kusmitch had been lying down." No wonder the motion of the earth and the oblique position of its axis was not fit to speak of. Of course, one might breathe a sigh of relief at the realization that Nikolai Kusmitch is a fiction, though a disturbing one. It is as though the gap between ordinary life and the astronomical construction of the universe disappeared, closed in upon itself. Action in ordinary life becomes impossible, even the simplest things like standing up so that there is a world at all present to us (as we learn from Aristotle). I am in jail because the "gap held;" Nikolai Kusmitch is lying down because the gap failed to hold.

The two examples are instructive. In the first, that of light and color, I am informed (by my textbook) about the existence of certain things quite removed from what I believe to exist in my ordinary, everyday clothes-buying life. In the second, ordinary perceptual experience simply contradicts the "facts," and when I opt for the "facts" my life becomes one of terror and inaction; I cannot even stand up but have to lie down in my room. It would seem that in our ordinary lives we accept, then rapidly pass over and readily hush up, the teachings of physics and astronomy. As it were, we continue to allow ourselves to be "deceived" as to the experience of our planet in a solar system. Or else if we face up to our experience there is either prison or terror or both. Even though it may not be fitting to speak of it, we live in two entirely different "worlds" or "sub-universes" at the same time, neither of which admits of the other. Overtly or covertly we must choose between them. Yet we do not insist that there are two realities rather than one. But what, then, is the connection between them? Must we really live in one to the exclusion of the other? There would seem to be no "enclave"[2] where they overlap; there would seem to be a limiting case to the overlapping "worlds," "sub-universes" or "multiple realities" which otherwise infect the paramount reality of our daily lives. How do we bridge the gap—assuming the unbridgeable is bridgeable? Can we survive at all if the gap does not remain? How do we accommodate the gap in our experience? Is it speakable even if unbridgeable?

Bridging the Gap

Were we to trace the course of scientific thought since the fifteenth century in even the most cursory and superficial way, we would still be struck by the way in which it becomes increasingly "abstract" when measured by the most rationally constructed affairs of daily life. To take a random example from another of those textbooks I stumbled across in the attic, in the nineteenth century Faraday and Maxwell found that when the magnetic pole is rotated something happens in space conceived as a contracting and expanding medium filled not just by air but also by other entities and aether. Although their construction was explained in terms of mechanics, it was nevertheless designed to make something visualizable. The mechanics contained what may be called

[2] See Maurice Natanson, *Anonymity. A Study in the Philosophy of Alfred Schutz*, pp. 96ff., 109f., 116.

4

an "intuitive content" but one for all that amenable to being constructed into a model described in mathematical terms. Thus despite the abstractness of their construction, events in Nature are still visualizable as contracting and expanding. Reading on I find that a remarkable change occurs in the twentieth century. Mechanics and physics no longer are said to have an "intuitive content," and only mathematical formulae are of importance whether or not there is "intuitive content."[3] I was not impressed or much interested by this until I began to wonder what that pathetic figure, Nikolai Kusmitch, did for a living. To find out I had to borrow someone else's fiction.

José Ortega y Gasset once likened the situation where "intuitive content" is lacking, where only mathematical formulae are important, to the cloakroom at the theatre where we leave our overcoats and in return receive a numbered check from the cloakroom attendant, Nikolai Kusmitch.[4] Obviously the check does not resemble in the least the overcoat; still there is a correspondence between the series of checks and of overcoats hanging on the rack so that each check corresponds to its respective overcoat. "Imagine, then," Ortega says, "that the cloakroom attendant has been blind from birth and can read the engraved numbers on the checks only by the sense of touch. He can distinguish between them or, what is the same thing, he knows them. When he touches a check and finds its number, he then runs over the series of coats and finds the coat which corresponds to the check, and this is possible despite the fact of having never seen a coat. The physicist, then, is the blind cloakroom attendant in a material universe. Can one say that he *knows* reality? Even at the beginning of the century the physicists…were saying that the method of physics is limited to the construct of mechanical 'models' which show us clearly the real process that manifests itself only confusedly in phenomena. …Physicists themselves called this blind knowledge 'symbolic knowledge' because instead of knowing the real thing, it recognizes its sign in a system of signs or symbols."

The question is not really, then, whether there is a "content" that is visualizable or constructable into a "model" of some sort. That proves to be unimportant and irrelevant. Even into the nineteenth century there is yet a connection of sorts, perhaps only confusedly manifest in phenomena, between the universe constructed by the physicist and ordinary daily life; the former can be visualized within the framework of the latter. But in the twentieth century that connection would seem to be gone, the gap in our experience become secured by virtue of its blind, symbolic bridging. In virtue of being bridged, the gap is secured and its very unbridgeability established in being bridged. At least as cloakroom attendant, as physicist, Nikolai Kusmitch is safe, the integrity of ordinary life remains intact.

Of course, nothing has been settled about the nature of ordinary life, the gap that secures or imperils it and Nature as constructed in scientific thought. The situation has a history and one which will be poked and probed in the chapters to follow. Moreover the situation just sketched concerning ordinary

[3] See Ernst Cassirer, *Determinism and Indeterminism in Modern Physics. Historical and Systematic Studies of the Problem of Causality*, pp. 171ff., and Chapter 12.

[4] José Ortega y Gasset, *La Idea de Principio en Leibniz y la Evolución de la Theoría Deductiva*, p. 41 (English translation, pp. 32f.) See below, pp. 206ff.

life and the result of scientific thought is not an unfamiliar one even if generally taken for granted, even if it becomes prominent as such under bizarre circumstances perhaps best left to fiction. Before it is possible to investigate the gap further, eventually reconstructing its "origin," there is another perhaps even more familiar encounter with the gap. The example also has its history and is a coincidental, historical cousin of the science with which I became acquainted in my attic textbook. In the attic I also found music scores and, of course, old records.

The Operatic Gap

Sooner or later (depending on how crowded the crush bar), having checked our overcoats, we leave the cloakroom and bar for the theatre auditorium to attend the opera. Writing about opera in one of the essays in *The Dyer's Hand*, W.H. Auden first illustrates the difference between acting and singing, then sums up what has been peculiar to opera since its invention at the end of the sixteenth century.[5] Because we have all learned to talk it is possible that most of us could be taught to speak verse. Yet very few of us have learned to sing or have been taught to sing so that in "any village twenty people could get together and give a performance of *Hamlet* which, however imperfect, would convey enough of the play's greatness to be worth attending."

Yet if they tried to stage a similar performance of *Don Giovanni* it would be quickly perceived that it was hardly a matter of a good or bad performance; they simply could not sing the notes at all. "Of an actor, even in a poetic drama, when we say that his performance is good, we mean that he simulates by art, that is, consciously, the way in which the character he is playing would, in real life, behave in nature, that is, unconsciously." However, in the case of a singer (or, Auden adds, a ballet dancer), there can be no question whatever of simulation, of singing the notes "naturally." Indeed, it would be "unnatural" to sing the notes "naturally." The reason is that the singer's "behavior is unabashedly and triumphantly art from beginning to end." The curtain has barely been raised before we are confronted with a gap, a discrepancy, with daily life not unlike that brought to light in the cloakroom. Auden calls it a paradox that is implicit in all drama, namely that "emotions and situations which in real life would be sad or painful are on the stage a source of pleasure [which] becomes, in opera, quite explicit." Here the gap between ordinary life and what is constructed, now, by "compositional thinking" takes on a shape rather distinct, at first sight, from that scientific thinking (perhaps even more bizarre than feeling the earth move or time pass by).

Suppose that a singer is playing the role of a deserted bride, Auden says, who is about to kill herself; as we listen "we feel quite certain...that not only we, but also she, is having a wonderful time." In a sense, there can be no tragic opera because whatever errors the characters make and whatever they suffer, they are doing exactly what they wish. Hence the feeling that *opera seria*

[5] W. H. Auden, *The Dyer's Hand and Other Essays*, pp. 468f.

should not employ a contemporary subject, but confine itself to mythical situations which, as human beings, we are all of us necessarily in and must, therefore, accept, however tragic they may be."

This is only the beginning of a characterization of the operatic gap. Auden finds Mozart "right" with the idea that feelings such as joy, tenderness even nobility are not confined just to noble characters but mark everyone's experience even if stupid, depraved, and just this is demonstrated by opera "to the shame of spoken drama that it cannot." It is a commonplace, of course, that in ordinary life we use language and in such a way that we identify our way of speaking, even our vocabulary, with our social character established as we are seen by and known to others. Now, in a play the limits are very narrow that circumscribe the range in speech that is possible for a character; if the playwright oversteps those limits the character becomes incredible rather than credible. However, owing to the fact that we do not communicate by singing it is always possible for a song to be out of place, but not for it to be out of character: "it is just as credible that a stupid person should sing beautifully as that a clever person should do so. ...No good opera plot can be sensible for people do not sing when they are sensible."[6]

Rather than the whimsical and incidental result of setting words to music, this is the direct consequence, Auden says, of music declaring its own "self-consciousness" achieved when music adopts time signatures, barring and, finally, the metronome beat—all things quite familiar in ordinary life, yet which do not belong there at all. The situation is rather similar to that of the checks in the cloakroom for without "a strictly natural or cyclical time, purified from every trace of historical singularity, as a framework within which to occur, the irreversible historicity of the notes themselves would be impossible."[7] In this connection Auden emphasizes an idea, hardly uncommon or especially original. He refers to the aria, *"Ah, non credea mirarti"* from *La Sonnambula*, and notes that while it may be of little or no interest to read, yet the verses accomplish just what they should by evoking in Bellini "one of the most beautiful melodies ever written and then leave him completely free to write it." The idea is that in opera we depend entirely on the music for comprehension of how the composer, and, by extension, we the listeners, conceive of the text.[8] To this commonplace,

[6] *Ibid.*, pp. 469f., 472.

[7] *Ibid.*, p. 466. See below, pp. 197f.; in Chapter Five we shall examine a precise analogue of this in Baroque science where not just time but space is "purified" from every trace of historical singularity. With respect to the laws of motion, Aristotelian science is to Baroque science what spoken drama is to opera.

[8] In this connection, see Edward T. Cone, "The Old Man's Toys: Verdi's Last Operas," p. 130: "In any opera, we may find that the musical and the verbal messages seem to reinforce or to contradict each other; but whether the one or the other, we must always rely on the music as our guide toward an understanding of the composer's conception of the text. It is this conception, not the bare text itself, that is authoritative in defining the meaning of the work." Cone provides a fascinating example of this idea in tracing the same music of Ford's "è sogno? o realtà" in *Falstaff* to that of Otello, pp. 130ff. (See below, pp. 230.) Another side of the coin of Auden's point is expressed in Carolyn Abbate, *Unsung Voices. Opera and Musical Narrative in the Nineteenth Century*: In "*Opera, or the Undoing of Women*, Catherine Clément argues that women are killed off

however, Auden adds a baroque twist: "The verses which the librettist writes are not addressed to the public but are really a private letter to the composer. They have their moment of glory, the moment in which they suggest to him a certain melody; once that is over, they are as expendable as infantry to a Chinese general: they must efface themselves and cease to care what happens to them. ...The poetic value of the words may provoke a composer's imagination, but it is their syllabic values which determine the kind of vocal line he writes. In song, poetry is expendable."[9]

The lack of simulation, the primacy of syllabic values over poetic ones, the "metronome beat," purification from historical singularity, pleasure in what in ordinary life would be sad or painful, fated, confined to mythical rather than contemporary situations: all such characeristics (and they are as "abstract" as any in scientific thinking) establish the same sort of unbridgeable gap between

by the operatic plots they occupy so that their dangerous energy, contained by death, will be rendered innocuous. The male observer, from his place in the audience, can thus gaze both upon these women and upon their defeat: a comforting pastime. A telling critique of Clément's thesis, however, comes from just such a male operagoer, Paul Robinson, who pointed out that in focusing on the women's final defeat by operatic plots, Clément neglected their triumph: the sound of their singing voices. ...Robinson hears opera in a way that has nothing to do with the events that its libretto depicts; he hears it as sonorous texture, and he redirects our attention from opera's representation of dramatic action toward one aspect of its musical body. ...Music, conventionally defined in terms of its events (and often its plot), also sets forth speaking and singing voices. Plotted explanations of music...are a familiar form of music-analytical discourse. The metaphor of music singing, having a voice, though a commonplace in nineteenth-century musical aesthetics, is today more unusual; it is most familiar to Anglo-American readers from Edward Cone's 1974 book *The Composer's Voice*. ...What I mean by 'voice' is, of course, not literally vocal performance, but rather a sense of certain isolated and rare gestures in music, whether vocal or nonvocal, that may be perceived as modes of subject's enunciations" (p. ix). In later chapters we shall be concerned to develop these ideas in terms of what we shall call the "non-mimetic" mode of representation.

[9] Auden, *op. cit.*, p. 473. For some indication of the nature of versification and ideas governing poetic and syllabic values of words, at least for Italian opera in the first part of the seventeenth century, see the detailed discussion (especially of strophic songs) in Barbara Russano Hanning, *Of Poetry and Music's Power. Humanism and the Creation of Opera*, pp. 156ff., which effectively bears out Auden's idea of verses as a "private letter to the composer." It may not be too far-fetched to regard scientific experiments in the Baroque likewise as a "private letter" to the scientist; for example, many writers have noted the strange lack of mention in Galileo's writings of specific descriptions of scientific experiments, which make it seem as though Galileo was more interested in polemics than in reporting his experiments. To be sure, the question is as complex in opera as in science; in this connection, see Stillman Drake, *Cause, Experiment & Science*, Preface, and pp. 203ff., 209f., 217f., where, as it were, Drake seeks to reconstruct the "private letters;" and A. Rupert Hall, *The Revolution in Science 1500-1750*, pp. 101ff., 112f.

There is yet another side to this issue; Galileo, like Monteverdi in the publication of his scores, only sketched his materials in the way Monteverdi only indicated his instrumentation. See Nikolaus Harnoncourt, *The Musical Dialogue. Thoughts on Monteverdi, Bach and Mozart*, pp. 29ff., 35; see below, Chapter Seven, pp. 209ff.

ordinary life and the "worlds" composed or constructed scientifically. Nikolai Kusmitch, the blind cloakroom attendant, is not just the physicist but he could just as well be the composer (for Descartes, Stevin and Leibniz, among others, he would be *ipso facto* the composer[10]). Moreover, as in the case of ordinary life and science, there is no "enclave," no overlapping of "multiple realities" or sub-universes of meaning. Yet that is not the whole story because it is only as cloakroom attendant that Nikolai Kusmitch is blind, only as composer that what in ordinary life would be sad or painful is a source of pleasure. When Nikolai Kusmitch locks the cloakroom for the night, when the performance is over, the theatre dark again, and he goes home, he is no longer blind nor does he find pleasure in the pain of a lonely life in a small room. He is no longer physicist, nor composer (shortly we shall refer to this as the "eccentricity" of human life). The gap remains unbridged. And ordinary, everyday life allows for the gap in so far as it is taken for granted "until further notice." If it is not taken for granted, if Nikolai Kusmitch or anyone else finds pain a source of pleasure when feeling time pass by and when experiencing the rotation of the earth on its axis around the sun, it is no longer a question of the gap being bridged *but rather of how to restore it*. For without the gap, ordinary life becomes confusing, debilitating; one cannot act, plan, carry out projects, operate with the familiar typicalities constituting the social world. Sociality itself would seem to disappear. This situation, too, has a history.

It makes sense to ask how such a situation has come about. It makes sense to ask for the epistemic and aesthetic foundation of the gap, the discrepancy, between ordinary life and science and opera—music and art generally—such that the gap surfaces only when no longer taken for granted in ordinary life. After all, is not the science of Nature about the world into which we are born and in which we die? Is not opera a "representation" of joy, tenderness, nobility, of situations which we must accept no matter how tragic? Have they no application to and influence upon our lives? Does not even the most "abstract" scientific theory, or the grandest opera, represent an intervention, if not intrusion, into the sociality of our economic and political well-being in the world?[11] How can we sanction and warrant what has no connection with us only in so far as it has no connection, only in so far as the gap is secure?

[10] For a detailed discussion of the "mathematization" of music, see H. F. Cohen, *Quantifying Music. The Science of Mustic at the First Stage of the Scientific Revolution, 1580-1650*, especially Chapter 2. A striking, but late example, can be found in Leibniz, *Der Briefwechsel zwischen Leibniz und Conrad Henfling*, especially those letters of 1706. We shall return to this issue, Chapters Three and Six, below.

[11] In this connection, see Manfred F. Bukofzer, *Music in the Baroque Era*, Chapter 12. Chapter Four, below, will deal with this issue from a phenomenological rather than economic or political point of view. See also an important, but much later example confined to France, Jane Fulcher, *The Nation's Image. French Grand Opera As Politics and Politicized Art*, Chapter 2. The whole question raised here has its theoretical and conceptual difficulties, and concerns much more than "historical stocktaking;" the best introduction to the problems and conceptual difficulties is to be found in Lydia Goehr, *The Imaginary Museum of Musical Works. An Essay in the Philosophy of Music*, Chapter 5. The problem is not unrelated to that mentioned in note 8 above.

Preliminary Stocktaking of the Gap

Modern science and opera are equally historical phenomena invented in the Renaissance and Baroque. Likewise the "gap," the discrepancy, between ordinary life and the "worlds" represented by science and opera is also a historical phenomenon. The gap is itself a phenomenological clue, as Husserl would say, as much to the nature of the constituting of modern science and opera as to the constituting of daily life. By virtue of the gap between them, science (or opera or even painting) and ordinary life are necessary but mutually irreducible correlatives. The next chapters will develop this unusual if not bizarre phenomenon by examining how the gap is established in its phenomenological "origin." Certainly before science in the "Galilean style," as we shall call it with both a Baroque and Husserlian nuance, there existed science (for example) in the "Aristotelian style" which conceived of Nature as a morphological rather than a mathematical manifold. Certainly before opera (in the "Florentine style"?[12]) there existed music in the polyphonic and other "styles" which represented a "world," for example, in function of an "other" world, Paradise. And certainly such "styles" did not require a gap between ordinary daily life and "worlds" constructed by science and music, let alone a gap that had to be taken for granted until further notice such that if notice is ever served, disaster, terror, inaction result. What is the basis for that "taken for grantedness"? What is the "origin" of the gap? Before we can come close enough even to shake hands with these questions there is yet another set of questions which must be mentioned.

If there are other cognitive and affective "styles," other acquaintances and pre-acquaintances with Nature and Society, with their processes and events, then it is necessary to ask whether one or another "style" simply replaces others, and even whether it is a question at all of "styles," of "paradigms," "patterns" or "models"? The very question of "styles" replacing "styles" (e.g, science in the "Galilean style" replacing science in the "Aristotelian style") after all presupposes an idea of historical change that has its origin in modern science and historiography. For example, if we read about the astronomy of Ptolemy in another of my attic books, we learn that even then astronomy had a practical aspect and was effective for observations in navigation (provided, of course, that we do not get too far from shore or from home). If the planets are apprehended as circling the earth at rest, and if each planet in circling the earth performs epicycles and other fancy footwork (always, to be sure, on the background of the visible motion of the whole heavens), then the Ptolemaic theory is quite useful and instructive. The blind cloakroom attendant is not required, we can find our own coats, thank you, nor will Nikolai Kusmitch be troubled by experiencing the earth in motion or time passing by, or at least troubled in the same way that got him into trouble in the first place. With the Copernican idea that earth and planets circle the sun it is possible to drastically reduce the number of epicycles

[12] Because Vicenzo Galilei may have been the first to have written a genuinely monodic melody with harmonic accompaniment, we may be permitted to keep it all in the family by speaking of both science and opera in the "Galilean style."

each planet must make to fit our observations nor must celestial bodies have the fancy footwork of Samuel Beckett's Watt. Were we now, in our exuberance, to further suppose that each and every planet circles the sun in an elliptical orbit, we can safely eliminate the epicycles from our computations. What criterion, what measure of experience, is at work in such a line of thought?

At first sight it would seem that the measure is nothing else than a simplification of computation. Were that correct, then it would not be so much a matter of one "style" replacing another, or of one "style" of knowledge and experience suddenly acquiring privileged access to Truth and Meaning. It is instead a matter of simplifying computation. Such a conclusion is hardly far-fetched (at least at first sight), although it may not provide us with the "revolutionary" character usually assigned to modern science. We do not have to read Brecht to learn that in 1632 Galileo went on trial, that among other things the trial centered around the Copernican ideas Galileo held rather than the specifics of Galileo's physics, that told if he held Kepler's ideas solely for the purpose of simplification of computation rather than for any metaphysical or theological reasons, Galileo could consider the trial over. Of course, as Brecht (and so many others) suspected, there were additional and perhaps even more important factors involved.[13] Yet for Galileo's physics, in a word, the universe is a mathematical manifold and the Book of Nature can be read only in the light of its mathematical structure.[14]

Still, first sight tends to give way to second sight, eventually to hindsight. It may not even be a question of sight. Computational simplification may not be entirely innocent even when taken at face value, and perhaps no sight is required at all. Erwin Strauss, ever attentive to shifts in experience, noted that when "Copernicus conceived and elaborated the heliocentric sytem he did not watch the skies...While in his thoughts he was concerned with the constellation of the stars in their continually changing positions, he was not bound to any particular place or time in this thinking" (Auden's "purification from historical singularity"). Copernicus "used, of course, all the observations made...by astronomers before him. But the heliocentric systems deals with the relation of the sun and stars, envisioned as if it were from a point outside the solar system and certainly from a position removed—in thought—from the earth, which Copernicus had cut loose from its moorings and enlisted in the company of the other planets. The Copernican system discussing the revolutions of celestial bodies comprehends, in one view as partners of one relation, the sun and the stars, which are actually never seen together by a terrestial observer."[15]

[13] See Galileo's ironic letter to Fortunato Liceti of 1641 cited in Giorgio di Santillana, *The Crime of Galileo*, p. 329, and Santillana, pp. 261ff.; for a different aspect, Pietro Redondi, *Galileo Heretic*, pp. 325ff.; see also Walter Kaufmann, *Tragedy and Philosophy* (New York: Anchor Books, 1969), pp. 395ff.; and Edward Rosen's commentary in *Nicolas Copernicus. On The Revolutions*, p. 332.

[14] See Drake, *Cause, Experiment & Science*, pp 207f.

[15] Erwin Strauss, "The Expression of Thinking," in *An Invitation to Phenomenology*, pp. 290f. And this remains the case even when Copernicus insists that he explains the phenomena of the heavenly bodies, "the celestial ballet," by a general account of the earth's motion, something which can only be accomplished if the sun and stars are

What is the case for Copernicus obtains for Kepler and Galileo as well. For the sake of simplification, their computations are made with reference to an unobserved and, as we shall see, in a certain sense, an *unobservable* fact for a terrestrial observer in daily life, as though the gap were as well between the observable and the unobservable. One of the tasks in the next chapters will be to examine the way in which the "unobservable" fact figures into the extraordinary reorientations of thinking and experience that reaches down into ordinary life even in our own times. At the same time it will be possible to identify its equivalent in opera and the common "origin" of the "unobservable" fact in science and opera (and in painting as well).

But before it is possible to turn to the specifics of science and opera in the late Renaissance and Baroque, and still under the spell of biker bars, attics, haberdasheries and jails, it is necessary to introduce a set of ideas about ordinary life and the gap, the experiential datum of which serves as the springboard for the invention of science and opera by allowing for it in the first place. It is the point of departure, then, and some of its phenomenological characteristics must be formulated at the outset.

The Gap Taken for Granted

Sometimes the term, *"common-sense,"* is introduced to characterize ordinary, daily life. This may be appropriate, but not the least of the difficulties with the term is that it is not very common-sensical.[16] One of the reasons why this is so is because, however defined, "common-sense" rests upon a number of assumptions or "ontic convictions" about life and reality.[17]

It is a familiar commonplace that we live our lives in a straightforward way among other people, events, things all of a cultural sort. What makes the place common is the acceptance as existent of people, events, things in one or many ways by belonging to one real world so that all our activities and dealings with things, events and people indirectly but sometimes directly rest on a basic ontic premise. Stated in utmost generality, the ontic premise serves as a position or stance our ordinary lives take with respect to the unquestioned (although always questionable) or taken-for-granted universal right and claim to existence of things, events, others, and of the world one real world itself. Although challangeable and at times challenged in fact, our ontic premise or acceptance, conviction, as we shall also say, is not departed from. No matter what the circumstances, no matter whether perceiving, judging, valuing, imagining, remembering, anticipating, doing, there is always at least implicitly a continuous believing in the existence of perceived, judged, valued, imagined, anticipated

"partners of one relation" that depends on an unobservable fact. Making this point about Copernicus does not mean that Osiander's "fictionalist philosophy of science" is foisted on Copernicus who clearly rejects it; see Rosen, *op. cit.*, p. 335.

[16] See Natanson, *Anonymity*, pp. 105ff.

[17] Some of what follows was first developed in Fred Kersten, "The Life Concept and Life Conviction: A Phenomenological Sketch," pp. 115ff.

deeds done as well as in, themselves, the perceivings, judgings, valuings, doings, imaginings, as real processes going on in a real life.

What makes the place of the common even more commonplace is the fact that each of us, present now, is born alive into the world and that each of us, at any given moment, is already preacquainted with what it means to be in the world. Just this preacquaintedness harbors the enactment of the ontic acceptance or premise, conviction, as an inextricable segment of our experience whether we are asleep or awake, whether we work alone or with others, whether we are at home or at the club. No matter if it is ever made explicit or always only left to its own account, this ontic position or stance, belief-premise, concerns not just oneself but other people as well, social and political institutions and roles, events random and planned. The first thing that makes this commonplace ontic premise or existential belief common-sensical is the fact that no reflection or theoretical construct is ever required to inform us whether some of those things we meet in the familiar ordinary world are real, whether they exist or not; of course, we may be deceived at times, may even mistakenly confuse the manikin in the shop window for a real human being, or the coil of rope in the dark corner of the attic for a real snake. Yet to correct the error, to replace the deception and confusion, no discussion of theoretical possibilities or impossibilities need be introduced; nor need we consult the latest studies in the physiology and psychology of perception, pore over the latest arguments of speculative brain physiology and what "scientists think" or consult the gurus of "artificial intelligence" to undeceive ourselves. None of that is required to set the ontic stand we actually take and have already taken here and now.

Of course such a ground may be adduced and supplied, but always only after the fact and as presupposing the ontic conviction as much impervious to its very ungroundedness as indifferent to theoretical-philosophical or even natural-scientific attempts to ground it. Our basic ontic premise, or conviction, acceptance, we may say, is characterized by a self-sufficiency and self-inclusiveness, at least *until further notice*. This draws our attention to a second peculiarity of the commonplace ontic conviction that makes it common-sensical when it bottoms out in ordinary life:

The ordinary world into which we are born is the object of many other sorts of beliefs and convictions, some acquired early on in the encounter with the milieu in which we are situated (e.g., personal identity) and some later on as we grow up and, in an increasingly greater degree, are party to the world of social and political life (e.g., belief in the efficacy of the work ethic). All of these beliefs are ones touching on professional concerns at one end of the spectrum and on general recipes of behavior at the other end. Taken collectively, all such beliefs and convictions, whether cognitive or affective, form our "stock of knowledge at hand" (Schutz) which can be brought to bear, more or less effectively, under varied and variable conditions, on the typical and typifiable "world within reach" at the moment.[18] Out of what eventually emerges as a vast array of beliefs, some are found to stem from our parents and relatives, teachers, colleagues, friends, enemies, from implied and, at times, explicit mores and customs; still others originate from the past that forms part of our cultural

[18] See below, pp. 111f.

heritage and from the êthos shaping our sight into the future. Still others, presumably, are shaped by ourselves in the on-going course of daily life while yet others are derived from books in the attic.

The significance of this brief inventory is that all such beliefs and convictions can be traced in one way or another, with greater or lesser distinctness, to a source in the immediate or remote past; they all can be dated somewhere in our own autobiographies or in the biographies of others. And by virtue of having a source, be it firm or flimsy, evident or obscure, stupid or intelligent, their claim and right as beliefs can be retrieved, their grounds measured and assessed.

In contrast to all those beliefs and convictions mentioned, the existential belief or ontic stand we take in the world and cannot help but accept, can never be dated in the same way in our autobiographies nor in anyone else's, can never be traced back to a source, be it philosophical speculation or scientific theory or even common-sense. There is no conceivable "first time" the existential belief or ontic premise was acquired, there were never "good reasons" entertained which may be said to have motivated the ontic conviction in the first place. The ontic acceptance is just there, no matter what its specific content or gravity, no matter how it might be determined or defined. In this connection, another and third peculiarity of the commonplace must be noted.

All the other sorts of beliefs are open to the possibility that their claim to validity will be overturned or at least modified in some manner: all are *presumptive.* There is always the possibility that, in the further course of experience, they will be replaced by other and, perchance, "better" beliefs, or, if not, that they will at least stand the test for the time being. We may even speak here of "positive" and "negative" fulfillment of beliefs: In the case of negative fulfillment, where a belief is cancelled out, we always find a foreshadowing of a new belief to replace the old. But just such an experience never arises in the case of our ontic conviction, or existential belief, for there is no further course of experience in which our existential belief foreshadows or allows a contrary positive fulfillment were the existential belief cancelled.

As Santayana expressed it, life "involves expectation, but does not prevent death: and expectation is never so thoroughly stultified as when it is not undeceived, but cancelled. The open mouth does not then so much as close upon nothing. It is buried open."[19] It is therefore difficult even to assign a meaning to "cancellation" of an existential belief, of an element of what Santayana called "animal faith." We might also say that the ontic acceptance, conviction, is a primordial credulity, a primitive certainty of existence, a last stand with no ground to stand on: an open mouth. There is no "yes" or "no" with respect to the ontic conviction

Here, again, it is possible to see the *self-inclusiveness* and the entirely *gratuitous self-sufficiency* of the ontic life-conviction that excludes not only other sorts of convictions and beliefs but theories and other interpretations of whatever sort. Its very nature sets it apart from from the other beliefs and experiences, creating for itself an "enclave" that does not overlap with other

[19] George Santayana, *Scepticism and Animal Faith. Introduction to a System of Philosophy*, p. 36.

domains of belief and meaning. Set apart, self-maintaining, self-excluding, it is taken for granted in all our activities in the world at least until further notice. And if that "further notice" is ever served on it, as in the case of Nikolai Kusmitch, its self-sufficiency collapses from within, its self-inclusiveness disappears, and its self-exclusiveness become inclusive of what is quite other also becomes completely self-effacing.

In other words, the very features of the ontic conviction, existential belief, that make the gap possible, such as self-sufficiency, self-inclusiveness, self-maintenance, provided the ontic conviction is taken for granted, disappear into a thin vapor. When that occurs, the earth is experienced in motion, time is experienced passing by, pleasure in found in the source of pain, social and political reality give way to myth. At this point the gratuitous and fortuitous nature of the existential belief appears; literally and figuratively we cannot stand or take a stand. If we are not buried with our mouths open, we must at least lie down. We may conclude, then, that the common-sense world has a *logos* but no *arché* or ground.

When is "further notice" served on the enactment of our ontic conviction and its preacquaintance with what it means to be and the be alive? To indicate what is buried in such a question—a question itself absurd with respect to our existential belief—we have to turn to what we shall call, with Helmut Plessner, the "*eccentricity*" of being and being alive.

The Eccentricity of Ordinary Life

We are born into a social world and Nature which preexist us and carry sufficient weight of their own so that we may say that they are expected to continue to exist after we die. In this sense they are given at any moment of our lives as imposed upon us of necessity and as a ballast which we cannot but accept and from which we can never entirely free ourselves. They are, of course, the only social world and Nature given at any actual moment in our lives, hence they are also that in and upon which alone we act and can act because they are the only things we possess and can possess in common. Such is, in a few words, the basic characterization of "being together in a situation in common." Working together, for instance, we leave the work situation when it ends and turn to other dimensions of life such as family, club, biker-bar, gambling casino. All are dimensions that are but horizonal peripheries while working together is in progress, but which are implicitly preindicated as posssible centers from the center of working together in a situation in common. When work has ended for the day, the horizontally present periphery itself becomes, for the time being, a new center of activity while what had been the center becomes, for the time being, a horizontally preindicated periphery.[20]

The awareness of the *transposition of center and periphery*, as a basic mode of presentation of the social world and Nature, is rooted in what Plessner

[20] Kersten, *op. cit.*, p. 118. See also Aron Gurwitsch, *Human Encounters in the Social World*, pp. 104-119.

called the "eccentric" nature of human being in the world. "Eccentricity" designates the ability to transfer a center of action into the preindicated periphery, so that the periphery turns into a new center of activity pertaining to a distinct mode of being together. But the name also designates the limiting case of boundaries of being together in a situation in common. Such limiting cases are manifested in the phenomena of "laughing" and "crying" which interrupt action centered in the ordinary, workaday world in a manner quite different from what occurs when, for instance, work is over for the day and we go home.[21] Not all cases of moving to peripheries are *ipso facto* cases where possible new centers of action are established. Instead, the periphery remains just that: periphery, not preindicated horizontally at the center of action, of working together in a situation in common.

Being in a common situation together, working, carrying out one or another task with others, creating custom in haberdasheries, answering questions in biker-bars, constitutes the *paramount reality* of ordinary life in the sense that we carry to completion, or seek to do so, the task or tasks at hand, which presupposes always the ontic claims and rights operative in our existential beliefs. Moreover, action and speech, gesture and expressive movement, all articulate the more or less adequate being together in a situation in common; it is an enclave the boundries of which are established by our always taken-for-granted ontic beliefs.

However, if we cannot do anything further together, if nothing more can be done because of disruptive circumstances of one sort or another, then there is no answer or response to the task at hand; action and speech break down, the common and communal possession of the social world as field of action is weakened and perforce even collapses.[22] Among such situations there are limiting cases which must be distinguished. Frequently, however, the center of action can be restored, just as periphery and center can be mutually transposed—such as when I work an eight-hour day, then return home; and the next day again leave home for work and grubbing for gruel in academia. There are taken for granted rules or recipes of mutual transpositions of center and periphery, and when the center does not hold it nonetheless generally allows for restoration, when the rules of mutual transposition are broken they can still be restored, or at least are restorable if there is due process. There are two extreme situations where a rather different set of circumstances occurs and which prove to be limiting cases. In the first place, there is the situation which, Plessner says, is *unanswerable but also threatening*, perchance even life-threatening. The second extreme situation is one which is *unanswerable yet non-threatening*. Both limiting cases serve notice on the taken-for-granted character of our ontic conviction in consequence of which ordinary life loses its status as a self-inclusive, self-contained enclave. Because it is in connection with the second limiting case that we encounter the gap between ordinary life and scientific and other self-interpretations of our experience, world and Nature, it is important to develop this idea further. Perhaps the shortest route to the gap is by way of contrasting the two kinds of limiting case.

[21] Helmut Plessner, *Laughing and Crying*, pp. 36f., 129, 148f.

[22] *Ibid.*, pp. 31f., 51f., 138f.

"Laughing" and "crying" are the names given by Plessner to situations which are *unanswerable and non-threatening*. In the case of such situations, Plessner says, "man capitulates as a soul-body, i.e., as a living creature; he loses his relation to his physical existence, but he does not capitulate as a person. He does not lose his head. To the unanswerable situation he still finds—by virtue of his eccentric position, because of which he is not wholly merged in any situation—the only answer still possible: to draw back from the situation and free himself from it. The body, displaced from its relation to him, takes over the answer, no longer as an instrument of action, language, gesture, or expressive movement but simply as body. In losing control over his body, in giving up a relation to it, man still attests to his sovereign understanding of what cannot be understood, to his power in weakness, to his freedom and greatness under constraint."[23] It is a "situation...dominated by the effective impossibility of giving it any other suitable answer," hence one that occasions laughing or crying.[24] Mentally and bodily, our response is to the unanswerable, and it is a response characterized by both self-assertion and self-abandonment.

Consider the case of laughter, such as when one doubles over with laughter: here one "gives way to his own body and thus foregoes unity with it and control over it"[25] so that it is impossible to continue to work together with others. Yet for several reasons one also asserts oneself as a person. In the first place, there is self-assertion because one allows the loss of control over the body (doubling over, throwing the head back); one cannot act or speak or do anything with anyone—except laugh. In the second place, doubled over with laughter, one is vulnerable and cannot, for instance, defend oneself against unexpected and sudden attack; thus it is possible to laugh only when safe to do so, under conditions which are not threatening, which are socially "acceptable." And when the laughter is finally over, work can be resumed or, if not, the disruption at least can be accomodated in some fashion.[26]

In this case of disruption and loss of action at the center, the enactment of the ontic conviction, of our existential belief, although no longer the silent premise of action, nonetheless remains operative at the periphery. No notice is served on it; it remains taken for granted and so much so that it would seem enhanced as though for a moment it can stand by itself, as though it could wear its "groundlessness" on its sleeve as a badge of honor, as though it were something by itself rather than a support for gearing into and for the world. There is no motive for not taking the ontic conviction at its face value, and here indeed its characteristic of being taken for granted becomes its groundless

[23] *Ibid.*, p. 62.

[24] *Ibid.*, p. 139.

[25] *Ibid.*, p. 142.

[26] As Plessner notes, p. 143, "letting oneself be overcome is the releasing and constitutive motive of weeping. Man capitulates—before a superior force with which he can no longer cope. Even in this respect, the situation of the person who cries formally resembles that of the person who laughs; behavior comes up against a barrier to all determinations of condition, before which word and deed, gesture and expressive movement, fail to be effective. He falls into an unanswerable situation." The open mouth, then, as Santayana says, is buried open.

confirmation apart from the world and bodily gearing into the world. In laughter, for no reason whatever, the ontic conviction can stand by itself and at the same time reveals the capacity of human being to be eccentric and therefore that human being is not of necessity locked into the dead-center reckoning of the ordinary world of work, of "yes" and "no," and into a center of action accomplished by being together in a situation in common. Laughter discloses the capacity to *move off center* to the periphery of action. The ontic conviction thus empowers itself, unenacted, as it were, as an assumption of all action.

As a consequence, no further interpretation is required of the ontic conviction, no interpretation need be introduced from outside ordinary life to maintain the ontic conviction, the primordial credulity. It is intact in its taken-for-granted character, able to maintain itself just for what it is. It is then to the other set of limiting cases that we must turn to find the motives for substituting a scientific or other theoretical concept for the ontic conviction of ordinary life, or else being confused with an aesthetic construct set to music. It would seem that it is in the case of a situation that is unanswerable *and threatening* that the gap is bridged between ordinary life, with its mutual transposition of center-periphery, and substitution by a scientific or aesthetic construction. Moreover, it is where the ontic conviction of ordinary life no longer operates as the premise of action together in the world, where instead of empowering itself even where the periphery remains just that, it is weakened or becomes inoperative all together, revealed as without source or ground, without efficacy as when Nikolai Kusmitch experiences the earth in motion.

Bridging the Gap at the Limit of Eccentricity

In ordinary life human action is eccentric in the sense that, when working together, peripheries of the center are preindicated which are themselves possible centers of action (perhaps of quite distinct kinds) and which, when realized, become new centers of action preindicating, in their turn, peripheries some of which were previous centers of action to which we can return if need be. There are limiting cases such as laughing and crying; they are limiting case because we move from center to a periphery not preindicated by the center (hence, as in laughter, we are surprised), and the periphery remains just that: periphery and not a new center of action, although always on condition that we can return from the periphery back to the center of action (after we have had our laugh, we can return to work). The surprise—the unanswerableness—and the transposition to the periphery, being put off center, does not affect the ontic premise of action together, our ontic conviction or existential belief. It is a limit allowing for, even if not preindicated, by action together in the world. The return to the center, moreover, is always an essential possibility and one realized "at will."

The other limiting case involves a situation where the periphery likewise is not preindicated by the center, thus a surprise, an unanswerable situation, a transposition to the periphery of action such that the periphery remains only periphery and not a new center of action, but which does not contain the return to the center of action as an essential possibility. It is a

situation where the ontic conviction of ordinary life no longer can serve as a premise of all action. It is no longer a matter of realizing at will, or under controllable conditions, the essential possibility of returning to the center of action. Perhaps the most obvious examples in ordinary life are extreme pathological cases such as life-threatening injury, terminal diseases, dying, even madness. In such cases, return from the periphery is difficult when not impossible. There the ontic conviction of ordinary life can no longer support action, is impotent to sustain the mutual transposition of center and periphery. As it were, such situations "invite" intervention of other convictions and interpretations based upon concepts, for instance, in biology or chemistry. Correlatively, the presupposition of action together in situations in common recedes as effective and the mutual enactment of the ontic conviction ceases to possess an explanatory power thus becoming prominent as having no ground in itself by which it will empower itself. And in extreme situations at that periphery which does not become a new center of action, that does not or no longer preindicates anything, which therefore is unanswerable and threatening, the ontic conviction can no longer be enacted so as to operate as a premise for action in the world in common. Extreme situations at the periphery become "unworldly" and uncanny; without ground, the ontic conviction, our primordial credulity, cannot stand on its own at such a periphery.

In unanswerable and (e.g., life-) threatening situations, notice is served on the *taken-for-grantedness* itself of the ontic conviction of ordinary life. *When not taken for granted, the ontic conviction or existential belief becomes a mere appearance or else a function of something else* (such as a scientific construction of matter in motion). The space and time of the enactment of the ontic conviction as premise of working together in a situation in common is now a function of space and time of, e.g., physics or mechanics; action together in turn appears as a function of metabolism, while the center of action, *centric/eccentric* characteristic of being together in the world for which, in ordinary life, we are bodily geared and into which we gear as a field of action, is no longer a center. There is no center/periphery and any place is every place.[27]

The gap between ordinary life and the universe constructed by science is bridged just when the ontic conviction as ungrounded premise of ordinary life is no longer taken for granted at a periphery that remains peripheral. If such a periphery, resulting from a situation that is threatening and unanswerable is made to go bail for all of ordinary life, if it becomes the "standard" measure of being in the world in common with others, then we have the kind of life lived by Nikolai Kusmitch whether in his room by himself or in the theatre with others at a performance of the opera.[28] Nikolai Kusmitch cannot stand up and must lie down; Emma Bovary no longer finds pleasure in the pain of killing herself as did the soprano who sang Lucia di Lammermoor.

[27] See Kersten, "The Life Concept and the Life Conviction," pp. 108ff., 124f. for specific examples; see also Kersten, "The Constancy Hypothesis in the Social Sciences," pp. 523ff.

[28] To borrow yet another fiction, there is Emma Bovary's attendance at a performance of *Lucia di Lammermoor*, then her "romantic" suicide; Gustave Flaubert, *Madame Bovary*, pp. 214ff., 293ff.

To continue on the course set in ordinary life, to live as though the ontic conviction of ordinary life prevailed as premise for all eccentric action together in the world in common, must ordinary life "deceive" itself, proceed "as though" its ontic conviction were self-sufficient, "as though" it were an enclave and the gap intact? How is it that, as cloakroom attendant, I must be blind but in possession of my sight when I go home on the bus? How can ordinary life be a periphery preindicated as a possible, realizable center by my present center of working out scientific theories? Is there any sense in which the universe constructed by scientific thinking is a periphery of ordinary life, and if so, a preindicated one? What experiential datum of ordinary life in its eccentricity allows for the extrapolation of the universe constructed in science and art? Is any bridging of the gap between ordinary life and such constructs consistent and compatible with the eccentricity of ordinary life? Or is it wholly incompatible, inconsistent? Does the scientist or composer or painter or sculptor refer to the same reality that appears in ordinary life, even in situations that are unanswerable and threatening, or perhaps non-threatening?

The incompatibility between ordinary life and thinking in science and art seems stubbornly incompatible especially with respect to the ungrounded ontic conviction that serves as premise of action together in a common world and the demonstrable claims to existence and validity of science and art. Between ordinary life, on the one hand, and science and art on the other hand, especially when confronted in local biker-bars but also in hallowed classrooms and research laboratories, conservatories and studios, there is a relation of mutual curiosity, of course, but also reciprocal distrust as well. It is an incompatibility which may be a contradiction, yet which is be allowed for by daily life. The ontic claims certainly are incompatible, not subject to yes or no answers, yet they must "play along" with each other. The common-sense enclave of ordinary life remains just what it is and prevails, even when conflicting claims to existence and validity are entertained and preserved in an incompatibilty that is always mutually correlative.

The essential connection between science and art, in particular opera, the centric/eccentric structure of ordinary life of working together in a world in common resting on an ontic premise or conviction without ground in itself: the phenomenological clue to the nature of both lies in the unbridgeable gap between them. That gap, that discrepancy and mutual correlativity of incompability, is as much a clue to the constitution of the relationship between science and art to ordinary life as it is to the essential connection between science and art. It is when the gap is bridged, when the incompatibility is resolved in favor of one ontic premise or the other, in favor of the existential claim of science and art, opera, or of ordinary, common-sense life, that difficulties and problems emerge in ordinary life from the biker-bars to the cloakroom at the opera, from the haberdashery to the jail. The gap is as much a "condition" for there being science and art as it is for there being ordinary life. How is this so? Certainly it was not always so; when and why did the gap arise as the mutual condition of science and ordinary life? The "why" is found in what earlier was called a specific "formulation of consciousness;" the "when" is a certain time in history, the Renaissance and Baroque. The rest of this book will

be devoted to exploring the How, When and Why. Whether the questions can be settled, finally, in the fashion of the biker-bar or the county jail or by the box of books in the attic, that is, in favor of daily life, is an issue we can only hope to avoid.

CHAPTER TWO

The Gap Represented

We are interested in developing a formulation of consciousness which belongs to the Renaissance and Baroque, i.e., to the fifteenth, sixteenth and seventeenth centuries. Moreover, our interest is not just "historical" and occupied with discovering the origin and genesis of that formulation. Our interest lies ultimately in discovering whether that formulation is still a possible formulation of consciousness and, if so, whether it can claim precedence over yet other and, as Leibniz would say, competing formulations. But how do we arrive at a formulation of consciousness? And how do we arrive at not just any formulation of consciousness but one specific to the Renaissance and Baroque? Even more, how do we arrive at a formulation of consciousness that both preserves the gap between science (and opera) and ordinary life but which also takes precedence over ordinary life in its existential and truth claims? The answer to these questions lies in the *"eccentricity"* of ordinary life and its common-sensical, ungrounded ontic conviction. But in what way?

The occasion of the conversation in the biker-bar revealed the basic organization and structure of the enclave of ordinary life as comprised of the mutual and transpositional relationship of center/periphery of social action, but always within the boundary-limits of the unanswerable, ungrounded situations (which are either threatening or non-threatening). Of course this is not the whole story of the "social cosmion" (Voegelin) of ordinary life, and certainly not at a given particular time in history. Nonetheless, what we have so far established is sufficient for the moment to identify the experiential data necessary to examine a certain formulation of consciousness. That is because tightly woven into the fabric of tradition of Western thought is an assumption, Greek in origin (what else?) but which operates as much in the self-interpretation of ordinary common-sensical life as it does in the most rarefied reaches of philosophical and scientific thought. The assumption is that *whatever counts as real is somehow accessible to experience* (an assumption that led, after all, to the ghastly fate of the sociologist cum biker). In other words, the assumption is that there must be some datum or data in experience which serve as the basis on which it is possible to extrapolate a true representation of the "real." Thus, for example, were I a philosopher in the Classical tradition I would insist that time and eternity are different and that what is real, eternity, is experienceable. This signifies, in turn, that I must find some aspect of eternity which is experienceable, something in experienced and experienceable time, some aspect of the temporal datum of my experience which serves as the basis on which I can extrapolate eternity. I might go on to say that the something in question is *temporal "presence,"* the representation of which equally represents that aspect

of eternity, the real, which is experienceable.[1] This self-interpretive disclosure of reality, in turn, serves as the core of what, at the moment, we may call the *"Classical" formulation of consciousness*.

What, then, is the core of the "Renaissance" or of the "Baroque" formulation of consciousness? What is the experiential datum of ordinary life on the basis of which a "true" representation of the "real" is extrapolated? At the beginning the most direct route to an answer can be found in a contrast between the Classical and Renaissance or Baroque formulations of consciousness as much as between those aspects of ordinary experience to which "true reality" is accessible in the respective formulations. For a phenomenological reconstruction of a possible, empirical example of the Classical formulation, certain features of the theory of motion in Aristotle's cosmology will serve our purposes here and in later chapters because it directly bears upon that datum of ordinary experience from which "real motion" is extrapolated or, equivalently stated, that aspect of "real motion" accessible to ordinary experience. There is, of course, the additional reason that Aristotle's cosmology and theory of motion, in their complex historical transmission, have exercized a highly significant, if not always obvious, influence.[2] In a later chapter it will be Galileo's theory of motion that will serve a similar function for reconstructing the Baroque formulation of consciousness.

The Near and the Far

Whether in Rome, Paris or Athens, whether in the opera house or the biker-bar, Nikolai Kusmitsch, fictional character though he be, suffers one of the most persistent facts of the ordinary experience of ourselves and of the world in which we find ourselves as existing actually, imaginarily or fictionally: "change" of all sorts. Like an unerring precursor of Malte Laurids Brigge, Aristotle identifies the most universal, yet basic, change of all as that of generation and corruption, of coming-to-be and passing-away the actual causes of which, Aristotle says, are found in the influences of heat and cold.[3] Boiled down to its basics, change is not random because generation and corruption, coming-to-be and passing-away, are tied down to and set into a context with respect to which alone we can comprehend the very organizing principles of experience and take the measure of change. This contexture of change proves to

[1] In this connection, see Hans Jonas, "Plotin über Ewigkeit und Zeit," pp. 296f.

[2] For detailed studies of this influence, see William Wallace, *Prelude to Galileo*, Chapter One; Stillman Drake, *Cause, Experiment & Science*, pp. 193, 205f.; A. Rupert Hall, *The Revolution in Science 1500-1750*, pp. 97ff., 106f., 125f.; Maurice Clavelin, *The Natural Philosophy of Galileo*, Chapters 1, 2, and 4. It is not our purpose in this chapter to review and rehearse these and numerous other studies; we are interested instead in making thematic that datum of ordinary experience to which the "real" and "real motion" are acessible and eventually in the change in the privileged status of that datum in the Renaissance and Baroque.

[3] Aristotle, *De Caelo* II, 12; cf. II, 3.

be the "outer shell" of the universe, the *protos uranos* or "first heaven"[4] consisting of a finite sphere or shell containing the fixed stars.[5] The fixed stars have no change or motion of their own, Aristotle tells us, but rather are carried round once every twenty-four hours by the uniform rotation of the "first heaven."[6]

Aside from all arguments and speculations that seek to explain change of all sorts (e.g., that rotation is unceasing because it has no contrary, that "natural" motion is rectilinear either to or from the center of the universe, or that the stars are divinities but subject to the "doom of an Ixion"[7]), *phenomenologically*, the question concerns how we experience the measure of celestial and terrestrial change and motion. Phenomenologically, what establishes the sense of the arguments and speculations in the first place which makes change of all sorts plain to experience? What is the datum of ordinary experience from which "real" change is extrapolated? The answer, I think, can only be the following:

At Night: Looking up at the sky we directly behold a great, starry hollow shell revolving around an invisible celestial axis. In relation to the rotation of this huge, nocturnal spherical cavity, the motion (*phora*), as an instance of change (*kinesis*), of some things like planets seems irregular as they go around in their spheres in contact with the air or fire beneath them.[8] Yet in the turning of this great spherical cavity the seeming irregularities of the motion of even the planets become regular in the "stations" and "retrogradations" of the planets. Against the great hollow shell the motions of the planets are measured, against the heavens the earth is measured, against the night day is measured.

That aspect of ordinary experience to which the "real" measure of change is accessible is, then, the *visible* rotation around an *invisible* celestial pole of the great hollow, starry shell of the night sky. In comparison to the planets, that rotation is most "natural" which has the properties of the circle. Rather than sublunary motion in a straight line, for instance, it is cosmic motion that fulfills the requirements of circularity of path and uniformity of speed of the "natural," the "real." More particularly, the requirements are *visibly* fulfilled only by the diurnal motion of the *total* sky[9] but under the condition of being beheld at night.[10]

The circular motion of the heavenly spheres visible at night is the experiential datum. The qualifier, "at night," is the heart of the datum, if not of darkness too, because it signifies that what is to be explained is the fact, rather than the shape, of change of which celestial motion is an instance. It would

[4] Aristotle, *Metaphysics*, XII, 7.

[5] Aristotle, *De Caelo*, I, 5; II, 4.

[6] *Ibid.*, II, 6, 8.

[7] *Ibid.*, II, 1; I, 9. See below, p. 206.

[8] *Ibid.*, I, 1; II, 7.

[9] *Ibid.*, I, 2, 3; II, 6, 8.

[10] By virtue of "epicycles" and "eccentrics" the planets too demonstrate the geometrical properties of circularity of path and uniformity of motion; see Aristotle, *Metaphysics*, XII, 8.

therefore seem "natural" for ordinary experience, in its self-interpretation, to introduce impetus in order to explain the fact that things change, that things move. If we make explicit the self-interpretation of ordinary experience of change, motion, the qualifier, "at night," further signifies that the *shape* of change, of motion, follows from the structures of the heavenly spheres: "At night" means that whatever rides on the circumference of a wheel, for instance, cannot help but describe a circularity of path—as Ixion learned upon his doom being sealed.

What, now, is that aspect of "real" change, motion, that is experienceable in ordinary life? More particularly, what aspect of "real" change, "real" motion, is experienced and experienceable in coming-to-be and passing-away and which serves as the basis on which "real" motion is extrapolated? The aspect in question is not difficult to find: a rigid body turning on its axis, such as the spoked wheel in the image of the Doom of Ixion. That is to say:

At night, beholding the hollow shell of the sky revolving, turning; at night, beholding a spatial order of cyclical change, of cycles on cycles, concentric sphere on concentric hollow sphere or shell, conceived like rigid bodies. As a result, given one continuous push imparted to the outermost sphere or shell, the push is *ipso facto* imparted to all the spheres like the push imparted to the wheel and transmitted to axle and spokes. Nothing more is required to account for change, motion, of the heavens. There is no need to introduce anything from "outside" such as, for example, a "moving force" or *vis viva* which will animate Baroque scientific thought with Leibniz and Newton.[11]

Grounded in the Classical formulation of consciousness, science in the "Aristotelian style," as we may say, need only give a speech about the *form of structures that move*. One impetus, one push, accounts for it all; no dynamics of the interactions of forces, of shoves, need be introduced. All that is required is a *geometry of mutually constraining forms*. Accordingly, the phenomenological datum of ordinary experience, rigid bodies seen turning in the night, is a datum of experience from which is extrapolated an *architectonics* and *not a kinetics*. It is in terms of an architectonics, then, that Aristotle's "first mover" must be understood as an impetus, as an "intelligence," and not as a force, as a shove. That aspect of ordinary experience to which "real" change is accessible is impetus, push—a "pushy structure" of mutually constraining geometrical forms.[12]

The paradigm of motion as an instance of change extrapolated from ordinary experience is the visible motion of the whole heavens *beheld at night*. That signifies that the Classical formulation of consciousness touches upon what we can contemplate but cannot manipulate or dominate. The datum of ordinary experience accessible to "real" change, then, is not a datum found at the center of action; it is rather characteristic of data found at the peripheral boundary-limit established by the unanswerable yet non-threatening.[13] Push without shove,

[11]See Hall, *op. cit.*, pp. 103f.; Marshall Clagett, "Some Novel Trends in the Science of the Fourteenth Century," pp. 278, 279; see also Aron Gurwitsch, *Leibniz. Philosophie des Panlogismus*, Chapter VII, §§3-6.

[12]See Clagett, *op. cit., loc. cit.*, pp. 278f.

[13]See above, pp. 16f.

impetus without force, is a datum of ordinary experience, moreover, not preindicated at the center of action. It is, as a consequence, a case where the ungrounded ontic conviction is empowered and, in its very ungroundedness, serves as the solid existential basis for extrapolating "real" change.[14] At the periphery of the unanswerable but also unthreatening—thus allowing for awe, wonder—and off-center from social action in the world, the most that is permitted is reading the earth off the stars, the "lower" off the "higher," *the near off the far*, but always seen at night. The Classical formulation of consciousness rests upon the periphery of the center of social action in ordinary life and one that remains a periphery. That is also the vantage point in ordinary, everyday life from which we can understand the *bios theoretike* as equivalent to an *episteme theologike*, or *to theiotaton* which, as Aristotle also says, is as much of the Divine, the "real," as appears in us.[15]

As much of the Divine as appears in us engages some aspect of experience to which the "real" is accessible. But that aspect of the datum of ordinary experience does not involve acting upon the "real;" it is a datum from the periphery and not from the center, thus precluding intervention and action on the "real" but also in and on the world. And the *corollary of this assumption* is that the "near" is read off the "far." The assumption and its corollary preclude as well yet another, even common-sensical assumption:

The experiential datum is the circular motion of the heavenly spheres visible at night, rotating on an invisible axis— a case of push or impetus without shove. Is there any such case in ordinary life, even at night? The image is that of a rigid body, a wheel. In ordinary life wheels are not unfamiliar. After all, I had been to Rome's Museo Nazionale and, inspired by Myron, went outside and threw a rotating wheel-like thing into the air: a discus. More generally, as I later explained to the arresting magistrate, this is an example of a projectile, and projectiles are, after all, characteristic of sublunary or terrestrial, motion. In addition, it is a case that involves impetus, push, as well as force, shove. For something to be a projectile an initial force is required but afterwards the projectile continues to move even though there is no longer contact with the force. Beholding the rotating discus in flight is beholding impetus, the push, without force. To be sure, like the arrow of the poet, the projectile falls back to earth, as did the discus when it landed across the square. Clearly the impetus is not permanent, but encounters resistance and contrary force; thus the impetus, the push, is destroyed. But if there were no resistance the impetus would be permanent.[16] The next push that came to shove was from the man in the fancy uniform who accosted me; I had thought him the doorman of a five-star hotel, but he turned out to be the cop on the beat. I laughingly explained that the flight of the discus is an example of a datum of experience at the center of activity disclosing push without shove. Why then, I asked him, cannot this datum serve for the extrapolation of the motion of the heavens? Why not read the motion of

[14]The boundary-periphery is akin to laughter and, bizarre as it may seem, the idea seems quite consistent with Aristotle, *De Anima*, III, 10.

[15]See Aristotle, *Metaphysics*, VI, 2 (1026a f.).

[16]So Buridan, for instance; see Clagett, *loc. cit.*, pp. 278f.

the heavens off the motion of the projectile? (Of course, at that moment the only thing read to me were the charges.)

The motion of the projectile can be quantified, can be expressed in ratios of velocity proportional to the initial force and inversely proportional to the resistance.[17] But just this ratio does not apply to the motion of the heavens, which cannot be "signified by numbers" (Oresme).[18] There is, then, for the Classical formulation of consciousness a dual physics, and that of terrestrial motion, of the near, is understood in terms of celestial motion, of the far. It is as though action at the center of ordinary life (such as working together in a world in common), were only understood in some detached way from the periphery which remains a periphery precluding its becoming a new center of action. *The converse* cannot be the case (motion understood from the center of action) because it would mean that impetus is not permanent, hence that the circularity of the structures of the heavens is an odd, non-standard case of motion, and even more that the standard case is rather terrestrial motion exemplified by the flight of the wheel-like projectile where impetus is destroyed. Additionally, were the experiential datum at the center to serve to extrapolate "true reality" of change, the implication would be that the cosmos were homogeneous such that an arithmetic of proportions would replace the geometry of constraining forms, that the architectonics were replaced by a kinetics, hence that push were always come to shove. *Just that is inadmissable for the Classical formulation of consciousness*.

Why, then, the preference of one experiential datum to another? Why the insistence on the preference of the *geometry* of structures to the ratio of force and impetus? The fate of the Classical formulation of consciousness is that a kinetics replaces an architectonics. What is there in the "eccentricity" of human being in the world that allows for a shift in preference of an experiential datum of ordinary life to which the "really real" is accessible, which serves to extrapolate "true reality" and thus inform ordinary life with meaning?

When Push Comes to Shove

What does it mean to read the near off the far? What does it mean to read an arithmetic of proportions of impetus and force, of push and shove, off the geometry of mutually constraining forms, structures? In short, how are we to relate the two physics of the Classical formulation of consciousness? For the moment we can set aside details of the often complex history of this problem[19] and for the sake of contrast consider later developments (which will be treated in the next chapters).

By the time of the Baroque, motion is not so much an instance of change as it is a "state" of a body, just as is rest. On the Classical formulation of

[17]See David C. Lindberg, *The Beginnings of Western Science*, pp. 59f.

[18]For Oresme, see Clagett, *loc. cit..*,pp. 277f.; and below, pp.42f.

[19]For important documentation of this problem, see Clagett, *loc. cit.,* pp. 280ff; Hall, *op. cit.* pp. 285, 292, 294f.

consciousness, unless they are pushed structures remain at rest: the "natural" state of bodies. Accordingly inertia is fulfilled only if the structures are at rest. As an instance of change, motion then is not a "cause" but rather *has* a "cause;" rest has no "cause." But if we think of motion rather as a "state" of a body, then rest is also such a "state." When, then, is motion? It is no longer the circularity of permanent push but instead *continuous retention of a given state of bodies and, therefore, no more requires a "cause" than does rest.* What requires a "cause" is change from rest to motion, or from motion to rest, or in motion itself.

But what is change in motion? Such a question can only be answered in terms of the unaltered state of motion, i.e., in terms of "sameness." But what is "sameness" of motion? As a state of a body, motion is defined by velocity and direction. Unaltered velocity, then, signifies that equal distances are covered in equal times; unaltered direction signifies progression on a straight line. Just this is belied by the geometrical measure of the heavens; it would seem to apply only to terrestrial motion. Why apply it at all to the heavens beheld at night? It would signify, to be sure, that a "force physics" has been transferred to the whole cosmos, that everywhere push comes to shove, from the heavens down to the local biker-bar. Moreover it would seem that in the case of the heavens we deal with structures, forms; in the case of terrestrial events we deal instead with bodies or with with states of bodies. The law of proportion of force and velocity or impetus holds only for bodies, not for structures. Not only are there two physics, but their very subject matter is different (although certainly not unrelated). It is interesting that one of the criticisms of Galileo is that he failed to formulate the laws of motion and thus failed to solve the questions about force and impetus.[20] Although we shall return to this issue later, it is worth noting here that Galileo applies the geometry of mutually constraining structures or forms to a very different datum, namely the state of a body, and therefore he does not need to introduce the interaction of forces in formulating the laws of motion.

Indeed, what makes Galileo rely on a formulation of consciousness quite different from the Classical one is that he no longer shares in the same way the assumption that the "real" is somehow accessible to ordinary experience. Thus a twist will be given to the fate of the Classical formulation: on the one hand, the assumption that the "real" is accessible to experience is radically changed, leading, if not to its abandonment, at least to making it superfluous; on the other hand, the near—where force is necessarily connected with impetus, where push necessarily comes to shove—is the experiential datum which is made to go bail for the far. Galileo's "geometrization" of bodies, like the "geometrization" of structures, is "mathematized" when applied to states of bodies.[21]

The Classical formulation of consciousness will be turned upside down by the Baroque formulation of consciousness. "At night" will no longer be an essential qualification, and the distinction between near and far will eventually be obliterated. It is not so much a matter of a reversal of ideas, where the far and

[20]See Clagett, pp. 286ff.; and Hall, *op. cit.*, pp. 103, 109.

[21]For the notions of "geometrization" and "mathematization," see below, pp. 161f., 166ff., 198f.

higher are understood in terms of the near and lower rather than the converse, but instead there is no difference between near and far, between higher and lower. Nor will it be the case that day replaces night; instead there will be no difference between night and day.[22]

Still the questions remain: Why does the experiential datum of of the periphery, *push without shove,* serve as the basis for extrapolating that aspect of the "real" accessible to ordinary experience? Why the decentering, as it were, of the eccentricity of being in the world? What is at the root of the assumption (and its corollary) upon which the Classical formulation of consciousness is based?

The Beauty of the Push

At issue are two sorts of quite distinct experiential data of ordinary life. Action in and upon the world in which we live our daily lives produces change and not just a random change either. At the center of activity is planned change of the changeable, Nature, according to projected goals of living and working together in a common world and according to the greater or lesser likelihood of chosen means to achieve those goals. A commonplace example we have employed is setting into motion of a rigid body such as a wheel-like thing, a discus. However we may proceed to quantify such a case of terrestrial change and motion, even formulate its behavior mathematically, it cannot serve as paradigmatic for "real" change and motion. For the Classical formulation of consciousness, the true measure of change is taken not from the center but from the periphery of action and, moreover, from a periphery not preindicated at the center and which itself is not transposed into another center of action. The measure, we may also say, is taken from structures, forms, and not from the things as to their own specific natures and their nearness to hand in ordinary, everyday praxis. From such a periphery of the center of action push does not necesarily come to shove; the shape of change follows from structures and the geometry of structures. Myron's *Discobulus* is the true measure of motion, of change.

There are, then, two kinds of data of ordinary experience at issue for the Classical formulation of consciousness: push without shove, and push that always comes to shove. The latter characterizes our experience of sublunary change (and motion), the former our experience of supralunary experience of change (and motion). Moreover, when push comes to shove the very "natures" of things undergoing alteration must be reckoned with at the center of action and activity. But when push does not come to shove action in and upon the world is not possible, "natures" are not reckoned with and only the "pure shape" of things serve to take the measure by showing what things are really like in their likeness (*Eidos*).[23] Phenomenologically, one of the first questions that arises with regard to the Classical formulation of consciousness is the question of why the preference for the peripheral datum of experience over the centric one? Why

[22]See above, pp. 10f. and the statement of Erwin Strauss.

[23]See Fred Kersten, "Phenomenology, History and Myth," pp. 258ff.

take the measure from the periphery of action—a periphery that remains a periphery? What allows for such a preference, for putting a premium on the periphery that is the limiting boundary of action at the center?

We need not look far to find the answer: after all, the very thingness of the things that surround us in ordinary life depends on the shape through which they appear and without which they would be neither knowable nor useful—be it a silver chalice for the libation to the gods in the temple or an obulos to get into the theatre (or the numbered check to retrieve one's coat) or tire irons and chains. Yet how does this commonplace of the enactment of common-sensical ordinary life give a priority to "knowableness" over "usefulness," to shape and appearance of thingness over things meeting the needs and necessities of the on-going process of use and consumption, of push over shove?

The milieu of the Classical formulation of consciousness can only be the *Polis*, the political form of the center of action and activity, governed by *peithein*, "the convincing and persuading speech...the typically political form of people talking with one another. Persuasion ruled the intercourse of the citizens of the polis because it excluded physical violence; but the philosophers knew that it was also distinguished from another non-violent form of coercion, the coercion by truth."[24] Hannah Arendt further notes that persuasion is opposed by Aristotle to philosophical discourse and dialog precisely because a philosophical speech is concerned with knowledge and truth, hence requires proof. "Culture and politics, then, belong together because it is not knowledge or truth which is at stake, but rather judgment and decision, the judicious exhange of opinion about the sphere of public life and the common world, and the decision what of manner of action is to be taken in it, as well as to show how it is to look henceforth, what kind of things are to appear in it."[25]

The datum of ordinary experience, then, accessible to "reality," which serves as the basis for extrapolating a true representation of "reality," is "judicious exhange of opinion" about action at the center and that, in turn, rests on the decision of how action is to look and what kinds of things are to appear in public life. The criterion for judging appearances is "*beauty.*" In order "to become aware of appearances," of things having a shape through which they appear, "we must first be free to establish a certain distance between ourselves and the object, and the more important the sheer appearance of a thing is, the more distance it requires for its proper appreciation. The distance cannot arise unless we are in a position to forget ourselves, our cares and interests and the urges of our lives, so that we will not seize what we admire but let it be as it is, in its appearance."[26] That freedom can only occur if the situation in which we find ourselves is non-threatening and unanswerabie or, as Hannah Arendt says, "released from life's necessity," we "may be free for the world." It is a species of "laughter:"[27] *a judging of appearances from a periphery of the center of action which remains a periphery and not another center of action, hence is*

[24] Hannah Arendt, *Between Past and Future*, pp. 222f.
[25] *Ibid.*, p.223.
[26] *Ibid.* p. 210.
[27] See above, pp16f.

opposed to persuasion, yet is non-violent because non-threatening and at a distance because unanswerable.

Right though Hannah Arendt may be in emphasizing the contrast between philosophical discourse and the persuasive exchange of opinion at the center of action and activity, the qualification has to be added that the contrast operates under the assumption of the Classical (specifically Aristotelian) formulation of consciousness, namely that the persuasion comes to decision, the "shove" of Polis-life in ordinary experience, only when the criterion of beauty is applied by reading the "lower" off the "higher." It is not so much that beauty and truth are simply contraries, opposites, but rather that beauty is read off truth beheld at night from afar. To express the matter in a different way, we may say that the eccentricity of human being in the world allows for judgments about the (political) world in common in its appearance and worldliness, about things in their appearance and their thingness, apart from their use and function and utility. For the Classical formulation of consciousness the measure is that of beauty: *that to which nothing can be added or taken away.* The example, the paradigma in the literal sense, the ec-centric, is the heavens seen by night rotating on an invisible axis—the "far," the "higher." Because nothing can be added or taken away, no shove (force) is required; it can only be allowed to be as it is. There are no cares, needs, urges, interests (to which more must always be added or removed). Those things in the Polis, then, are "best" to which least must be added, from which least must be removed, so that actions, deeds, words are converted into things "permanent enough to carry greatness into the immortality of fame" and make them worthy of remembrance.[28]

Whatever counts as "real" is somehow accessible to experience owing to its eccentricity. It is one thing to understand action at the center in the light of the non-threatening boundary-periphery but quite another to make action at the center conform to the "real" accessible at the periphery. The latter is a matter of action, of "political" action. It is the former which is of interest for our present discussion.

The Representation of the Gap

The assumption belonging to the Classical formulation of consciousness, and its corollary assumption of reading the lower off the higher, the near off the far, the earth off the stars, discloses a gap between lower and higher, near and far, earth and stars, finally ordinary life at its center and at its periphery. That gap is bridged by a mode of representation which is *"mimetic."* I use the word, *"mimesis,"* in its basic signification of making present in one medium something in another medium; thus the "imitation" or "copying" or re-presenting of something in one medium in that of another.[29] for example, the heavens in the earth (by means of number, proportion), the permanence of the stars in the deeds and words of the *Polis* (by means of the criterion of beauty).

[28]Arendt, *op. cit.*, p. 214.

[29]See Kersten, *op. cit., loc. cit.,* pp. 257f., and the references there to Plato, *Republic,* X.

We may also express the same thing by saying that the *Polis* imitates the heavens, that in part the projectile imitates the diurnal motion of the sky, that what is enacted at the center imitates the judgment about what should appear beheld at the boundary-periphery. More specifically and in the case of change as motion, there are then *two* sciences: a science of celestial motion and one of terrestrial motion, the mimesis of the former by the latter expressed by arithmetical proportionality. *Together* the two sciences are extrapolated from the eccentricity of experience, from the center of ordinary life seen or viewed from its non-threatening yet unanswerable boundary-periphery. The proportionality is the quantified appearance of motion, the movingness of terrestrial motion, the "imitation" or "copying" in numbers of visible rotation of the heavens around an invisible axis beheld at night. The relationship between the geometry of forms and numerical proportion *is a mimetic one*; it is not that in one case of motion we have to employ the theorems of geometry, and in the other the arithmetic of proportions. Just as in the drama actions in the world (which are "serious, complete, and of a certain magnitude") are made present, "imitated," in play-acting through the medium of song and diction, just as experierenced sound is made present, "imitation," "copied," in numerical ratios between consonances (at the interval of the fourth, fifth and the octave),[30] so terrestrial motion is made present, "imitated," by the ratio of velocity, force and resistance.

Ordinary life is comprised of its centers and its preindicated peripheries, as well as its boundary-peripheries. For the Classical formulation of consciousness the relationship of centers to boundary-peripheries is one of mimesis, the center of action "imitated" at the boundary-periphery apart from use, cares, interests— just as laughter or crying discloses the true shape of things at the center when action and activity are temporarily interrupted suddenly and in surprise. The Classical formulation of consciousness is either tragic or comic and the beautiful is of no more "use" than laughter, even though still disclosive of the true shape of things in their thingness and worldliness. Moreover the mimetic boundary-periphery is as sudden, surprising and interruptive of the center as is laughter (or crying). There is no more "reason" for wonder, *Thaumazein*, than there is for laughter. Like laughter, the beautiful offers no ground or "reason why" for suddenly and in surprise standing at the boundary-periphery. The very ungroundedness of the ontic or existential conviction of being at the center working together in a world in common is set forth at the boundary-periphery, a self-sufficient setting of the beautiful just as laughter (or crying) are self-sustaining and without ground. No more than laughter does the beautiful stand upon a ground, no more than laughter does the beautiful require an explanation, or does push require shove. Indeed, like laughter, should push come to shove (just as when one tries to "explain" a joke), wonder disappears, night hides rather than discloses the beautiful, the boundary-periphery is no longer disclosive of the true shapes, appearance of things and world; cares, drives, interests are then restored at the center.

With the restoration of the center, the unanswerable becomes answerable thus overcoming the distance between ourselves and the things of

[30]See Giovanni Comotti, *Music in Greek and Roman Culture*, pp. 77ff.; H.F. Cohen, *Quantifying Music*, pp. 1-6; the references to Aristotle are to the *Poetics*, 6

ordinary life which is itself, as enclave, restored and judged in the mimesis of numbers, words and song in the judicious exhange of opinion. And it is experience at the non-threatening, unanswerable boundary-periphery which is both disclosive of the true shape of things at a distance from the center and accessible to the "real." Still, on the Classical formulation of consciousness the boundary-periphery can never itself count as a (restorable) center of action and activity in the world.[31] Accessible to experience, the "real" remains transcendently alien to its mimetic extrapolation. I would imagine that the antique equivalent to Nikolai Kusmitch was Thales, who fell into a well while beholding the heavens at night and had to be pulled out, dripping wet and still drunk on the heavens, by a Thracian water-woman whose cheerful but sardonic laughter still haunts the beginnings of Western Philosophy. Rather than mimetic, the experience itself of the "real" for the Classical formulation of consciousness is *arrheton* (Plato), *aneu logous* (Aristotle). Between ordinary life and the "real" there is an "unspeakable" and unbridgeable gap, a brutal *"chorismos."*[32] Nonetheless, in the Classical formulation of consciousness the corollary assumption is that the lower can always be read off the higher (and, we may add, on the condition that the higher never gets any higher, nor the lower any lower).

It is precisely the *corollary assumption* that foreshadows the fate of the Classical formulation of consciousness. But what does it mean to "read" the lower off the higher? What sort of hermeneutic surplus is hung out to dry in the backyard of Classical philosophy? Phenomenologically, what is the foundation of mimetic representation? And, more specifically, of what does mimetic representation consist for the Classical formulation of consciousness?

The task of the rest of this chapter is to sketch an answer to these questions by making explicit a basic ingredient of the Classical formulation of consciousness: representation by way of mimesis, by way of mimetic "resemblance." Because the problem intrinsic to representation by way of mimesis is its limiting case where it is "without word," at the same time, it will be possible to chart the fate taken by the Classical formulation of consciousness. Its collapse from within both presages and makes room for the Baroque formulation of consciousness.

[31] Thus the Classical ideal of the life of *Skolé* on the Isle of the Blessed; see Werner Jaeger, *Aristotle. Fundamentals of the History of His Development,* pp. 280ff., and Appendix II, pp. 426ff. In our lingo, life on the Isle of the Blessed is life at the boundary-periphery—a life which is, after all, a "death." Perhaps a better way of expressing it (in *Nicomachean Ethics,* 1177b, 25—1178a, 5), is by saying that "One should not think as do those who recommend human things for those who are mortals, but immortalize as far as possible." (The translation is by Hannah Arendt, *Between Present and Future,* p. 231, note 26, where *athantizein* is intransitive. In strict Classical terms, the Latin equivalent should be *aeternare* rather than *immortalem facere*.) See above, pp. 21f., and note 1, p. 22.

[32] See Fred Kersten, "Heidegger and the History of Platonism," pp. 276ff.; see also Hannah Arendt, *The Human Condition* , p. 20; Gurwitsch, *The Field of Consciousness,* p. 390.

Representation by Way of Mimesis

Mimesis is no stranger to the eccentricity of ordinary life, or perhaps it is the converse: ordinary life is no stranger to mimesis. As considered in this and the previous chapter, the idea of ordinary, common-sensical life may seem uncommon and even bizarre, though for all that no less than ordinary and commonplace. And the idea of ordinary life as an enclave may make ordinary life appear as a piece of exterritoriality torn from the fabric of reality. Granted that, there are still other workings of ordinary life that must be made explicit no matter how unusual they may seem to ordinary life itself. By "mimesis" we have understood the presentation of one thing in the medium of another—action in song and diction, motion and change in ratio and proportion, to mention only two examples of representation by way of mimesis. But there are other and even more commonplace examples such as the making of images and copies of things.

So defined, *mimesis* is a special case of what, with Husserl and Schutz, we may call *"appresentation"* and *"apperception."*[33] By "appresentation," I mean nothing obscure or foreign to ordinary experience (and the story of Nikolai Kusmitch is nothing else but a case of appresentation gone awry). Consider an example: smoke as a sign of fire. Both the smoke and the fire are events given to ordinary sense experience; they can be seen and felt as much in theatres as in backrooms and biker-bars, they can be analyzed chemically, dissipated and put out by large quantities of water. But if smoke is construed as indicating fire, then certainly smoke manifests something other than itself. Smoke and fire constitute a pair of events, and the "pairing" is an example of "appresentation." And we use the term, "appresentation," to emphasize that two (or more) things are associated together *and apperceived as* together. Accordingly, "presentation" has a much narrower meaning: the experience of something of and for itself, smoke experienced qua smoke, no matter whether it gets in your eyes.

In the on-going course of ordinary life we sometimes take things for themselves, we heed their presentation; at other times we take things as indicating something other than themselves, as paired with other things; we heed their appresentation. Both presentation and appresentation are basic and easily recognizable features of ordinary life, of our working and acting together in a world in common. To analyze appresentation further we have to distinguish the appresent*ing* component of the pair from the appresent*ed* component; in our example, smoke is the appresenting component, while fire is the appresented component. There are other equally common, perhaps even more prosaic examples: Like Bartleby and all other scriveners, I am staring at the wall; but it is not merely a wall, a façade at which I stare; instead I stare at a wall which I also mean as having another but unseen side. The front of the wall appresents the back of the wall. The immediately given front, seen directly, appresents what I do not directly see yet which I mean as having a back of some, if not this specific, kind.

[33] In this connection, see Alfred Schutz, "Symbol, Reality and Society," pp. 294ff.

For every sort of experience there is a confirmation peculiar to it. No experience is so complete that it does not point or indicate beyond itself to something, if not quite particular, at least quite typical and general. In the lingo of Husserlian phenomenology, we may say that experience evokes "horizons" for further experience; the potential seeing of fire when seeing smoke is a "horizon;" having a vague idea of what the back of the wall looks like is a potential seeing of the back of the wall; and I can go around to the next room and look at it, I can realize the potentiality of the reference to other potential seeings of what is appresented. Still other cases of appresentation would be seeing the face on the bar room floor appresenting my father—seeing the face now, I recall what my father looked like. Or seeing or hearing something now might appresent something yet to come: I hear the opening bars of Beethoven's Grosse Fugue and on the basis of hearing it now, can appresent the end of the work 60 minutes hence.

There are yet other and still more specific examples of appresentation, some of which are of special importance to us: pictures, images, copies, imitations, resemblances. More particularly, we are interested in the appresentational nature of the making of resemblances and likenesses, and of how resemblance is constituted in the appresentation of the center by the boundary-periphery, by the shapes and forms through which things, events, deeds at the center appear as what and how they are—in short, that appresentation which is the basis for reading the lower off the higher. It is necessary therefore to examine in greater detail the special case of what we may call, "resemblance-making appresentation" as an essential component of the Classical formulation of consciousness. To this end we can single out what is phenomenologically as well as historically important for mimetic resemblance, for image-making. In our eccentric experience of the world in which we live and work, we are fabricating beings and one kind of fabrication is that of resemblances, images, copies, pictures, imitations.[34] In an important study of "image-making," but in a very different connection, Hans Jonas makes the obvious point, or it becomes obvious when he makes it, that what here we call fabrication of "mimetic resemblance" entails ends apart from purely biological ones, yet which generally serve them by way of being instruments, more generally by having a use. In that connection eight properties are listed, one or all of which something must have to be a resemblance such as an imitation, an image, a copy, a picture, of something. Moreover, such a case of mimetic resemblance is thereby genuine, hence knowable as such; the requirements are

[34]For what follows, I draw on Hannah Arendt, *Between Past and Future*, pp. 59ff.; *The Human Condition*, Chapters 4 and 5; Hans Jonas, "Homo Pictor and the Differentia of Man," pp. 201ff.; Dorion Cairns, "Perceiving, Remembering, Image-Awareness, Feigning Awareness," pp. 251ff.; Aron Gurwitsch, *Human Encounters in the Social World*, §§ 17-20. For a general, systemtic view, see also Edward S. Casey, *Imagining. A Phenomenological Study*, Chapter One.

Two other works are central to this discussion, but will be considered later in connection with the Baroque formulation of consciousness: Madeleine Doran, *Endeavors of Art: A Study of form in Elizabethan drama*, pp. 46ff., 54ff., 342ff.; and Maria Rika Maniates, *Mannerism in Italian Music and Culture, 1530-1630*, Chapter XIII. For the late Renaissance, see Michel Foucault, *The Order of Things*, Chapter Two.

ipso facto epistemic criteria defining the "knowability" (although not necessarily the truth) of mimetic resemblance.

Mimesis now may be defined more precisely as a specific and special case of appresentation, the appresented component of which consists of things, deeds and actions belonging to our cares, interests, drives linked by use to biological ends at the center of action in ordinary life, and the appresenting component of which consists of fabricated "resemblances:" images, copies, pictures, imitations. Rather than by way of indication (or, symbolization, signification), mimesis is representation by way of appresenting resemblance, likeness. To clarify further what we have in mind we need to briefly examine several of the properties which characterize the fabrication of resemblance of "image-making" in the broadest sense and then, more specifically, as essential to the Classical formulation of consciousness.[35]

Some Characteristics of Mimetic Resemblance.

Starting from Jonas' account of image-making basic to the idea of "*homo pictor*," but adapting it to the assumptions underpinning the Classical formulation of consciousness, we note in the first place that an image, picture, imitation, is something in one medium that appresents by means of resemblance, of "likeness," something else in another medium. Secondly, resemblance, likeness, must be produced with the clear intent of being a resemblance recognizable by others. And even though there may be a mutually discernible resemblance of two things, even if they are like one another, for all that the mimetic relationship is one-sided: thing A may be an image, a picture or an imitation (in word or song) of thing B, but thing B is not *ipso facto* a mimetic resemblance of A [36]—the face of my father can never be an image of the face on the barroom floor. In the third place, the resemblance—likeness, copy, picture, imitation—cannot be complete, for if it were then, instead of the mimetic relation of image and imaged, of picture and depictured, imitation and imitated, there would be duplication of the original: the actor playing Oedipus would gauge out his eyes on stage, the mirror on the wall would actually speak, the ratio of force and velocity would come to ground 50 feet away, the harmony of the strings on the lute would rotate on an invisible axis. Mimetic resemblance must always be incomplete and inadequate and perceivable as such. (Of course, a resemblance, likeness, may indeed deceive me, or it may always be obvious until and when something happens to remove the deception, or make the thing obtrusive, even intrusive.[37]) Or, as Jonas expressed it, the resemblance, the

[35] Later, below, pp. 97f., 133f., 250f., we shall reformulate these properties in the light of the (non-mimetic) Baroque formulation of consciousness.

[36] Were that not the case, we would find ourselves in the "nauseous" situation of Roquetin in the portrait gallery; see Jean-Paul Sartre, *Nausea*, pp. 82ff.

[37] For what is still the best phenomenological account of image-deception and its correlative undeception, see Herbert Leyendecker, *Zur Phänomenologie der Täuschungen*, §§8f.

likeness, must always be deliberately superficial; the appearance of the original, we may say, is reproduced in mimetic resemblance.

Expressed in yet another way, in so far as the eccentricity of our being in the world is concerned, as is the case with the thingness of things and the worldness of world, mimetic resemblance belongs to the boundary-periphery and not to the "substance" of the center of activity of ordinary life. Mimetic resemblance—image, copy, picture, imitation—belongs to the thingness of things rather than to things, to the worldness of world rather than to world.[38] Of itself, mimetic resemblance does not belong to the biological life-process in the world, to acting together on a task in common in a world in common. In short, even though mimetic resemblance may be made to serve the ends of the life-process, be put to use, even be a means to an end, it is itself of no intrinsic use.[39] Mimetic resemblance is "disinterested;" it may have of itself impetus, push, but no force or shove.

As a result, and in the fourth place, within the realm of incompleteness and superficiality of mimetic resemblance, there is freedom[40] to omit certain aspects even of appearance itself (through which things acquire their shape). The omission is the result of a deliberate choice based (so far as the Classical formulation of consciousness is concerned) on the assumption of reading the lower off the higher. There is therefore selection of the representative or mimetically relevant features of the object.[41] This is because such features must provide recognizability in the absence of complete likeness regarding all features of things, such as fabricated things that "matter" (e.g., consumer goods) or even tools, instruments, or lawful as well as virtuous conduct in the *Polis* (such as a law prohibiting certain behavior, or establishing a mean between excess and deficiency performed for its own sake).

The "less" of "less complete" of mimetic resemblance does not therefore make the original more "abstract," or even more "subjective." The result is rather the opposite: the original is given more sharply and "objectively" by the emphasis on what is essential in the mimetic resemblance. The proportional ratio of force and velocity makes the original, the projectile, more "objective" and "concrete" rather than subjective and abstract; or the ratios of fourth and fifth make the original, the sound, more "objectively" right, listenable, rather than abstract.

Accordingly, in the fifth place, the more the mimetic resemblance stands out at the boundry-periphery, the greater the difference between mimetic resemblance, image, picture, imitation, and original. The more that is the case, the more the mimetic acquires, we may say, a life of its own, the less it is tied down to that of which it is specifically a resemblance, a likeness, in a specific

[38] And has, accordingly, its own moral dimension as well; see Arendt, *Between Past and Future*, p. 156.

[39] For an account of the notions of use and no-use, see Fred Kersten, "The Line in the Middle (The Middle of the Line)," pp. 89ff.

[40] See above, p. 29f.

[41] Of course, the selection of relevant features may be based, *in turn*, on the usefulness of things to achieve certain ends at the center of action.

situation (what may be called with Aron Gurwitsch the "acquisition of empirical meaning and function"[42]). The greater the difference, then, between original and resemblance, the greater the freedom there is, for example, of purely pictorial representation; and the greater such freedom the less we are tied down to an "exact likeness" of the original. The less we are tied down to an exact likeness, the more manipulatable the original becomes; the greater the control over it the more it can be put into service.

Consequently (in the sixth place) for the Classical formulation of consciousness, the more visual or visualizable the mimetic resemblance, the more "formal" the image, picture, imitation, because of the greater stability of the visual form: at night, the visible heavens rotating around an invisible axis, the "beautiful." Because mimetic resemblance need not be a strict or exact resemblance, copy, picture, imitation, it need not be in motion, for example, to represent something moving, the imitation of dangerous or violent action need not itself be dangerous or violent. Stated more generally, mimetic resemblance does not represent the "substance" of what is imaged, depictured, imitated, namely the cares, interests, generally the whole means-end or "for the sake of" nexus of our lives[43] in gearing into and upon the world for which we are eccentrically geared. At the very same time, the gearing into and being geared for the world are revealed just and how they are: *homo pictor* is as much *homo faber* as *homo ludens*.

A conclusion that we must draw here is that, on the Classical formulation of consciousness, mimetic resemblance has an ontic status quite distinct from that of things, events, actions imaged, depictured, copied, imitated. Moreover, it is an independent ontic status in the sense that it remains unaffected by what is imaged, depictured, imitated. There is in this sense a freedom in the establishing, fabricating, of mimetic resemblance. Finally, we have to distinguish between the mimetic resemblance—the image, picture, imitation— from the vehicle of mimetic resemblance, such as a stage performance, sounds, sights, numbers, barroom floors. There can be many vehicles, but, e.g., only one proportional ratio of velocity, force and resistance, many performances but only one *Hamlet*.

From Mimesis to Analogy

With qualifications, the characteristics or properties of mimetic resemblance singled out hold as much for the Classical formulation of consciousness as for any formulation whatever of consciousness. As one means of extrapolating a representation of reality on the basis of some data of ordinary experience, the characteristics of mimetic resemblance are, for the most part, tied down to the pragmatic motives of working and acting in the world at the exchangeable center/periphery of daily life. What, then, is peculiar to mimetic resemblance in

[42] See Fred Kersten, "Heidegger and Transcendental Philosophy," pp. 212ff. for the development of the idea of the "acquisition of empirical meaning."

[43] See Kersten, *loc. cit.* pp. 208ff.

the case of the Classical formulation of consciousness? What is it about image, copy, picture, appearance and shape that is peculiar to the Classical formulation rather than to any other?

The simplest and most direct example we can take to illustrate what is peculiar to mimetic resemblance *on the Classical formulation* of consciousness is a painting such as a portrait (although this is by no means the only or even the most important example).[44] When is a painting a painting and not just a copy? A painting is but a copy of something if it does not seek to be anything more than a reproduction of that something and if its function lies only in its identification of that something. We may also say that in its appresenting function the painting-copy cancels itself out because the appresenting serves as a means of identification, and like all means loses its function when its goal is achieved. Under the pragmatic (or even biological) motive the appresenting serves only to be realized in the appresented, in the original something depicted in the painting. The painting as a copy has a purposive component in the very being of the copy itself; it exists by itself to cancel itself out.

In other words, the *appresenting*, in our example, the face on the barroom floor, is such that, by not being cancelled out, by being released from pragmatic motives (e.g., of identifying my father when he came in for his evening pail of beer), enables the original, the appresented, to undergo an increase in being *in so far as* it is appresented. The painting makes what is appresented, my father, into a painting thereby effecting the original. Or: the painting gains in its own reality by making the appresented into the *appresented-in-a-painting* and immediately present in the painting, hence, correlatively, with an increase in the being of the original. And this is the case whether the appresenting component is a painting, whether diction and song or whether ratios and proportions. In each case, the appresented increases by being there in the appresenting itself, and the appresenting has its own being in a sharing of what it appresents, in being a "beautiful" appearance of what is appresented.

Accordingly, genuine mimetic resemblance on the Classical formulation of consciousness consists of the representation of something (change, motion, work, action) experienced from a boundary-periphery so that, 1) there is release from life's necessities in the ordinary world of working at the center of action;[45] 2) the mimetic resemblance, which need not be an image or copy, must not be cancelled out by its function in the world of working; 3) the appresented original is increased by being appresented and only in so far as appresented; and 4) the appresenting resemblance acquires in consequence an independent status purely as appresenting, purely as appearance (thus approximating the beautiful). Granted these characteristics of genuine mimetic resemblance, the appresented is read off the appresenting, the center off the boundary-periphery in its independent status, thus as measure. This raises

[44]See below, pp. 61f. Leaving aside the emphasis on the ontological dimension of mimetic resemblance, this discussion draws on Hans-Georg Gadamer, *Truth and Method,* pp. 122ff.

[45]Were it a case of representation from a periphery preindicated at the center there would be no release from life's necessities and cares or at the most only their temporary interruption and respite.

several questions on which hangs the historical fate of the Classical formulation of consciousness:

1. As Plato suggested in the 10th Book of the *Republic*, even if genuine, even if "beauty" operates as the criterion for judgment of things of the *Polis*, mimesis ranks third after truth.[46] And it has that rank even though resemblance acquires an independent ontic status, a life of its own as appresenting because, as sheer appearance, it is nonetheless revocable as is any appearance in contrast to the appresented deed, event, thing at the center of action which is irrevocable. In and of itself, despite its independent status, the mimetic resemblance does not provide a ground for truth-claims. Neither song and diction, nor image and copy, nor numbers and ratios can make truth-claims; they exhibit and lay claim to greater or lesser degrees of rationality, of universality, of validity, even and especially of persuasion and the judicious exchange of opinion about public life and the common world and about what kind of things are to appear in the *Polis*.

2. The second question concerns the two sciences of Nature. Mimetic resemblance, such as the ratios of force, velocity and resistance, yields rational representation of terrestrial events, changes, motion. But what about celestial events, changes, motion? The basic assumption of the Classical formulation of consciousness is that whatever counts as "real" is somehow accessible to experience. So far as it counts as "real," terrestrial motion, for example, is accessible to experience represented by numbers and ratios. But such motion is always a case of push coming to shove. What about a case of motion that is pure push and which never comes to shove, such as the revolutions of the great hollow shell beheld at night? Without force and resistance there are no ratios and numbers. To be sure, paraphrasing Aristotle, earlier we spoke of an architectonics of mutual constraining geometric forms (in contrast to a kinetics). But in saying that, pure push was likened to the push imparted to the wheel, transmitted to axle and spokes.[47] Instead of mimetic resemblance an *analogy* was employed to represent the architectonics of the heavens in their eternal swing. It was not by accident that even to speak of a "geometry" of forms is a matter of analogy and not of mimesis. Analogy, to be sure, is a case of appresentation; yet it is one that differs from mimesis because, although there is no cancellation of the appresenting component, there also is no increase in being of appresenting and appresented.

Even though analogy, too, provides a basis for rational speculation about the heavens, it cannot make a truth-claim because it does not supply the

[46] Plato, *Republic*, X; see Hannah Arendt, *Between Past and Future*, pp. 224f. Arendt quotes with approval Cicero's statement: "*Errare mehercule malo cum Platone...quam cum istis (sc Pythagoraeis) vera sentire*" ("I prefer before heaven to go astray with Plato rather than hold true views with his opponents"), and which Arendt construes as being "a matter of taste to prefer Plato's company and the company of his thoughts even if this should lead us astray from the truth." Or: "In what concerns my association with men and things, I refuse to be coerced even by truth, even by beauty" (p. 225). In this respect, Arendt may be said to work with the most extreme case of the Classical formulation of consciousness.

[47] Above, pp. 22f

apodictic proof necessary for a genuine philosophical speech. For the Classical formulation of consciousness, analogy is at best a substitute for mimesis and is derived from beholding what is unspeakable, from as much of the Divine as appears in us.[48] At the same time, however, analogy has a primacy over mimesis because it is only twice removed from the truth. Appresentationally, we read the lower off the higher by analogy rather than mimetically. The analogically appresented is higher than the lower appresenting component: the mutually constraining geometrical forms.

In contrast to a political speech, how can a philosophical speech be made, on the Classical formulation of consciousness, about the "real" accessible to experience (mimetically or else analogically)? How can ordinary experience in its eccentricity serve as a basis for extrapolating the "real"? How can analogical-mimetic representation overcome the gap between the "real" and ordinary experience at the boundary-periphery into which we are interruptively set by wonder and for which there is no more reason than laughter? Suppose we were to carry the Classical formulation of consciousness as far as it can go? An important example for us is found at the "end" of the history of the Classical formulation of consciousness.[49]

Representation by Way of Analogy

The example I have in mind at the "end" of the Classical formulation of consciousness is the rational speculation of Oresme in the fourteenth century. There are, more particularly, two speculations which are of concern to us. The first involves a set of distinctions concerning motion in connection with the Aristotelian distinction between a physics of the heavens and another of the earth. Still operating with the Classical formulation of consciousness, Oresme introduces the Medieval distinction between, on the one hand, push without shove, and, on the other hand, push that comes to shove. Or, in language more germain to Oresme, it is the distinction between "intelligences" moving celestial bodies as they "will," and forces that are "natural" but "involuntary." They differ, moreover, in that natural force requires exertion or effort "as some horse strives and exerts itself to draw a cart," but voluntary force moves by volition alone and without effort (rather like putting the cart before the horse). Yet another difference is that natural force can be designated by numbers and ratios, but "force which is will is not designatable by numbers or ratios. Therefore, one such voluntary force ought not be described as twice or triple another....<It> is not susceptible to comparison [by ratios]." Yet another distinction concerns resistance; the "proper" understanding is that velocity of motion either increases or decreases as resistance decreases or increases. In the "improper" way of understanding, resistance "is nothing but a certain impossibility of moving faster or slower. And thus it can be said that a heaven resists being moved faster."

[48] See above, p. 25.

[49] In Chapter Three, below, pp.61f., we shall consider yet another example drawn from Euclid.

Finally, "sometimes a certain effect or motion arises from a natural force, such is the motion of a stone downward, while sometimes a motion arises primarily from a force which is an intelligence...such is the motion of a heaven." This leads Oresme to the following conclusion: "between an intelligence and a [celestial] orb there is no ratio, but *only something analogous, in a way similar to that of things [here] below*. For we see that a certain velocity arises from a definite ratio, and the cause is that every ratio, if it is rational, is signifiable by numbers. But an intelligence cannot be signified by numbers."[50]

Oresme operates with the assumption that the "real" is accesible to experience, and that aspect from which we extrapolate the "real" is force, velocity, resistance—change, motion. But not all cases are comparable, admit of comparison, i.e., mimetic resemblance and representation. It is just such cases that do not admit of mimetic resemblance that are the basic experiential data in which the "real" is accessible—*but only on the further assumption that the motion of the heavens can be explained in analogy to kindred* natural forces *rather than by "intelligences."* This further signifies that what cannot be explained mimetically, that is to say, what cannot be designated by numbers and ratios, can yet be understood in an "improper" way, as Oresme says, by thinking of push, impetus, in a rather different way. "It is not impossible that the heavens be moved by an inherent corporeal quality or power [and that it be moved] without violence and without work, for the resistance which is in the heavens inclines it to no other movement nor rest but only so that it does not move more rapidly [or, we could add, more slowly]."[51]

The analogy is of the motion of the heavens with push that becomes shove, with an experiential datum from the center of action rather than from the eccentric boundary-periphery. In other words, by analogy with the experiential datum of implanted forces and resistances so characteristic at the center of action there are implanted forces and resistances in celestial bodies, and these can be related by the same formula, by the same "ratio of ratios," as terrestrial bodies even though the motion of celestial bodies may be different. Designation by numbers and ratios, then, is no longer to be regarded as a case of mimetic resemblance even though the motion of celestial bodies may be different.[52]

This returns us to the earlier problem, namely why the preference of one experiential datum over another to which the "real" is accessible. It would seem at first sight that Oresme has elevated a datum from the center over that of the boundary-periphery, and one to which, by analogy of course, celestial motion is akin. However, first sight may not be quite sufficient here. There may well be a profounder reason for the choice on the basic assumption of the Classical formulation of consciousness. Representation by analogy would seem to imply that instead of reading the lower off the higher, the higher is read off the lower, that the heavens are brought down to earth, that more than

[50]Oresme, *Questiones de spera*, cited in Clagett, *op. cit., loc. cit.,* pp. 277f. (The translations and glosses in square brackets are by Marshall Clagett; the emphasis is mine.)

[51]Oresme, *Livre du ciel et du monde,* cited and translated by Clagett, pp. 279f.

[52]*Ibid..*, p. 280.

contemplating pure push we can give it a shove. Still, we may have overstated our case here, at least as far as Oresme is concerned.

The End of the Classical Formulation of Consciousness

Among the many ideas touched upon by Oresme's rational speculations was the idea that if we argue for the rotation of the earth we encounter considerable difficulty in placing such an idea within the bounds of natural philosophy[53]— and, we might add with Nikolai Kusmitch, within the bounds of ordinary life. One of the "objections" to the idea of the rotation of the earth, hence to the exiling of such an idea from its place in natural philosophy, is that the rotational motion of the earth would falsify astrology. Oresme's answer is significant (and later we shall find a similar argument in Descartes): all of the Zodiacal events, all of the conjunctions and oppositions, meaningful in astrology would be seen to occur just as they do now even when we posit the rotation of the earth; the tables of motions and the theories of celestial influences would all remain without change.[54] In other words, providing we "withdraw" (Hall) the reality of motion from the heavens and give it to the earth, *it makes no difference whatever whether we read the lower off the higher or the higher off the lower*. Or to express the same another way, once we insist that "arithmetic," designation by number and ratio, no longer counts as a case of mimetic resemblance we need no longer take for granted the corollary assumption of the Classical formulation of consciousness. And if it makes no difference whether we read the lower off the higher or the higher off the lower, then any recourse to the higher is indeed superfluous. At night: beholding the heavens turning on an invisible axis loses its privilege and priority as an experiential datum to which the "real" is accessible.

By not taking for granted the corollary assumption of the Classical formulation of consciousness, that very formulation itself loses its assumptional character. Nor is it a matter of finding another experiential datum, for instance, a datum from the center of action, infused with the pragmatic or biological motives of the life-process, to replace the datum located not just at the eccentric periphery but at a boundary-periphery of ordinary life. The corollary assumption is not incidental to the main one of the Classical formulation; it is essential to the idea that the "real" is accessible to some aspect or fact of ordinary human experience. Even if we continue to retain the basic assumption, we can no longer take it for granted. That of course, does not entail its rejection. Nevertheless, mimetic resemblance and analogy are no longer twice or thrice removed from the truth; they have nothing whatever to do with the truth: they simply are not anchored in the sight of the truth. In terms we shall employ in the next chapters, the heavens are not an architectonics because the mutually constraining

[53] See Hall, *op. cit.*, pp. 68f.; Lindberg, *op. cit.*, pp. 258f.

[54] Hall, p. 68; see also pp. 69f. for the striking similarities between the arguments of Oresme and Copernicus in this connection; see Clagett, pp. 284ff. for the similarities with Kepler.

geometric forms are "arithmeticized." Moreover, that facet of ordinary experience to which the "real" is accessible is not a facet or an aspect prominent in consequence of an interruption of the action at the center. Where push comes shove, where impetus, force, velocity and resistance are directly and inversely proportionally conjoined, the language of quantity displaces the language of quality, *slc.* of beautiful appearances.

Once we have come down from the heavens, the first task is to develop a non-mimetic but also non-analogical language of numbers and ratios, of quantity. Nonetheless, it would seem that, for the most part, until the Renaissance and Baroque the formulation of consciousness still operates with Euclidean numbers and ratios; definitions of velocities are expressed in the language of mimetic representation as the ratios of quantities and not as metrical statements expressed algebraically.[55] Even so, an important change has occurred for representing ostensible relations of force and resistance to velocity in the production of motion. Leaving aside the history of the development of quantification both as to theory and as to method of measurement, and the many and intricate historical implications of that development, we can take one brief example to serve our purposes here to illustrate the end of the Classical formulation of consciousness. The example mentioned by Clagett is the so-called Bradwardine rule expressing the relationship between degrees of intensity of moving things and resistance ($\frac{F_2}{R_2} = (\frac{F_1}{R_1})\frac{V_2}{V_1}$).

Aside from the difficulties and problems with this example and Bradwardine's alterations of it, it is a language of quantity which cannot be borne by the Classical formulation of consciousness and which, as Clagett points out, may well have an intriguing origin in the treatment of medicinal compounds in the writings of Alkindi where we find degrees of intensity ordered arithmetically and qualitative powers ordered geometrically. Thus a compound is "in equality" when its frigidity is equal to its calidity; it is hot in the first degree when its calidity is twice its frigidity, hot in the second degree when its calidity is four times its frigidity; and so on. In other words, there is an *exponential* relationship between degrees of intensity of motion and the ratio of motion and resistance. And we treat intensities of qualities and intensities of velocity in a parallel manner.[56]

We have come close enough to the fate of the Classical formulation of consciousness to take some stock of the increasing burden it bears as well as to get a glimpse of its collapse from within which, to some extent, sows the seeds for yet another possible formulation of consciousness. Our glimpse shows us that the moment we cease to take for granted the corollary assumption of the Classical formulation of consciousness and read the higher off the lower, the heavens off the earth, we deal with exponential and not mimetic-appresentational relationships. Moreover, once we deal with change in exponential terms we no longer deal with an architectonics but instead with the "quantification" of qualities of things undergoing alteration and in motion.

[55]See Clagett, pp. 283f.; Clavelin, *op..cit.*, pp. 468-471.
[56]Clagett, pp. 284f.

"Quantification" begins to emerge as a new meaning of the thingness of things, and therefore we can no longer adequately employ the language of mimesis, we can no longer represent the "real" by way of mimetic resemblance (at least in the Classical or antique sense of "mimesis"). Finally, the privileged experiential datum of ordinary life is where push everywhere and of necessity always comes to shove so that it must be represented as arithmetical in proportion to geometrical increase.

As a consequence, the Classical formulation of consciousness no longer operates at the boundary-periphery of the eccentricity of our ordinary life, no longer sets us out and at a distance from the center of action and the specious present of our being the world; it no longer releases us from the needs, necessities and cares of the world into which we are born and upon which we must act to survive. Judgments of how and what should appear are no longer decided by the criterion of beauty; "disinterestedness" and with it "objectivity" no longer hold sway as the dominant philosophic and scientific stance. In turn, the very eccentricity of ordinary experience undergoes a radical change in self-interpretation. The gap between the speakable and the unspeakable borne and preserved in the Classical formulation of consciousness[57] has disappeared, to be sure. But to the dismay of heirs of Oresme and Bradwardine, such as Nikolai Kusmitch and so many others fictive and actual, yet another gap will eventually appear and with which we are much more familiar today. The question we are left with, though, is, *phenomenologically*, what is the foundation in ordinary experience for "exponential representation"? Of what does the change in this self-interpretation of the eccentricity of ordinary life consist?

In order to answer these questions, and a number of other and subordinate questions, it is necessary to develop in much greater detail the structure and inner workings of ordinary life in its eccentric sociality. Ordinary life as an enclave is not some kind of pliable mush, bent and bendable to whatever shape or form. It has instead a life of its own, a room of its own with its own view—a structure that is quite specific with clearly identifiable features. Thus we have to begin the next chapter with a much more detailed account of ordinary life in its eccentricity, not only as it figures into the Classical formulation of consciousness, but in other actual and possible ones as well.

[57]With disappearance of the gap, we may add, there is disappearance of the "distance." We shall return to this question in the next chapter.

CHAPTER THREE

The Gap at the Center

While not quite like being eaten by a wolf and thrown over a cliff, the prospect of the internal collapse of the Classical formulation of consciousness has a serious impact. It lays bare the ambiguity at the heart of ordinary experience by serving notice on the ungroundedness of its underlying ontic conviction, leaving in sore need of resilvering the tarnished prestige of the power of mimesis and analogy to represent the "real."[1] The contemplative sight of the measure of the higher and the far, beheld at night, has become blurry and increasingly myopic. At worst, mimetic and analogical resemblance will prove to be inadequate to the task of meeting the needs, cares and necessities of ordinary life under the yoke of the criterion of beauty. At best they will be reduced in rank to become the "tools" of the rhetoric and logic of scientific persuasion.[2]

Of course there is no historical date for the internal collapse of the Classical formulation of consciousness. No one went to bed one night under the Classical formulation and awoke next morning under a new and different one. The situation is rather like that of Nikolai Kusmitch with a headache: it is not quite certain when it started but suddenly it is clear that the headache had now already begun. The specious present of the headache, the "now having already begun," is the focus of our attention because it involves a significant shift in the self-interpretation of the on-going process of ordinary life.

The basic structure of ordinary, daily life we have so far identified is the mutual transposition of center and periphery circumscribed by two limiting or boundary situations: where the action and activity of the center is interrupted and shifted to the periphery in a way not preindicated at the center by virtue of being unanswerable but non-threatening, or unanswerable and threatening, and where, in either case, the periphery does not become another center of action. It is the former case, "laughter," we noted, which is the proving ground of the experiential datum upon which the mimetic and analogical representation of the "real" is extrapolated. But this boundary-periphery is not isolated. On the Classical formulation of consciousness and under the criterion of beauty, appearances of things and actions are judged by themselves apart from their function and use at the center of daily life. Mimetically and analogically, the enclave of ordinary life transcends itself, takes the measure of motion and

[1] See below, pp. 73f. for the specific form and problem taken by the internal collapse of the Classical formulation of consciousness.

[2] For the rhetoric and logic specific to scientific persuasion, see Maurice A. Finocchiaro, *Galileo and the Art of Reasoning. Rhetorical Foundations of Logic and Scientific Method*, Chapters 1 and 3; for a more general discussion, see Madeleine Doran, *Endeavors of Art*, Chapters 2 and 12; Eugenio Garin, *Italian Humanism. Philosophy and Civic Life in the Renaissance*, Chapter 6; and Mario Biagioli, *Galileo Courtier. The Practice of Science in the Culture of Absolutism*.

change in our experience, be it of the starry heavens, or the "greatest *kinesis* that had ever stirred the Hellenes" (Thucydides), or just plain working together on a project in a world in common.

Unlike the other existential convictions and claims of ordinary experience, the ungrounded ontic conviction of ordinary experience has no negative fulfillment.[3] Even so, the accent of reality (Bergson) can shift from the boundary-periphery to the center and form a "new" foundation for self-interpretation of common-sensical experience in ordinary life. Other measure-takings of ordinary, daily life are therefore possible, signifying that the self-interpretation of ordinary life from the boundary-periphery is not the only possible one. That one self-interpretation ceases to be "the" privileged measure and becomes "not the only possible one," is part of what is meant by the internal collapse of the the Classical formulation of consciousness: it becomes "not the only possible" self-interpretation of ordinary experience precisely when it should be the "only possible one." This was in part the point of our reference to Oresme at the end of the last chapter.

More specifically, at issue then is the sort of self-interpretation that belongs to acting and working together at the center in a world in common into which, bodily, we gear and for which we are geared. The center of the enclave that is ordinary life cannot help now but invite further examination of other aspects that have been taken for granted but can no longer be so when the accent of reality of our ontic conviction undergoes a shift. Indeed, the very taken-for-grantedness itself of ordinary life requires scrutiny sufficient to recover a "new" and newly entitled or privileged datum of experience to which the "real" is accessible. To carry out such an scrutiny without falling into the fallacy of *hysterion proteron* requires delving more deeply into some of the elements of what we may call a "phenomenology of social action" to be applied to an example drawn from the Renaissance.[4]

By "social action" I mean, with Alfred Schutz, behavior governed by a project that entails a decision of the will with respect to one or another pragmatic purposes or motives; in addition, involved and identifiable are planning and setting of goals and the intention to achieve them no matter whether the project is vague, murky or highly detailed.[5] However we proceed to

[3] See above, pp. 13f.

[4] Below, pp. 56f.

[5] Among other writings, see Alfred Schutz, "Common-sense and Scientific Interpretation of Human Action," *Collected Papers*, Vol. I, pp. 19ff., 38ff.; and "Choosing Among Projects of Action," *ibid.* pp. 67ff. Schutz's definition of social action, employed here in modified form, is quite narrow; the context in which he developed it, and the reasons for the necessity of making it as narrow as it is, may be found in Alfred Schutz, *The Phenomenology of the Social World*, pp. 15f., 57ff., 144ff.

The basic modification of Schutz's account of social action introduced here is that the structure of center/periphery is regarded as the chief principle of the internal organization of social action in ordinary life. However, no attempt is made here to systematically develop, or imply the development of, a phenomenology of social action, for which see Alfred Schutz/Thomas Luckmann, *Strukturen der Lebenswelt*, Vol. I (1979), Vol. II (1984).

further specify "social action" so defined, it is always understood as embodied, geared for and into the experienced world of daily life. Obvious as this may be, it is just what is in need of further phenomenological analysis because it signifies that the presented and appresented world of daily life in and upon which we act is always relative to our experience and its self-interpretation.

Stocking up on the Stock of Knowledge at Hand

Unlike a box of books in the attic, to be dusted off once a year during Spring cleaning, the stock of knowledge at hand which each of us possesses at any given moment in our lives includes past experience and not only my insights, values, beliefs, accruing through my past experiences, directly, but also insights, values, beliefs each of us has taken over from others such as parents, teachers, friends, likewise predecessors with whom there is only indirect acquaintance, but also those experiences and ideas, practical and theoretical, of what is important and relevant at the moment. The stock of knowledge at hand, we may also say with Schutz, serves as a schema of reference which each of us carries around all the time and which continually shapes and influences, *interprets*, the given situation in which we find ourselves.

Like a warehouse in the mall of ordinary life, the stock of knowledge at hand continually restocks its inventory, continually stocks up its recipes of action, insights, values—in short continually enriches its generalized acquisition of empirical meaning and function on which, in large part, the content of any given formulation of consciousness depends in order to establish the intelligibility of the ordinary, daily world into which each of us is born, lives and which we take for granted "until further notice." We may also say, then, that it remains the *operative ground* of ordinary experience no matter what and how changed the content of any given formulation of consciousness.[6] As a consequence, examination of the structure of the stock of knowledge at hand prevents treating what occurred as though it were occuring because an actual ground can be supplied. Yet it also allows of historical specification[7] when that "further notice" is in fact served on the taken-for-grantedness of ordinary life.

If there is always at least implicit knowledge brought to bear on the present situation, then, at least with respect to the *general kind of experience*, the ordinary world of daily life is not given as chaotic and filled with just this or that thing, this or that event; no matter how novel the situation may or might be, at least as to general kind or type it can be recognized in the light of past recipes for action, past rules of behavior, past ideas of what such or similar things and events are. So far as common-sensical, ordinary experience is concerned,

[6]See Alfred Schutz, "Common-sense and Scientific Interpretation of Human Action," *loc. cit.*, pp. 7ff.; *Reflections on the Problem of Relevance*, Chapter 3, especially pp. 66ff.; and "Tiresias, or Our Knowledge of Future Events," *Collected Papers*, Vol. II, pp. 281ff.

[7]For the idea of "historical specification" with respect to the stock of knowledge at hand, see Fred Kersten, "Phenomenology, History, and Myth," pp. 242ff.

absolute novelty is excluded from ordinary life. The limiting case of common sense and the commonplace is not sheer novelty but instead the absurd for it rests on an ungrounded primordial credulity. And no doubt this is one of the reasons why ordinary life, when viewed from the center, oppresses us with its banality, its lack of novelty and absurdity. The limiting case is rather like that recently described by Paul Griffiths in a review of a production of Debussy's *Pelléas et Mélisande*: "A reason for the opera's present ubiquity is possibly this inability of its characters to understand the kind of world in which they exist, even though they may be aware, intensely, of the noises it makes. Debussy's score is a stream of information—a gorgeous stream as Mr. Rattle makes it appear—and one that the people onstage can detect and parse: among the cases of operas, they have the most discerning ears. And yet they fail to recognize the relevance to them of what they hear. The world is clear to them, and opaque. It's a situation that may be as familiar at the end of this century as it was at the close of the last."[8]

The stock of knowledge at hand may prove inadequate at times, even fail or collapse such as in situations where action is interrupted by events unanswerable, threatening, or where we fail to recognize the relevance of what we hear, see, touch, where a situation is clear *and opaque*. Or the stock of knowledge may indeed prove adequate, even grow, perhaps grow up. But like everything else comprising the common-sense character of ordinary life, the stock of knowledge at hand is always good only *until further notice and subject to greater or lesser overhaul when that notice is served*—such as happened to Pelléas and Mélisande at the castle of Allemonde.

Most social action at the center of daily life, and upon which I bring my stock of knowledge at hand to bear, consists largely of action upon the world that modifies my environment, seeks accomodation to new situations or adapts old ones. It is a commonplace that things and environments often prove resistant and change me in my effort to change them when meeting the necessities, cares and desires of embodied and eccentric being in the world. That means that my environment and things and events in it have their spatial and temporal loci peculiar to them, endure somewhere over a period of time, but always relative to action in and upon them. The space and time of the ordinary life are made manifest, in other words, in the reciprocal effects of bodily gearing into the environment and the presented or appresented reaction, resistance of the environment. The ordinary, pragmatic world of ordinary life is organized around me at the center which serves as zero-point of a system of spatial-temporal coordinates.[9]

Thus at any moment of my life it is my body that occupies an actual Here serving as the starting point and fulcrum by and from which I get my bearings and orientation in space. It is, moreover, a ubiquitous Here because it is always Here even when I go over there; and when I am there I am Here, never There—and that despite the story about Zoroaster who, when walking down a street, turned the corner and met himself coming the other way. As the zero-

[8]Paul Griffiths, "Rattle and Sellars: Hearing Debussy," *New Yorker*, 28 June, 1993, p. 86.

[9]See Edmund Husserl, *Cartesian Meditations*, pp. 116f.; Alfred Schutz, "Husserl and the Social Sciences," in *Edmund Husserl, 1859-1959*, pp. 95f.

point of a system of directional coordinates orienting me in my environment in and upon which I act, carry out my intentions, honorable or otherwise, my plans, best-laid or awry, and projects best known to me, it is my Here to which all things are relative, with respect to which things are near or far, to the right or left, above or below. Likewise, just as I am always Here, I am always Now and this Now is as ubiquitous as Here: I am speciously Here and Now. Here and Now accordingly are the "origin" of all space-time perspectives with respect to which I organize events, plan actions. The Here/Now which permanently marks my life and, I assume as part of my ontic conviction, the life of each of us, I shall call (if Derrida will still allow it) the "specious present" and, at times, the "specious appresent" and I shall speak as much of the "specious Now" as the "specious Here" (which is about as specious as I can get).

The limiting case of this zero-point of the system of spatial-temporal coordinates governing social action is the boundary-periphery of the unanswerable, non-threatening or threatening as the case may be; in other words, the two cases where my Here is no longer the fulcrum of action, where things and events are no longer relative to my bodily gearing into the world, and therefore lacks the sector of the experienced world at the center of which I am. With Alfred Schutz I shall call the experienced world at the center of which I am the "world within actual and potential reach." It is to the world within actual and potential reach that the accent of reality has shifted from the hollow shell of the heavens forever out of reach.[10] Correlatively, a new measure is taken from the "real," extrapolated not from the experience of push without shove, but precisely from push that comes to shove, where push is within actual and potential reach.

Holding the Center

The world within actual and potential reach is a delimited and limited but extendable region of the experienced world which each of us can manipulate, or to which we can accomodate or adapt ourselves (and which can be extended through the use of tools and technology). That sector of the *outer world* which can be influenced directly or indirectly, but upon which it is always possible to act, may be called the "manipulative zone" of action (a phrase which Schutz borrowed from G. H. Meade, and whether Meade borrowed it I don't know). It does not seem difficult to identify within common-sense either the world within actual and potential reach or the manipulative zone of action. Nor is it difficult—indeed, it may even be a commonplace—to see that because of actual and potential change in orientation to that segment of the outer world within actual and potential reach, *Here* is not just the spatial placement, the setting of my bodily gearing into the world and acting upon it. It is equally and already the

[10] See above, pp. 21f. In terms of the center of action, the world out of actual and potential reach is, on the Classical formulation of consciousness, the measure of the world within actual and potential reach. In what follows we shall examine how the new measure of the "real" is what is within actual and potential reach rather than what is out of reach, with correspondingly new meanings of "objectivity" and "measure."

autobiographical placement of my life and therefore the means of access to a unique and non-transferrable perspective on the world. Much more specifically, the manipulative zone is oriented around the zero-point of Here, but that orientation is "elastic" in the sense that it includes potential peripheries which themselves become centers and zero-points, reorganizing the spatial-temporal coordinates of action. Strictly speaking, it is not another Here, not another zero-point of spatial-temporal coordinates, when center becomes periphery and periphery becomes center.[11] And in each case of mutual transformation of center and periphery, whether preindicated or not, the outer world itself undergoes a change of meaning relative to Here and Now.

The Here and Now that define my life so uniquely are, to my lasting regret, unchoosen by me; I have no choice but to be Here and Now. Thus the uniqueness peculiar to me, presumably to each one of us, and by which I am what I am, who I am, is imposed on me by the manipulative zone of my world within actual and potential reach into which I am born and by virtue of being born. But that on in which I am dependent, Here and Now, is at the same time my field of action in the outer world which I perform my life, live it out. Like my unique biographical placement in the world, my eccentric and eccentered sociality is not just imposed on me but is also the field in which I initiate and carry out my actions in the outer world, plan and form my projects, realize my intentions, meet my needs, deal with my cares and even those of others.

From all of this it is possible to get the impression that the center of ordinary life, where push comes to shove, is a dead center of dead-center reckoning. Although that is not impossible or even far-fetched, it overlooks the fact that to the extent that the manipulative zone of my world within reach is telescoped into my unique biographical situation, the manipulative zone belongs as well to my world within reach in the past as part of my recollections, and even in a past that may no longer be within actual reach, perhaps not even potential reach. Correspondingly there are expectations and anticipations of a potential world yet to be within my actual reach, where it may be necessary to alter my orientation in the world, move from Here to There and transform There into Here. The specious Here and Now is a roomy one, not necessarily always within actual reach, sometimes out of potential reach, yet restorable—just as center and periphery are restorable.[12]

In other words, the center too has its "transcendence;" the world within reach relative to social action at the center is given with a reach beyond itself: The reach relative to Here and Now is equally an outreach. And it is to the

[11]The mutual transformation of periphery and center requires further analysis beyond what we have introduced. This is not the place for such an analysis. However, I do not wish to imply that there is a multiplication of Here's nor of zero-points of the system of spatial-temporal coordinates. It is instead a question of further analysis of internal organization and reorganization of the world within actual and potential reach consistent with the systems of relevances governing ordinary life as a whole.

[12]For the limiting cases, see Kersten, "The Life-Concept and the Life-Conviction," pp. 121ff. Death, for instance, would be a zero-point without any system of spatial-temporal coordinates to which a world within reach would be relative; it is "being" neither here nor there. See above, p. 32 and note 31.

nature of the the reach and outreach of eccentric being in the world that we must turn our attention because it will disclose still more of the experiential data from which the "real" is extrapolated in a new—Baroque—formulation of consciousness.

Indicational Appresentation

What is not actually within my reach, what is temporarily out of reach, I know can be restored when I return to it at the office or biker-bar. For practical reasons, to restore what had previously been out of reach and find my bearings again in the manipulative zone of my world within reach, certain things must be marked out so that they will once more be recognizable. There is always the motivation to mark out things useful at least as subjective reminders of where I was before (my initials on the classroom desk, bookmarks, the broken branch of a tree in Brooklyn, the "x" on the boat marking the place on the lake where fish are biting). The *mark* is one of the simplest forms of appresentation, and unlike those forms considered before, mimesis and analogy, the mark can be arbitrary and divorced from an intersubjective context, thus can be purely private and need not bear any similarity whatever to what is marked out.

But because I am not, and need not, be equally interested in all that there is within my reach, because my action is characerized by major and minor relevances of things and events which are means and ends, or obstacles to fulfillment of plans and projects, diverse things and events are known to exist by me in certain, often typical ways in relation to other things, with greater or lesser degrees of plausibility. Until further notice I expect A to appear with X and typically to reappear with X. Thus I may say that A appresents X and refers to past, present and even future appearances of X. Accordingly, more than a mark, we have to say that A *indicates* X. And the X so indicated need not be experienced by me, but still can be something the existence of which I am convinced. The presence of A is a motive for believing in the existence of X. For example, the presence of the halo around the moon indicates, not just marks but rain; the presence of smoke indicates fire, the pointer on the dial indicates an empty gas tank, the blob on the computer screen indicates a new file.

As a form of appresentation, indications are important because they allow for transcending the sector of the world within immediate reach to elements lying outside it which are, nonetheless, of interest and use to what is within reach. Although indications certainly need not be arbitrary or even be purely private or subjective, as in the case of the mark on my boat, they need not be mimetic either and need not entail some degree or other of resemblance or similarity. Yet indications can have a generality and typicality as well as a more or less specific relation to the indicated, perhaps even a relation recognized universally (like the pointer on the dashboard dial). In addition, owing to their transcendence some appresenting indications refer to things of the same order of existence, as in the case where smoke indicates fire. But in other cases we find that they indicate things of more than one order of existence. For example, some of the things indicated are not just bodily things, but living bodily things; more particularly, some of those very living, bodily things are indicated

appresentively as "bodies of minds," even of something else, namely, *someone else, an Other.* Still more particularly, some bodies of minds indicationally appresented are bodies of minds whose existence is taken for granted until further notice as human others. *Empathy, expressiveness generally, then, is built on indicational,* rather than mimetic or analogical, *appresentation.*[13]

Our "knowledge of other human beings," of others and even of the Other, is not a matter, then, of resemblance or of any form of mimesis because its very "origin" lies in our ungrounded ontic conviction of the existence of other people on which mimesis itself rests. In other words, it has no ground. That means that *we cannot arrive at the human world and the experience of other people from appresentational, indicational and expressive phenomena themselves.* Indicational phenomena, like expressive phenomena, are not the only or even the most original domain of experience of other people founded in the ungrounded ontic conviction or existential belief which makes the human world recognizable *as human* in the first place.

Now, the ungrounded ontic conviction or existential belief in "other minds" is one thing. Quite another thing is the sharing of *the community of Here and Now,* of the specious present in which push comes to shove in social action. The latter case necessarily involves indicational, not mimetic or analogical, appresentation.[14]

For our purposes here we need not develop further an account of the common-sensical experience of "other minds" in ordinary life. What has been sketched so far is sufficient to turn to another element essential to the self-interpretation of ordinary life.

The Reciprocity of Perspectives

When we sketched the development of the Classical formulation of consciousness we made a point of emphasizing its presence in the case of social action in the *Polis* and working together in a world in common—the manipulatory zone of the world within actual and potential reach. In that

[13] For the idea of indication as a form of appresentation, see Alfred Schutz, "Symbol, Reality and Society," *Collected Papers,* Vol. I, pp. 294ff., 306ff. The distinction between mimetic and analogical appresentation on the one hand, and indicational appresentation on the other hand, although not Schutz's, is not wholly inconsistent, I believe, with Schutz's distinction between sign and symbol. As I use the terms here, the distinction between mimetic and indicational appresentation cuts across that between sign and symbol. The discussion here is then a development and transformation of Schutz's view, rather than its application. See "Loneliness and Solitude," pp. 306ff. where I first argued against the idea that the experience of someone else is a case of mimetic or analogical appresentation; see also my "Constancy Hypothesis in the Social Sciences," pp. 559ff.

[14] See Schutz, *op. cit., loc. cit.,* pp. 312ff.; "The Problem of Transcendental Intersubjectivity in Husserl," *Collected Papers,* Vol. III, pp. 61ff.; see also Fred Kersten, *Phenomenological Method: Theory and Practice,* §§ 19, 80, 89, 96.

connection, we referred to the dominant idea of "persuasion."[15] That is a case of the "intersubjectivity" of social action, however always subject to the judgment by the criterion of the Beautiful beheld from the boundary-periphery of the center of action in the world. It is in this sense that we shall say that "intersubjectivity" is not essential to the Classical formulation of consciousness. The measure of ideas, points of view, opinions, at the center is subject to judgment based on a criterion which is not, and cannot be, another point of view.[16] In this chapter and the next I shall argue that what we shall call the "Baroque formulation of consciousness" is quite the opposite: it is *essentially intersubjective*.

It is therefore necessary for our purposes here to develop at least one facet of the common-sensical experience of intersubjectivity at the center of social action in the world. First and foremost, intersubjectivity is an indicational-appresentational experience that involves an event in the outer world in the manipulative zone within actual and potential reach, namely the perception of the body of someone else *as someone else's body*. On this case of appresentation rest relations of communication so that all cultural objects are never perceived just for their own sake; a book, for instance, is an object in the outer world but I am not directed toward it, nor do I act upon it, as simply a material thing. Instead I live in its meaning, as I did with the book I found in the box in the attic, and I am directed toward what the book expresses (appresents) and despite the damage it did to my foot. I apprehend the meaning based on perceiving the material thing in the outer world, and it was just that which got me into trouble in the first place. Similarly, sounds or patterns of marks on paper in the outer world are directly apprehended in their meaning. In short, our basic mode of communication is through an intermediary event in the outer world. Phenomenologically, the most original case of communication with someone else is what Alfred Schutz called the "face-to-face" relationship.

Like other diehard convictions of ordinary life the face-to-face relationship harbors assumptions unique to it. The sector of the world within actual reach defined by the manipulative zone is centered around Here, seen from Here; the sector of the world within your actual reach circumscribed by your manipulative zone centered around your "Here" and seen from your "Here" is, for me, a There.[17] The tacit assumption always is that both these sectors may overlap so that there are co-existing systems of orientational coordinates, and in ordinary life I take it for granted that substantially they can be transformed the one into the other, such as when we act and work together on a common project in a world in common. In other words, until further notice I assume as a matter of course that typically your experiences are instances of the same kinds of experiences as mine and, conversely, that typically my experiences are instances of the same kinds as yours so that, for pragmatic motives, we can disregard the unique differences of our biographical placements in the world as a result of

[15]See above, pp. 28ff.

[16]Above, p. 30.

[17]To speak of your Here and my Here is, of course, a linguistic impossibility, just as it is to speak of your "I" and my "I." As with most such difficulties in ordinary life, we can ignore them for the practical purposes at hand.

which our perspectives on the world can be exchanged. It is just this typicality of the *reciprocity of perspectives* (Schutz) based on disregarding "for the moment" the unique differences of our biographical placements, that is properly designated as "*We.*" It is in this sense that "we" speak of sharing a common world, of working on tasks in common, of acting together when push comes to shove.

In this connection a few other observations are in order. As a case of indicational appresentation, the face-to-face relationship originates in the manipulative zone of my world within reach; the appresenting vehicle is always a bodily one even in the outer world in which each of us is individually, biographically located Here and Now. Moreover, it is an outer world within actual and potential reach accepted not only as existing before we were born, inhabited by others but interpreted by them in typical ways based on coinciding stocks of knowledge at hand socially rooted and distributed. The social matrix in which this occurs is, then, like a landscape lying before me, oriented and organized with respect to my Here and Now comprising a zero-point in a system of spatial-temporal coordinates of relevance and importance. Still, "the" world within my actual and potential reach presents itself and is taken for granted by me as "the" world within actual and potential reach of and for others. Although I am Here and the other There, and even though I can never quite stand in the other's shoes (not that I would ever want to), I take for granted that the Other experiences what I experience from Here: we experience the "same" no matter what differences in perspectives from Here. Events, things, bodies in the world within actual and potential reach by way of indication appresent reciprocally exchangeable perspectives.

The core of social action, then, is the reciprocity of perspectives based upon indicational appresentation which, in turn, is the core of the self-interpretation of ordinary life at the center of action. Of course a "phenomenology of the social" does *not explain* the human world as human and our "knowledge of other minds" as "knowledge." That is an entirely different task.

Specious Objects in the Specious Present

We have mentioned the temporal form of the experiential stock of knowledge at hand at the center of social action: the specious present. Two features of the stock of knowledge at hand remain to be sketched. The first is what Schutz called "socially derived knowledge," and the second "socially approved knowledge." Both of these terms harbor problems of developing and clarifying ordinary experience, and both entail the assumption that ordinary life is never just private but intersubjective as well, that "privacy" always entails "publicity," that the individual human sleeve wears the heart of others as its own. For others are as much objects of my experiences as I am of theirs; ordinary common-sensical experience is always in some sense, to some degree, shared experiences of a world in common and within reach. What others experience and have experienced (contemporaries as well as predecessors) is also part of my stock of knowledge at hand. Physical things, embodied events, actions in the world are as

much actually existing objects of the actual experience belong to others as they are objects of my possible experience. They are, we may say, coining a horrid phrase, "*specious objects*" of my actual and possible experience in the specious present.

The same holds for Others' possible experiences which, in turn, are actually and potentially mine exponentially to a second degree of possible experiences. Such socially derived knowledge has its own forms of verification and refutation, its own forms of trust, veracity, prestige, authority. In the latter form, for example, socially derived knowledge has additional "weight," credibility, greater relevance owing to approval of Others. When that happens socially derived knowledge is also socially approved knowledge and there is sharing in the second degree. But the certainty, the credibility and relevance of socially approved knowledge is not simply a stamp put on it; its "weight" is multiplied, exponentially increased. If the secretary of the local chapter of the *Linceo* confirms my experience, then my experience not only bears a stamp of approval but I find myself undergoing an increase in self-worth, prestige and esteem: I become an "expert" as well, a dependable witness to the chorus invisible singing the praises of floating bodies or the dome on the local cathedral.

Socially derived knowledge which is also socially approved forms the foundation for the transactions and negotiations making up social relationships of whatever sorts, from the most personal to the most anonymous. Depending on such knowledge are the very ways in which our expectations and anticipations are formed, the ways in which our experiences succeed or fail, to one extent or another, to fulfill our self-interpretations and mutual understandings.[18] It is the socially derived, socially approved segments of the stock of knowledge at hand that are the condition for realizing the possibility of our being consociates, sharing a world in common which appears in and through our social action (and codified in every form from Homer to Castiglione to Samuel Smiles and Isabella Beeton).

In summary: The basic consociative relationship is the face-to-face relationship which consists of sharing a community in the specious present in which we are self-interpretively attuned to each other, appresented indicationally, such that our perspectives of the world are interchangeable, reciprocal, because we have maximum access to each other's body as indicational and expressional field, because a segment of the outer world is our common environment and because our sense of time is synchronized. We share a "community of time" as well as of space, or, equivalently stated, the most original case of consociate eccentric being in the world is, rather than logocentric, then, if we are to believe Derrida, "phonocentric" in the broadest sense.[19]

[18] See Alfred Schutz and Thomas Luckmann, *The Structures of the Life-World*, Chapter 4, especially pp. 304ff.; also Schutz, *The Phenomenology of the Social World*, pp. 160ff. For Schutz's account of the specious present, see especially "On Multiple Realities," *Collected Papers*, Vol. I, pp. 214ff. In this connection, see below, pp. 73f.f., and also Lydia Goehr, *The Imaginary Museum of Musical Works*, pp. 70f.

[19] For this distinction, see R. Kearny, *Dialogues with Contemporsary Thinkers*, pp. 115f.

The *common specious present*—and it makes no sense to speak of it except as common and shared by virtue of the reciprocity of perspectives—consists of the ongoing flux of action as it proceeds phase by phase. And while, e.g., the other's action goes on it is a segment of the specious present belonging to the other as much as to me; I participate in the other's ongoing action directed toward its goal, as it realizes the other's plans or projects (be they known or unknown to me). As a result we have to say that the planned goal, the realization of the project, is an ingredient of our shared specious present. However, in contradistinction to the fixed moment, the Now, that is the experiential datum of the Classical formulation of consciousness,[20] it is the ongoing flux which is the privileged experiential datum. However, this is not the only significant contrast that we can point to once the accent of reality has shifted from boundary-periphery to center. The shift entitles other experiential data as privileged at the center, data under the sway of the center. By turning our attention, now, to the shift in the accent of reality we can discover other privileged data of the common-sensical stock of knowledge at hand peculiar to the late Renaissance and early Baroque.

"Medii Cupperdine Victae"

All of the structural elements of ordinary life that we have sketched, the specious present and appresent, the spatial-temporal orientation around the biographically set Here and Now, the indicational appresentation and transcendence of the world within actual and potential reach relative to the actual manipulatory zone, the surrounding presence of others and the reciprocity of perspectives, are part of the shared community of space and time of the social world and originate in the ungrounded and taken-for-granted ontic life-conviction that underlies and supports the mutual transpositions of center and periphery of our lives. Moreover, the mimetic and analogical appresentation with which we are familiar from the last chapter always presuppose indicational appresentation, although the converse is not the case as Hume clearly demonstrated.

In short, living and working together in a world in common and in actual and potential reach is "*swayed by the desire for the center*" (Giovanni Battista Agucchi, 1611[21]) rather than for the boundary-periphery.

In other words, eccentric ordinary life in its structure and content, its stock of knowledge at hand, is dominated by a "desire for the center," and common-sensical experience, no matter how commonplace, is pervaded by the "sway of the desire for the center." How do we represent the "desire for the center," where push comes to shove? More particularly, in what way is the reciprocity of perspectives accessible to the "real"? How is the "real" extrapolated from the change and motion effected at the center rather than the

[20] See above, pp. 21f.

[21] Cited by Panofsky, *Galileo as Critic of the Arts*, p. 41. We shall return to Agucchi at the end of this chapter.

periphery of working together in a world in common, marked and indicated appresentationally? What is a representation like when "built" upon the center into and for which we are geared by virtue of being born in the world of ordinary life? What is the "fate" of the ontic conviction in such representation or "reproduction" of the "real" which allows for its indicational appresentation in the first place? Is the role of the ontic conviction the same as in the Classical formulation of consciousness when the privileged experiential datum to which the "real" is accessible is precisely and only that datum "swayed by the desire for the center"?

Those and similar questions all have in common one thing: the search for a foundation for a formulation of consciousness that will serve us as a springboard to the Baroque formulation of consciousness. Such a foundation can be found, I believe, in the idea of representation of Leon Battista Alberti at the beginning of the fifteenth century. There are a number of reasons for this choice, as much philosophical as historical, some obvious and some not. In part, the significance of starting with Alberti rests upon the observation of Arnold Hauser referred to much earlier:[22] it is a wonderful example of where "artistic imagination in science makes itself felt relatively late, actually not within the classic period of the Renaissance at all." Where that artistic imagination makes itself felt is in the Baroque science of Kepler, Galileo, Descartes and others. We can only make a plausible case for this, and for a basic thesis of this book, when we can examine *how* it makes itself felt—part of the task of the remainder of this chapter and of the next chapter.

Yet another reason for beginning with Alberti is that it allows for a kind of "historical specification" of a stock of knowledge at hand with respect to the shift in the accent of reality; in other words, it is a stock of knowledge at hand swayed by the desire for the center. It is interesting, in this connection, that Alberti, but later also Da Vinci and Dürer, sought to develop a theory of the proportions of the human body that went beyond Medieval and Classical standards by approaching the "living body with compass and ruler,"[23] selecting from many living models those deemed most beautiful, seeking the ideal by defining the "normal" with exactitude. Moreover, it is the living body, not just what is visible on a plane, but rather the "natural" living three-dimensional human body in its organic articulation, hence as acting, working, as changing, as in motion and initiating motion at the center of ordinary life. *The idea of human proportion is fused with the idea of human motion (and emotion).*[24]

It is this fusion of proportion and motion that sets the formulation of consciousness peculiar to the Renaissance and Baroque. It arises out of a basic set of circumstances shared as much by the Classical as the Renaissance and Baroque formulation but which, when the accent of reality of the ungrounded ontic conviction is shifted from the boundary-periphery to the center of ordinary life, leads to a radically distinct formulation of consciousness.

[22]Above, p. x.

[23]Erwin Panosky, "The History of the Theory of Human Proportions as a Reflection of the History of Styles," p. 94.

[24]*Ibid.*, pp. 97ff., 113ff.; see also Erwin Panofsky, *The Life and Art of Albrecht Dürer*, Chapter VIII, especially pp. 253f., and 272f.

What Is "Right" Appresented by What Seems "Right"

What is at stake is this: like the physicist, the philosopher and the mathematician, the artist—the painter, the sculptor, the poet, the composer—seeks to "reproduce" things in Nature just as they are, as "they themselves," in paint, words, marble, sounds.[25] There are then two problems facing the artist which determine the kind of representation employed.[26] Both problems concern the socially derived and approved stock of knowledge at hand within a certain historical framework, and both disclose the shift in the accent of reality from boundary-periphery to the center.

To "reproduce" things in Nature as it is, a certain stock of knowledge at hand has to be furnished about natural things and events, about the structure and function of the human body, the expression of human and animal emotions, the action of light and atmosphere on solid bodies, even about the construction and properties of many-sided bodies. In addition, a theoretical ("scientific") process must be developed in order to unify natural phenomena in three-dimensional space and time so that any thing can be correctly reproduced or reconstructed, on a two-dimensional plane, for example as in painting, or in words, such as in rhetoric or logic.

For the most part, it would seem, the artist generally had to produce that knowledge; the stock of socially approved and derived knowledge of anatomy of the body in motion, of bones turning in their joints, of muscles expanding and contracting, often proved inadequate or entirely lacking for purposes at hand. Pollaiulo, for example, found it necessary to dissect corpses,[27] Dürer, like Da Vinci, often had to construct his own "proofs" for geometrical figures,[28] or Da Vinci had to further develop astronomy, mechanics, geology and meteorology beyond what was available to him. If there is any one general characteristic of the fifteenth century it is that of the necessity of creating a new stock of knowledge at hand, but now under the sway of the desire for the center

[25] The received wisdom is plausible that the elevation of the artist with the scientist and philosopher only occurs with and at the time of Dürer. However, if we consider significant, for instance, the fact that the fusion of the theory of human proportion and human motion, the basic epistemic condition for "perspectivism," already occurs in Alberti's works on architecture, in "architectual thinking," such as the *Descriptio urbis Romae*, c. 1431, or *De re aedificatoria*, c. 1450, then we must count the elevation rather earlier. Cf. also Stefano Ray, *Lo Specchio del Cosmo. Da Brunelleschi a Palladio: Itinerario nell'architettura del Rinascimento*, pp. 47f.

[26] What follows is based chiefly on Erwin Panofsky, *The Life and Art of Albrecht Dürer*, pjp. 244ff., and Erwin Panofsky, *Renaissance and Renascences in Western Art*, Chapter 3; Kenneth Clark, *The Art of Humanism*, pp. 79ff.; John White, "Paragone: Aspects of the Relationship Between Sculpture and Painting," in *Art, Science, and History in the Renaissance*, pp. 43ff.; and Clagett, *op. cit., loc. cit.*, pp. 283ff.

[27] Just as whoever did the plates for Vesalius' *Fabrica* had to work out the anatomy distinct from the largely Galenic text of Vesalius; see Hall, *op. cit.*, pp. 48f.; White, *op. cit., loc. cit.*, pp. 48f.

[28] See Panofsky, *The Life and Art of Albrecht Dürer*, pp. 257ff., 266f.

and bearing on the world within actual and potential reach: in short, a stock of knowledge at hand for what is near to hand or which can be brought near to hand and rooted in a new "differential" and "aesthetic 'anthropometry'" (to borrow Panofsky's impressive terms[29]).

To this commonplace a further complexity has to be added because the creation of a new stock of knowledge at hand led to a theory of perspective which broke with the past—another commonplace, but one which must be mentioned with the others just because it is so common, just because therefore it is taken for granted as much by the history and philosophy of art as by the history and philosophy of science. But these commonplaces were not always taken for granted, nor need they have been taken for granted. In the early and high Middle Ages, likewise in Antiquity, the reconstruction of three-dimensionality on a two-dimensional surface was, after all, not a problem in the sense that a painting, for instance, could be interpreted as symbolic of three-dimensional objects. A strip of green was sufficient to appresent symbolically, and that means mimetically, the ground on which trees and houses stood. By the fourteenth century (Panofsky), the forms that appeared *on* the surface appresented symbolically what lay *behind* the surface.[30] The near, such as an object on a two-dimensional surface, a painting, is understood and appresents, if not the far, almost the same thing: the hidden. The Near is understood in terms

[29] See Panofsky, "The History of the Theory of Human Proportions," *loc. cit.*, p. 106: "When, after the 'revival of classical antiquity' had spent its momentum, these first concessions to the subjective principle came to be exploited to the full, the role of the theory of human proportions as a branch of art theory was finished. The styles that may be grouped under the heading of 'pictorial' subjectivism—the styles most eloquently represented by seventeenth-century Dutch painting and nineteenth-century Impressionism—could do nothing with a theory of human proportions, because for them solid objects in general, and the human figure in particular, meant little in comparison with the light and air diffused in unlimited space. The styles that may be grouped under the heading of 'non-pictorial' subjectivism—pre-Baroque Mannerism and modern 'Expressionism'—could do nothing with a theory of human proportions, because for them the solid objects in general, and the human figure in particular, meant something only in so far as they could be arbitrarily shortened and lengthened, twisted, and, finally, disintegrated." Eventually the stock of knowledge at hand becomes codified, socially approved as, broadly conceived, a "theory of human proportions," only eventually to collapse under the weight of the continuance of its social derivation.

[30] This sketch is, admittedly, rough; but our purpose is neither to develop nor to refine it; see Panofsky, "The History of the Theory of Human Proportions," *loc. cit.*, pp. 80ff.; White, *op. cit., loc. cit.*, pp. 48ff. The symbolic appresentation takes an unusual turn in the Platonism of the Renaissance, even, for instance, in the later views of Dürer; see Panofsky, *The Life and Art of Albrecht Dürer*, p. 281. For the most part we are concerned here with what chiefly consists of a non-Platonistic or even anti-Platonistic formulation that will be more consistent with the formulation of consciousness deriving from Alberti's work. To what extent Alberti himself was influenced, in any significant way, by the revitalized Platonism of his time does not admit of any simple answer. Judging by his *Della pittura*, he bought into very little of it. See Eugenio Garin, *Italian Humanism*, p. 66, and below, pp. 67ff., 121ff. for an account of the nature of just that neo-Platonism antithetical to Alberti and the Baroque formulation of consciousness.

of the hidden, the Far, which is, after all, a basic assumption of the Classical formulation of consciousness.

Precisely here we find a change: for if we are to reproduce things in Nature as they are, and if we take as experiential datum the Near, the world within actual and potential reach, then there are three issues to be resolved: 1) the issue of the influence of organic movement; 2) the issue of perspective foreshortening; and 3) the issue (especially in the case of painting and architecture) of the visual impression of the beholder geared into and for action in and upon the world within actual and potential reach. All three issues concern how there can be adequate representation of push when it comes to shove, and therefore have one thing in common: the presupposition of bodily gearing into and world upon the world within reach from Here and Now. To express the matter in the art-historical terms of Panofsky and others, they presuppose the recognition of "subjectivity" in the specific sense that organic movement, bodily gearing into the world, entails and introduces the "subjective will" along with "subjective" intentions and emotions bound up with specific projects of action.[31] Yet another way of expressing the same thing is by saying that of necessity, in the pragmatic and practical calculations and negotiations of social action, there is introduced into the representation—e.g., in the composition of a painting—the visual experience of the artist-actor on the social scene along with those "eurhythmic" or proportioned adjustments made from Here and which are incorporated into the composition, into the representation. For example: the field of action seen always from and organized around Here, expansion and contraction of muscles attendant upon bending or stretching the knee and elbow, the thickening of joints, the estimation of distances and magnitudes.

That signifies that what is right (true, valid) of things in Nature must be altered *in favor of what seems right* (true, valid) as much to reproduce in a painting, sculpture, building, as in actual action—from reaching, lifting, carrying, laying out bricks, or calculating forces at a distance.

As a consequence, the reproduction and representation of action, of the realization of projects and the generalized acquisition of empirical meaning and function, can never be a copy, can never be mimetic in any of the senses we distinguished,[32] not even in the arithmetical sense of mimesis. The appresentation of *"what is right"* by *"what seems right,"* of *"what is there in and of itself"* by *"what is always only here,"* is *strictly indicational* and never otherwise.[33] *The far is always read off the near*, off what is within actual and

[31]Above, pp. 48f.

[32]Above, pp. 33f.

[33]The equivalent in music, for example, to "foreshortening," as we shall suggest below, pp. 176f., is "temperament." Even though it is not our purpose here to develop an art-historical theory of styles, we may at least refer in this connection to the interesting point made by Panofsky, "The History of the Theory of Human Proportions," pp. 99f.: Egyptian art, he says, is "objective" in the sense that people represented in a painting or sculpture do not move of their own volition but rather by virtue of mechanical laws eternally arrested in a given position." In other words, Egyptian art is another version of the Classical formulation of consciousness and mimetic appresentation (in our sense) where, again the near is read off the far. In the Middle Ages, bodies, for instance, turn,

potential reach, seen or acted upon from a Here which is never There so that inevitably and of practical necessity push always comes to shove. The experiential datum, then, accessible to the "real" is my autobiographical placement in a world in and upon which I must act by virtue of being born and into and for which I am bodily geared. But this is not the only aspect of the datum from which, now, the "real" is extrapolated. To explore this further we need to go outside and take another (and by no means our last) look at the night sky.

Mirror and Scenery

At Night: looking up at the sky I directly behold a great, starry hollow shell revolving around an invisible celestial axis. Phenomenologically, what do I see, or what ought I to see, granted the Classical formulation of consciousness?

Where indeed does one look?[34] To find out, I dug deeper into my box of books in the attic and came up with some real Hellenistic surprises. In his commentary on Euclid's *Elements*, Proclus conceives of optics and canonics as offshoots of geometry and arithmetic, stating that, in a narrower sense, optics "explains the illusory appearances presented by objects seen at a distance, such as the converging of parallel lines or the rounded appearance of square towers;" and general catoptics, he adds, "is concerned with the various ways light is reflected." Catoptics, this marvelous feline discipline, is closely yoked to the art of representation called "scene painting."[35] Scene-painting, e.g., scenes such as those painted by Aeschylus when producing his tragedies, consists of "images

twist, are even "distorted," but without depth; actual bodily movements are dictated and manipulated from on high: again, motion is read off from a Will afar (cf. the ideas of Medieval anthropometry discussed by Panofsky, pp. 77ff., especially the Byzantine canons of harmony). To be sure, in Greek antiquity we find organic movement and foreshortening as well as optical adjustment so that for a moment it would seem that the Classical formulation of consciousness must include yet other formulations for antique art. However, it is necessary to note with Panofsky that, e.g., Polyclitian anthropometry was not paralleled by an equally developed theory of movement nor by a theory of perspective, i.e., there was not explicit fusion of human proportion and movement. Morever, as I shall try to suggest now, the catoptics, as an essential chapter of Euclidean optics, does not allow of a theory of perspective such as is developed by Alberti. Thus whatever foreshortening there is does not result from the visual image as a projection that can be constructed in the same way by geometrical methods. The temptation is to say that "perspectivism" is found in antique art only in retrospect, and then only in an "inferior" way providing we forget and dismiss the theory of reflections in mirrors.

[34]Above, pp. 22ff.

[35]Proclus, *A Commentary on the First Book of Euclid's Elements*, p. 33. Proclus continues to explain that canonics, a branch of arithmetic rather than geometry, deals correspondingly with "the perceivable ratios between notes of the musical scales and discovers the divisions of the monochord, everywhere relying on sense-perception and, as Plato says [*Republic* 531ab] 'putting the ear ahead of the mind'," *ibid.*. For a general account of music theory in antiquity, see Edward Lippman, "Aesthetics in Theoretical Treatises on Music," pp. 217ff.

that will not seem disporportionate or shapeless when seen from a distance or from an elevation:"[36] "given a center in a definite place, the lines should naturally correspond with due regard to the point of sight and the divergence of the visual rays...so that, though all is drawn on a vertical flat façade, some parts may seem to be withdrawing into the background, and others to be standing out in front" (Vitruvius).[37] That is to say, in ordinary experience things of equal size begin to diminish as they move away from Here and out of my manipulatory zone: the walls, floors, ceilings delimiting an interior, or the ground on which elements of a landscape are laid out, in a scene-painting, begin to recede into a background. And the lines that were at right angles to the plane are regarded as "vanishing lines" tending to converge on one center.

Accordingly, if we take together Euclid's definitions about rectilinear rays diverging from the eye, and Propositions VI, VIII, XIX of his *Optics*,[38] we may say that, on the Classical formulation of consciousness, there are two basic assumptions:[39]

1. the visual image is produced by straight lines connecting the eye and the objects;

2. the size and shape of the objects as they appear in the visual image are determined by the relative position of the (straight) visual rays.

It follows—and I must confess that this came as real news to me—that an object is perceived by straight visual rays converging in the eye so that the visual image may be thought of as a cone (or pyramid) having the object as its base and the eye as its apex. The apparent size of a real magnitude, hence the configuration of the visual image, depends on the width of the corresponding angle at the apex of the cone or pyramid. So far so good, and probably even polticially correct. But the Euclidean optics is not just that; it is also, as mentioned, a catoptics: a theory of mirrors.

The Mirror and Eternity

Whether written by Euclid or whomever, the *Catoptics* provides the clue to understanding the optics of "scene-painting" and clarifies the meaning of the two assumptions. The visual cone or pyramid is defined by the laws of reflection in a mirror (planar or spherical), and, by extension, then, what is beheld at night: the great hollow shell revolving around an invisible celestial axis. "The rays incident upon which polished bodies are reflected have, then, in our opinion, been adequately proved. Now by the same reasoning, that is, by a consideration of the speed of the incidence and the reflection, we shall prove that these rays are reflected at equal angles in the case of plane and spherical mirrors. For our proof must again make use of minimum lines. I say, therefore, that of all

[36]*Ibid.*

[37]Cited in *The History of Mathematics. A Reader*, p. 200.

[38]*Ibid.*, pp. 200f.; see Heath, *A Manual of Greek Mathematics*, pp. 267ff.

[39]See the discussion by Panofsky, *Renaissance and Renascences*, pp. 123ff.

incident rays [from a given point] reflected to a given point by plane and spherical mirrors the shortest are those that are reflected at equal angles; and if this is the case, the reflection at equal angles is in conformity with reason."[40]

To return now to the Classical formulation of consciousness: The way in which the near is read off the far is, as we have said, by means of mimetic appresentation. Of what does the "reading" consist? *The reflection (planar or spherical) appresents (images, copies) the far as it appears reflected.* Phenomenologically, the mirror is an indirect medium of access to the distant, the far. The lines on the appresenting image, be it mirror or scene-painting or eye beholding the great starry and hollow shell at night, must actually converge so as to represent lines only apparently converging in the object; or we may also say that in the near zone, the image or copy, the lines actually converge to represent the apparent convergence in the far zone.

On the Classical formulation of consciousness, then, *what seems right*—actual convergence—*appresents what is* right—parallel lines. No wonder Thales fell into the well, and no wonder either that the Thracian laughed when she pulled him out. It comes as no surprise, accordingly, that on the Classical formulation of consciousness the influence of organic movement, perspective foreshortening and the visual impression of the beholder are irrelevant to the mimesis of the mirror. The specific problem is rather how to unify the reflection or image, and then to determine the right sequence of equidistant transferals on one plane. This can be accomplished if there is adherence to the two assumptions about visual rays and the size of objects. Certainly those assumptions, and the optics and catoptics that follow from them, comprise part of the Classical stock of knowledge at hand, always providing we think in terms of reflections in a mirror. If, like Alice, we think of our experience in terms of reflections in mirrors we think of it not from the center of action, but from the boundary-periphery.

Embedded in the Classical formulation of consciousness is a geometry and, more specifically, an optics and catoptics, of the boundary-periphery of our eccentric being in the world: a mirror held up to laughter and crying proves to be the experiential datum in ordinary life to which the "real" is accessible and from which the "real" can be extrapolated. But the mirror shows us only the present moment, Now, and reflects an "eternal" present, even the everlasting swing of the great hollow sphere of the heavens. It does not, and cannot reflect the specious present and certainly not past and future. Euclidean optics, on the Classical formulation of consciousness, is an optics and catoptics confined to the "eternal Now," the *"nunc stans."* When I look up at the heavens at night, I behold the heavens as though reflected in a mirror. And when I behold the terrestrial its measure is taken by the image of the eternal in the mirror.[41] In short, on the Classical formulation, access to the "real" is always indirect and two or three times removed from the original.[42]

[40]Cited in *The History of Mathematics. A Reader*, p. 202; the proofs are reproduced pp. 202f.

[41]See Plato, *Republic*, 595ff.; and Kersten, "Phenomenology, History, Myth," *loc. cit.*, pp. 256ff.

[42]See above, pp. 30f.

The change from the Classical and, to some extent, Medieval, formulations of consciousness to the Baroque formulation is first and foremost a change from indirect to direct access to the far. *It is a change from a geometry of the boundary-periphery to a geometry of the center, from the apparent, the mirror, the reflected appearance, as mark of the "real," to the "real" as mark of the apparent.* Why and how the Classical formulation of consciousness and its socially approved and derived stock of knowledge at hand proves inadequate, or fails or collapses from within, why and how the reflection in the mirror dims or fails as a representational mode—: important as these questions may be in their own right, for our purposes at the moment they are unimportant. What is important here is the shift of the accent of reality to the center of action. And perhaps equally important is that instead of beholding the night sky in a mirror, under the sway of the desire for the center the night sky is beheld by looking out the window.

The Window and the Veil

There is a quietly outrageous (and justly famous) statement of Alberti in *Della Pittura*: "First of all about where I draw, I inscribe a quadrangle of right angles, as large as I wish, which is considered to be an *open window through which I see what I want to paint*"[43] and, we may add, no matter if it be day or night. Alberti no longer thinks in terms of the mirror, let alone its derivative scene-painting, nor of the great rotating hollow of the night sky. He is looking out the window and painting what he sees. What he sees is not a reflection in a mirror; his optics is not *ipso facto* a catoptics. And it involves several assumptions antipathetic to the Classical formulation of consciousness but quite congenial to a new one. What he sees: "an open window through which I see what I want to paint;" or, "*an open window from which the* istoria *is seen*," if we translate from the Latin version of *Della Pittura*.[44] Shortly we shall return to the idea of *istoria*, that untranslatable term of the fifteenth century which designates what we may refer to as the future perfect of the specious present (as Alfred Schutz might have said, but never did say). Still, before we can see what Alberti sees through the window, or what we ought to see through the window, two things at least have to be mentioned.

In the first place, rather than a mirror, or even through the looking glass, it is the window that serves as the vehicle of appresentation; in the literal sense it is, according to Dürer, "*perspectiva:*" "ein lateinisch Wort, bedeutt ein Durchsehung" ("a view through something").[45] From Alberti to Dürer and Da

[43] Leon Battista Alberti, *On Painting*, p. 56. The emphasis is mine.
[44] *Ibid.* p. 109
[45] Cited by Panofsky, *Renaissance and Renascences*, p. 123. For the history of the meaning of the term, "perspective," as it comes to be used by Alberti and Dürer, see Panofsky, *The Life and Art of Albrecht Dürer*, pp. 248f.

Vinci to Descartes to Merleau-Ponty,[46] if we wish to "reproduce" things in Nature, become acquainted with the "real," we look out through the window. And in the lines that follow the statement about the quadrangle-like window Alberti proceeds to establish the strict geometrical basis for the exact construction of the "image"—hardly a mimetic one—not of the night sky or of a scene in a tragedy, but instead of a man, of a human being.

Second, besides the two assumptions of the Classical formulation of consciousness (p. 57), there are two further and additional assumptions behind the geometrical constructions fashioned now "through the window:"

One further assumption is that all points of the visual image are located on a plane rather than a curved surface.[47] The correct representation in perspective means the projection of the visual image on to a plane intersecting the visual cone (better from now on: pyramid). It is a plane inserted between what is appresented out the window and the eye. The appresenting "image" is then a "cross-section" through the visual pyramid (*"l'ntersegazione delle piramide visiva"*). The intersecting place, the *"graticola,"* or veil or grid, is constructed by compass and ruler. The veil or grid is the *"prospectiva pingendi,"* the "painter's perspective" or *"prospectiva artificialis,"* the "artifactual perspective," and in contrast to the Classical *"prospectiva naturalis"* or "natural perspective."[48] The window, the appresenting vehicle, is transformed into a plane intersecting the visual pyramid and, after explaining the construction of the perspective appresenting what is indicated by the veil or grid, Alberti sums it all up with an aphorism: "Never let it be supposed that anyone can be a good painter if he does not understand what he is attempting to do. He draws the bow in vain who has nowhere to point the arrow."[49] We shall return to this aphorism later. Still, it must be noted here that pointing and shooting an arrow out through the window is an image from the center of action, an image of a projectile in motion rather than an image drawn from the boundary-periphery.

Yet another further assumption is that all orthogonals, and not just on one plane, have to converge in one "vanishing point" which, in turn, establishes the "general horizon" of the picture, if a painting.

The consequent geometrical construction "through the window" is distinguished, in turn, by two properties.

The first property is "infinity" in the sense that any set of objectively parallel lines, no matter where or in what direction they move, converge toward one single "vanishing point," a point where parallel lines "meet."[50] Such a point,

[46]See Maurice Merleau-Ponty, *Phénoménologie de la perception*, pp. 345ff. (English translation, pp. 299ff.)

[47]Alberti, pp. 56f.; see Panofsky, *Renaissance and Renascences*, pp. 123ff., and especially the note on p. 125 which reconstructs the appropriate "recursive formula" for the location of the visual image.

[48]Alberti, pp. 68ff.; see Panofsky, *The Life and Art of Albrecht Dürer*, pp. 252f.

[49]Alberti, p. 59; see below, pp. 161ff. for the fate of Alberti's arrow.

[50]See *ibid.* (and Spencer's notes, pp. 110ff. for lucid diagrams representing the construction); briefly, the base line of the *"quadrangulo"* or window is divided into a number of equal parts, and within it assumed a central vanishing point; when the central

the vanishing point, is privileged only in so far as it directly faces the eye and thus forms the focus of only those parallels that are objectively perpendicular to the plane. The convergence of those orthogonals, in turn, indicates the succession and alteration of quantities *"quasi persino in infinito,"* hence precisely defines what fits, and how it fits, or does not fit, into the picture. Not everything falls to the sway of the desire for the center.

This leads to a second property because it follows that every point of the perspectival visual image is uniquely determined by three coordinates and that if there is a series of objectively equal and equidistant magnitudes succeeding each other in depth, then they are transformed into a series of diminishing magnitudes separated by diminishing intervals. The diminishing moreover is *constant and continuous* and can be expressed by a recursive, self-generating formula of geometrical proportions rather than the Vitruvian arithmetical
fractions.[51]

Finally we have to note that in his geometric construction Alberti employs what he calls a "method of comparison" by which all things are known "for comparison contains within itself a power which immediately demonstrates in objects which is more, less or equal."[52] And, Alberti says, because "man is the thing best known to man," human being and its proportions serve as the standard of perspective. The implication is significant and hardly Protagorean: by assuming a centric line, any centric line you please, leading to a "vanishing point" in infinity, i.e., a fixed, absolute but arbitrary point, any point you please, comparison is possible. Thus the comparative "relativity" derives from the

vanishing point is connected with the terminals and dividing points of the base line a "pencil" of converging but apparently equidistant orthogonals are obtained extending into infinity. See also Panofsky, *The Life and Art of Albrecht Dürer*, p. 248; *Renaissance and Renascences*, pp. 125 ff.

[51]For a correct statement of such a recursive formula which predetermines all other geometrical or exponential ratios in a given perspective space, see Panofsky, *Renaissance and Renascences*, p. 127, note 1; Spencer, *op. cit.,* p. 113 (thus the difference between Brunelleschi and Alberti: Brunelleschi "ends with a point rather than beginning with one. Geometry does not enter into Brunelleschi's construction, for it relies solely on sightings"—such as the famous painting from inside the door of Santa Maria del Fiore, where the door frame, the *"quadrangulo,"* provided the sightings of the points and angles he wished to draw. See also Alberti, *op. cit.,* pp. 51ff., and 53f., where he translates the proportions into construction of the visual pyramid. In any case, once the ratio of transverals a/b is established according to the distance of the eye to the projection plane and its elevation above the horizontal ground plan, the ratios of transverals b/c, e/d automatically follow. We shall return to this from a different aspect when we come to Leibniz and the mature Baroque formulation of consciousness—it is nothing else than the same internal principle of organization of substances in the monadology; see below, pp.113f., 196ff. See also Panofsky, "The History of the Theory of Human Proportions," note 19, p. 69, where the contrast generally with the Classical formulation of consciousness and Vitruvius is emphasized. Whereas Vitruvius would consider such ratios under the heading of *symmetria*, Alberti considers them under the heading of *proportio*. We cannot delve further into this intriguing problem of a change in the stock of knowledge at hand in painting; see Spencer, pp. 107ff., 111ff.

[52]Alberti, p. 55.

"absolute." The familiar Cartesian *ego cogito qua cogitatum* has sprung full-grown from the *prospectiva pingendi*.

Here and There

With Alberti we have the beginning of an answer to our earlier questions about how the "desire for the center" is represented, how the"real" is extapolated from change and motion effected at the center of action, of working together in a world in common. Living under the sway of the desire for the center itself becomes "geometrized," transformed into a method that determines with exactitude and certainty a "reproduction" of things in Nature as they are. Nature must be rendered by a self-generating method or formula that produces exactitude by its application so that the application of the method renders the "real," precisely as the "real" just as the centric point renders a perspective. We shall see that this will prove to be one of the essential features of the Baroque formulation of conciousness.

The plane cutting the visual pyramid *here* (the window or, with Brunelleschi, the door frame) appresents the apparent magnitude and distance of the Far. With mathemtical precision (in a geometrically recursive formula) the Far is measured off the Near and, moreover, the Near of my actual manipulatory zone: the eye that establishes the construction as to distance and direction (the "aim of the arrow")[53]—the centric line—is extrapolated from the zero-point of Here which is never There but always Here no matter where it is. The "eye" of the painter, looking out through the window from Here and locating the "beholder and painted things <the painter> sees" so as to "appear to be on the same plane,"[54] has its ground in the zero-point of action in the world within actual and potential reach. With much reason and some exaggeration, in this connection Panofsky speaks of the "victory of the subjective principle" which affirms the "autonomous mobility of the things represented and the autonomous visual experience of the artist as well as the beholder."[55]

This radical change in the experiential datum to which the "real" is accessible can be seen most evidentially in the "most fruitful innovation" of Alberti's account of vision: his break with the traditional idea that vision takes the form of a cone. By grounding the eye that establishes distance and direction in the zero-point of the ubiquitous Here, Alberti *substitutes the pyramid for the cone* so that the object seen through the window varies in direct proportion to the height of the artist's and beholder's eye and the distance to the object.

In one of the invaluable notes to his translation of Alberti's *Della Pittura*, Spencer notes (p. 103) that although he "was physiologically incorrect, Alberti made it possible to represent objects on a plane surface with greater

[53]Alberti, pp. 57f., and p. 59; see Spencer's comment, p. 116, on how Da Vinci combined the two constructions of Alberti into a single one.

[54]Alberti, p. 56; see also Panofsky, "The History of the Theory of Human Proportions," pp. 98, 105f.

[55]See also Spencer, pp. 103, 115f.

apparent exactitude." Although there is no reason to disagree with Spencer, I think we can nudge his observation a little further and suggest that it is rather that the datum of ordinary life, the specious present of the zero-point of my Here, in action geared for and into the world within actual and potential reach, in its practical calculations and estimations of action, allows for the self-interpretative extrapolation 1) of the distance and position of the centric ray 2) which simultaneously appresents indicationally the vanishing point. That is to say, *the centric ray from the eye Here appresents indicationally its opposite, the vanishing point* (cf. Spencer, p. 115).

This case of appresentation is then an extension of a very practical and specific case of action bringing to bear a highly specialized dimension of the stock of knowledge at hand in the manipulatory zone: *surveying*. "If Alberti's construction derives from surveying, the apparently arbitrary location of the perpendicular cutting the height-distance lines becomes clear. For Alberti it would have been a staff held at arm's length or the surface of the panel—in any case, the same predetermined intersection of the visual pyramid in both steps. His silence on the distance from the eye to the object becomes clear from surveying; he knew that the distance had to be the same in both parts of this construction. Hence his insistence on the location of the point of the pyramid. It is not surprising that such a system based on the height of man, the length of his arm, and the distance from eye to arm is expressed in terms of *braccia* and the height of man" (Spencer, pp. 115f.). And if universalized, surveying, that indicational appresentation par excellence, is rooted most explicitly in an exemplary case of the stock of knowledge at hand which is both socially approved and derived.[56]

The experiential datum of ordinary life at issue is not just "subjective" (in Panofsky's sense) but "intersubjective" (in Schutz's sense). The artist and beholder in the one case, you and I working together on a task in common in the other case: at least as to kind, we can exchange viewpoints, perspective, and where the reciprocity of perspectives is sufficiently effective for the task at hand, even determined and determinable with mathematical precision.[57] The eye of the artist, or of the surveyor, or of the beholder, is an "absolute" just as is the zero-point of spatio-temporal coordinates Here. If not obvious, all of this is at least taken for granted. The "*prospectiva pingendi*" will prove to be the geometrization of the self-interpretation of social action internally organized in and around and from Here.

The purpose of geometrizing the self-interpretation of social action, if we may be permitted a hideous short-hand expression, is not just to calculate the action and its consequences but also to "reproduce" things of Nature, to represent them. But the representation is not a copy or an image in the sense of a resemblance, nor one or another case of mimetic appresentation, no matter how abstract. It is instead a case of indicational appresentation, and there are a number of reasons why this is so. In terms of, but contrary to, the Classical formulation of consciousness, the representation is not of the far as far but rather

[56] See Spencer, pp. 103, 115, 115f., and 116.

[57] See Fred Kersten, "Phenomenology, History, Myth," for discussion of the constituting of "pure" and "empirical" kinds involved in the reciprocity of perspectives, pp. 262ff.

of the far as near at hand and even on hand. The representation is rooted in the world actually and potentially in reach *on the assumption that objects retain proprtionately equal size,* or would be of the "same" size were they near. Thus the assumption involves the *still further assumption that reciprocally a "far-perspective" can be a "near-perspective"* and conversely ("I can see the 'same' from There and see it again").[58] The near can just as well be far, the far near, Here can just as well be There (which is to say, Here), and There Here. Precisely these two assumptions are impossible on the Classical formulation and the Euclidean optics and catoptics because the reflection in the mirror is irreversible.

Yet another reason for the representation being indicational rather than mimetic is that the window through which we look is itself, as the appresentational vehicle, rather more than a window in the sense that it is a veiled intersection "finely woven, dyed whatever colour pleases you and with larger threads [marking out] as many parallels as you prefer. This veil I place between the eye and the thing seen..." so that it "presents to you the same unchanged plane," "the same thing in the process of seeing."[59] The lines, marks, "the movement of the outline," appresent indicationally in this parallel the forehead, in another the nose, in yet another the cheeks, and so forth. The lines are indications which, like all indications, transcend the segment of the world within immediate reach—a transcendence which can be formulated with geometrical exactitude. Moreover, located in the near sphere, the lines have a strict universality and typicality, thus appresenting the far and what lies in a specific distance and direction in its "true" proportions: the *costruzzione legittima.*[60]

Any Far, or distance or size or direction, you please can be transferred graphically to any Near you please of the manipulatory zone, just as I can transform any planimetrical figure from an unforeshortened one into a foreshortened figure. We might say, then, to coin a phrase, that the *hic et nunc pingendi* controls and manipulates with the mutually opposing eye and vanishing point all of the spatial coordinates both as a whole and in part. Any Far you please can be read off Here, and this is guaranteed by the very method of construction. The certainty of this method guarantees the "true" proportion, the certainty and correctness of things seen through the window.

The View from the Window

We can protect ourselves from the cold of the night by going inside, we can relax the crick in our necks from looking up at the heavens by looking out the

[58] See Alberti, p. 69: "You know how impossible it is to imitate a thing which does not continue to present the same appearance...you know that as the distance and position of the centre are change, the thing you see seems greatly altered. Therefore the veil will be...always the same thing in the process of seeing."

[59] *Ibid..*, pp. 68, 69.

[60] See Panofsky, *The Life and Art of Albrecht Dürer*, pp. 250f.

window. But what is it that we see looking out through the window? What is it that is appresented indicationally rather than mimetically?

We have already noted Alberti's answer:[61] from the open window the *istoria* is seen. The idea of *istoria* is not "limited to narrative or historical painting,"[62] although that is important because it signifies that the view from the window transcends the immediate present to the past, thus outstripping the "always only the present-eternal" of the mirror. For Alberti, painting has a representational power because it is the chief medium of access to *istoria*, because it is a method based on the idea of proportions which are understood as "the multiples of modes,"[63] and because the order of reality is assumed to remain the same in changing appearances with respect to Here and Now and in a specific order determined from, and only from, Here.

In what looks like a fit of "painterly" megalomania, Alberti makes just this power of painting go bail for all other powers of representation. It is a new measure of all representation and self-interpretation, indicational and mimetic, and in this sense the painter is "god;"[64] It is "building anew an art of painting" which "in all things public and private, profane and religious...has taken all the most honorable parts to itself so that nothing has ever been so esteemed by mortals."[65] Yet, what is the *istoria* seen through the window? What comprises the view from the window?

In the first place, *istoria* comprises the many themes of Greek and Roman mythology evincing a selection of certain themes, the avoidance of

[61]Above, p. 59.

[62]Spencer, Introduction, p. 13; and Lippman, "Aesthetics and Theoreical Treatises on Music," pp. 226ff.

[63]Alberti, p. 63. See Panofsky, *The Life and Art of Albrecht Dürer*, pp. 268f.; and "The History of theTheory of Proportions," pp. 89, 95 (and note 19, p. 68, for a summary of Vitruvian fractional proportions). See above, note 47, for the change that Alberti inaugurates with respect to the Vitruvian ideas of *proportio* and *symmetria*. In rather different Gestalt-phenomenological language, we may say that Vitruvian proportion means that the whole is viewed from the point of view of a part working together with other parts; whereas Vitruvian symmetry is the the case of a part working together with other parts viewed from the whole. Together, combined, they produced a "good" Gestalt.

[64]Alberti, p. 54. The significance of this statement will be explored briefly in the discussion of Descartes, below, pp. 201f. There is, after all, Alberti's personal hieroglyph of a winged eye from which thunderbolts radiate. There are any number of interpretations (reviewed by Ingrid D. Rowland in a letter to *The New York Review of Books*, 12 January, 1995); I am in no position to take issue with them, except to note that I believe that the godlike eye is that of the eye establishing the vanishing point from which the whole perspectival structure is established, i.e., the recursive formula for the internal organization of the "istoria," indeed of the world. In this sense, Alberti is identified with God (Jove) on the obverse. There is a similar idea in Nicolas of Cusa, *De Visione Dei* (c. 1451) who, in the Preface, likens the omnipresence of the eye of God to that of the godlike eye in a portrait of Roger van der Weyden. For the moment it suffices to note that I place much more importance on this statement than does, e.g., Spencer, p. 108.

[65]Alberti, p. 65. See also Leon Battista Alberti, *On Architecture*, in *Documentary History of Art*, Vol. 1, pp. 221ff. and 242f.; and Eugenio Garin, *Italian Humanism. Philosophy and Civic Life in the Renaissance*, pp. 61ff., especially p. 65.

others (e.g., the themes illustrating "the truly virile emotions" are included, the "lachrymose and erotic" avoided[66]). The window affords a view in which a stock of knowledge of the past is brought to bear in its social derivation and approval. More importantly, however, the *istoria*, as a compendium of thematic stories and deals with the overt manifestation of emotions by face and gesture of a "clear indication of a disturbed soul:" the external gestures and expressions appresent indicationally the inner workings of the soul in contradistinction to the Classical formulation of consciousness where nothing of the soul is to be found in the mimetic reflection of the mirror. The view from the window not only brings into view the past, impossible for the mirror, but, equally impossible for the mirror, it brings into view the inner workings of the soul and of Nature herself: "The *istoria* will move the soul of the beholder when each man painted there clearly shows the movement of his own soul. It happens in nature that nothing more than herself is found capable of thinking like herself: we weep with the weeping, laugh with the laughing, and grieve with the grieving."[67] The *istoria* then comprises the experiences of the boundary-peripheries of our eccentric being in the world (laughing and crying) *but now viewed from the center, from the window* by virtue of the perspective construction representing the emotions appresented indicationally by the movements of the body in its "true" proportions.

In the second place, *istoria* is more, or even other than, the depiction of specially tailored events and figures out of Greek and Roman mythology. As the view from the window, *istoria* is, in the viewing itself, *an internal law or principle which "circumscribes" the plane cutting across the visual pyramid.*[68] Because there is no room for modesty here, we may as well say that such an internal law is the *rule of organization that generates the contexture and establishes the system of criteria by which we judge what fits and does not fit the view from the window*: "First of all I think that all the bodies ought to move according to what is ordered in the *istoria*. In an *istoria* I like to see someone who admonishes and points out to us what is happening here; or beckons with his hand to see; or menaces with an angry face and with flashing eyes, so that no one should come near; or shows some danger or marvelous thing there; or invites us to weep or to laugh together with them."[69]

Among the criteria that Alberti lists are harmony of bodies in motion together in size and function with respect to events occurring in the *istoria*;

[66]See Spencer, p. 24. Alberti even altered the antique themes to make them fit the window, e.g., the "Venus pudica;" see Alberti, pp. 90f., and Panofsky, *Studies in Iconology. Humanistic Themes in the Art of the Renaissance*, pp. 157ff., and note 100, p. 158.

[67]Alberti, pp. 77f.; cf. Spencer, p. 25. See below, pp. 73f.. For the impossibility of the reflection of the soul in the mirror, and in general of the soul to seize upon itself on the Classical formulation of consciousness, see Kersten, "Heidegger and the History of Platonism," pp. 276ff.

[68]For the idea of "circumscription," see Alberti, pp. 68f.

[69]Alberti, p. 78. In Chapter Five we shall consider the idea of *istoria* as *fabula*, and in Chapter Seven *istoria/fabula* as *ego cogito qua cogitatum* and the pre-established harmony of Leibniz.

pleasure in copiousness, variety and novelty (as in music and food) which is yet moderate and grave, possessed of dignity and truth; pleasantness, gracefulness; solitude; modesty, admirableness.[70] The criteria themselves are not surprising even for the early Renaissance. What is important for our discussion, however, is that they are new measures for judging appearances which replace the measure of the Classical formulation of consciousness: Beauty.[71] And as criteria replacing the indivisibly single measure of Beauty, they are tied to the cares and interests and urges of our lives, the representations of which rest on the forms and kinds of bodily gearing into and being geared for action in the world of actual and potential reach. They are all, specifically, criteria for judging the appearances of the fusion of proportion and motion under the sway for the desire for the center.

That center, for Alberti, that is to say, for the *prospectiva pingendi*, is defined by the painter's and beholder's eye, the Here and Now of which is grounded in, and extrapolated from, the zero-point of the ubiquitous Here of spatial coordinates in the specious present of ordinary experience: "Anything which moves its place can do so in several ways: up, the first; down, the second; to the right, the third; to the left, the fourth; in depth, moving closer and then away; and the seventh going around. I desire all these movements in painting. Some bodies are placed towards us, others away from us, and in one body some parts appear to the observer, some drawn back, others high and others low."[72] At the center animate movements "collected from nature" operate like a proportional mechanism of a balance and weights, e.g., "when a weight is held in an extended arm with the feet together like the needle of a balance, all the other parts of the body will displace to counterbalance the weight ..."[73]

The view from the window, then, is a vista opening out upon animate, if not always human, *proportion in motion appresenting the movements of the soul in a determined and determinable context* (specifiable in narrative, in myth if not in history) *of the basic experience of others working together in a social world within actual and potential reach.*

[70]Alberti, pp. 75ff., 80.

[71]See above, pp. 29f.

[72]Alberti, p. 79. For a similar development in Dürer of the representation of the fusion of human proportion in action, see Panofsky, *The Life and Art of Albrecht Dürer*, pp. 267ff.

[73]Alberti, *ibid.* What Alberti describes is a "statics," to be sure, and which we shall consider in a rather different form below, pp. 161ff. What is important for us here is that it is applied equally to animate as to inanimate things, pp. 81f. "Thus one member is taken which corresponds to all the other members in such a way that none of them is non-proportional to the others in length and width" (p. 73). And, in their just proportions, bodies in motion are understood, as it were, from the bones, then the muscles. Later we shall see (below, pp. 90f.) that this is part of the self-interpretation of the center of action as subject to the properties of the circle (Galileo) rather than the ellipse (Kepler).

Notes from the Center

Under the "*sway of the desire for the center*," we have brought to boil some of the basic ingredients of a new formulation of consciousness. To prevent those ingredients from boiling over or turning into academic gruel, at this juncture we need a more general reflection on the sway of the desire for the center and its representation.

Agucchi's motto is written on an *impressa*, or emblem, for a work he wrote and sent to Galileo in 1611:[74] *Del Mezzo, Discorso Accademico*. The book is hardly "academic" in our sense today; it is instead dominated, indeed obsessed by "*mezzanità*" ("centricality"), signifying both center and mean or middle in Agucchi's mixture of Aristotelianism and Platonism that gives a frame to his preference for the system of Tycho Brahe with its dual centers of sun and earth. *Mezzanità* is the principle permeating each and every facet of human life: the capital in the middle of a country, the most beautiful monument in the middle of the square, the palace in the middle of the city, substance as the central core of accidents.[75] *Mezzanità* has metaphysical, theological and cosmological features as well, some of which Agucchi found "confirmed" by Galileo's telescopic discovery of the four satellites of Jupiter.[76] And it is the sway of the desire for the center which is, in Agucchi's estimation, the experiential datum as much of ordinary life as of cosmological speculation which holds together and in balance all the components of the world.[77] Now, even though Agucchi and his motto, along with the almost whirlpool-like *mezzanità*, nicely illustrate for our purposes the long-reach of the change in the formulation of consciousness that emerges with Alberti, it also harbors an unpleasant difficulty which has colored our discussion all along.

The difficulty is that, after all, the sway of the desire for the center has been dominate in the development of the formulation of consciousness over the last four centuries or so and grounds the critical optics through which we view the Classical formulation of consciousness. It certainly is not easy to set aside the sway of that desire, nor does it seem possible to get along squinting without those optics, so as to entertain the Classical formulation of consciousness or even its the incipient Baroque formulation. Of course neither formulation is "closed" or even "strange" to us.[78] A point emphasized before, and worth emphasizing again, is the fact that the Classical formulation of consciousness as expressed in antique philosophy and science, art and politics, is founded in specific, appresentational aspects of ordinary life owing to an assumption

[74]See Panofsky, *Galileo as Critic of the Arts*, pp. 39ff. for an account of the content of Agucchi's work and a reproduction of Agucchi's emblem.

[75]*Ibid.*, p. 39.

[76]Agucchi's cosmology is sketched by Panofsky, *ibid.*. pp. 40f.

[77]*Ibid.*, p. 41.

[78]See Jacob Klein, *Greek Mathematical Thought and the Origin of Algebra*, p. 118. For the difficulty under discussion here, see also the very clear statement of the problem in yet another connection by Carl Dahlhaus, *Foundations of Music History*, pp. 58ff.

essential to them: that the "real" is accessible to ordinary experience in its eccentric being in the world. This is also true to a limited extent for the Renaissance and Baroque formulation of consciousness. I say, "to a limited extent," not because it is any less founded in ordinary experience than the Classical formulation, but rather because it is *also* grounded in the science and philosophy produced in the Classical formulation and developed over almost twenty centuries. Although Jacob Klein was thinking primarily of the development of mathematics in making a similar point, I do not agree with his conclusion that it was therefore the case that ordinary experience has been "replaced by a *science already in existence*."[79] I would much rather say that the new formulation of consciousness is founded as much in ordinary experience—that it shares in its own way the basic assumption of the Classical formulation: that the "real" is somehow accessible to, and extrapolated from, ordinary experience—but that it is founded as well in an already existing science, philosophy, aesthetics "whose principles are denied, whose methods are rejected, whose 'knowledge' is mocked—but whose place within human life as a whole is placed beyond all doubt. *Scientia* herself appears as an inalienable human good, which may indeed become debased and distorted, but whose worth is beyond question. On the basis of this science, whose fundamental claim to validity is recognized, the edifice of the 'new' science is now erected, but erected *in deliberate opposition to the concepts and methods* of the former."[80]

The mocking, rejecting and nose-thumbing opposition has its foundation in certain aspects of ordinary experience at the center of social action: not just in surveying, but in instrumental optics and applied mechanics, in architecture and machine construction, in fortification; and the like. The Renaissance/Baroque formulation of consciousness, unlike the Classical, however, has only one foot in ordinary experience (and quite different experiential data at that). The other foot, cloven according to some, is in the "tradition" so that we have to say that the stock of knowledge at hand operative in the new formulation of consciousness from Oresme to Galileo and beyond down the thin grey line of the seventeenth century, at the very least, acquires a novel complexity. It is derivative in part and is so in a largely polemical way sanctioning quite distinct issues of social approval. But it is also partly novel and creative owing to the experiential data governed by the principle of *mezzanità*. On the one hand, there are new insights and ideas derived from traditional concepts resting on the claim that *scientia* is an "inalienable good." On the other hand, every claim of transmitting true knowledge, whether in painting, architecture, mechanics, or geometry, demands continual reorientation with reference to the tradition, no matter if it be drawn from Zeuxis or Aristotle and in the light of quite different data of ordinary experience to which the "real" is presumed to be accessible.

[79]Klein, *op. cit.*, p. 119.

[80]*Ibid.*.To be sure, the sharing of the basic assumption eventually will be denied afterwards—a denial which, in my view, marks the division between "modernism" and "post-modernism;" see Kersten, "The Constancy Hypothesis in the Social Sciences," pp. 523ff.

The new formulation of consciousness then shares with the Classical the most general assumptions and returns to their ground in ordinary experience in the daily world, yet reinterprets them from the center of social action in its fusing of human proportion and motion rather than from the stasis of its boundary-periphery, from the needs and necessities of daily life *rather than from its release from them*. This reinterpretation and reorientation of the Classical formulation, which "brings with it a characteristic transformation of all ancient concepts, lies at the foundations not only of all concept formation in our science, but also of our ordinary intentionality, which is derived from the former."[81]

Despite the aptness of Klein's statement for our purpose, he is speaking only about mathematics and on the verge of launching a monumental and ground-breaking discussion of Diophantus' influence on Baroque mathematics. But what he says of mathematics is true as well, I believe, for painting, architecture, sculpture and, of course, music, and that in a special way which will allow us to refomulate our basic idea in a new form. The nature of the transformation of the Classical into the Renaissance and Baroque formulation of consciousness may be expressed in terms of *scientia* as "theoretical" (or "speculative") and "practical" (or "art") and by the fate undergone by that distinction.[82]

Under the sway of the desire for the center there is clearly a preference for the "practical," the *answerable*, over the "theoretical," *slc.* the *unanswerable and unspeakable* (threatening or non-threatening). But it is not a mere preference, nor misguided whimsicality of Renaissance humanism: with Alberti (but also Da Vinci, Dürer) the rules of "art" (such as laid down in *Della Pittura* or in *Underweysung der Messung*) are precisely what give painting, music, architecture, sculpture, the status and *theoretical dignity of a science.*[83] We may also express the same thing by saying that it is the rules of "art" which bestow social approval upon painting, sculpture, and the like, as components of theory essential to the stock of knowledge at hand bearing on the world within actual and potential reach. There is even, Klein insists, an "obliteration" of the distinction between theoretical and practical disciplines under the sway of the desire for the center. To the extent that one can make this assertion, it is the rules of the "art" of painting where this "obliteration" occurs for the "first" time in a systematic way, leading finally to the transformation of the Classical into a new formulation of consciousness. More broadly speaking, the accomplishment of the transformation is fundamentally an *aesthetic* one (human proportion fused with motion viewed from the window) before it is ever a physical and mathematical one.

[81]Klein, p. 120. See above, pp. 64f. For a sketch of the complex "history" of these ideas, see Paul Otto Kristeller, *Renaissance Thought II*, pp. 166-189.

[82]Klein, pp. 122ff.

[83]See Klein, pp. 243f. (note 132); Hans Jonas, "The Practical Uses of Theory," in *The Phenomenon of Life* (New York: Harper & Row, 1966), pp. 188f.; Ruth Katz, *Divining the Powers of Music. Aesthetic Theory and the Origins of Opera*, pp. 15f., and, for specific socio-economic-political elements, pp. 66ff. Cf. Goehr, *The Imaginary Museum*, pp. 70ff.

Portent of the Gap at the Center

Rather than chart the "obliteration" of the distinction between "theoretical" and "practical" disciplines our task is to characterize further the new formulation of consciousness in which the "obliteration" occurs. More particularly, we need to examine a formulation of consciousness, often implicit, that allows the *artes liberales*, which are speculative, theoretical (with the inclusion of arithmetic and geometry, hence canonics, optics and catoptics) to be identified with the *artes mechanicae*,[84] so that *episteme* and *techne*, as we may also say, are one. The consequence is that, taking our phenomenological cue from the *prospectiva pingendi* in the *istoria* of the world within actual and potential reach, all mathematics, all philosophy, all civic life, all architecture, are "artful." Thus the corollary assumptions of the Classical formulation of consciousness that the near is read off the far, the lower off the higher, the image off the original, the speakable off the unspeakable, the answerable off the unanswerable (but non-threatening), are not so much obliterated as they are rendered superfluous. The implication is that representation by way of mimesis is, at the very least, subordinate to representation by way of indication; or, at the most, mimesis (and so far as it is based on it, analogy) becomes itself superfluous as a power of representation. And it is just here that the internal collapse of the Classical formulation of consciousness becomes a reality. Of course, it is an easy step, whether on the battle fields of the Renaissance or in the biker-bars of today, to insist that what is superfluous ought to be obliterated. Vivat Savonarola![85]

Taking a page from Alberti's "universalization" of painting extended to all arts that will become science, we may say that the "real" is accessible to very specific appresentational data of ordinary experience only on condition of demonstrating how objects become objects by a self-generating method of *costruzione legittima*: in the world within actual reach, the window, as the veiled plane cutting the visual pyramid, with its correlative eye-bound centric line and vanishing point, determines its object. In other words, it is a method that identifies the object indicated (even symbolized) "istorically" with the means of indicating (even symbolizing) and therefore replaces (extrapolates) real determinateness of things or objects in Nature with the *possibility* of making objects determinate.[86] *And precisely this is the portent of the gap at the center* between ordinary experience and art that has become science. Once the window

[84]The terms are those of Aquinas, cited by Klein, *op. cit.*, p. 243.

[85]Eventually this will raise two questions of theoretical consequence: the first is to what extent dismissal of the corrolary assumptions effects the basic assumption, that the "real" is somehow accessible to ordinary experience. In other words, are the corrolary assumptions necessarily included in the basic assumption, implied or even entailed by it. The second question arises if we ask whether dismissal of the corrolary assumptions is therefore tantamount to dismissing the basic assumption. I think that we still have to go the whole nine innings before we can attempt an answer. See above, pp. 43f.

[86]The next step, with Descartes and Galileo, will be to reformulate the nature of "method" for the Baroque formulation of consciousness as developed on aesthetic grounds by Alberti. See below, pp. 129 ff.

is veiled, or gridded, method reflects on itself, griding becomes self-griding, painting becomes aware of itself painting, determining possible things in possible self-organizing contextures. Or using expressions introduced before and which will be developed further, we may say that what is "right," what is "real," is appresented indicationally by what seems "right," what seems "real." That signifies that what is right is a *possible* object determined by what seems right, "real," where by "what seems right" we have to understand the self-reflective method of the *prospectiva artificialis,* the *prospectiva pingendi.* What is right is then a function of what seems right (i.e., of the *costruzione legittima*).

The appresentational-experiential datum of organization of the center is the zero-point of coordinates and the reciprocity of perspectives essential to social action, thus human proportion fused with motion indicating the movements of the embodied souls of others acting together in a manipulable world in common within actual and potential reach of those who "admonish and point out what is happening," who "beckon with his hand to see," or who "menace with an angry face" or "show some danger" or, if not, who "invite us to weep or laugh together with them," *but always viewed in and through the window* that takes stock of its own perspective determined by an eye which is ubiquitously Here correlative to a point vanishing in infinity on a continuum.

If it has not become visible already, then now for the first time the "invisible" plays a role correlative to the "visible," is read off the "visible" (or, we may say, more universally, the "incommensurable" plays a determining role in the "commensurable," is read off the "commensurable").[87]

And the window, most surely, is the window *of a room,* and the room having supplied the window takes on the shape and form of an enclave in the world in which window and perspective occur. As the room of the window even when it cuts the plane of the visual pyramid, the room is taken for granted *precisely and only as the room of the window,* thus allowing for the window in the first place just as the darkness of the auditorium allows for the presence of the play on stage.[88]

The room is the silent premise of the self-interpretation of ordinary experience indicating appresentationally the world within actual and potential reach; it is that Here "where" the reciprocity of perspectives of an intersubjective social world occurs, it is the "where" likewise of the *prospectiva pingendi* and, when universalized, the "where" of mathematical (indicational and symbolic) representation "reproducing" of things in Nature occurs. How is

[87]See Klein, *op. cit.*, p. 123.

[88]See Panofsky's descriptions of the various kinds of apparatus invented by Dürer and Keser which "replace" the window, but not the room within which they are utilized in *The Life and Art of Albrecht Dürer,* pp. 252f. (See also figures 310 and 311). Even the needle in the wall, which "replaces" the human eye and the length of the human arm, still "presupposes" the inclusion of the room *as the room of the window*; and it is interesting that in Dürer's drawings of the apparatus for constructing perspective in painting the room itself is included, in proper perspective of course. The room itself would seem to be self-generated as an essential part of the *costruzione legittima* and the *prospectiva artificialis.* Just how the specious present of the room is related to, e.g., the past, present, and future of the view from the window remains a question for phenomenological analysis.

the room related to its window? What is the relation between Here and Where? Unfortunately a phenomenology of "Here and Where," of window and room, will not provide an immediate answer because it is only in the Baroque, only at the end of the sixteenth and beginning of the seventeenth centuries, that the Here and Where make themselves felt in a new formulation of consciousness which successfully establishes the claim to "universality" of art become science.[89] Landino is quoted as having said of Alberti that he was a "master in geometry, astrology and in music."[90] As a result, we shall have to look out the window, but now out and up at the stars and follow Plato's dictum by "putting our ears ahead of our mind."[91] The hope is that we shall see and hear the "music of the future" in the midst of the Vahalla-like collapse of the Classical formulation of consciousness.

[89]See above, pp. 56f.
[90]See Garin, *op. cit.*, p. 65.
[91]*Republic*, 531ab.

CHAPTER FOUR

Room at the Center

Once, many years ago, while driving my Harley up a rough mountain road in the wilderness of a Western state, I came to a bend in the road. As I turned up the bend I came upon a large, crudely lettered sign that said, "If you have come this far, you have gone too far." Sure enough; a few hundred yards on, in the middle of the old road, I confronted a large, raunchily dressed man—no leathered-up, bechained biker, either—with a large rifle, pointed directly at me and a look on his face like a mangy red-bone hound. With a very dry mouth and my life passing before me, I explained that I had taken the wrong road and was just looking for a place to turn around. I found it, did it, and set a new record for downhill driving. I mention this story because I was put in mind of it while reflecting on where Alberti had taken me in the last chapter: if I had come that far, perhaps I had gone too far. Moreover, the new formulation of consciousness it entailed in the face of the Classical one made me feel once again the rude and potentially violent meeting of civilization and wilderness at the bend of an old logging road. However, rather than give in to the instinct to turn around and get back on the royal road of the Classical formulation of consciousness it is worth the risk of seeing how far we have come, and whether we may have come too far.

The sway of the desire for the center governs the fusion of the proportion of embodied human being and motion. It is a fusion extrapolated from experience of action in the world of ordinary life that, under the reciprocity of perspectives, indicationally appresents the movements of the soul. To this summary we have to add that it is not just the proportion of the animate body that is fused with motion, but also the inanimate body as well.[1] The sway of the desire for the center governs the *prospectiva artificialis* of the proportions of any body you please in motion. The paradigm of representation (indicational appresentation) that has occupied our attention is the *prospectiva pingendi*, but not because painting is superior as a way of representation (even though we might grant such to be the case). Instead it is because of necessity it contains the elements of a new formulation of consciousness and ones, more particularly, which make themselves "relatively late, actually not within the classical period of the Renaissance at all" (Hauser). They are elements of a formulation of consciousness which will become, as Kepler says, "shaped to grasp quantities:"[2] "As the eye was provided for perceiving the beauties of Nature and the ears for hearing sounds, so the human mind was provided, not for understanding just anything at all, but for understanding quanta."[3] At the center, in the midst of

[1] See Alberti, *On Painting*, p. 81ff. At issue too are colors, light, shadows.

[2] Kepler, cited by H. F. Cohen, *Quantifying Music*, p. 17.

[3] Kepler, cited by Wihelm Dilthey, *Weltanschauung und Analyse des Menschen seit*

social action where push always comes to shove under the influence of the needs and necessities of human life, as in my unpleasant encounter with the shotgun, motion is motion or change of continuous magnitudes or quanta diminishing in infinity and not of discrete forms ("qualities"—push without shove). Even the specious present is a magnitude, a quantum, and not a series of discrete "now's."[4] The specious present is a continuous magnitude, temporal to be sure, just as the ubiquitous zero-point of social action is a "specious" Here, a spatial magnitude. The center of ordinary social action and experience is the magnitude, the quantum, of motion in a specious Here and Now, hence its representation is "geometrical," not "arithmetical," its appresentation indicational rather than mimetic.

It is that indicational appresentation which is essential to the Baroque formulation of consciousness, and it marks how far we have come: indicational appresentation is foundational to non-mimetic "imitation," and even though the term, "imitation," is still employed in the Renaissance and Baroque as a name for the forms of appresentation, with the shift in the accent of reality its indicational, rather than its mimetic, meaning has become dominant. Thus even the mimesis of the mirror has been transformed: "A good judge for you to know is the mirror," Alberti says. "I do not know why *painted things* have so much grace in the mirror. It is marvellous how every weakness in a painting is so manifestly deformed in the mirror. Therefore things taken from nature are corrected with a mirror. I have here truly recounted things which I have learned from nature."[5] With respect to the Classical formulation of consciousness, the idea that the mirror "corrects" things taken from Nature is, of course, outrageous. The mirror does not mimetically appresent ("reflect") the "real" and things taken from Nature. It appresents instead the painting. The mirror is no longer the privileged appresenting medium, therefore no longer the principal medium of access to the "real." Indicational appresentation takes precedence over mirror-like or reflectional mimetic appresentation, just as the center of social action has replaced the boundary-periphery as the basic datum of ordinary experience to which the "real" is accessible.

Of course, this is too simple;[6] we have only arrived at the bend in the road, and may not even have come far enough. After all, arithmetic is concerned with numbers, and, in Kepler's words,[7] "arithmetic is nothing...but the

Renaissance und Reformation, p. 258. The translation is mine.

[4] The arithmetical "now" of daily life is no longer the privileged datum of ordinary experience from which the "real," "eternity," the *nunc stans,* is extrapolated.

[5] Alberti, p. 83; the emphasis is mine. See above, pp. 60f.; and Ernst Cassirer, *The Individual and the Cosmos in Renaissance Philosophy*, p. 163.

[6] The changes in the signification of "mimesis" are many and subtle; "imitation" and "analogy" undergo broad changes in meaning; see, e.g., Cohen, pp. 58f., and p. 269, note 7, who charts the changes in "analogy" when by the sixteenth century *analogia* comes to mean *ratio*; see also D. P. Walker, *Studies in Musical Science in the Late Renaissance*, p. 121; and Madeleine Doran, *Endeavors of Art,*, pp. 47ff., and 75ff. We shall return shortly to these changes. Eventually, to speak of "mimesis" it will only be possible by specifying *which* formulation of consciousness is at issue.

[7] Cited by Cohen, p. 17.

expressible part of geometry." Geometry expresses measurable magnitudes or quantities which are not discrete but rather continuous. And the broader task is how to represent Nature and things of Nature by "reproducing" them.[8] Thus it has been said of the "new science" of the sixteenth and seventeenth centuries that it deals not with a "'natural' nature but <rather with> an *artificial* nature, never to be seen in daily life."[9] But certainly this cannot be true: the *prospectiva artificialis* is after all just what I see in ordinary life when looking out the window or going out through the door. What I do not see in ordinary life is the *prospectiva naturalis,* perhaps best represented by a Barsotti cartoon in the *New Yorker:*

The contrast hardly seems to be one of science as "artificial," and of ordinary life as "natural." Still, just as the statement is most certainly false, it is also most certainly true for I can climb out the window, or go out through the door, and when I do the perspective goes with me; the ubiquitous Here of my bodily gearing into the world always remains Here and not behind in the room. The very "construction" of perspective guarantees that nothing "actually" shrinks in the distance.[10] Were that not the case, then, indeed, it would be what is not seen in daily life. Both, what can and what cannot be seen, constitute an "artificial" nature and it had better be so for otherwise social action, such as working together on a task in common in the world within actual and potential reach, would be impossible.

[8] See above, pp. 58f.

[9] Cohen, p. 8. This is what we may call the "Kusmitch" view of the history of Western science so favored among politically correct academics in the humanities. For an "interdisciplinary" eulogy of this view, see Ruth Katz, *Divining the Power of Music. Aesthetic Theory and the Origins of Opera,* pp. 2ff., 15ff.

[10] See Maurice Merleau-Ponty, *Phénoménologie de la perception,* pp. 284ff. (English translation, pp. 245ff.)

That is as absurd as having gone too far by coming this far. And we have not even turned the bend yet. The absurdity may arise from forgetting the underlying assumption: that the "real," "nature," is somehow accessible to ordinary experience. The question, then, is from what datum of ordinary experience do we extrapolate the "real"? The datum we have so far identified, is the specious, ubiquitous zero-point of social acting and working together in the manipulatory zone of the world within actual and potential reach where the needs and necessities of human life are met, where desires are realized, where our fundamental ontic conviction can be taken for granted with relative security. As noted before, what distinguishes the formulation of consciousness under the sway of the desire for the center from the Classical formulation is that shift in the accent of reality which, to use Panofsky's phrase, is the "victory of the subjective principle," where the "objectivity" of the representation of the "real" lies in its "subjectivity."[11] We noted too that yet another distinctive feature of appresentational experience at the center, the indicational characteristic of appresentation that marks it off from the mimesis of the boundary-periphery, is the principle of "what is right" or "true" or "real" is indicated—not copied—by "what seems right" or "true" or "real." Having come this far, it is just as well that we keep going, shotgun or no shotgun, that we risk our lives in going too far and around the bend. For if it is the case that "what seems right" appresents indicationally "what is right" under the shift in the accent of reality, under the sway for the desire for the center, then for that to be so *"what is right" must be altered* ("measured") *quantified and read off "what seems right" when and wherever push comes to shove. The magnitude of the "real" is read off the magnitude of the specious present, Here and Now, the center of social action within the world of actual and potential reach.*

The only way to round the bend with any hope of surviving the unknown dangers of having come too far, is to follow the precept Suetonius wrenched from the mouth of Caesar: *festina lente* (or *festinatio tarda est*, to use the more humorous turn of the phrase by Rufus). Thus we take time to remind ourselves of the silent premise: the room from out of the window of which we look, through the doorway of which we pass. The room is included in the appresenting element, in the grid or veil of "what seems right," or, as Scheler would say, the "milieu" we carry around with us and which defines the concrete character of our quite specific manipulatory zone of the world within actual and potential reach.[12] To go around the bend as fast as we can slowly we may also remind ourselves with Alberti that it can be any room, any milieu, you please, and then with our ears ahead of our minds, why not the entire cosmos?

[11] See below, pp. 84f.

[12] See Max Scheler, *Der Formalismus in der Ethik und die materiale Wertethik*, pp. 161ff., 172ff., 297ff. (English translation, pp. 143ff., 153ff., 282ff.) Later (below, pp. 111ff.) we shall return to the idea of the room as a "milieu" in Scheler's meaning of the term, and as a silent premise of the Baroque formulation of consciousness. Although the concept is adapted from Scheler, no attempt has been made here to provide a Schelerian analysis with its correlative concept of "person." Our approach here follows more closely that of Helmut Plessner and Alfred Schutz.

Getting Around the Bend

"Every high C accurately struck," Auden says, "demolishes the theory that we are the irresponsible puppets of fate or chance,"[13] or even of ordinary experience in the form of a mathematically mechanized "true" division of the octave, or of the absolute distinction between consonance and dissonance. That accurate pitch cannot be achieved if the singer takes all the intervals of a sequence as pure.[14] Thus the "dilemma" of the singer, the solution to which is to operate with a "just division," a "just intonation," which contains some "false" consonances, thereby making "practical concessions" to the purity, e.g., of the fifth or fourth, or the major third or the minor sixth.[15] In other words, as in painting, "what is right"[16] is indicationally appresented by "what seems right" (e.g., that "accurately struck high C"). The principle is clear; the actual practice is not so simple.

Nor is the situation so simple in the case of musical instruments because there is hardly the flexibility of the human voice so that tuning cannot be changed in the playing (or at least it cannot be done without great difficulty). Accordingly it is necessary to calculate a series of adjustments (creating "mean tone" and eventually "equal temperament")[17] which nevertheless preserve the

[13] *The Dyer's Hand*, p. 477. The example I always have in mind is Jussi Björling's accurately struck, ringing High C's in *Di quella pira* in his debut performance at Covent Garden in 1939 in *Il Trovatore* (as heard on *Legato Classics* LCD 173). It may be added that precisely those top C's (the *do di petto*) of the tenor were described by Rossini as the "screeching of a slaughtered chicken" (cited by Celletti, *A History of Bel Canto*, p. 150). Rossini, to be sure, had other devices for demolishing the theory that we are irresponsible puppets of fate or chance; see below, pp. 230ff.

[14] See Cohen, p. 40 (with a charming example drawn from Huygens).

[15] *Ibid.*, p. 44. See also Walker, *op. cit.*, p. 36: "For music which is monodic, or in which the interest is concentrated on melody, Pythagorean intonation is more suitable than just, since all the fifths and fourths can be untempered, and the very narrow semitones give greater sharpness to the melody. For polyphonic music such as that of the late sixteenth to the nineteenth centuries, in which the major triad occupies a dominating and central position, just intonation has the advantage of making this chord as sweet as possible and in general of making all chords, both major and minor, more consonant, though it has the disadvantages of much greater instability of pitch, of unequal tones, and of much wider semitones..." Cf. also Maria Rika Maniates, *Mannerism in Italian Music and Culture, 1530-1630*, pp. 136, 138.

[16] Whatever "right" (or "real" or "true" of "sweet") may be; see Cohen, pp. 41ff., 79ff., who traces the elaborate, vituperative controversy through the writings of Stevin (who surely must have been tone-deaf), Zarlino, Benedetti (who follows Galileo Galilei), Salinas, and, the most facile of them all, Vicentino.

[17] See Cohen, pp. 41ff.; Maniates, pp. 139, 142f., 146 It is worth noting in this connection Maniates' discussion of the private and public functions of temperament, the social and political implications of which deserve a careful analysis in relation to correlative functions of perspective; see Jean Dietz Moss, *Novelties in the Heavens. Rhetoric and Science in the Copernican Controversy*, p. 280, who examines similar functions of rhetoric in Galileo's *Dialogo;* for the historiography of the problem, see

"purity of the octave" on the assumption, made in ordinary daily life as much as in perspective painting, that things remain of proportionately equal size and shape.[18] Just as perspective in painting deliberately alters and "distorts" size and distance, so temperament consists of the "deliberate 'impurifying' of at least some of the consonances" and the decision as to which consonances are to be "impurified," like the eye-terminus of the centric line in painting, "depended on preferences" of the listener/performer.[19]

Even so, the question remains whether such "impure" or tempered consonances are "natural."[20] The fact remains, though, that temperament, like perspective, "demolishes the theory that we are puppets of fate or chance," deeply imbedded as it is in the many controversies in the fifteenth and sixteenth centuries centered around whether words, speech, set the meaning for music or whether the music establishes the final meaning of the words. Although we cannot ignore this issue even today—it is like the shotgun pointed at our heads as we round the bend—it is no more our purpose to reconstruct the controversies or examine their resolution in their own terms or with respect to later developments in music.[21] Going around the bend, the problem confronting us is rather that of eliciting the essential elements and shape of the Baroque formulation of consciousness in the arts and sciences. But the Baroque formulation has a unque complexity all its own.

It is a truism that there are close connections and interactions in the Renaissance and Baroque between painting, poetry, music, sculpture and architecture, on the one hand, and science (especially "experimental science") on the other hand. And it is even now more of a commonplace to suggest that the common ground between painting or music, for instance, and science is "mathematics." But the question for us with respect to the formulation of consciousness concerns what it is which makes "mathematics," or anything else for that matter, a *common* ground. Of what does the commonness of the ground consist? The answer that we shall suggest is that it is nothing commonplace at all—neither "mathematics" nor "form" or "function"[22]—but instead what we

Cohen, *The Scientific Revolution. A Historiographical Inquiry*, pp. 204ff.

[18]Of course the assumption begins to lose its taken-for-grantedness the moment that we are struck by the fact, as was Galileo, that when we look at the stars through a telescope the stars are magnified less than the distance between them; see Stephen Toulmin and June Goodfield, *The Fabric of the Heavens. The Development of Astronomy and Dynamics*, pp. 192f. We will return to the stars and the telescope later in this chapter, below, pp.149ff.

[19]Cohen, p. 44.

[20]See Cohen, pp. 80ff.; Walker, Chapter II, especially pp. 19ff. for detailed discussion of this issue in Renaissance and Baroque music.

[21] See above, pp. 6f., and note 8, p. 6; and below, pp. 227ff.

[22]For the interaction, see the chapters in Cohen, especially Chapter 7; and Katz, especially Chapter III, pp. 55ff.; see also Walker, Chapter VII. For the dangers of considering that new stock of knowledge at hand as comprising, in part, only metaphors which need not be taken very seriously anymore, see Gary Tomlinson. *Music in Renaissance Magic. Toward a Historiography of Others*, pp. 98f. For a different view, see Cassirer, *The Individual and the Cosmos in Renaissance Philosophy*, pp.162f., where

shall call the "compossibility of concepts"[23] of the Baroque formulation of consciousness.

We can, of course, always speak of a common ground of the Arts and Sciences during the Renaissance and Baroque in the sense of the common assumption underlying their new stock of knowledge at hand, namely that the "real" is accessible to ordinary experience, and that that accessiblility is different depending on whether the accent of reality of our ungrounded ontic conviction is at the center of daily life or at its boundary-peripheries. This is as true of the Classical formulation of consciousness as it is of the Renaissance and Baroque formulations. But which experiential data of ordinary, ec-centric experience are privileged data? If we take the experiential data from the center in its self-interpretative, appresentational character—and it is only *appresentational* data that allow us to extrapolate the "real" because only such data point beyond themselves, mimetically or indicationally—then we are in the midst of a profound change from the Classical formulation of consciousness and operate with the principle (expressed in shorthand terms) of "what is right" appresented by, and *can only* be appresented by, "what seems right."

This change, in turn, lands us squarely back into the central problem of our discussion: How is the "real" adequately represented? How are the things of Nature truly "reproduced"?[24] The answer depends on the character of appresentation at the center of ordinary life, of working together. As suggested, the appresentation is indicational rather than mimetic, hence "experimentation" is possible; experiential data at the center can and will be altered, changed, manipulated so that the far can be read off the alterable near, so that "right" can be read off the manipulable and changeable "seems right," and work be accomplished suitable for purposes at hand, for realizing plans and projects of life in the "polis." It is not a question of either/or: *either* the representation of absolute truth, *or* the relative truth. Whether truth is relative or absolute, whether theory or practice have a primacy, is irrelevant for the Renaissance and Baroque formulation of consciousness.[25]

Finally, we have to add that, at least on the Baroque formulation of consciousness, indicational appresentation at the center of social action is of

the idea of the common ground consists in the "apriori" of empirical reality and artistic beauty (which Cassirer contrasts with Panofsky's notion of the common ground as a sort of "aposteriori" of art and beauty).

[23] Below, pp. 101ff.

[24] See above, p. 58.

[25] See Katz, pp. 179ff. for discussion of these issues in the light of contemporary theories (which she eventually boils down to "referentialist" and "absolutist" views, neither of which excludes the other). The problem consists of "how meaning (whether intrinsic or extrinsic) comes to be attributed to music at all. How, in other words, do specific emotions or cognitive reactions come to attach themselves either to an 'abstract, non-referential succession of tones' or to 'the musical symbolisms depicting concepts, emotions and more qualities'?" (p. 181) Katz's solution, which ignores the phenomenology of consciousness at issue for us, perhaps rightfully, is that music takes meaning from a text, but that in turn the text is "enhanced by the music." But, then, one might say the same of any art—painting, poetry, sculpture, architecture—and even empirical science itself!

necessity "intersubjective," dependent on the reciprocity of perspectives, hence expressive of the "movements of the souls" of others. Thus I will have to try to show that the so-called "theory of affections" so prominent in the late Renaissance and Baroque[26] is quite distinct from the Pythagorean and Aristoxenian views from which it is ostensibly derived and which belong to the Classical, but not the Baroque, formulation of consciousness.[27]

The Chorus Invisible
And the Harmony of the Spheres

Kepler's chorus invisible singing the inaudible harmonies of the motion of celestial bodies (last seen at night revolving around an invisible axis in the great hollow shell of the heavens)[28] can serve as an example which unites the various elements of the Baroque formulation of consciousness so far elicited. At the same time, the example will provide us with a test case of the interaction with Science which points to the commonness of their common ground. We may formulate the basic premise of a Keplerian view as follows: Given that mathematical regularities serve as guides to the creation of the universe by the Deity,[29] it follows that our socially approved scientific stock of knowledge at hand is then acquired through the discovery of those same regularities expressed by events in the world. The corollary to this given is that the idea of motion proves to be the true paradigm of expression of those mathematical regularities. And when they turn out to be geometrical ones, it also happens that some of the figures, such as circles inscribed by regular polygons, eventually prove to be criteria for distinguishing, e.g., consonance from dissonance.[30]

The upshot of Kepler's equally elaborate and ingenious mathematical analyses[31] in connection with music is that "sound is a species emitted by a body and its constitution is in conformity with that body's size, to a certain

[26]See Barbara Russano Hanning, *Of Poetry and Music's Power. Humanism and the Creation of Opera*, Chapter II; Maniates, Chapter XIII; Walker, Chapter V; Manfred F. Bukofzer, *Music in the Baroque Era*, pp. 389f.; and Gary Tomlinson, *Music in Renaissance Magic*, Chapter Three, especially pp. 78ff.

[27]Thus my approach drawing on the phenomenology of the social is distinct from (although not irrelevant to) the Foucault-grounded "historiography and archeology of others" of Tomlinson; see Tomlinson, pp. 20ff., and 32ff.; and above, pp. 49f., 52f.; below, pp. 176f.

[28]My point of reference is chiefly to Kepler's *Harmonia Mundi* of 1619; I rely primarily on Cohen, Chapter 2; Walker, Chapter IV; Panofsky, *Galileo as Critic of the Arts*; and Hall, *The Revolution in Science 1500-1750*, Chapter V.

[29]See Cohen, p. 17; Walker, pp. 53, 61.

[30]How it is a criterion is lucidly shown by Cohen, pp. 18ff.

[31]In particular, see Cohen, p. 21: "It is not possible to find a flaw in the entire axiomatic system that Kepler had elaborated."

extent also with its shape, and with its motion."[32] According to Cohen, following the great Keplerian Dijksterhuis,[33] we may plausibly suggest that Kepler here follows a "traditional theory" which asserts that when sounds are transmitted to the ear they are further transmitted to the soul and transformed into musical sounds judged as "sensible harmonies" when the soul's judgment is positive. If anything, this is a comfortable theory, traditional or otherwise (the appresentational experience upon which it rests seems to me more indicational than mimetic, hence it may not be traditional at all). Be that as it may, there is something important in this theory for the Baroque formulation of consciousness, and which sets it aside from tradition.

On Cohen's account, the sense of Kepler's view is this: the soul compares the terms of proportions of consonances and, on that basis, "turns them into harmony." Harmony is then the product of the soul's machine shop. That with respect to which the soul compares the terms of consonances, converting them into "sensile harmonies," is an "Archetype of a most true Harmony," in Kepler's words, "which is present in the soul." At first sight, Kepler certainly seems to operate with a version of the Classical formulation of consciousness, and in that light Cohen ingeniously reconstructs his thought to say that the archetypical harmony is established by reference to the circles and arcs cut off from their circumference by construction of regular polygons inscribed in circles. Because the proportions of these arcs are independent of the size of the circle, we can disregard the size in consequence of which the circle may "shrink into a point,"[34] or as Kepler says, the soul, correlatively, becomes a "potential circle," and one "provided with directions," a "qualitative point."[35] There are specifically mathematical reasons (tied up with geometry) for Kepler's account of the soul and which will figure into the idea of the *cogito* in Descartes and the geometry of Leibniz. For the moment we have to examine another feature of Kepler's thought, still putting our ears ahead of our minds.

The "soulful center" is, like the eye and the vanishing point in painting, extrapolated from the ubiquitous Here in the specious present of ordinary experience—that Here from which things are compared and judged and estimated for specific pragmatic purposes. But once Kepler has arrived at his theory of the role of the soul in the "world harmony," he can proceed to distinguish between (inaudible) celestial music on the one hand, and (audible) terrestrial music on the other hand. Moreover, the latter is not an imitation of the former, although both share a common link: the geometric archetypes (the geometric ratios derived from inscription of regular polygons in circles) of which celestial and terrestrial music are independent products.[36]

[32]Kepler, cited by Cohen, p. 24.

[33]Cohen draws especially on E. J. Dijksterhuis, *The Mechanization of the World Picture* (1961).

[34]Cohen, p. 25.

[35]Cited *ibid.* We shall return to Kepler's account when we come, in Chapter Seven, to Leibniz and the idea of the ellipse (of which the circle is then the limiting case); see below, pp. 192ff.

[36]Walker, pp. 59f. See below, p. 90.

Now, each planet has its own scale defined by the extreme speeds of the planets at their aphelion and perihelion, and thus the lowest and highest notes of the scale are not articulated in tones and semitones, as in the case of terrestrial music, but represent the continuous acceleration and deceleration of the planets' speed (the first and second laws of motion). The chords made by two or more planets are defined by intervals comprised by their scales and the intervals between their scales.[37] Celestial music begins and ends with a divine concord while in between there is an immense series of dissonances ultimately resolved on a final chord.[38] In contrast, terrestrial music, such as the polyphony exalted by Kepler over the monody of the ancients and contemporaries like Vincenzo Galilei,[39] consists largely of concords, with any dissonances becoming quickly resolved.

Having put our ears this far ahead of our minds, it is not surprising that at this point we begin to puzzle over what all of this might sound like, and no one has puzzled more than Walker who suggests that the kinds "of music which come near to Kepler's heavenly music would be: the cadenza of a classical concerto, which is a very long interpolation between a 6/4 chord and its 5/3 resolution, or a piece written entirely on a pedal-note (e.g., one of Bach's *Musettes*)."[40] In this connection Walker cites the following ecstatic and rather over-bejeweled statement of Kepler: "The motions of the heavens, therefore, are nothing else but a perennial concert (rational not vocal) tending, through dissonances, through as it were certain suspensions or cadential formulae (by which men imitate those natural dissonances), towards definite and prescribed cadences, each chord being of six terms (as of six voices), and by these marks distinguishing and articulating the immensity of time; so that it is no longer a marvel that at last this way of singing in several parts, unknown to the ancients, should have been invented by Man, the Ape of his Creator; that, namely, he should, by the artificial symphony of several voices, play out, in a brief portion of an hour, the perpetuity of the whole duration of the world, and should to some degree taste of God the Creator's satisfaction in His own works, with a most intensely sweet pleasure gained from this Music that imitates God."[41] Other than a perversely baroque pleasure in Baroque hyperbole, Walker's purpose in citing Kepler at this length is that the comparison of celestial and terrestrial music is not a metaphor but rather a "real connexion between the two polyphonies which accounts for their likeness," and that this is a causal analogy which establishes the meaning of music.

Walker's conclusion is both plausible and important for our purposes especially because of its other side. Celestial and terrestrial music share common

[37] Walker provides examples, p. 60.

[38] *Ibid.*, p. 61.

[39] *Ibid.*, pp. 38f.

[40] *Ibid.*, p. 61. That is, a pedal-note in the sense of a note constantly sustained over which celestial harmonies play and into which they are finally resolved. Even though I cannot substantiate it on musicological grounds, my own candidate for what Kepler's heavenly music would sound like is Satie's "Description Automatiques."

[41] *Ibid.* pp. 61f.

archetypes consisting of geometric ratios derived from polygons inscribed in circles.[42] Now because celestial music is defined by planetary speeds around the sun we have to conclude that the polyphony of the Chorus Invisible is perceived from the standpoint of the sun. Indeed, the "soulful center," the harmonic vanishing point, we might say, is identified by Kepler with the sun from which, however, not just celestial but all harmonies, including the terrestrial, are perceived—the primal chordal *mezzanità* tuning the Keplerian cosmology. By "sun" Kepler would seem to mean not so much a huge blob of hot gas but more like the vanishing point of perspective painting, at least with respect to how it is shown in our experience. Moreover, as the quotation from Kepler suggests, terrestrial polyphony, the "artificial symphony" (like the *prospectiva artificialis* of painting) appresents or "plays out," owing to its common, shared archetypes, the "whole duration of the world" in a "brief hour" the celestial music "imitative" of God.

Translating this summary of Kepler into terms more amenable to a formulation of consciousness, we may say that celestial polyphony is read off terrestrial polyphony, the Chorus Invisible off the Chorus Visible; the steps of tones and semitones, the thirds and sixths, appresent the celestial harmonies which, in turn, "imitate" their Maker in ape-like fashion. Terrestrial polyphony, consisting chiefly of consonances, more particularly, *indicationally* appresents its opposite, dissonances and a glissando (the scales of the planets "would sound like a siren giving an air-raid warning," as Walker says) "resolved (perhaps) on the final chord."[43] And we have to express the matter this way because the experiential datum from which the "real," the celestial polyphony, is extrapolated is not perception of the shared geometrical archetypes—the foundation for comparison—but instead of the consonance of thirds and sixths perceived by an "unprejudiced observer with a good ear"[44] and presumably one who has put the "good ear" ahead of the "good" mind. Thus terrestrial music is not imitative of celestial music, nor derived from it, hence not a mimetic copy of it.[45]

Not only are all celestial harmonies read off terrestrial ones from a zero-point center that is the sun (perhaps they would be better called "helio-terrestrial" harmonies) but *what is right, the immense series of* (inaudible) *dissonances,* is appresented indicationally by *what seems right* (audible to a "good ear"), *by consonances appropriately tempered:* the opposite. As it were, "imperfect" (or "impure") consonances indicate "perfect" ("pure") dissonances.[46] Moreover, the scales of the planets are like "simple song or

[42] See Walker, pp. 44f. for some of the reasons for Kepler's "geometrizing" of the "real." Geometry is clearly superior to the arithmetic of the ancients; see the texts of 1619 of Kepler in *The History of Mathematics. A Reader*, p. 328

[43] Walker, p. 61.

[44] *Ibid.,*, pp. 38, 41f.

[45] *Ibid.,* pjp. 39f.

[46] Cf. *ibid.,* p. 37. To speak of "perfect" or "impure" dissonance seems absurd; for the moment I find it the only way to describe the situation.

monody" (Kepler)[47] and their chords, what is right, are appresented by what seems right, not monody *but polyphony*. Accordingly Kepler emphasizes the fact that polyphony is not an imitation of celestial music but, as we have to say, appresents its opposite: monody. The "polyphony" of the Chorus Invisible, at least as far as inaudible chords go, is monody.

Granted that I may have gone too far having come this far with Kepler's ideas so as to get around the bend, the reason has been to make a point: the representative power of polyphony follows the principle that what is right is appresented by what seems right *and that, moreover, what is right is the opposite of what seems right*. We have a way to go before we can further elaborate this basic element of the Baroque formulation of consciousness sprung Venus-like when looking out the window through the veil. In addition, the representation is geometrical or exponential, resting on inaudible ratios of polygons inscribed in circles, appresented indicationally by the ratios of major and minor thirds and sixths, extrapolated from the center of action in and upon the world.

Easily lost sight of in Kepler's *Mysterium cosmographicum*, this datum of ordinary experience, to which the "real" is accessible, proves to be the zero-point of social action. That point is ubiquitous as we have said emphasizing the obvious: it is "any Here" in the specious present of bodily gearing into and for the world within actual and potential reach, and from this is extrapolated the zero-point (the "qualitative point") identified with the sun and from which are perceived the "true" harmonies of the *Harmonia mundi*. How is that extrapolation accomplished?

Muscles and Bones

Kepler's three planetary laws are these:
 1. The center of planetary revolutions is not an abstract geometrical point but the center of the sun's "body," and the revolutions are ellipses not circles.[48]
 2. The planets move faster as they approach the perihelion, slower as they approach the aphelion, and acceleration and deceleration are defined by the fact that the radius vector covers equal areas in equal times.
 3. Squares of the periods of revolution are proportional to cubes of "mean distances."

In a later chapter we shall return to these laws, and in several different connections with Galileo, Leibniz and Nicolai Kusmitch. Here we have to set these laws into the context not of the *Harmonia mundi* but of the *Astronomia nova* where, after paying some theological lip-service (political correctness, after all, is as Baroque as it is baroque), Kepler seeks to justify his celestial

[47]Cited by Walker, p. 34.

[48]See *The History of Mathematics. A Reader*, pp. 323f.; Panofsky, *Galileo as Critic of the Arts*, pp. 24f.; Cohen, *Quantifying Music*, p. 27; Hall, *The Revolution in Science 1500-1750*, pp. 139ff. See below, p. 193.

mechanics as follows:[49] "All muscles operate according to the principle of rectilinear movement...There is no limb that can rotate in a uniform and comfortable manner. The bending of the head, the feet and the tongue are brought about, through some mechanical artifice, by many straight muscles stretched from here to there."

Now, just as the self-interpretation (an "unprejudiced observer with a good ear") of polyphony appresenting (inaudible) celestial monody allows of yet other self-interpretations, so does the effort of stretching limbs and head and tongue, i.e., the human body at work in the manipulatory zone of the world within actual reach. With his sense of the bizarre in full sail, and his stunning perceptiveness at its brightest, Panofsky notes that Galileo comes to exactly the opposite conclusion as Kepler *with the very same data of ordinary experience*:[50] "...I tell you that the joints are made so that the animal can move one or more of its parts, keeping the rest stationary, and that as to kinds and differences of the movements, they are of one kind only—the circular. That is why you see the ends of all moving bones to be convex or concave, and some of these spherical: namely those which have to move in every direction, as must the arm in the shoulder knot of an ensign where he is displaying the colors, or that of the falconer when bringing the hawk to his lure. And such is the elbow joint, upon which the hand turns round when boring with an augur..." Galileo then proceeds to extrapolate the motion of the earth on its axis and around the sun from the experience of all human proportion in motion (the ensign, the falconer, the carpenter) as a system of circles and epicycles, provided, as recommended by Alberti,[51] we think of bones in their joints before muscles stretched (as any arthritic jogger knows).

At issue is the self-interpretation of the data of ordinary experience: action of the human body at work in the manipulatory zone of the world within actual reach. What principle governs that self-interpretation, taken for granted by both Kepler and Galileo? Of two equally plausible, taken for granted self-interpretations of the *mezzanità* peculiar to our gearing into the world, which do we choose? Do we make the choice of the painter and the griding of the "real"? Or do we make the choice of the singer (or instrumentalist) with tempered tones and the high C accurately struck? Do we stick with Kepler or with Galileo? Do we think of bones in their joints before or after the muscles are stretched?[52]

In whichever case, to be sure, we are not puppets of fate or chance, or at least no more than we are as actors in the social world. And our point with either Kepler or Galileo or both is the same: both rest on the same principle, namely that what is right, true, real, natural, is always and only appresented

[49] Cited by Panofsky, pp. 26f.

[50] Panofsky, *ibid.*, and Galileo Galilei, *Dialogo sopra i due Massimi Sistemi del Mondo* in *Le Opere di Galileo Galilei*, pp. 283f. (*Dialogue Concerning the Two Chief World Systems*, p. 259.)

[51] Alberti, *On Painting*, p. 74; see Spencer's comments, note 41, p. 125.

[52] It is only when Kepler has answered the question by affirming *the second alternative* that we can agree with Cassirer's statement that "The 'innate' idea of number and the 'innate' idea of beauty led Kepler, as he himself always emphasized, to establish the three basic laws of planetary movements," Cassirer, *op. cit.*, p. 164, note 62.

indicationally by what seems right, true, real, natural. And because that principle entails reading the far off the near, the inaudible off the audible, the invisible off the visible, it is a principle that allows for manipulation and change of the "real," expressable in geometric rather than merely arithmetic terms.

To express the matter in terms used earlier, in Chapter Three, the self-interpretation of bodily gearing into and for the world within actual and potential reach makes explicit its character of being taken for granted when it serves as a privileged datum for appresenting the "real."[53] This is not obvious, and deserves further examination. Before doing so, and to provide a little comic relief, it is worth while drawing some tentative conclusions from the discussion of Kepler as an example bringing together the several facets of our argument about the beginnings of the Baroque formulation of consciousness.

After all, in the case of self-interpretation of the data of ordinary experience at the boundary-periphery there is at least the "motive" of disinterested "objectivity" and the persuasive exchange of views in the light the apprehension of the measure of the "real." But what "motive" is there at the center of our eccentric being in the world for the transformation of the self-interpretation of certain data of ordinary experience into privileged experiential data? Perhaps it is not so much a matter of the particular data in question as a medium of access to the "real" as it is instead of the self-interpretation itself, *become aware of itself as self-interpretation* of common-sensical experience, otherwise taken for granted. In other words, ordinary self-interpretation of social action becomes itself a self-conscious method, and perhaps the most obvious case where this occurs is in the case of "mannerist" and Baroque music. Thus the introduction of Kepler with particular emphasis on the role and meaning of music in his cosmology which, along with perspective painting, is not just another example of the beginnings of the Baroque formulation of consciousness, but includes within it an essential feature of the Baroque formulation: the self-conscious exercise of self-interpretation of social action, of the center. *Mezzanità* acquires "style," "*sprezzatura*."[54] Action at the center, where push comes to shove, is "*maniera*" in the sense of *both* "style" and self-conscious method.[55] It is then a matter not of the priority of "knowledge" over "usefulness," nor of the shape and appearance of the thingness of things over reckoning things in their "natures" undergoing change and alteration, or of persuasion over coercion (and even violence), or of "innate" ideas of number

[53]It remains an open question whether, on the Classical formulation of consciousness, the "real" is ever strictly presented, rather than appresented. As a basic mode of representation, however, mimesis and analogy are always only appresentational, never presentational. On the Baroque formulation of consciousness, however, there is no question: the "real" is always only appresented, the medium of access to the "real" is always indirect, never direct.

[54]See Maniates, pp. 201ff., 210f., and Chapters I-III; Katz, pp. 63ff.; Hanning, pp. 44ff., 56ff., 77, note 120, p. 226, and the "new "harmonic graticula" or grid, we might say, that regulates harmonic movement in accord with affections expressed in speech, pp. 58f., 74ff.; Bukofzer, Chapter 11, especially pp. 375ff.

[55]See Maniates, p. 258.

and beauty, but rather just the contrary: the interest, needs, necessities, usefulness of the center now has a priority.

In the "polis" of the Renaissance and the Baroque the "priority" of the center signifies that self-interpretation of social action in ordinary experience is self-interpretation of the ways in which push comes to shove, thus is a matter not so much of persuasion but of polemics. Push comes to shove as much in the mechanics of quanta in motion and in motion fused with human proportions as it does in the social and political encounters of daily life.[56] Just as the "nature" of things takes precedent over their mere thingness, the on-going process of "use" and consumption over the beauty of appearances, the answerable (and threatening, or if not, the resistant) over the unanswerable and non-threatening, so polemics takes precedence over persuasion, just as being right takes precedence over "erring with Plato" (even when we follow his advice and put our ears ahead of our minds). Moreover, this is not simply a process of replacement and preference, not simply a matter of substituting one "style" for another, not simply a transformation of one cogntive and affective acquaintance with nature and society by another. Nor does it quite seem to fit the specifications of a Kuhnian "paradigm shift" despite the prospect of the internal collapse of the Classical formulation of consciousness.[57]

There are a number of reasons why we have to make these qualifications here as before. In the first place, when made explicit, the taken-for-grantedness of ordinary experience reveals itself in its self-inclusive ungroundedness, exhibiting the gratuitous and fortuitous nature of that existential belief peculiar to ordinary experience. As we said before, this signifies that the accent of reality has shifted from the ungrounded existential belief to what is generated by the self-conscious exercise of the self-interpretation of ordinary experience *made method*. In the second place, in this and the next chapter we shall examine the result: *the making of ordinary life an "enclave" separated from what is produced by its own self-conscious exercise of its own self-interpretation.*

[56] The vituperative, often vitriolic, polemics of this period deserve a separate study along the new developments in rhetoric; see above, p. 45; and Jean Dietz Moss, *Novelties in the Heavens. Rhetoric and Science in the Coperican Controversy*, Chapter 1 for the use of rhetoric in science in the 16th and 17th centuries, and especially pp. 78ff. This important book does for science in the Baroque what Maniates' does for music in roughly the same period, and what Hanning's does for libretti in a somewhat earlier period. See also Pietro Redondi, *Galileo Heretic*, pp. 33ff., 179ff. *Polemos* replaces the ancient *Peithein* as a political means in the late Renaissance and Baroque.

[57] See above, pp. 75. This does not mean, however, changes and shifts in paradigms, alterations in "styles," even seeking the ways in which cognitive and affective experiences are transformed, are not important, or even of fundamental importance. It is that phenomenologically no foundations have yet been established by which to develop them, examine them in a critical-conceptual way as concerns the phenomena we are trying to describe.

For the moment we have to leave those reflections and turn to a preliminary characterization of the Baroque formulation of consciousness. The term, "Baroque," is now used in the same way we employed the term, "Classical," in the Classical formulation of consciousness: a name for a set of identifiable features which, to be sure, are historical phenomena, have a "date" in time, yet the meaning, or ideal possibility ("essence"), of which cannot be confined to when it became prominent, or when it became operative by providing a telling account of eccentric being in the world in common with others. This leads to a problem peculiar to our discussion of the Baroque as much as the Classical formulation of consciousness.

The Baroque formulation of consciousness obviously involves a clearly discernible "break" with the Classical formulation, and, like the latter, the former has to be relearned and its otherwise forgotten (at times, hidden) elements and conventions have to be re-established but not just as a date in the history of philosophy, science, painting, music. Instead they have to be relearned and re-established also as *possible* formulations, with reasons of their own.

For such purposes, in our particular context, it is not so important that further qualifying adjectives like "early," "middle," or "high" Renaissance or Baroque be employed, or that some aspects be identified as more of the Renaissance or Baroque or even of Mannerism.[58] This is not to deny that all such approaches and distinctions in philosophy, science, music or painting are historiographically important; they are, and it is not my wish to avoid them as such. But the touchstone is always the same: adherence to our (challenged and challengeable) ontic acceptance or belief-premise which underlies our eccentric being in the world. Thus names such as Aristotle, Kepler, Oresme, Galileo, Alberti, and the like, designate specific facets of an actual as well as possible formulation of consciousness.

That said, so far it is the sway of the desire for the center felt at the heart of social action which has governed the new, the Baroque, formulation of consciousness which has been brewing. This datum of ordinary life is significant for many reasons, not the least of which is that the Baroque formulation of consciousness shares a basic assumption with the Classical: that the "real" is somehow accessible to ordinary experience in its appresentational character and therefore can be extrapolated from ordinary experience.

There is nevertheless a twist to that assumption, now, because at issue is not a datum of ordinary experience resulting from the interruption of action, not a datum which is unanswerable (even if non-threatening)—not "laughing" or "crying"—*but instead a "serious" datum of effort, work, action to meet the needs and necessities of biological and social life.* It is, in short, a datum of dead-center reckoning to which the "real" is appresentationally accessible. Such

[58]See Arnold Hauser, *Mannerism*, Vol. I, pp. 11-22; Katz, *Divining the Powers of Music*, pp. 63ff.; and Maniates, *Mannerism*, pp. 208f., 228f. The distinctions cut across time and place as much as subject matter—e.g., painting in Flanders, the theatre in France, music in Florence or Venice, the novel in Spain.

a datum is grounded in social action rather than in release and freedom from it as is the case with the data of the boundary-periphery which allow for the Classical formulation of consciousness. With this in mind, we may draw several conclusions concerning the Baroque formulation of consciousness and, at the same time, deal with yet another, and more difficult, problem confronting us: the constituting of the commonness of the ground of the interaction between science, music, and painting in the Baroque formulation of consciousness.

1. Minimally, to meet the needs and necessities of biological and social life the representation of action at the center cannot simply resemble and imitate the "real," judge things in their thingness and shape of appearance. Instead it must be a representation that appresentationally links events so that A follows B, or else is the cause of B, or the occasion of B—in short, so that push can come to shove, work can be done, events and things manipulated in the world within reach, near at hand and in hand, for pupeses and goals according to procedures and rules of work and production and so that action is of "use."[59] More specifically, the *appresenting* element is, in the first place, "geometrically" defined, be it the veil or grid of painting, Bradwardine's laws of motion or tempered articulation of harmonies. The appresenting element is no longer represented by a mirror held up to Nature and Society, no longer a case of reflectional mimesis. In the second place, the "geometrically" represented appresenting element is always only what seems right on the corollary assumption that what is *appresented* is what is right. That means that what is right, "the real," accessible to ordinary experience in its social action, *is not obvious*. Obviously what is not obvious can be indicated, eventually even "symbolized," but never copied, mimetically or even analogically represented.

It is the appresenting element of the appresentational relationship so conceived that, in turn, allows for the extrapolation of the "real," the making present of what is right although not obvious.

2. The indication of what is right by what seems right is, at least with respect to its origins, chiefly an aesthetic principle of beauty and harmony when the self-interpretation of the appresenting element is self-consciously made into a method and style. As in the case of the Classical formulation, the measure taken of the "real" is beauty and harmony,[60] proportion and motion. On the Baroque formulation of consciousness, "beauty" and "harmony" pertain to the appresentation of what is right *by what seems right* in the manipulatory zone of experience so that the measure of the far is read off the near, the invisible off the visible—in short, "beauty" and "harmony" belong to the specious present. On the Classical formulation, in contrast, "beauty" and "harmony" measure the near off the far (the world out of actual and potential reach), and therefore can only copy, imitate it, respresent it by resemblance (perhaps by analogy), can only image the "looks" *(Eidos)* of what something "looks like" *(Eikon)*. In contrast and in addition, on the Baroque formulation what seems right appresentationally indicates *its opposite* rather than resembles it *on the corrolary assumption that*

[59] See Fred Kersten, "The Line in the Middle," pp. 90ff. for the idea of "use" at issue here.

[60] Although "beauty" now has many different meanings; see Panofsky, "Theory of human Proportions," *loc. cit.*, pp. 89ff., note 63; Cassirer, *op. cit.*, pp. 163f.

things and events, emotions and feelings (the movements of the soul) *at hand and in hand in the manipulatory zone of social action retain their size and shape and magnitude.*[61] The assumption is that everything being equal, "things remain the same" in their nature, magnitudes remain continuous, the specious present remains specious, Here remains Here. As a result, in the Renaissance and Baroque the Classical vocabulary often acquires a new meaning. Two examples will suffice here.

"Catharsis" and "Mimesis"

The first example is that of "catharsis," a basic idea in the revival in the Renaissance of Greek tragedy. Setting aside all discussion of whether poets, playwrights and musicians actually had or only thought they had revived antique tragedy, we can immediately note that catharsis is no longer characterized by those two emotions which, more than any others, interrupt action and work at the center: pity and terror, which are unanswerable and threatening thereby leaving one stranded at the eccentric periphery of life.

Reviewing the genealogy of the idea of catharsis in writers and composers in the fifteenth and sixteenth centuries, Barbara Hanning, for example, charts a variety of changes in usage and meaning with respect to the humanist ideas of the "power of music to move the passions of the soul." One of the first significant changes she notes is the extension of catharsis to cover "those tragedies that do not represent altogether sad action but which progress from *misera* to *felicità,*" thus bringing "delight" for the reason that "'feeling pity is virtuous and virtue is synonymous with joy'" (Lorenzo Giacomini[62]). In the second place, catharsis has the function of alleviating, not pity and fear or terror but a "nameless melancholy" by awakening in the audience "not the pity and terror of old, but rather '*più dolci affetti,*' the sweeter affections to which tragicomedy also aspires—to express the matter in terms of the 'La Tragedia' in Rinuccini's prologue to *Euridice.*"[63] In other words, instead of bringing us to confront the unanswerable, catharsis returns us to the center, to work, in much the same way as does elevator music or Musak, today's "*maniera più affettuosa*" which "'delights and moves the affections of the soul'." In this

[61]Recall the distinction of Hannah Arendt that, on the Classical formulation of consciousness it is the form that is retained and which defines the thingness of things; we may say that on the Baroque formulation, in contrast, rather than the form it is the geometrized grid or veil that defines the thingness of things—in general, the appresenting element of "what seems right."

[62]Hanning, *Of Poetry and Music's Power*, p. 29 and pp. 29ff. Hanning's chief purpose here is to develop the "emergence of a musical aesthetics from the humanistic assumptions of the late Renaissance—an aesthetics aimed at stirring the passions of the soul." For a brief overview of the development of Italian tragedy, see Madeleine Doran, *Endeavors of Art*, pp. 128ff

[63]*Ibid.*, p. 31.

respect, there is a close affinity between Alberti's idea of *istoria* and the theory of affections.

The second example in need of brief mention is that of "imitation," *mimesis*. There is Giacomini's definition of a poem as "an imitation in figurative language reduced to verse, of human actions...made according to the art of poetry, proper for purgations, for instruction, for giving recreation or noble diversion."[64] To which we can add the strictures of Girolamo Mei that imitation is to be contrasted with artifice and as such is the "true soul of poetry," and what is imitated are the "conceits of the soul" so far as expressed in human speech and, by extension, in song.[65] Eventually, in Italy, this leads to the invention of a new literary genre: the libretto.[66] The "conceits of the soul" boil down to the motions of the soul. Their representation is complex and becomes more so in the Baroque.[67] Thus "Aural figures, then, entail musical shapes based on rhythm and motion: running melismas, sighing contours, unexpected stops, jagged intervals, rising and falling melodies. Such devices concretize aspects of motion <of the soul> contained in the words and dramatize innate gestures implied by the affective meaning of the conceits."[68]

[64]Cited and translated by Hanning, p. 23 (see note 21, p. 198: "imitazione con parlare favoloso ridotto in versi di azione umana.") We shall return to the meaning of "parlare favoloso" below, pp.140f. See Doran, *op. cit.*, pp. 70f., who makes a point of emphasizing the fact that it is the Aristotelian, rather than the Platonic, notion of *mimesis* which influenced the Renaissance thinkers, and this would seem to be borne out especially in the English theatre of the Renaissance as she traces its development, i.e., the idea of poetry as the "imitation of life" and hence its significant features of "universality," "verisimiltude," "decorum" and the "marvelous." She also emphasizes the fact that the very idea of "imitation" is subjected to changes in meaning depending on the individual writer, and which often depart from a strict reading of what Aristotle had in mind; see pp. 74ff. Certainly there are similarities between the authors Hanning cites and those that Doran cites, as well as common sources among them (especially Cicero). While it would be worth pursuing the similarities and differences between the Italian and English authors, still such a task is outside the present one. For a beginning, see Vivian Foss, "Massinger's Tragicomedies: The Politics of Courtship," Chapter IV, which provides a good example of the use of tragicomedy as a vehicle of verisimilitude (see also pp. 291ff. for its limitations). A few of the similarities will, however, be noted as we proceed.

[65]Hanning, p. 35, and pp. 36ff.; see Maniates, pp. 199f, and 196f., for the important distinction in music between *fuga* and *imitazione*. For Girolamo Mei's aesthetics, see Edward Lippman, *A History of Western Musical Aesthetics*. pp. 32ff.

[66]See Hanning, pp. 44, 54, 57, 77, 89f.

[67]See Maniates, p. 201: "The theoretical conception and practical use of musical conceits is a complex phenomenon. Purely pictorial word painting consists of eye music whose visual effect depends on esoteric puns grasped only by performers. This tradition is a very old one going back to the Middle Ages; but even then it was viewed as a witty rhetorical trope. Aural figures are more ambiguous in as much as they depict conceits and affect the listener. They have a double purpose: to imitate *concetti* by their graphic shape and to dramatize the effective meaning of the conceits by drawing the listener's attention to them."

[68]*Ibid.*, p 201; see Doran, *Endeavors of Art*, pp. 72-79, where the equivalents in literature

Here again we have a good example of the aesthetic principle of what is right appresented indicationally by what seems right. Or, as Maniates expresses it: "We must understand that we are here dealing with an illusion, an illusion of affective drama created by use of these devices <scl. aural figures>. But this illusion appears very real because of the mannerist conviction that music can match the tangible rhetoric of speech"[69] which, as Hanning has shown, is also a conviction of the Renaissance humanist as well. If we take "illusion" in a broad enough sense to include the "fantastic" but also whatever else "seems right," then an example of such imitation is this:[70]

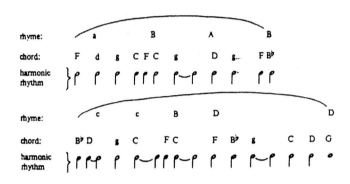

As can be *seen*, the chords and harmonic rhythms are hardly a "copy" of the text, let alone of the conceits of the soul. Nonetheless, they effectively indicate appresentationally, although following a "logic which is independent of the text structure."[71] In short, as shown by the examples of Hanning's exemplary analyses of Peri and Caccini, "imitation" consists of the musical equivalent of the grid or veil of painting—a sort of "harmonic grid" that cuts the aural "pyramid" in much the same way the veil cuts the visual one.

are discussed under the headings of "universal truth" and "decorum," the doctrine of which "brings universal truth down from these speculative heights to a practical level. It gives directions for the embodiment of universal truth in poetic symbols. For it is a *doctrine of the fitness of the means to an end*" (the emphasis is mine). As in music and painting, the doctrine of decorum is grounded in action at the center.

[69]Maniates, p. 201; cf. Doran, 74f. For the philosophical and aesthetic problems of notation, which cannot be considered here, see Lydia Goehr, *The Imaginary Museum of Musical Works*, pp. 21ff.; Peter Kivy, *Sound and Semblance. Reflections on Musical Representation*, Chapter VI. Both take their point of departure from Nelson Goodman's *Languages of Art* (1969).

[70]Hanning, p. 87; the example is from Caccini's *La Dafne*, and is reprinted by permission of the publisher. See also Claude V. Palisca, *Humanism in Italian Renaissance Musical Thought*, pp. 429ff.

[71]*Ibid*. To be sure, in this case, we are no longer operating with Giulio Cesare Monteverdi's dictum, "L'oratione si padrona dell'armonia e non serva" (cited by Maniates, p. 200).

Neither of the traditional terms, catharsis and imitation, have the same meaning they do on the Classical formulation; rather than on mimetic appresentation, they rest chiefly on indicational appresentation. In each case, it is rather the opposite that is represented verbally and harmonically to appresent the conceits of the soul (the souls of Others).

For two reasons this is important for the Baroque formulation of consciousness. The first is that the appresenting element of the appresentational experience of sounds as music, specifically of the monodic *"stile rappresentativo,"* although not, strictly speaking, "geometrized" as in the case of the laws of motion in mechanics and of motion fused with human proportion as in the case of the *prospectiva artificialis* in painting,[72] nonetheless and for all that is still hardly an image, copy even in the sense of the arithmetic ratios of the Pythagorean tradition. The harmonic veil or grid, and the syllabic constructions of the text, of "speech in song," and of "song in speech," are indicational rather than mimetic of the conceits of the soul, are always only what seems right in practice (and then in theory); not even the "aural figures" are arithmetically but instead indicationally proportional. The assumptions are the same in all cases: not just that the appresented "real" is somehow accessible to ordinary experience but also that things, events, as well as others, their emotions, desires, pleasures and conceits, remain the same in the manipulatory zone of action.

This leads us to the second reason why our brief discussion of catharsis and imitation in music is important for putting us in touch with the inner workings of the Baroque formulation of consciousness: it introduces us to the problem of what it means to be in touch with those inner workings in the first place. I said before that the Baroque formulation is not considered here simply as a replacement of the Classical formulation; nor, phenomenologically, is it a question of finding the same or a similar paradigm or pattern of appresentation in the arts and sciences, nor even of finding the same or a very similar aesthetic principle at at work in them. Nor is it immediately a question of the "historical genesis" of a principle in one discipline imported into another, nor, for the moment at least, of a mutual influence of artists and scientists[73] wandering

[72] Although certainly the attempt is made to "geometrize" music along with everything else that crawls out from the woodwork; see Cohen, *Quantifying Music*, Chapter 3, and pp. 209ff. (on Huygens).

[73] The question remains open whether we can even make such distinctions apply to the Renaissance and Baroque; see the discussion by Katz, Chapter 3, especially pp. 54ff., pp. 108ff., 177ff.; Maniates, Part I, is devoted to the attempt to make these distinctions in Mannerist painting, architecture, scuplture and literature. The whole issue is practically and theoretically difficult and not easily stated in a few words, but is nicely sketched by Moss, p. 268 and p. 268, note 23, by taking two opposite views. The one view is that of Finocchiaro (e.g. in *Galileo and the Art of Reasoning*) who insists that rhetoric is a non-logical, non-intellectual and non-literary/aesthetic, and who, despite his ahistorical pretensions, reveals the emotional along with the logical elements at work in Galileo's *Dialogo*; the other extreme is represented by Brian Vickers (in e.g. "Epideictic Rhetoric in Galileo's *Dialogo*," pp. 69-102), who deals with the use of a "literary rhetoric" of praise and blame. These two different treatments are grounded in different ideas of rhetoric and those different ideas are grounded, in turn, in their different disciplines. Neither sees rhetoric allied with dialectical argumentation, that is, neither considers how

around admiring each other's work or standing each other drinks in local gin-mills. One reason I have remarked several times on these questions and interests is because they are themselves *precisely and only characteristics and products of the Baroque formulation of consciousness*. To deal with them means that if we have arrived this far at the Baroque formulation we have come too far. We not only have begged the question, but are begging to get it—as I was told by the bartender in the saloon where I stopped to calm my nerves after coming down the mountain and recounting my adventure.

What the discussion of the concepts of catharsis and imitation shows is the need for what we may call a *"transformation formula"* which, for the time being, will set aside such questions, begged or otherwise, yet which allows for dealing with them in a way that is more than just a matter of who influenced whom, when and how. Moreover it will then be possible to establish the significance of mutual influence when and if it can be established, whether it is essential or simply coincidental, whether paradigms and patterns, their success or failure, are significant or insignificant.[74] All of these problems and issues, as well as others not arising from the very Baroque formulation of consciousness they seek to clarify, can be made subordinate by a transformation formula which, with those two gloriously Baroque and baroque thinkers, Leibniz and Husserl, we shall call the *"principle of compossibility."*

Although it is certainly not our purpose here to develop a "logic of the natural and cultural sciences" as Cassirer, for instance, tried to do with his theory of symbolic formations, nonetheless it is necessary, having come this far around the bend, to say a few things about the "principle of compossibility."[75]

concepts that are framed for one set of problems (rhetoric) are compatible with those framed for another set of problems (dialectical proofs). In contrast to Finocchiaro and Vickers, this is just what Moss does, I believe, pp. 269ff., and is one of the great merits of his book.

[74] In this connection, see Kurt Blaukopf, *Musical Life in a Changing Society*, pp. 132ff. Blaukopf sees these phenomena of music, painting, science as sharing a "common social basis" rather than being compossibles, and the common social basis lies in the rise of the idea of artistic genius, the creation of a work as a totality and the integrity of the concept of a "work"—all of interest to a sociologist for whom genius, creativity and production of a work are "learned," and the learning sociologized; cf. Lippman, *op. cit.*, pp. 506ff. In contrast, I am suggesting that instead of common social basis there is a founding formulation of consciousness, that painting, music, science are "related" by compossibility rather than analogy.

[75] See Ernst Cassirer, *The Philosophy of Symbolic Forms*, Vol. III, Introduction; and *The Logic of the Humanities*, Chapter III. Of course, the idea of a transformation formula is as old as the Classical formulation of consciousness, and is implicit in every attempt since then to classify and arrange the arts and science; see Kristeller, *Renaissance Thought II*, Chapter IX. In "Style and Medium in the Motion Pictures" (1947, pp. 101ff.) Panofsky seeks to formulate a similar principle, although much narrower in application, which he calls the "principle of expressibility."

The Principle of Compossibility

The introduction here of the principle of compossibility does not introduce anything really new to our discussion. It has been implicit in much of what has been scrutinized so far, perhaps even too far, and that is because it is implicit in the very eccentric nature of ordinary experience of the world within actual and potential reach. Just the commonplace universe of our ordinary experiences makes up and allows for a "universe of compossibilities," as Husserl expresses it, in the "unity-form of the flux" of experiences in the specious present.[76] This universal form belonging to all particular forms of concrete experiences, *scl.* the Classical or Baroque formulations, is therefore the "form of motivation <in the phenomenological sense> connecting all and governing within each single process in particular," such as the experiential data of social action and the reciprocity of perspectives. More particularly, connected and governed are those data at the center which make up a "paramount reality" because they are always presupposed, in their ungroundedness, by all other data even at the periphery and boundary-periphery not predelineated at the center of life, and regardless of any shift in the accent of reality.

Such is the "principle of compossibility" (for Husserl, an eidetic law[77]). Each formulation of consciousness, most universally and formally, "predelineates a compossible universe"[78] as a concrete possibility, that is, a universe posited which does not display an inner contradiction. Borrowed and adapted for our purposes here, the principle of *com*possibility means that 1) representations, and the concepts expressing them, framed for dealing with one set of phenomena and problems (for instance, in painting, in music) are compossible and compatible with those framed for dealing with another set of phenomena and problems (in mechanics, in astronomy, for instance); 2) if and only if representations based on actual cases of indicational appresentation are compossible and compatible with the totality of our actual, empirical eccentric experiences of (privileged) data of the world within actual and potential reach of

[76] Edmund Husserl, *Cartesian Meditations. An Introduction to Phenomenology*, p. 75. (This translation is the only one I am aware of which can be cited in lieu of the original. It is indeed a Renaissance masterpiece.)

[77] For a discussion of "eidetic laws" as employed here, see Kersten, *Phenomenological Method: Theory and Practice*, pp. 88ff. It should be noted that the concept of "compossibility" used here is a *Husserlian*, and not Husserl's, concept; moreover, it is— in strictly phenomenological terms—applied to the transcendental community of experiences (transcendental intersubjectivity constituted in the natural attitude) and is not the "egology" of Husserl; for the basis for a Husserlian concept of compossibility, see Fred Kersten, "Private Faces," pp. 174f. For Husserl's, and not the Husserlian concept used here, see Paul Ricoeur, *Husserl. An Analysis of His Phenomenology*, pp.108-114. (Alfred Schutz frequently employed the idea of compossibility to deal with the differing domains e.g. of economics, political theory and sociology, and in some manuscripts treats of possibility as "meaning adequacy," compossibility as "causal" or "motivational" adequacy.) See also Aron Gurwitsch, "Compossibility and Incompossibility in Leibniz," pp. 10ff.

[78] Husserl, *op. cit.*, p. 141.

the commonplace, common-sensical world of ordinary life in the specious present.

The development at and over a given time, mutual influences of ideas and concepts at certain times, paradigm shifts, origins of representations and development of theories, preferences for one rather than another set of data of ordinary experience in their accessibility to the "real" at different or even at the same times:—all of these are then to be regarded as *occasions*, "occasional expressions," as Husserl says, of compossibility and incompossibility. In this respect, *all compossibilities are "contingent aprioris."*[79] It should now be no surprise to the patient reader that, in turn, this signifies that compossible formulations of consciousness must of necessity be extrapolated from actual, concrete data of ordinary experience. Here more precise expression is required of the principle of compossibility as a transformation law.

What I have in mind is more of the Leibnizian, i.e., Baroque, aspect of a Husserlian (not Husserl's!) monadology. Our datum of ordinary experience is the zero-point of social action, of the ubiquitous Here in the specious present; as such it is the privileged datum from which the "real" is extrapolated and on the basis of which it is represented in its indicational appresentation. It is privileged, in part at least, because the datum is self-consciously self-interpretative, that is to say, self-generative.[80] As a consequence, it is sort of like growing up to go home to your grandmother's cooking: the datum allows, or better, with a Leibnizian nuance, *decrees,* the extrapolation of the "real" in its indicational appresentation. The "real" extrapolated is always the "real decreed" because its extrapolation is the consequence of self-conscious exercise of the self-interpretation of ordinary experience of social action in a world within actual and potential reach. Thus the "real decreed" is always and only a correlate of ordinary experience in so far as it bears traits indicationally appresented (perhaps even symbolized) which correspond to ordinary experience in the taken-for-granted ungroundedness of its ontic conviction. That signifies, in turn, that the "real decreed" is *independent as well as self-sufficient, self-inclusive and therefore not dependent on ordinary experience.* This is the technical, specifically phenomenological meaning of the "gap" between the "real" and ordinary experience. The "real decreed" (or "allowed") is a necessary correlate of ordinary social action in the world because, while bearing traits (e.g., of ungrounded ontic acceptance and indicational as well as mimetic appresentation), as "decreed" it is self-inclusive, independent of ordinary experience. This is also another way of expressing the idea that ordinary life is made into an "enclave," separated from what it "produces" by means of the self-conscious exercise of its own self-interpretation.[81]

[79] For the important, too often neglected, idea of the "contingent apriori," see Fred Kersten, *Phenomenological Method: Theory and Practice*, pp. 155f., 167, 215.

[80] It is worth emphasizing here that the same situation prevails in the case of painting; for example, the light in the paintings of Caravaggio such as the *Conversion of St. Paul* or, better, the painting attributed to Caravaggio, *David and Goliath*, where the light is self-interpretatively self-generative from the knee of David kneeling over the decapitated Goliath; see Howard Hibbart, *Caravaggio*, pp. 332f.

[81] Above, p. 92.

If we now use the name, "formulation of consciousness," as a shorthand expression for the "real" appresented and decreed, as well as for the indicational appresenting and extrapolating, by applying the principle of compossibility we may say that the "best possible" formulation of consciousness is that formulation compossible with every other to which it is reciprocally related in a contexture (or universe) of compossibilities which they fashion together and the traits of which correspond to the operations of ordinary experience. To express the matter in still another way, we may say that, on the Baroque formulation of consciousness, under the principle of compossibility, the appresenting and the appresented (indicated) are mutually correlative yet mutually self-inclusive, that they subsist in and of themselves, but also to that extent they subsist for each other because of their "internal necessity of organization" (to paraphrase Aron Gurwitsch).[82] To be sure, instead of "ordinary experience" and "social action" Leibniz would say the Divine Mind or Intellect. For our purposes, that is neither here nor there (as Leibniz admits of the Deity).

It has to be emphasized that the principle of compossibility, with its monadological aura, is peculiar to the Baroque formulation of consciousness, but certainly not to the Classical. On the Baroque formulation, it and the Classical formulation are compossible, except that the former is decreed while the latter is not, hence the additional claim on the part of the Baroque formulation that it is not just actual but also the best. In contrast, on the Classical formulation, the Baroque formulation is *incompossible*, and therefore we have had to speak of a *break between the Classical and Baroque formulations of consciousness*.[83] But obviously it is a break *to be understood* only *on the Classical* formulation: an incompossible formulation of consciousness. What ratifies the decreed, hence the extrapolation based on the preference of one rather than another datum of ordinary experience (a datum of the center rather than of the boundary-periphery)? Leibniz would answer that it is the Deity who does the ratifying. But, strictly speaking, as we shall see with Descartes, and have already suggested with Alberti, "Deity" turns out to be nothing else but the Baroque formulation itself. Why call it "Deity" or "God," then? It may simply be the baroque tendency, prevalent even today, to turn difficult philosophical and political questions into theological ones and those in turn into legal ones. And once there is "ratification" of an ontic decree, the door of the room is opened up for "litigation," i.e., polemics and rhetoric and logic. Yet another "gap" between ordinary experience and the "real" is opened up, the description of which would require borrowing not the fiction of Rilke, but of Kafka and Nicolai Kusmitch's literary brother-in-law, Joseph K.

In short, when push comes to shove, the mutually correlative formulation of consciousness is its own ratification: *cogito ergo sum.*

[82]See Aron Gurwitsch, *Leibniz. Philosophie des Panlogismus*, pp. 451ff.

[83]E.g., above, pp. 73f.

104

The Sun and the Window

We now need to bring to expression the compossible traits of ordinary experience at the center which correspond to the Baroque formulation of consciousness, that is, those traits which predelineate a "compossible universe."

During the Day: Looking up at the sky we directly behold a great spherical and blindingly bright mass seemingly suspended in mid-air on a vast bluish and greyish background. A little over three hundred and fifty years ago Descartes, looking up at the sun, made a statement for us obvious but which, on the Classical formulation of consciousness, would be rather outrageous: "Thus, for example, I find in myself two completely different ideas of the sun: the one has its origin in the senses and must be placed in the class of those that, as I said before, come from without, according to which it seems to me extremely small; the other is derived from astronomical considerations—that is, from certain innate ideas—or at least is formed by myself in whatever way it may be, according to which it seems to me many times greater than the whole earth. Certainly these two ideas of the sun cannot both be similar to the same sun existing outside of me, and reason makes me believe that the one which comes directly from its appearance is that which least resembles it [*est celle qui luy est le plus dissemblable*]."[84]

Descartes' statement contains the now-familiar Baroque (aesthetic) principle of what seems right indicationally appresenting what is right. But there is an additional specification: *what seems right*, the idea of the sun "which comes directly from its appearance," *is that which least resembles what is right*. And it is "reason" which makes me believe that this is the case. It is a classic, i.e., standard (but not Classical) case of reading the far off the near. Such a reading of the far off the near specifically introduces what we might call a *"deus ex ratio"* as the principle that decrees which case of "what seems right" is to appresent what is right—namely, the appresenting element which least resembles what is appresented indicationally.

Some four years earlier, down south of the border, writing about the motion of projectiles with his new Mont Blanc pen, Galileo had already expressed the same principle in another way: "I imagine any particle projected long a horizontal plane without friction; then we know…that this particle will move along this same plane with a motion that is uniform and perpetual, provided the plane has no limits."[85] In the various demonstrations which he manages to adduce from this "imagining,"[86] Galileo points out that what we see is quite different after all from what we "imagine:" What we certainly would see are "disturbed motions," hardly uniform, and of course on a plane that has limits—like having gone too far appresented by when coming this far. But what

[84]Descartes, *Philosophical Essays,* p. 96; *Oeuvres de Descartes, Meditations* (1641), Vol. IX-1, p. 31. In passing we may note that at the very least "reason" here signifies dialectical argument as much in Descartes as in Galileo.

[85]Galileo Galilei, *Dialogues Concerning Two New Sciences,* p. 244; cf. p. 153.

[86]*Ibid.*, pp. 252ff. (Galileo's term is *"mente concipio."*) See also Clavelin, *The Natural Philosophy of Galileo,* pp. 404ff., for further examples.

I see when "imagining," he says, appresents indicationally just the opposite: "undisturbed" and uniform motion on a limitless plane.

Descartes and Galileo follow, if *not the same principle* operative in painting and music, most certainly a *compossible* one which constitutes the commonness of the "common ground" of painting, music and science: just as with the "vanishing point" of the painter (Alberti), or the rigid pedal basses (Peri[87]) or the harmonic rhythms of the composer (Caccini), there is no resemblance of "undisturbed" motion by the appresenting element; "undisturbed" motion is indicated but not portrayed. This is especially so when, during the day, Descartes says, we "may by chance look out of a window and notice some men passing in the street, at the sight of whom I do not fail to say that I see men, just as I say that I see wax; and nevertheless what do I see from this window except hats and cloaks which might cover ghosts or automata which move only by springs? But I judge that they are men, and thus I comprehend, solely by the faculty of judgment which resides in my mind, that which I believed I saw with my eyes."[88] As for simply believing what one sees with the eyes, in the next paragraph Descartes warns us that if we are to improve our understanding beyond the ordinary, that is, beyond what we believe we see with our eyes, beyond the means of the external senses, as when we learn to distinguish the "real wax" from its superficial appearances, we shall have "removed its garments," we shall "consider it all naked"[89] just as we removed flesh and muscle from the "men" we see from the window and whose bones are like springs that make them move.

In other words, I can no more have an (appresenting) idea resembling "undisturbed" motions than I can have one resembling the sun or even one resembling the "purity of the octave," let alone one resembling size and magnitude let alone of parallel lines meeting in infinity or of disturbed emotions resembling undisturbed ones. "Reason" (or "imagination") makes us believe in that idea which least resembles what it appresents. The appresenting "true idea," moreover, is the opposite of what is appresented, what is right. The compossible trait of the aesthetic principle, what seems right appresents what is right, is then the *principle of truth by least resemblance*.

Of course, long before Descartes, under the Keplerian expression of the sway of the desire for the center, Galileo had also framed a "true idea" of the sun and its spots and, as we shall shortly learn, by looking out the window. At first sight, in his "Letters on the Sunspots" (1613) and in *The Starry Messenger* (1610)[90] his approach to the phenomena of the sunspots does not seem too

[87]See Bukofzer, *Music in the Baroque Era*, pp. 56f. Like the harmonic rhythms, the pedal basses of Peri serve as the grid or veil: "The bass of the recitative is written predominantly in the slow pedal-point style, the dramatic purpose of which is attested by Peri <in his Preface to his opera *Euridice*>. He stated in the preface that he sustained the bass even against the dissonances of the singer, and moved it 'according to the affections' whenever they made a change in harmony necessary." See also Nikolaus Harnoncourt, *The Musical Dialogue*, pp. 29ff., and below, pp. 179f.

[88]Descartes, *op. cit.*, p. 89; *Meditations, loc. cit.*, p. 25.

[89]*Ibid.*

[90]Galileo Galilei, *Discoveries and Opinions of Galileo* (1957).

unusual, not even especially baroque, though certainly novel because he is looking out the window through the telescope. He clearly explains what he is and is not looking for, of which there are but two possibilities.[91] Either by speculation we try to penetrate into the true nature of a substance, into the nature of the "sun most pure and lucid," or we try to penetrate into the empirical marks or signs of the sun. Yet we do not know the primordial substance peculiar to the sun and its spots any more than we do those of the leopard. If I ask, for example, what is the nature of the clouds, the answer might be that it is a humid vapor; and if I ask what is humid vapor, I may answer that it is nought but rarefied water. What, then, is rarefied water? It is that liquid which we can see and touch and when in Venice smell. What is the primordial substance of what we feel and touch? Whatever it may be, Galileo says, our knowledge of it is reserved for the condition of "happiness" in the after life.[92] The only other approach, then, which is at all fruitful, is asking, not what something is, but instead *how* it is.

How do sunspots appear? In the "Letters on Sunspots" Galileo exemplifies his approach to the phenomena of sunspots with an account of how motion of a body is represented: "and therefore all external impediments removed, a heavy body on a spherical surface concentric with the earth will be indifferent to rest and to movements toward any part of the horizon. And it will maintain itself in that state in which it has once been placed; that is, if placed in a state of rest, it will conserve that; and if placed in movement toward the west (for example), it will maintain itself in that movement. Thus a ship, for instance, having once received some impetus through the tranquil sea, would move continually around our globe without ever stopping; and placed at rest it would perpetually remain at rest, if in the first case all extrinsic impediments could be removed, and in the second case no external cause of motion were added."[93] Galileo's example is drawn directly from the center of action where push (impetus) comes to shove, or where shove (impediments) can be removed. It is a case of reading the far off the near, easily learned from sailing boats on a pond in Central Park. And it is push-come-shove which appresents the true idea of motion. But sunspots cannot be sailed on a pond. Still, how do we proceed to read the far off the near in the case of spots on the sun? We need a window:

"Direct the telescope upon the sun as if you were going to observe that body. Having focused and steadied it, expose a flat white sheet of paper about a foot from the concave lens; upon this will fall a circular image of the sun's disk, with all the spots that are on it arranged and disposed with exactly the same symmetry as in the sun. The more the paper is moved away from the tube, the larger this image will become, and the better the spots will be depicted. Thus they will all be seen without damage to the eye, even the smallest of them-- which, when observed through the telescope, can scarcely be perceived, and only with fatigue and injury to the eyes. In order to picture them accurately, I first describe on the paper a circle of the size that best suits me, and then by moving the paper towards or away from the tube I find the exact place where the

[91] *Ibid.*, p. 92. See Koyré, *Études Galiléennes,* pp. 161ff., 277ff.
[92] *Ibid.*, pp. 100, 123ff.
[93] *Ibid..*, pp. 113ff.

image of the sun is enlarged to the measure of the circle I have drawn."[94] Galileo, quite rightly, proceeds to chastise the "Aristotelians" for not having included in their views "our present sensory evidence," such as just described.[95]

Presupposed by Galileo are both the room and its window from out of which sticks the telescope, pointed at the sun. In addition, he presupposes the furniture of the room, minimally a table on which the telescope is mounted, and on which is spread out, like the veil or grid cutting the visual plane, a piece of paper with a circle (already) drawn on it "of a size that best suits" him, i.e., of a

[94]*Ibid.*, p. 115

[95]*Ibid.*, p. 118. For discussions of Galileo's idea of "sensory evidence," see Clavelin, *op. cit.*, pp. 389ff., 394f., 400f. (the combining of geometric construction and observation of sunspots). Despite the thorough and perceptive account of Galileo's views, valuable by itself, Clavelin still does not examine either the presentational or the appresentational nature of the "sensory evidence" by which Galileo replaces the "occult qualities" and final causes of the Aristotelians in colleges and universities all over the country. The "sensory," after all, is a construction of the "imagination" (or "reason"); see *ibid.*, pp. 397f. for Clavelin's own assessment; Clavelin notes that "Tycho and his predecessors used instruments exclusively to support and refine the evidence of the senses, so that their science could never transcend the limits of sense perception;" in contrast Galileo's use of the telescope did precisely that: transcended the limits of sense perception and was therefore "quite unlike its traditional counterpart," introducing a "sharp break between observation as it had been understood and practiced before Galileo and observation as it would be understood and practiced after him," with the help of the telescope "endowing man with a 'superior and better sense than natural and common sense'," in Galileo's words. The result is that the content of sensory evidence was renewed and vastly extended by Galileo. See *Ibid.*, pp. 398f. for a discussion of the differences between Aristotle and Galileo; and pp. 399f. tells how the new idea of sensory evidence operates: first, a telescope is stuck out the window, casting images on a piece of paper; "*daily drawings* then showed that the two spots kept moving across the solar disk until they had reached the other side in a little less than two weeks..." (emphasis mine); then measuring the spots drawn their apparent distances were determined. Once the drawing is constructed, then the whole is represented by a further geometrical construction (illustrated p. 400). "Sensory evidence," then, consists of the combining of the painter's (compossible) perspective construction with a further and geometrical one. For the current historiography of experiment and experimentation in the Baroque, see Cohen, *The Scientific Revolution*, pp. 186ff.

Finally, it should be noted that, as Clavelin says, on the basis of his new idea of sensory evidence Galileo ends up "converting celestial bodies into true physical objects" or, as we would say, reads the far off the near just as does the painter. With his story in *The Assayer* of the monkey and the mirror (*Discoveries and Opinions*, p. 255; Clavelin, p. 399; see also Moss, *op. cit.*, Chapter 4, for details about the "sunspot quarrel," espc. pp. 112ff.; also Finocchiaro, *op. cit.*, pp. 247f. for a critique of Clavelin's discussion), Galileo rejects the Classical formulation of consciousness and especially the idea of sensory evidence according to which the near is read off the far reflected in the mirror; see above, pp. 62ff.

Too, we also have to note in this now over-long footnote that once "celestial bodies" are converted into "true physical objects," divested of their garments on Descartes' testimony, we are no longer talking of the same thing when we read the far off the near: Galileo is not talking about forms, as did Aristotle, for instance, or Plato, but of things whose thingness is quite distinct. See above, pp. 26ff.

size determined by "reason" or "imagination." Without leaving my room, I can read the far off the near; the reproduction of the things of Nature is a case of *prospectiva artificialis* and of "perspective" in the basic meaning of the term, "perspective:" construction "through the window" and the properties that follow from it.[96]

The Compossibility of Sensory Evidence

"Sensory evidence," what is given to the senses, is not only presentive but *also appresentive*. At first this idea may lead one to wonder why Aristotelians, or anyone for that matter, would even bother to object and have to be chastised for not heeding sensory evidence. It is almost as basic as no sensory evidence, no supper; or like having to go home to Kentucky to get a little lovin'. Of course closer scrutiny shows that there are a number of possible reasons why your average, politically correct Aristotelian would be bothered. Galileo introduces his idea of sensory evidence in an unusual way, referring not to the substantial nature of things in motion, for instance, but to motion of bodies unobservable, strictly speaking, by the senses (such as the motion of a ship on a spherical surface concentric with the earth, or motion of a projectile without impediment). Moreover, the sensory evidence he adduces does not really *present* anything; at the most it only *appresents* indicationally by means of a telescope stuck out of a window—sort of an extension of the grid or veil and indeed indicational because Galileo does not even look through the telescope, but rather draws images on a piece of paper from the reflection of the telescope. As Plato would say on the Classical formulation of consciousness, the images drawn are at the "third remove" from the original.

Perhaps it is no accident that Plato is mentioned in this context of looking at the sun. In the *Phaedo* Socrates says that he "must be careful not to suffer the misfortune which happens to people who look at the sun and watch it during an eclipse. For some of them ruin their eyes unless they look at its image in water. ...I thought of that danger, and I was afraid my soul would be blinded if I looked at things with my eyes and tried to grasp them with any of my senses. So I thought I must have recourse to concepts and examine in them the truth of realities."[97] The specific context in which Socrates makes this statement is the following: he says that he began as a philosopher of Nature, and that in his youth still cherished the idea of finding the reasons of things in Nature. But the passage cited expresses his disillusion with such an attempt, and not just because of possible retinal damage. Universally, the phenomena of Nature given to the senses are illusory and transitory; they hardly constitute "evidence" of any sort

[96]Above, pp. 92f. That the "perspective" is "artificial" does not mean that it is not "natural" or drawn from Nature. Rather it is a "creation" made either with the understanding or the imagination as Leonardo da Vinci expressed it (*"la scienza è una seconda creazione fatta col discorso; la pittura è seconda creazione fatta colla fantasia,"* cited by Cassirer, *op. cit.*, p. 161).

[97]Plato, *Phaedo*, 990. The translation is by Harold North Fowler, *Euthyphro, Apology, Crito, Phaedo, Phaedrus*, p. 343.

and of course not "evidence" which has the weight and importance imputed to it by Galileo. Perhaps Cassirer's designation of Plato as a "metaphysical Platonist" and Galileo as a "physical Platonist" is apt,[98] for it would seem that their objects of scientific knowledge are just the opposite.

Yet what makes sensory evidence "sensory" for Galileo is hardly anything present to the senses in either an ordinary meaning or even in Plato's; after all, it is neither a *methexis* nor a reflectional scene-painting which makes me believe that the "true idea" of the things of Nature, e.g., the sun, passers-by in the street, the ball of wax, is not drawn directly from the senses; it is rather the case that the things of Nature are indicated by way of appresentation, and that the indicating-appresenting element consists of geometrical and astronomical determinations combined with clever draughtsmanship that makes me so believe—and indeed those determinations presuppose that we have removed the garments of the things of Nature and considered them, interpreted them, "all naked." It is an indicational appresentation that considers things naked of the garments of the senses. And, after all, it is the *opposite* of what is presented by the senses that is indicated and of which the "true idea" of the sun is framed once its sensory garments are removed, the grin wiped off its face, just as the "vanishing point" is indicated by the convergence of lines, just as consonance is indicated by dissonance.

It may well be, as Cassirer suggests,[99] that Galileo applied Plato's "problematical analysis" to a "subject in which it had never been used before," and that Galileo "was also one of the great 'dialecticians' in the Platonic, not the Hegelian, sense of the term," by proving the "fertility" of that analysis "not only for mathematical but also for physical thought" (all at the frightful risk, we may add, of blinding the soul). But of course Galileo operates from the Albertian/Keplerian *mezzanità* that provides the mind for understanding, not just anything, but naked quanta. The "soulfull," appresenting center is compossible "sensory evidence" and non-mimetic as well. It is not so much a question to what extent and in what sense Galileo was a Platonist as it is that what is operative in "Galilean" (or Keplerian, Cartesian) thought is the principle of non-mimetic appresentation drawn from the center rather than the boundary-periphery of ordinary life. Nor is it a question whether this trait of the Baroque

[98] Ernst Cassirer, "Galileo's Platonism,", p. 280, and Cassirer's discussion of the passage from *Phaedo*, pp. 282ff. Also see Clavelin, *op. cit.,* pp. 424ff. for a strong case for the opposing view and criticism of Koyré and others. It seems to me that both sides of the controversy of whether and in what sense Galileo is a "Platonist" miss the non-mimetic nature of Galileo's thought. To be sure, the use of the terms *experientia* and *experimentum*, and the conceptual differences they express, is important; in this connection see Charles B. Schmitt, "Experience and Experiment: A Comparison of Zabarella's View with Galileo's in *de Motu*," pp. 80-138; in addition see Moss, *op. cit.*, pp. 82f. for the distinction between "dialectical arguments (*rationes*) and physical proof (*experimenta*)" in Galileo's *Siderius Nuncius* that "Galileo, as the father of the rhetorical revolution in science, led the way in demonstrating that rhetoric could indeed invade the scientific domain and spearhead the cause of science and of a reformed theology," *ibid.*, p. 332. See also Cohen, *op. cit.,* Chapter 2.

[99] "Galileo's Platonism," *loc. cit.,* p. 297; see also *The Individual and the Cosmos in Renaissance Philosophy*, pp. 160f.

formulation of consciousness is realized and applied in painting and music prior to its explicit application in science; nor can it even be a question of whether, as Panofsky asserts, that it is the self-same principle or trait: "If Galileo's scientific attitude is held to have influenced his aesthetic judgment, his aesthetic attitude may just as well be held to have influenced his scientific convictions; to be more precise: both as scientist and as critic of the arts" he "may be said to have obeyed the same controlling tendencies."[100]

The statement just cited is made by Panofsky in answer to the criticism that Galileo's interest in art, in painting, sculpture, in music and in poetry were the result of a "youthful error."[101] Of course, one can never rule out "youthful error," anymore than one can escape the vicissitudes of old age. Although Panofsky makes a strong and plausible case against attributing Galileo's views to his youthfulness, it is still difficult to accept his conclusion that the appresentive principle is the same, that the "sensory evidence" is the self-same "sensory evidence" of painter and musician, or that it is the same "controlling tendency" that is operative. The "sensory evidence" that led Galileo to reject Kepler's idea of the elliptical orbits of the planets[102] is instead, I believe, compossible "sensory evidence." The cases of "sensory evidence" are not the same, but reciprocally implied in the same way that monads and concepts reciprocally imply each other. The clue to the fact that the evidence is not the self-same, but instead, a compossible "sensory evidence," is found in the "*hantise de la circularité*" (Koyré) which beset Galileo (and his heir, Nikolai Kusmitch) under the sway for the desire for the center. Unless we regard the cases of "sensory evidence" as compossible, but not the same, Galileo's view will continue to remain as incomprehensible as youth.

It is then necessary that we turn our attention to the indicational appresentation that founds "sensory evidence" when the specification of "truth by least resemblance" is added to the principle of appresentation of what is right by what seems right. Moreover, at the same time we shall be able to further clarify the idea of compossibility as an essential core of the Baroque frmulation of consciousness. So far we have only examined the shining surface of the Baroque formulation. But if that is the case, that "sensory evidence" in science, painting, music, sculpture, philosophy, is a matter of compossibility and not of self-sameness, then it is also the case that room has been made at the center of action in the world of daily life within actual and potential reach for extrapolating the "real" not from the interrruption of, but from the on-going process of social action. And again the silent premise is the room with the window: the ubiquitous Here in the near, the manipulatory zone with its own specific milieu. The far, the sun and its spots, is read off the near in a room with a window. The room at the center is the room with the window. And the question, who, and perhaps who else, inhabits the room, may be more important than what is in the room.

[100]Panofsky, *Galileo as Critic of the Arts*. p. 20.
[101]*Ibid.*, pp. 19f., and p. 20, note 1.
[102]*Ibid.*., pp. 25ff. and above, pp. 90f.

What, then, is the room which serves as a silent premise of the Baroque formulation of consciousness when ordinary self-interpretation of experience becomes self-conscious method? To say that the premise is "silent" means that it is taken for granted in the extrapolation of the "real" from privileged (appresentational) data of ordinary experience of action at the center. A clue to the taken-for-granted meaning of the room at the center can be found in the phenomenological idea of "milieu" first formulated by Scheler and which we can adapt for our purposes here as a complement to our phenomenology of social action.[103]

The Milieu of Social Action

The basic experiential datum of ordinary experience for the Baroque formulation of consciousness is action at the center of ordinary life, which is to say, bodily gearing into and for the world within actual and potential reach to realize purposes and goals of drives, desires, strivings, that meet the needs and necessities of human life-processes. This signifies that what is presented and appresented in the first place are not mere physical things but instead things that meet those needs and necessities and answer to the drives, desires, strivings. In this connection Scheler defines "milieu" as the counterpart and correlation of given sets of drives, desires and strivings and their organized structures. In its broadest meaning, milieu is ontically relative to whatever is bodily geared into and for the world within reach with respect to determinate, organized drives, desires and strivings. The implication of this is important because it signifies that, as Scheler points out, there is no perceptually given *constant* in ordinary experience to which, then, are added differing "world views," or differing "attitudes" of differing peoples or living beings at various times in history. In the on-going course of ordinary experience there are no aggregates of "sensations" to which are added perceptual constants and "cultural" determinations. Or to express the matter yet another way: what seems right and least resembles, the indicational and appresenting element, is never an aggregate of sensations or a perceptual constant but instead what Scheler calls a "relative intuition of the natural world"—*relative* because we have a "world" only in relation to a kind of living being geared into and for it (e.g., a certain kind of human being as member of a class, of a people, a culture or representative of a type such as aristocrat, butcher, philistine, conserative, etc.) exemplified in patterns of drives, desires, strivings; and it is *natural* because it is the correlate of a pattern of drives, desires, strivings of living beings and for given kinds of human being (hunter, painter, musician, politician and the like).

In a narrower meaning, "milieu" is defined as the totality of what is experienced by a living being as performing that living in contrast to what *"objectively"* operates on that being. Too, we must add that we are always already acquainted and pre-acquainted with what is experienced, presented and

[103] What follows is based on Scheler, *Formalism*, pp. 139ff., 150, note 1; 157, 188f., 274f., and 287; and Aron Gurwitsch, *Human Encounters in the Social World*, pp. 58ff.

appresented, as effective and affective. To be sure, the acquaintance and pre-acquaintance may vary from person to person, from group to group; but they are nonetheless always an articulation of one's milieu rather than an interpretation (or self-interpretation) added on, or a cognitive apprehension of the milieu; they are always constituents of one's life; I always "know" about my milieu and draw on the stock of knowledge at hand and on hand peculiar to it.

Things are always in a certain milieu or other, thus what seems *right* are always things on which we can rely just because they are this and not something else. Taking a page out of Scheler, it means, Plessner says, that "we can address something as something—at the risk that it may disclaim the address; or make something into something—at the risk that it may elude our grasp; or let something pass current as something—at the risk that it may turn out to be something else. Life reckons with this capacity for organization, this stability and flexibility, with a minimum of definitiveness and elasticity, order and pliability, closure and openness. The medium <i.e., the milieu> in which it is to develop can be neither absolutely unyielding and complete, nor absolutely fluid and indeterminate. It must offer stopping points, footholds, talking-off places, pauses, safeguards—also to escape from and to oppose."[104] Everything and everyone has its milieu, with "expectation of continuities and references" with respect to which it is oriented and adapted "to something *as* that in terms of which it is addressable, interrogable, controllable: in a word, as what he takes it as."[105] What seems right, then, we may say, is what we take as our ordinary experience (addressable, interrogable, controllable) in the manipulatory zone of the milieu-world within actual and potential reach. We have "to do" with it and therefore have "to do" something with and about it (Ortega y Gasset).

Moreover, each of us carries around with our patterns of drives, desires and strivings the structure of the milieu in which we find ourselves; and it is a structure which remains invariable even though individual things and contents change because it is, after all, the structure which tells us in the first place what is admitted or not, accepted or not, addressable or unaddressable, controllable or uncontrollable, interrogable or not in the milieu in so far as the "objective" components of Nature are presented and appresented. In this connection we have to note with Scheler and Plessner that no change in attention, for example, can alter the milieu or extract us from one milieu and plunk us down into another one. Indeed, our biographical placement is constituted precisely by being born into and living in a milieu related to drives, desires and strivings and not primarily to cognitive-perceptual functions. Immediate data of ordinary experience are not so much physical things with material qualities but rather are expressive unities and, to be baroque about it, conceits of the soul. Social action, primarily, is set into the mortar of unities of expression.[106] With Scheler we insist that these unities of expression are founded, not on the perception of physical things, but on the threatening, the uncanny or the enchanting, the awe-

[104]Plessner, *Laughing and Crying*, p. 140. To Plessner we may add that, on our view, both laughing and crying, in the literal sense and as names for representation from the boundary-periphery of daily life, are, strictly speaking, *"hors de milieu."*
[105]*Ibid.*
[106]See above, pp. 46ff.

inspiring or the ingratiating, the amiable or the warmly familiar or the cruelly unfamiliar, the addressable and controllable: they obtrude and stamp a given milieu. And they are there so comprehensively that they are often only vaguely presented and need not be based on any particular perception of any particular physical thing.

What, then, is the specific characteristic of the room with the window as a milieu? What and how is a room-milieu as a premise of the Baroque formulation of consciousness? We are, after all, "captives" of the milieu into which we are born, into which we are fitted and geared and in which we heed the different milieu-things. It is the milieu itself which determines the scope of our attention and refines the focus of our action and our eccentric ways of being in the world within actual and potential reach. Even the peripheries predelineated at the center belong to the milieu in their exchange with the center: they become themselves centers only within the frame of the milieu. In contrast, the boundary-peripheries of laughter and crying are "outside" the milieu, released from the milieu, "for the moment "unanswerable (non-interrogable), non-addressable, non-controllable.[107]

It may now seem as though we have not only gone around the bend, but have travelled all the way to the top. However, there is a purpose for introducing the idea of the milieu just at this bend in the road. The room with the window is a milieu at least in the narrower meaning of the term, "milieu."

The View from the Window Of the Room with a Window

But, then, what sort of milieu is the room? In what way is it specifically different from the other sorts of milieu that characterize ordinary experience? The affective-conative milieu-things, after all, appear as similar to other milieu-things, part of the gear by means of which we are outfitted to gear into and and for the world within reach—the gear of the painter, the sculpture, the musician, the astronomer. Still more particularly, what must such milieu-things be so that their use is self-interpreted in a self-conscious way as indicating just their opposite— "physical things," "quanta," for which the mind is also fitted, so that when certain operations are performed on them the Chorus Invisible is apprehended or parallel lines recede as parallel in the distance? Milieu-things become what seems right only when they indicate what is right by least resemblance. And this only occurs when the zero-point of coordinates in the specious present of ordinary life is the centric line, only when the far and the other is measured off the near in the manipulatory zone of action.

[107] According to Scheler, it is only when we carry out a process of disenchantment, of decomposition of the milieu, much like the Cartesian divestiture of clothing as well as flesh and muscle (above, pp. 105f.), that we outfit the things of the milieu with exclusively material properties. He grounds the decomposition of the milieu in a drive-structure that itself is characterized as a drive toward domination of Nature by the "rational spirit" and, more particularly, if we add into this brew Max Weber and Ferdinand Tönnies, the "rational spirit" of capitalism. We cannot pursue this idea further in our discussion.

Eccentrically we are biographically placed into the world within reach, and that means we are biographically placed in one or another or any number of milieux correlative to our drives and dispositions with respect to which our stock of knowledge at and in hand is shaped and defined. The unities of expression with and by which we operate in the world are set by the sorts of milieu we inhabit. When unities of expression, sensory perspective and harmonies appresent indicationally what they least resemble, their opposite, we cannot quite say with Scheler that they are "disenchanted," absolved of their expressiveness, that their unities cease to be unities, because only in so far as they are what they are do they only *seem right*; they must retain their shape and appearance to seem right. They must seem to be expressive unities so as to indicate what is not expressive at all; lines must seem to converge so as to appresent what does not converge; sounds must seem dissonant so as to appresent what is consonant; and so forth. In other words, the room with the window and its view must be taken for granted in its milieu-expressiveness and affectiveness so as to seem expressive and affective appresenting what is not expressive and affective, i.e., what least resembles them. What happens in the room is that sensory milieu-things in their expressive unities and their correlative dispositions of drives and desires are "put out of gear" so that they seem right, are answerable, addressable, controllable, but appresent what is right, as is the case in the drawing of Dürer:[108]

[108] The reproduction is taken from *The Complete Woodcuts of Albrecht Dürer*, No. 338.

The room is indeed an unusual and bizarre milieu, far transcending anything that might be found in most any other room you please. And its recognition sets several problems of the Baroque formulation of consciousness. There is, to be sure, the most general problem of how we move from one milieu to another (or, as Schutz or James would say, how we move from one "subuniverse" of reality to another) once the accent of reality shifts to the center. That we do is accounted for by the eccentricity of ordinary life and its underlying ontic conviction. However, the development of a transformation formula and principle of internal organization of the compossibility and incompossibility of differing sorts of milieu and their structures is another problem. Both presuppose the mutual exhange of center that becomes a periphery and a periphery that becomes a center (and, of course, the limiting cases we have noted as well as others that become incompossible, i.e., where for one reason or another, illness, insanity, death prevent the possible exchange of periphery and center).

The room-milieu, however, is not quite like any of these situations, although I can surely leave the room and instead of painting or making astronomical observations I can become a Medici accountant and prepare a second set of books. Thus like other cases of eccentric exchange, the room becomes a periphery with respect to a new center; or I can reenter the room in which case the periphery becomes a center again. Like any other case, the room-milieu determines what fits and does not fit; it defines the expectations of continuities and references of life within it. But it is different in that, although extrapolated from the centric datum of ordinary life, it is not predelineated by the center of ordinary life. Unlike other cases of milieu, the room-milieu, on the Baroque formulation of consciousness, has no affective stamp of its own, no expressive unities. Instead of affectivity, the room-milieu is characterized by the non-expressive, the cognitive-perceptual, be it Alberti's room, or Brunelleschi's, which we have mentioned; or Galileo's with the table on which telescope and drawing paper are placed, or Descartes' which contains a stove and sides of beef[109] hanging from the ceiling; or the room at the Barberini Palace for the opera, *Chi soffre speri* with 3500 in the audience,[110] or the opera house itself,[111] and eventually the scientific laboratory; or the room we are best familiar with, that of Nikolai Kusmitch (his apartment, or the "room of rooms," the cloakroom at the opera house). Moreover, the room-milieu is compossible with others, but the converse is not the case. The room-milieu, with its essential constitutents, the window and door—even when the curtains are drawn over them during daylight hours to enhance El Greco's visions in the dark[112]—take precedence over all other sorts of milieu, its decree precedence over all others.

[109]See Albert William Levi, *Philosophy as Social Expression*, pp. 219f

[110]See Carl J. Friedrich, *The Age of the Baroque*, pp. 86f.; Frederick Hammond, *Music & Spectacle in Baroque Rome*, pp. 11ff.

[111]See Hélène Leclerc, *Venise Baroque et l'Opéra*, Chapters I, VIII, XV. See also her magnificent, *Les Origines italiennes de l'Architecture théâtrale Moderne* (1946); Hammond, pp. 186ff., 212ff.

[112]See Hauser, *Mannerism*, pp. 53f. In the next chapter we shall note the scepticism,

Still, the room with the window is not a paramount reality in the sense that daily life can be said to be so because it is a center to which all other milieu are peripheral and yet inexchangeable in the sense it is not itself yet another periphery e.g., for ordinary life. The room with the window, rather than a boundary-periphery, is a *boundary-center*. Just as the boundary-*periphery* is the necessary condition for the Classical formulation of consciousness, so the boundary-*center*, the room with the window, extrapolated from the zero-point of coordinates of social action, is the necessary condition for the Baroque formulation of consciousness with its compossible concepts and sensory evidence applying as much in painting as in astronomy, in music as much as in mechanics. The room with the window is the taken-for-granted presupposition of the principle of indicational, specifically non-mimetic, appresentation that what seems right appresents what is right, and that what is right, what least resembles, is the *opposite* of what seems right. As such, we will learn, the room-milieu has a life of its own and is equally the "origin" of the gap between ordinary life and "scientific thinking" that so disturbed Nikolai Kusmitch.

Is there a drive and striving peculiar to the room-milieu, correlative to its structure? Can we find the answerable, addressable and controllable to which the milieu responds, like every other center of action in the world within reach? Is there indeed anything "out of reach" for the appresentational experience of the room made method and manner? How is the room-milieu related to others? Is it included in others, compossible with them? The "real," appresented under the condition of the room with window and door, is still assumed to be accessible to ordinary experience and its representation extrapolated from the center of ordinary experience, social action, where push always comes to shove. But how is it accessible?[113] We have already suggested the "real" accessible is always the "real" decreed, extrapolated from the taken-for-granted ontic conviction of ordinary life in the specious present at the center of social action. And it is this accessibility which we have to explore further, among other things, to arrive at the dilemma of Nikolai Kusmitch.

Note

Just as there is an ambiguity in the experiential data of muscles and bones for the extrapolation of the "real" from the center, the center itself, the *mezzanità*, also contains an ambiguity which can only be indicated, but not clarified, here. The ambiguity is best seen astronomically: in the case of Copernicus, the "center," the fixed point, is located near the sun; in the case of Tycho Brahe, both the earth and the sun are fixed, while the other celestial bodies revolve around them, i.e., there are two "centers," two fixed points; in the case of Kepler and Galileo, the sun is the "center," the fixed point, while the earth moves.[114]

neuroses, above all, melancholy and madness that mark the room-milieu as human habitation.

[113] Above, pp. 101f.

[114] See Hall, *op. cit.*, pp. 54ff.

Disregarding all differences between them, they all still share the common principle that the true idea of the sun and, except for Tycho, of the earth, is not only the one that least resembles them, but which indeed is just the opposite: the true idea of the sun is not only that it is large, but fixed, unmoving; the true idea of the earth is that it moves, is not fixed; and so forth.

What remains obscure is why Tycho otherwise has so much difficulty in getting off the earth, why he was so earth-bound, even granted that he did his day's work by night for so many years. Even Agucchi remained earth-bound in his allegiance to Tycho rather than to Copernicus or his friend Galileo.[115] Perhaps there was too much Kusmitch in him, as in Tycho, to give in fully to the sway of the desire for the center.[116] To be sure, this need worry us now no more than the issue of muscles and joints because, as Kuhn observes, the "Tychonic system is, in fact, precisely equivalent mathematically to Copernicus' system" (providing we expand the sphere of the stars sufficiently so that parallax is imperceptible).[117]

Still, phenomenologically, it suggests that there is no certain criterion for preference of experiential data, resting on the ungrounded ontic conviction of daily life, from which to extrapolate the "real." Notice has not yet been fully served on the taken-for-grantedness of daily life even in the light of a new stock of knowledge based on astoundingly accurate naked-eye reckonings of the positions of the planets and the stars. In daily life it may well be that we are "irresponsible puppets of fate and chance," and not just "conservatives," when it comes to extrapolating the "real" from experience at the center of social action wherever push comes to shove.

[115] See above, pp. 73f.

[116] See Hannah Arendt, *The Human Condition*, §37.

[117] Thomas Kuhn, *The Copernican Revolution*, pp. 204 and 206.

CHAPTER FIVE

The Room, the Universe And the Gap

I first heard the story about El Greco's curtain-drawn room in a bar called "*Pub des Artistes*." It was what my effete grandmother called a "watering hole" for painters, writers, aesthetes, and others who, although they had never heard of it, were more fin than siècle. Most of the custom there believed they were bar-coded for fame and immortality and increasingly suffered, like El Greco, from what can only be called "room fever." They were neurotic, manic depressive, melancholy and sceptical. In short, the patrons of the *Pub des Artistes* were Baroque and, at times, even baroque: they were victims of a room-milieu essential to Art, yet uncongenial to healthy living. Once the pink gin flowed, there were those who even insisted that it was simply because El Greco was near-sighted, hence the perspectivism of his painting was always visually awry, and only made more so by the darkened room.

Others insisted, however, that El Greco was part of that group of painters who thumbed their noses at the geometricity of perspectivist painting, who, even though they would never deign to use such expressions, opposed the geometrized compossibility with aesthetics, cynically siding with the roomless Federico Zuccaro when he said that "the art of painting does not derive its principles from the mathematical sciences, indeed it may not even refer to them in order to learn any rules or manners of procedure, or even to be able to discuss them by way of speculation...but if one wants to engage in considering all things and understanding them by meditation on mathematical theory, and to work in conformance to it, then besides the unbearable labor it would be a waste of time with no useful result; as has been shown by one of our profession [*scl.* Dürer], albeit a capable painter, who wished to shape human bodies by mathematical rules after his own whim" which can only lead to "vanity and madness."[1]

Reading a statement like that in a bar either puts patrons to sleep or starts a fight. There were even some who, in good mannerist tradition, wanted to put up a sign over the entrance to the *Pub des Artistes* saying, "Those Who Know Geometry Stay Out!" But there were those, too, who noting the universally acknowledged mediocrity of Zuccaro's paintings, thought him a little severe in his criticism of Dürer. Still, for all that Zuccaro certainly put his finger on one thing: vanity and madness. Wrong-headed if not wrong he may have been (after all, he is said to have been the "first example of the academic official" [Holt]), yet he certainly spoke for his times. What were his "times"? After noting at the end of the sixteenth and beginning of the seventeenth

[1] Federico Zuccaro, *L'Idea dei scultori, pittori e architetti* (1607), cited by Panofsky, *Idea. A Concept in Art Theory.*, p. 77. See also *A Documentary History of Art*, selected and edited by Elizabeth G. Holt, Vol. II, pp. 87-92.; Maniates, *Mannerism in Italian Music and Culture*, pp. 18f., 22.

centuries the "sudden appearance" of neurosis especially among intellectuals and artists, the emergence of scepticism and the "fashionable complaint" of melancholy, the break up of old bonds and groups, the old sense of security, the setting in of a state of anxiety along with fierce and unrestricted competition, & etc., Arnold Hauser speculates as to the reasons for this "pathological condition" marking Zuccaro's times: "The striving for personal success, the remorseless drive of competition, which first appeared in practical and then intellectual life, is a typical symptom of capitalist development and if, as seems impossible to doubt, the neurosis of the age is connected with it, the beginnings of mannerism are hardly to be explained without linking them with the origins of modern capitalism."[2]

The introduction of modern capitalism takes us out of the private room at the pub to the public room of the market place, raising a number of different questions, such as when (if not where) are the beginnings of capitalism (were the idea of competition and the profit motive to define the beginnings, then the High Middle Ages must be included in the era of capitalism); and if capitalism also entails the exploitation of labor and the control of the labor-market by owning the means of production ("the transformation of labor from a form of service...into a commodity," Hauser), then it is the fourteenth century that marks the beginning; but if we must also include the accumulation of capital, then it is only with the sixteenth century that the real beginnings of capitalism rears its ugly, or noble, head.[3] However we decide this issue—and it is not our place to do so here—so far as Mannerism and the Baroque are concerned, Hauser makes a plausible case for several basic features of modern capitalist economy associated with a "completely new outlook" with which we are indeed concerned. The first feature is that of "economic rationalism:" "Careful, caluclated, systematic planning took the place of primitive, medieval acquisitiveness. ...rationalisation was applied with a view to the elimination of chance from the supply of raw materials and the distribution of finished products as well as of improvisation and waste in the use of labour...The real novelty in all this...was the consistency with which henceforward tradition was sacrificed to rationalisation, and every factor in the process of production was considered on material grounds alone, quite independently of its human, personal, or emotional aspects"—the economic equivalent to the purification from every historical singularity in barring, time signatures and the metronome beat.[4] This is the first aspect of the market place where push always comes to shove—the "realism that turns the worker into a mere entry in the calculation of investment and yield, profit and loss, assets and liabilities."[5]

In addition to the sacrifice of tradition to rationalisation, the placing of the process of production on material grounds alone, we have to add that

[2]Hauser, *Mannerism*, Vol. I, p. 54. Also see Foucault, *The Order of Things*, Chapter, for another approach from the standpoint of the change in the idea of wealth in the seventeenth century and the creation of the idea of "exchange value."

[3]*Ibid.*, pp. 55f. See also Friedrich, *The Age of the Baroque*, Chapter 1.

[4]See above, pp. 9. We shall return to this equivalency, below, pp. 122f.

[5]Hauser, *ibid.*,, pp. 55, 56.

mechanization applied not just to machinery but also to human labor, with the result that human labor becomes depersonalized and its valuation measured only in terms of its results.[6] Finally we have to add yet another feature: "Political control became a function of capital."[7] These are all essential to the Baroque formulation of consciousness in contrast to the Classical formulation, and this returns us to Zucarro. Precisely those features of Baroque work and action, transforming labor, action at the center, from a form of service to a commodity, are impossible on the Classical formulation, and it is a version of the Classical formulation that Zucarro sets forth.[8] Indeed, contrary to Panofsky and Hauser, I believe Zuccaro's importance lies in the fact that his view represents an anomalous and very late neo-Platonic version of the Classical formulation of consciousness within the context of the Baroque formulation. A short reflection on Zuccaro will provide us, within that context, an alternative to the Baroque formulation which, among other things, will emphasize the new meaning of representation as non-mimetic and the compossibility of concepts in music and art and science, thus measuring our distance around the bend.

The Lion and the Library

Zuccaro is famous for the notion of what he calls "*disegno interno.*"[9] As the basic aesthetic category, "internal design" is neither matter nor accident of a substance but rather the "form, rule and object of the intellect" which represents "the thing comprehended by the intellect and which is the intellect's ultimate goal and object." There are two kinds of operations performed on the intellectual apprehension: the first is "external:" drawing, painting, sculpting and building; the second is "internal:" comprehension and volition.[10] Zuccaro gives the example of comprehending a lion, not the predator in the forest but instead the "immaterial form shaped in my intellect" and which represents the form, "lion." And while the goal of the "external operation is a material thing, like the figure drawn or painted, the statue...the goal of the internal operation of the intellect is an immaterial form representing the thing comprehended."[11]

[6]*Ibid.*, pp. 56ff. See also Fred Kersten, "The Line in the Middle," pp. 90ff., 96f.; "Heidegger and the History of Platonism," pp. 289ff.

[7]Hauser, *ibid.*, p. 58; see also pp. 68ff.

[8]To be sure, it is a formulation somewhat different from the rather more Aristotelian version that we have considered so far. Zuccaro, like others, gives the Classical formulation a much more Platonic and neo-Platonic twist; see Maniates, p. 22; Hauser, p. 92; in contrast, see Panofsky, *Idea*, pp. 86, 88ff. who finds a much more Aristotelian (and Scholastic) aspect to the Classical formulation in Zuccaro—except for the idea of beauty, which Panofsky sees as much more neo-Platonic (pp. 94f.), more Platonic than in name only (p.86). Certainly Lomazzo is much more neo-Platonic, pp. 95ff. See above, pp. 94f.

[9]See Panofsky, *Idea*, p., 86; Holt, p. 87, note 2.

[10]Zuccaro, in Holt, *op. cit..*, p. 89.

[11]*Ibid.* Thus, for Hauser, Zuccaro suggests that the creative category is "neither purely

We can examine Zuccaro's idea of what Panofsky calls *idea* with two examples. Suppose that we create a statue of the lion for the New York Public Library: the external operation. Because there must be "agreement between the internal and external operations," and because the ultimate goal is to comprehend the thing in the intellect, with Zuccaro we would say that with the statue of the lion an attempt is made to embody a certain vision in stone for the eye to see. What guides us in the materialization of the form is a "pure idea," a "Design [*Disegno*]." But because we are, alas and after all, mortals, and being mortals we have this way of bringing into the realm of the visible and material what is essentially invisible and immaterial. As mortals, in other words, we need the external operation *for if we were pure intellect we would rest content with simply beholding or contemplating the* disegno interno, *the perfect idea, Lion*— which is of course still only an image, the *"Disegno interno e pratico artificiale proprio"* and not the original itself, *"Natura stessa."*[12]

In other words, the external operation of producing the sculpture of the lion, the productive, creative process, *is a substitute for the thing itself, the pure idea*. The imitation of Nature, for which we need no other rules than those given by nature, and certainly not all that lousy mathematics and geometry, consists of *substitution*, more precisely, of mimetic likeness by substitution.[13] The lower is a substitute for the higher, and always, to be sure, an imperfect substitute which makes the substitute "free."[14] Or, we can also say, what is in actual and potential reach is a *substitute*, an ontic crutch, for what is out of actual and potential reach, and it is only because of the fallibility of the human condition itself that we require a substitute at all. The substitute, as a consequence, overcomes the *"prava disposizione della materia"* responsible for the depraved and deprived status of the phenomena of nature. It is the perfectibility of the near read off the far, the creation of the *"perfetta forma intenzionale della natura."*[15]

So far, so good. Let us now take another example: instead of a work of art, the sculpture of a lion, the building of the New York Public Library. We are architects, we construct a building. If we were in full possession of the idea of the building, of the Design, then the library would need not be built at all. Which is of course absurd, and some would say just what is to be expected of a Mannerist. And it is absurd because what we can grant in the case of the work of art we cannot in the case of a building, an artifact. Yet, as Zuccaro himself

subjective nor objectively present in nature, and therefore, as Erwin Panosky rightly saw, there arose for the first time the question of how it is possible for the mind to form an idea which cannot simply be derived from nature and yet cannot originate in man—which amounts in the last resort to the question of how artistic creation is altogether possible," *op. cit.,* pp. 91f. Maniates insists that the "most sensational embodiment of the *disegno interno* is...the *Self-Portrait in a Convex Mirror"* by Parmigianino, *Mannerism in Italian Music*, p. 43 (reproduction Figure 6, p. 44); see also Hauser, *Mannerism*, p. 120, and below p. 133.

[12] Holt, p. 92; Panofsky, p. 77 (for the original text).

[13] See Holt, pp. 90f. for Zucarro's account of how the "substitution" and likeness are effected. The term, "substitution," is not Zuccaro's.

[14] See above, pp. 35f., 38f., 48f.

[15] Zuccaro, cited in Panosky, p. 95.

insists,[16] the same principle ought to be equally applicable to an artifact as to a work of art. The library is not built to be contemplated, to be a mimetic substitute for a form or idea.

My job in the library is, after all, to shelve books, documents, or to check out and fetch books for readers. It is not to contemplate books or readers. Nor can I spend my day contemplating the building. Of course just this reading of Zucarro ended my career as librarian, for like Bartleby when ordered to examine and copy papers, when ordered to perform my duties as librarian invariably I gave Bartelby's answer: "I prefer not to." Like Bartelby I was always there, in the morning first, throughout the day, and at night last. Like Bartelby I ate, slept and dressed in the library without plate, bed or mirror. And, as did Bartelby, in my room, my office in the library, a battered xerox of Zucarro's only book scattered about the floor, I stood looking out at the "pale window...upon the dead brick wall" in a "dead-wall revery." Having taken the library as a substitute for the *Eidos* "library," I spent my days contemplating the grand "*disegno interna*" that is the New York Public Library. My response to all questions from employers and clients in the library was the same: silence. When finally my employment was brutally terminated, and when I did not leave my office, my room, I was taken to prison: like Bartelby I said not a word. Others were hired to get the job done, who regarded the library not as a substitute for an idea but as a place where serious action was carried out, where a "dead-wall revery" is seen as nothing but gold-bricking and leads to quick dismissal. Certainly my labor was not for sale.[17] Like Bartelby, after all, I was a scrivener, a copyist, a mimeticist if not of legal documents then of "designs." Like Bartelby I was finally condemned to The Tombs; unlike Bartelby I was rescued from oblivion only by the patrons of the *Pub des Artistes*.

There is a discrepancy between the work of art and the building that emerges in action that makes or builds something. Even were the discrepancy overcome, and even if it were overcome by the tax-and-spend liberal dream of making or building the world as a work of art, a problem emerges on this last vestige of the Classical formulation of consciousness: working and building, even of works of art, is but a *substitute qua action for contemplation*. In other words, action is *not and cannot be serious* action; the results of the action are of no use even though present to the senses, accessible to ordinary life. By extension, labor, then, as a mode of working in the world, remains at best a form of service (the basic forms of which were slavery and serfdom), which is the most that can be hoped from a substitute for contemplation. And, as one writer put it, the artist, whether painter or architect or sculptor is but a "steward of divine grace."[18] In contrast, the transformation of labor and of action at the center into commodities on the Baroque formulation signifies that action is serious and useful. Moreover, it thereby transcends human mortality in its status as commodity and in that way acquires an independence of the human condition so that the worker is equated "with his output and his output with his money-

[16]Holt, p. 90.

[17]Herman Melville, "Bartelby," in *Billy Budd, Sailor & Other Stories*.

[18]Carlo Ridolfi, cited by Panosky, p. 95.

value—his pay; in other words, the realism that turns the worker into a mere entry in the calculation of investment and yield, profit and loss, assets and liabilities."[19]

Only on the Baroque formulation of consciousness do we find the *compossibility* of concepts in aesthetics, science, economics and politics—the realization of Alberti's "universalization" of painting. Zuccaro's aesthetic theory, of course, has at least one foot in the Baroque formulation with the notion that mimetic representation as a perfecting substitute of Nature embodies the "proper and universal aim of painting: to be the imitator of Nature and of all artifacts" in such a way *"that it deludes and tricks the eyes of men, even the greatest experts."*[20] Yet the antipathy to mathematics along with the whole self-generating "method" of what we called indicational appresentation, so vituperatively expressed in Zuccaro's criticism, prevents establishing the Baroque formulation in its essentials: the self-interpretation and representation of the "real" at and from the center of action together in a world in common. The obviously unintended discrepancy and overlooked incompossibility between works of art and artifacts, the absurdity of applying the notion of *disegno interno* to building and making under the sway of the desire for the center, and the impossibility of its "universalization," brings to the fore the fact that it is extrapolated, not from the center, but from the boundary-periphery of experience. The Classical marrow in the new bones of Zuccaro's theory is revealed as well as in another facet of the internal collapse of the Classical formulation. And with that we are at last around the bend.

For Zuccaro provides us with an important and instructive an example of a limiting case of the Baroque formulation of consciousness in the Baroque itself. As an alternative in the Baroque, the Classical formulation cannot adequately account for the new meanings of the thingness of things, as we expressed it before,[21] be it the "quantification" of qualities or the transformation of things into commodities, because it cannot treat as serious action at the center of life meeting human needs and necessities. Accordingly it devalues the human condition, subjects it to the limiting condition of mortality and fallibility. In a fit of baroque reality-override, Zuccaro's theory ignores the shift in the accent of reality from periphery to center, the *mezzanità,* and that means a new self-interpretation of ordinary experience correlative to a new and non-mimetic meaning of "imitation." On the Classical theory of consciousness as a limiting case in the Baroque, the near is not just read off the far, the lower is not just read off the higher, but the near and the lower, perfected in the mind of the artist, are also sleight-of-hand substitutes for the far and higher.

Zuccaro of course may have had it just right when he sees that when action is taken seriously, vanity and madness, melancholy and scepticism are bound to set in. However, we are not interested so much in the psychology and pathology of the Baroque[22] as we are in a formulation of consciousness in which

[19]Hauser, p. 56.
[20]Cited by Panofsky, p. 93.
[21]See above, pp. 41f.
[22]See, for example, Hauser, Chapter VIII on narsicism and alienation.

the aesthetics are "universalizable," that is, compossible with concepts in science and economics, but in which action is serious. Serious action, moreover, lends itself to a new kind of tragedy (and comedy) in the Baroque. And the self-interpretation of serious action dominated by the sway of the desire for the center presupposes the appresenting vehicle of the room and room-milieu to which we must now return in the dank, dark interior of the over-crowded *Pub des Artistes.*

The Rhetoric of the Room

No doubt the Baroque room par excellence is Velázquez's *Las meninas,* and running it a pretty close second is Veronese's *Feast in the House of Levi.* The former especially is interesting because it is a room that takes account of itself, where the portrait painter paints a portrait of a portrait in the process of being painted.[23] Characteristically both paintings disclose rooms filled and crowded with people and animals, both have windows and doors. Aside from iconographical and aesthetic significance, both paintings exhibit the characteristics of the room-milieu: neither are predelineated by the center of ordinary life, and indeed the very ambiguity of their vanishing points of perspective make such predelineation impossible; nor is there an affective stamp peculiar to the rooms as appresenting components, as the Inquisition rightly noted in the case of Veronese,[24] or as disclosed in *Las Meninas* by the radiation of the light from the window striking the edge of the canvas, reflected in the mirror and spreading over the surfaces of objects and figures. Of course we can "add" iconographical and affective-aesthetic meaning—but only on condition that we already indicationally apprehend what is appresented: then we are nervous about German soldiers, curious about a nose bleed, suspicious of St. Peter slicing the lamb, or anxiously confused about whose portrait is being painted, whether the figure at the back is coming in or going out and why, uneasily disgusted by the dwarf; & etc.

This is only the beginning of the characterization of the room-milieu as an essential feature belonging to the non-mimetic representation on the Baroque formulation of consciousness. It is not simply that it is non-mimetic, that the appresentational experience is an indicational one, but also that it is as well exponential[25] and therefore never a copy or resemblance. To be sure, that "exponentiality" has yet to be clarified in the context of the compossibility of concepts on the Baroque formulation of consciousness; it is easy to see in the case of motion, or in that of music. But how is it seen in the case of painting? Or of sculpture? While we may express the exponentiality in mathematical

[23]José Ortega y Gasset, *Papeles sobre Velázquez y Goya,* p. 105: "...*Las meninas,* donde un retratista retrata el retratar." See also Foucault, *The Order of Things,* Chapter 1, pp. 6f.

[24]See Holt, *op. cit..,* Vol. II, "Trial Before the Holy Tribunal," pp. 66ff., especially pp. 67-68.

[25]Above, pp. 42f.,

126

terms, that is, after all, an expression resting upon a sophisticated account of the self-interpretation of an appresentational experience which is self-generating, self-reckoning.[26] And, finally, the room-milieu is the appresenting vehicle which allows for generating the compossibility in the first place.

Reference to yet other rooms may be helpful here. We mentioned before the room of Galileo with its table on which sat the telescope and piece of paper with the drawings of the sun spots. But there are also noises coming from that room where the telescope is not the only thing on the coffee table: there are also a brass plate and an iron chisel, a glass filled with water, and on a shelf over in the corner an apparatus from which three lead balls are suspended by strings. We can take a further look into Galileo's room, and particularly as he fills it with "learned conversation" articulating a new stock of knowledge at hand. In the words of Stefano Guazzo, "Nature herself has given man the power of speech. But certainly not in order that he converse with himself. ...It was given to him so that he could use it as a means of communication with others. You can see that we are using this tool in order to teach, question, negotiate, deliberate, improve, discuss and judge. Also, in order to express the emotions of the soul...One cannot acquire scientific knowledge if it is not taught by others. ...Conversation is not only an advantage but also a necessary condition for the perfection of man." He then goes on to say that the "solitary man deserves the Hellebore as much as the madman. And if one examines the etymology of the word 'man' (in Greek, according to the opinion of some scholars, it is supposed to mean 'together') one will find that nobody can be a man without conversation. For he who does not converse with his fellowmen has no power of judgment; and he who has no power of judgment, is not far from an animal."[27] In the particular case we have in mind, the learned conversation is between Salviati, Sagredo and Simplicio. And it may be no accident, after all, that Sagredo, fictive to whatever extent he may be, is, like Guazzo, a Venetian.[28]

In Galileo's room, toward the end of the day, having delved deeply into an account of the properties of the pendulum, the conversation shifts to why it is that when sounded together, consonant pairs of notes give us pleasure when sounded together, why it is that just those notes have certain numerical ratios: a problem familiar to everyone from Pythagoras to a biker revving up his Harley. Salviati-Galileo rises to the occasion, first with recounting the story that by chance he just happened to be scraping a copper plate with an iron chisel in order to remove some spots (what spots? why?—we never learn); when the chisel was moved rapidly back and forth a whistling sound occurred and a row

[26]Above, pp. 101f.

[27]Stefano Guazzo, *La civile conversazione* (Venezia, 1586). Cited by Garin, *Italian Humanism*, p. 159; see above, pp.52f. When we come to Descartes, below, pp.143f., we shall try to see whether "learned conversation" is essential or not to the room-milieu. It certainly is for Galileo, as is the fact that rather than night his learned conversation always proceeds *by day*—as it does for Descartes; see above, p. 104.

[28]Galileo Galilei, *Discorsi e dimostrazioni matematiche intorno a due nuove scienze* (Leyden, 1638), in *Opere* Vol. VIII, pp. 138ff. (Galileo Galilei, *Dialogues Concerning Two New Sciences*, pp. 94ff. (This edition contains the pagination of the Edizione Nazionale.). Cf. Palisca, *Humanism,* pp. 275ff.

of little parallel lines appeared on copper plate. The faster the chisel moved, the higher the sound and the closer the lines were to each other. The result is that we can count the vibrations, and determine with exactitude the true ratios of consonances: when the chisel makes a sound of a certain pitch, and then one-fifth higher, in the same space respectively are 30 and then 45 little lines. And, aha! we have the form attributed to the fifth, i.e., the ratio 3:2.[29]

To be sure, Galileo presumably checked his results with a harpsicord he just happened to have in the room. Also in the room was a glass filled almost to the rim with water. If the rim is rubbed with the finger Galileo notes that not only is a musical note sounded, but at the same time the water undulates in a very regular way—in this case, the 2:1 ratio of the octave. The great virtue of this "experiment" is that we can count the vibrations which it is very difficult do in the case of strings.[30]

Finally, as though Sagredo and Simplicio were still not convinced, Galileo resorts to a set of three pendulums that he just "happens" to have in the room. Here, as in the other two cases, the attempt is made, again, to provide *visual* demonstration of the true ratios of consonance. The room, during the day, even with curtains drawn, is still a visual room. Salviati-Galileo asserts the so-called (not by him) "consonance theory," according to which, on the view that pitch is determined both by the number of vibrations per unit of time as well as proportional to it, the degree of consonance of a two-note chord is defined by the coinciding pulses of sound waves.[31] The pendulum ostensibly provides a visual demonstration of this theory. Assuming that the vibrations of the pendulum are isochronous, and that their frequency of vibration is in inverse proportion to the square-root of their length (thus lead balls hanging by strings of lengths of 16, 9, and 4), and swinging in arbitrary arcs, then the vibrations will coincide "at every fourth vibration of the longest string" or, as Salviati says: "Now pull all these pendulums aside from the perpendicular and release them at the same instant; you will see a curious interplay of the threads passing each other in various manners but such that at the completion of every fourth vibration of the longest pendulum, all three will arrive simultaneously at the same terminus, when they start over again to repreat the same cycle. This combination of vibrations, when produced on strings is precisely that which yields the interval of the octave and the intermediate fifth. If we employ the

[29] See Walker, *Studies in Musical Science in the Late Renaissance*, pp. 29f.; cf. Cohen, who says that Walker is the first to try this "experiment" in 350 years, *Quantifying Music*, pp. 89f. Walker's criticism is that Galileo would seem to have recorded (Cohen: "with the help of an early forerunner of the gramophone record") musical vibrations exactly and so as to compare them; however, instead of comparing the strokes made in the same distance Galileo should have compared the number of lines made in the same time; see also Cohen, p. 89f. Walker insists that this "experiment" was unlikely to have been carried out in reality. We shall return to this issue shortly.

[30] Walker claims to have tried the "experiment," but insists that the waves in the water are as difficult to see as the vibrating strings; moreover, unlike Galileo's claim, he could not make the sound jump an octave, p. 29; cf. Cohen, pp. 88f. See Koyré, *Metaphysics and Measurement*, pp. 96ff. See below, pp. 211f.

[31] Walker, p. 31; Cohen, pp. 90f.; Palisca, p. 275.

same disposition of apparatus but change the lengths of the threads, always however in such a way that their vibrations correspond to those of agreeable musical intervals, we shall see a different crossing of these threads..."[32]

Walker emphasizes the fact that Salviati-Galileo introduces and is interested in his theory not so much to establish the degree of consonance as he does to explain "why traditionally less perfect consonances may be more pleasing than the octave—the fifth, for example, is more pleasing than the octave" because, in Galileo's words, it "produce[s] a tickling of the ear drum such that its softness is modified with sprightliness, giving at the same moment the impression of a gentle kiss and of a bite [*che temperando la dolcezza con uno sprezzo d'acrimonia, par che insieme soavement baci e morda*]."[33] The statement is made by Sagredo, not Salviati-Galileo. And Salviati-Galileo puts him back on track by telling him that the laws of the pendulum provide a "method" by which the "eye may enjoy the same game as the ear," an almost Leibnizian expression of the principle of compossibility of the senses.[34] Ear and eye playing the same game (*"scherzi"*), at first blush, may seem rather different from, together, kissing and biting. As facets of serious action of ordinary experience from which sensory evidence is extrapolated appresenting the "real," however, they are not all that different.

Galileo's visual "demonstrations," his "experiments," have been declared to be mere thought-experiments of little or no scientific value, or self-contradictory, or incapable of replication. Yet, as Panofsky did with Alberti,[35] it is possible to correct a "subtle mental error" in the case of the pendulum (Cohen), or revise the parameters of scraping a piece of brass (old gramophone records from the turn of the century, after all, frequently contained a set of groves to establish the pitch at which the music was recorded), and perhaps when the olive is put in the martini the sounding glass will jump an octave. But this is of no importance to us, and can best be left to the sober scholars of the philosophy of science and hybrid scientist-musicologists. The reason it is unimportant is not that we are interested in something other and different; it is unimportant in the same way that it is unimportant to project a particle along a plane with a motion that is uniform and perpetual.[36] What is important, then?

What is important is the verisimiltude of the non-mimetic indicational appresentation of the auditory by the visible, of musical notes by scraping sounds made by an iron chisel, of consonances by waves in water, of agreeable

[32]Galileo, *Dialogues*, p. 107; see Cohen, p. 91; Walker, pp. 30ff.

[33]Walker, p. 32; Galileo, p. 107; cf. Cohen, p. 91 (Cohen is concerned, however, just with the account of the "visual" demonstration of the degrees of consonance). See above, pp. 83f.

[34]Nor does it take a Heidegger (*Der Satz vom Grund*, p. 186) to translate the marginal note of Leibniz, discovered by Cassirer, *Cum deus calculat fit mundus*, as "while god plays, the world gets made." The principle that governs the compossibility of the conceptual as much as the "sensory" is the self-generative "game" one expression of which is the calculus. See below, pp. 189f.

[35]See above, pp.65f. and note 47, p.65.

[36]See above, p. 104.

musical intervals by crossing of threads; and so forth. And verisimilitude is an essential feature of the rhetoric of the room-milieu in which the compossibility of sensory evidence and concepts occurs, determining the defining limits of the self-interpretation of those features of ordinary experience from which the decreed "real" (e.g., the true ratios of conconances) are extrapolated. What establishes the verisimilitude of indicational appresentation is decorum. Verisimilitude and decorum together are the rhetoric of the room, and together circumscribe the parameters of its milieu in which what seems right appresents its opposite, what is right. To be sure, the ideas of verisimilitude and decorum are "borrowed" from literature, particularly poetry and by extension, theatre, in the late Renaissance and early Baroque. But they are, as we shall see in the next sections, concepts compossible as well in science as well as music. The rhetoric of the room-milieu purports both a universality and a particularity in the Baroque formulation of consciousness, and it is this which we must now explore.[37]

The Gentle Kiss and the Bite

The self-interpretation of the sensory evidence, extrapolated by means of the "imagination," ranges in Galileo's examples of "serious action" from rubbing the rim of a glass filled with water, scraping metal upon metal, swinging lead balls attached to strings, at one end of the spectrum, to gently kissing and biting at the same time, to hearing the intervals of the octave and the intermediate fifth at the other end of the spectrum. What can we find in these "images" that indicationally appresent the "real," what is right? What can they possibly have to do with "truth," "scientific truth"?

In the discussions of art and literature, it would seem a commonplace as much in the Renaissance and Baroque as to day to invoke Plato's distinction between icastic and fantastic images. Similarly, we are also accustomed since antiquity to distinguish sharply between the verisimilar and the truth, between the looks of things and what they look like (the icastic), or between the fantastic and the phantasied. The latter especially have had a bad press since they generally invite repeated attempts to discover whether and how and in what sense they can be "true images." Or is it that they can only be verisimilar but not true? Yet how can verisimilitude be defined in any case without already appealing to the "true"? Is it "reason" or "imagination" that makes me believe, for instance, that the fantastic and phantasied are seemingly true? Or, to express the problem more consistently with our previous discussion of the characteristic features of the Baroque formulation of consciousness, how is it possible for what seems right or true to appresent indicationally what is right or true? One answer to the question is suggested by Doran (in reference to Alessandro Lionardi's *Dialogi...della inventione poetica*—yet another Venetian work,

[37]For what follows, I draw upon Doran, *Endeavors of Art*, pp. 74ff., and pp. 216ff.; Maniates, *Mannerism in Italian Music*, pp. 19ff.; Vasari, *Lives of the Artists*, Preface to Part Three (volume 1, pp. 249ff.).

published in 1554) where the verisimilar is defined in terms of "artistic credibility." Artistic credibility, then, is what determines which cases of serious action are accessible to the true and the "real," the right. Of course, "artistic credibility" is no more "scientific truth" than any other sort of verisimilitude. But perhaps that is the wrong approach. It is not so much a matter of one theory "replacing" another, as has been emphasized several times, but rather, in these terms, of artistic credibility indicationally appresenting truth. This can only be the case if concepts, e.g. of painting, are compossible not only with those of sculpture, architecture, and music, but also with those of mechanics and physics. The common self-interpretative expression of compossible concepts consists of geometrical determinations, and what enables the common expression are the characteristics of the room-milieu. Or, to express the same thing another way, on the Baroque formulation of consciousness the verisimilar, defined by artistic credibility, appresentationally indicates the true, its opposite. *The room-milieu is then a milieu which establishes the decorum, the artistic credibility of verisimilitude.*

Referring to Girolamo Fracastoro's *Naugerius sive de Poetica Dialogus* (Venice, 1584), Doran lists the conditions that must obtain for verisimilitude to be genuine. Those conditions include contriving, e.g. in the fantastic images of poetry, only what is compatible with truth, only what accords with the universal forms (more in an Aristotelian than a Platonic sense, it would seem); the poet neither invents nor falsifies but rather expresses form in its visible appearance, in its visible "beauty."[38] The "'verisimilar,' then, generally implies the universal or the probable. Though it is sometimes used in the sense merely of the credible, the credible is likely to be referred to testimony (as in Castelvetro and Fracastoro) outside the limits of the poem." Doran's summary will serve our purposes for the moment as a definition of verisimilitude as artistic credibility and is sufficiently broad to extend beyond poetry to other sorts of artistic endeavor such as the pastoral and fable, as well as music and painting. Moreover, it is a definition not inconsistent with its geometrical (as opposed to arithmetical) expression of what is appresented. Verisimilitude may comprise the fantastic and the phantasied, may deal in and negotiate with the fictional. But it does so nevertheless as though it were, and probably is, the serious action of ordinary experience.[39]

It is, moreover, "the doctrine of decorum" which "brings universal truth down from these speculative heights <of verisimilitude> to a practical level. It gives directions for the embodiment of universal truth in poetic symbols" and, we may add here, in the exponential symbols of geometry as well. It is true that, for the most part, the doctrine of decorum is discussed in connection with character in drama and fiction. But essential to decorum is not just the credible but also the possible. What is said about character, "Ideal truth asks for the

[38]Doran, pp. 76f.; and Garin, *Italian Humanism*, pp. 168f. Garin gives a rather more Platonistic account, bordering on the sort we sketched in connection with the neo-Platonism of Zuccaro, above, pp.121f. Doran would seem to find Aristotle more prominently in Fracastoro, despite the latter's Platonistic lingo at times. I think she is right in this respect.

[39] See below, pp.184f., 235ff..

invention of characters in terms of men not as they actually are in every respect of individuality but as they would be if they conformed only to some accepted notion of the type" of character, applies as well to other events. Character is, after all, defined by its milieu, for example, the room-milieu of the stage—and that, of course, may be all the world. The typology of characters, produced by "empirical typification,"[40] applies as well to other sorts of events as we shall learn shortly from Galileo himself. Here three things must be noted immediately. The first is that the idea of decorum affects style, especially the various kinds of verse; the second is that the idea of decorum alters the notion of imitation, of mimesis,[41] and hence of appresentation of what is right. In the case of drama and poetry, this alteration of mimesis yields new ideas of tragedy and comedy, but also of lyric poetry where, according to Alessandro Guarini, the lyric "imitates" passions and affections better than other sorts of poetry and a sequence of imitated passions forms a *favola*.[42] The third and final thing is the combination of the "marvelous" and the "historical" determined by the idea of decorum, the idea of *istoria* with which we first became acquainted with Alberti, and which requires reappropriation by the Baroque formulation of consciousness.[43] All three come together in Galileo, in science as much as in opera, in painting as much as in sculpture.

The most striking of the three "fantastic" images used by Galileo is that of the kiss and the bite, of which, perhaps, the most famous Mannerist example is Othello's "I kiss'd thee ere I kill'd thee: no way but this; killing myself, to die upon a kiss." This would seem to be more a kiss with a bite (or even with an over-bite), surely a case of serious action—no doubt the most serious action from the "real" which is extrapolated; it is a kiss with a bite, moreover, that is hardly gentle, yet "With dignity it puts things straight, as they need to be put straight, so that we do not confuse motive and deed."[44] It is quite distinct from that purely Renaissance kiss with a bite of Paolo and Francesca: In Francesca's words: "When we read how the longed-for smile was kissed by so great a lover, this one, who never shall be parted from me, kissed my mouth all trembling [*la bocca mi basciò tutto tremante*]."[45] And both cases of the kiss are serious because they result in a judgment that "sets things straight," indicate what is "right" and is therefore a "tragedy" in the Baroque sense of a "nameless melancholy" which delights and moves the affections. Yet neither the Mannerist nor Renaissance examples of the kiss quite accord with Galileo's image. We need to take further stock of Galileo's rather unusual stock of knowledge at hand.

[40]See F. Kersten, "Phenomenology, History and Myth," *loc. cit.*, pp. 256f.

[41]Doran, pp. 77f.; Maniates, pp. 24ff.

[42]Maniates, p. 26, reference is to Guarini's *Lezione* (Naples, 1599).

[43]See above, pp. 69f.; Doran, pp. 79-84; Maniates, pp. 27f.

[44]Doran, p. 334.Cf. Hauser, *Mannerism*, pp. 126f., where the kiss itself represents the narcissistic alienation of Othello.

[45]Dante, *Inferno*, Canto V, 133-136. (Dante Alighieri, *The Divine Comedy: Inferno*, translated by Charles S. Singleton, p. 55.)

What after all, has occurred in the "learned conversation" which provides the acquisition of a new stock of scientific knowledge at hand and perfects human being? The "demonstrations" or "experiments" go from waves interrupting the smooth surface of water in the glass to the marks on the copper plate to vibrating strings. Set in motion, those events appresent indicationally the properties of the pendulum as well as the "sympathetic resonance" of the octave and the fifth and, as Guazzo says, they enable us to exercise our power of judgment, as do both Sagredo and Simplicio. Moreover, in each case the indication of what is right is self-generating; it is a "method."[46] But what is the appresenting element? What are the "mechanics" of its indication, that is, of the accessibility to the "real"? From what is the extrapolation of the "real" made? Of what does the verisimilar consist from which the "real" is extrapolated, appresentationally indicated?

The "demonstrations" and their order presented by Galileo proceed by means of three fantastic images: from *Narcissus*, the waves undulating in the ratio of the octave, to *Hermes*: the fifth, "tempering the sweetness with a dash of sharpness" so that "it seems delightfully to kiss and bite at the same time."[47] And the transition from the octave to the contrasting fifth, from Narcissus to Hermes, is effected the "by chance" engraving of lines on the copper plate, that is, by *Fortuna*.[48]

[46] See above, p. 101.

[47] The translation is Walker's, *op cit.*, p. 32.

[48] I do not believe that it is "by chance" that Galileo introduces the second "demonstration" *by chance*. Among the "fantastic images," in contrast to the icastic ones, we have to count those identified already by Alberti in *De Statua*; see the thorough discussion by H. W. Janson, "The 'Image Made by Chance' in Renaissance Thought," pp. 254-266. Images made by chance, "the spontaneous discovery of representational meanings in chance formations," is precisely the case with the lines engraved in a certain order and form on the copper plate. The association of *fortuna* and chance-images is already established in antiquity (see Janson's references, p. 255f.). Galileo's example, aside from its intrinsic meaning as a permanent visual representation of a fifth, may well have a precedent in the chance-images in stone as a special branch of Renaissance mineralogy; see Jurgis Baltrusaitis, "Pierres imagées," in *Aberrations, quatre essais sur la légende des forms* (Paris, 1957, pp. 47ff.; referred to by Janson, p. 256, and p. 264, note 50, in connection with a group of paintings from the first half of the seventeenth century "done on the polished surfaces of agates or other strongly veined stones in such a way that the colored veins become a part of the composition, providing 'natural' backgrounds of clouds, landscapes, etc. for the figures." In the case of the copper plate, however, and the iron chisel the sounds of a fifth that are appresented rather than visual images. We cannot develop this historiographical, but interesting, reflection on the precedents for what Galileo introduces: the appresentation of consonant pairs of notes. We shall return to the chance-image and sculpture shortly when we examine Galileo's view of the controversy of painting and sculpture and the non-mimetic representation of music, below, pp. 135f.

Narcissus, Fortuna, Hermes

In the case of Narcissus, it is as though the water in the glass, the rim of which is caressed, reflects the properties of the pendulum on Salviati's account. Caressing the rim of the glass, we see reflected in the water the waves which mirror the ratios of vibration of the pendulum and of plucked strings and their "sympathetic resonance." But this is the Mannerist (generally, the Baroque) mirror[49] which, like the reflection of Narcissus in the pool of water, is hard, crystaline, firm, and yet easily disturbed: rubbing the finger around the rim has the the same chiaroscuro effect (especially in its octave jump) as dropping a stone in the pool of water. In the case of the water in the glass, the distortion, if right, properly appresents the true ratio of the octave just as the distortion in the convex mirror properly appresents in its chiaroscuro way the (Narcissus-) self in the famous self-portrait of Parmigianino. And if the distortion is by chance, if Fortuna intervenes, and the distortion is set in copper, or in stone as in the sculpture of Narcissus by Cellini, then there is complete "alienation" (to use Hauser's term for the conceit of Narcissus), the reflection in the shining, reflecting surface of copper becomes completely (permanently?) Other. Moreover, the *character*, be it Narcissus, or a self-portrait or, by extension, the properties of pendulum or plucked strings, is determined, not by logical consistency, but by its opposite: inconsistency.[50] The greater the inconsistency, the greater the individualizing, the greater the verisimilitude.[51] And, of course, the extent to which we can carve the "distortion" in copper, if not bronze, provides a permanent basis in serious action which appresents indicationally its opposite, the fifth. And it does so in

[49] The Mannerist and Baroque mirror is hardly that of the Classical formulation of consciousness, the change in which is already signaled by Alberti (above, p. 80).

[50] Hauser, *Mannerism*, p. 121. See and compare Maniates, *Mannerism in Italian Music*, pp. 40ff. for other examples (although I disagree with the idea that Parmigianino's self-portrait is a case of *disegno interno*, any more than are the waves in the water produced by rubbing the finger around the rim of the glass); the examples are distributed throughout the various stages of Mannerism that she distinguishes. The term, "inconsistent," used by Hauser is not the best, or most consistent, i.e., it tends to belie the coherency of image, of character, of decorum generally. Doran uses the term, individualizing, but that too has its difficulties. Perhaps it is best to say, without elaborately developing the issue, that "inconsistency" does not signify incoherence and impropriety as to type or typology; "individualizing" and "individuality" do not signify character without paradox, or clarity without obscurity; see Doran, pp. 217f., 256ff.

[51] We shall return to these ideas below, pp.184ff. when we discuss Monteverdi's Euridice, Arianna, Penolope and Poppea as the archetypes of the Baroque Narcissus (in much the same way that Joaquin Casalduero pointed to Maritormes as the "Baroque Venus" (*Sentido y Forma del Quijote*, pp. 91f.). The study of the Baroque Narcissus has yet to be written, and the Baroque Venus is indeed the Baroque Narcissus. Narcissus figures throughout Galileo's scientific writings as well.; for example, the account of motion with constant velocity is a "narcissistic" account of motion—as yet unstudied, though by no means unnoticed by commentators on Galileo's account of motion. See below, pp.149f. Orfeo, Nero, for instance, are more plausibly exemplifications of Hermes rather than Narcissus.

just the same way that, e.g., the ugly—Maritormes in Cervantes' *Don Quijote*—appresents the beautiful.

No doubt the most familiar, but the least obvious, of the appresenting elements of the properties of the pendulum holding for the "sympathetic resonance" of sounds is the third "experiment," represented by the image of the kiss, although the image is not quite that of the typical Mannerist or Renaissance variety. The fantastic image of the kiss is, like the "demonstration," a unity, even a synthesis of the first two. In the spirit of Valéry, we may be permitted to use this or fantastic, Hermes-image to clarify iconologically Galileo's third example—an image governed, of course, by the rules of decorum.[52]

Hermes is, like Narcissus in the Ovidian tradition so precious to the Baroque, a binary figure (*res bina*) in contrast to Narcissus, and who is noted for twofold enthusiasms, for being enchanted by the double, for the twinned but dissimilar.[53] Our Galilean example combines Narcissus, Hermes and Fortune. But it is of course a descendent rather than the progenitor of the fantastic image of Hermes. Granted that, and leaving aside genealogical differences, one of the reasons why the example is important is that, as though in retrospect, it allows us to see the parameters of the rhetoric of the room-milieu in which Galileo operates with learned conversation. It suggests that we cannot read Galileo's "dialogues" except within the structure of the room-milieu and in the light of its appresenting vehicles: the fantastic images which are part of the taken-for-granted ingredients of the stock of knowledge at hand with which he operates. The accounts in the dialogues, as mentioned before, may well be inadequate to Galileo's and the scientific enterprise, that is, as empirical experiments and demonstrations not only may they be inadequate, but erroneous, perhaps even wrong-headed and incapable of being replicated. But one of the things we learn from the kiss and bite (which, after all, makes the action of the kiss serious) is that we cannot read the dialogues except as learned conversation in Guazzo's meaning: the way in which the "real" decreed (the "bite of the real," we may say paraphrasing Marcel) is extrapolated and represented non-mimetically with a set of ostensibly compossible concepts.

Moreover, the experiences in ordinary life, the commonplace and taken for granted serious action is governed by the images of Narcissus and Hermes, that is to say, by tragedy and comedy or, as we expressed it ad nauseam before, by the eccentricity of daily life. Narcissus and Hermes are rhetorical names for that eccentricity: they are the images of decorum and verisimilitude. The idea I want to suggest is that the glass of water, the distorted reflection in the pool, the chance scrapings on a copper plate, and the kiss and bite are all features of the decorum and character formed in the room-milieu. This is not to say that the "experiments" Galileo reports and the sensory evidence he provides are a matter of verisimilitude *rather than* truth about the "real." Instead it means that the

[52]See Doran, pp. 219ff. for a discussion of the rules of decorum.

[53]In this connection, for the iconographical history of Hermes see Eric Heller, *Thomas Mann. The Ironic German* pp. 286ff.; see also Elder Olson, *The Theory of Comedy*, Chapters 1 and 3; and Hugh Kenner, *Samuel Beckett,* Chapter 1 (which is also important for the "room-milieu" in literature).

decorum, the tragedy and comedy, the character of the learned conversation and the verisimilitude *indicationally appresent* the truth and the universal.

Thus for the Baroque formulation of consciousness we must add to the other features of its non-mimetic representation by least resemblance[54] the idea that what "seems right," what appresents "what is right," is the verisimilar expressed by fantastic instead of icastic images. In short, the verisimilar indicates the true. There is, to be sure, the further specification that the verisimilar not only conforms to the rules of decorum but that those aspects of ordinary experience that are verisimilar are serious, that the action where push comes to shove is serious action. Only serious action allows, in its verisimilitude, of access to the "real."[55]

To develop this further we have to shift gears and, along with a few guide posts derived from Baroque tragedy and comedy, that is from the decorum of character of serious action, and the lyrics of Tasso and Ariosto, consider the compossibility of concepts in sculpture, painting and music so as to arrive at Galileo's laws of motion— framed, to be sure, in the milieu of the room filled with learned conversation. In other words, the compossibility of the concepts of the properties of the pendulum and of consonance of musical notes is not an exception, but essential to "scientific thinking." Granted that this assertion is something the cat might drag out of the dumpster at the back of the *Pub des Artistes*, it is too late to turn back now.

At the Virgin's Feet

Galileo published his *Starry Messenger* in 1610 and, as Panosky points out, in that same year his friend Cigoli in Rome had painted an "Assumption of the Virgin" in the Papal chapel of Santa Maria Maggiore in Rome. In that painting Cigoli pays lip service to the Virgin but tribute to Galileo by painting the moon at the Virgin's (remarkably large) feet exactly as it had appeared "in" Galileo's telescope, complete with craters (the "little islands") which helped prove, eventually, that celestial bodies did not differ from terrestrial ones.[56] Two years later Cigoli also provided ostensibly independent confirmation of observations of sunspots which contributed to "Galileo's argument that they were not optical illusions caused by the telescope or by atmospheric conditions or by asteroids" zinging in and out and around the sun. In the midst of the "sunspot campaign" we find an unusual letter of Galileo to Cigoli, date 26 June 1612.[57] The letter is

[54] Above, pp. 91f.

[55] In contrast to the Baroque formulation of consciousness, the appresenting element on the Classical formulation is skiagraphic rather than versimilar. See below, pp.182f..

[56] Panofsky, *Galileo as a Critic of the Arts*, pp. 5ff.; Cigoli's painting is reproduced as Figure 2. For the relationship between Cigoli and Galileo, see pp. 5f. (including an account of Cigoli's role in the "sunspot campaign"); see also Drake's *Galileo, Discoveries and Opinions*, pp. 32ff.

[57] Panofsky discusses the letter, pp. 8ff.; it is printed in its original on pp. 32f., its authenticity documented p. 32, n. 1. The letter is published in Galileo, *Opere*, Vol. XI

especially unusual because it concerns, from its first lines on, a still heated controversy about whether, on comparison, painting or sculpture is superior the one to the other.

In the second to the last paragraph of the letter[58] Galileo says that he has written "what I recall at the moment as a possible reply to the arguments of those champions of sculpture, communicated to me this morning at your request by Signor Andrea."[59] What was communicated, apparently, was the argument that because sculpture is three-dimensional it is therefore more "real" than any two-dimensional representation such as a painting. Thus a sculpture would apparently have the greater power of "deceptive" illusion of what it represents, i.e., it's verisimiltude makes us believe that the sculpture is the real thing which it represents, "imitates." In his letter of 26 June Galileo answers this argument in the following way: He begins by drawing a sharp distinction between the visible relief of a painting and that sort of relief which is perceived by touch. As for the visible relief of sculpture, Galileo says that if we color dark those parts of the sculpture exposed to the light, so that the sculpture then has a uniform coloring under the same conditions of illumination, the visible relief disappears. As a result sculpture cannot be asserted superior to painting because of its three-dimensionality. Conversely, it might also be argued that by the very use of colors in a painting, the painting also has a sort of three-dimensionality, a visible relief.

It is important to note that the comparison of sculpture and painting presupposes the room-milieu where conditions of illumination can be manipulated and where both painting and sculpture are within actual reach, thus where their appresenting and indicational verisimiltude and decorum can be established.

To be sure, Galileo continues, a sculpture may be said to be closer to Nature because of the material it uses and which is as three-dimensional as the sculpture. Galileo, however, never one to give into the obvious, insists that this is just what makes sculpture inferior to painting: "The farther removed the means of imitation are from the thing being imitated, the more marvelous the imitation will be," and then "The most artificial <or artistic> imitation will be that which represents the three-dimensional in its opposite, which is the plane."[60] Here, to be sure, Galileo adds to the principle, that the idea which

with the caveat about dubious attribution and the alleged fact that it does not always have the "sapore *galileiano.*" (As Panofsky notes, the letter was authenticated as early as 1922 by Margherita Màrgani, "Sull'autenticità di una lettera attribuita a G. Galilei," pp. 556ff. That it would still be printed as of dubious authenticity in the 1934 edition of *Opere* XI is unusual.)

[58] *Opere* XII, p. 342; Panofsky, p. 34.

[59] This and other translations of the letter are Panofsky's, pp. 34-38.

[60] Galileo, *Opere* XI, pp. 341, 342; the translation, slightly modified, is by Panosky, pp. 36, 37. I have retained Galileo's "maravigliosa" and "artificiosissima" ("the most artificial")—the "most artistic"—to emphasize the distinction made earlier between "artificial" and "natural" made earlier, e.g., above, pp. 76f. We shall return to the "marvelous" below, pp.140ff. Panofsky finds these statements of Galileo without "parallel in either sixteenth or seventeenth-century criticism," p. 9. However, we have

least resembles its object is the true idea, the further specification that the idea which least resembles is also the superior idea. Moreover, it is "reason""or "imagination" which makes me believe this[61] because, by least resembling its object, painting, unlike sculpture, is farther removed from its object. To illustrate what he has in mind in the comparison of painting and sculpture, Galileo finally asks: "Do we not admire the musician who moves us to sympathy with a lover by representing his sorrows and passion in song much more than if he were to do it by sobs? And this is so because song is a medium not only different from but opposite to the <natural> expression of pain while tears and sobs are very similar to it. And we would admire him even more if he were to do it silently, on an instrument only, by means of dissonances and passionate musical accents; for the inanimate strings are <by themselves> less capable of awakening the hidden passions in our soul than is the voice that narrates them."[62]

The "true" idea of the passions and sorrow is the very opposite: song. It is song which is the opposite of pain rather than similar to it. (Whether it is on an instrument only or just strings or the voice that narrates is another question, never quite settled even by Wagner.)

Sunspots, painting and sculpture were not the only things to engender controversies that engaged the non-mimetic principle of representation. Even before Galileo became embroiled in the sunspot controversy, perhaps before 1609, he did not hesitate to dip his oar into the controversies involving the poetry of Tasso and Ariosto. One of the major, and perhaps most important issues was whether Tasso and Ariosto in their epics conformed to or violated the rules set down by Aristotle, for instance, whether the ostensible multiplicity of

seen that, rather than without parallel, the view expressed is central to the Baroque formulation of consciousness and, indeed, a commonplace. See above, pp. 104ff. One can also make a similar case for Da Vinci, see Emanuel Winternitz, "The Role of Music in Leonardo's Pargone," pp. 270, especially, pp. 290ff.; Janson, *op. cit., loc. cit.,* pp. 261ff. See also Kivy, *Sound and Semblance*, pp. 125ff., who discusses Vincenzo Galilei's criticism of representation and opts, instead, for what we have called here a "non-mimetic" appresentation, e.g., of emotions—a criticism and alternative obviously expressed by Galileo in the passages cited.

[61]Panofsky, p, 9, stresses Galileo's reliance of "reason" or "imagination" (see above, p. 104), referring to "Galileo's unbounded admiration for Aristarchus and Copernicus 'because they trusted reason rather than sensory experience'," *Opere*, VII, pp. 355, 362.

[62]*Opere*, XII, p. 342; the translation is by Panofsky, p. 37. Panofsky notes that Galileo would seem to express a preference for instrumental over vocal music, in contrast to the views of his father; but see Walker, *op. cit.*, pp. 27ff. for a quite different picture of the relationship and continuity of views of music in the "Galilean" style. For what Galileo has in mind here, see Celletti, *A History of Bel Canto,* pp. 3, 5—the "'singing' of instruments in the execution of melody." In any case, whatever the preferences, the "mimetic" principle is operative in vocal as well as instrumental music; see also our discussion above, pp. 83ff. It would seem that Galileo's principle of non-mimetic representation is consistent with that found in Vincenzo's *Dialogo* of 1581 (see the passages cited by Kivy, *op. cit., loc. cit.*); see also Walker, *op. cit.,* and the problem of intervals in music, p. 65.

action can be boiled down to a unity of action.[63] Interesting and fascinating as this is or may be, it is of no more concern to us than whether painting and scuplture are superior, whether sun spots are sun spots or something else. We are rather interested in Galileo's criticism of Tasso because it makes an issue of the very things which would prevent reason or imagination making one believe that the "true" idea is the one which least resembles. It is worth while assembling several examples drawn from Galileo's early *Considerazioni al Tasso*.[64]

Galileo notes that Ariosto "shades and models in the round...Tasso works piecemeal, dryly and sharply...and this manner of filling his stanzas, for want of words, with concepts having no cogent connection with what is said or to be said, we will call *intarsiare*...When setting foot into *Orlando Furioso* I behold, opening up before me, a festive hall, a regal gallery adorned with a hundred classical statues by the most renowned masters, with countless complete historical pictures..., with a great number of vases, crystals, agates...in fine, full of everything that is rare, precious, admirable and perfect." When one reads *Gerusalemme Liberata*, in contrast, one enters "the study of some little man with a taste for curios who has taken delight in fitting it out with things that have something strange about them, either because of age or because of rarity...but are, as a matter of fact, nothing but bric-a-brac—a petrified crayfish; a dried-up chameleon; a fly and a spider embedded in a piece of amber."[65] In other words, Galileo not only favors the finished and final over the fragmentary, but the large over the small.

As in the case of the sunspots, of the pendulum, of painting, sculpture and song, so too here the verismilar appresents the "true," the genuine. And part of what defines the proper case of appresentation, hence of verisimiltude, is the room-milieu itself: the festive hall, with its regal galleries, classical statues. And this is contrasted with a "false" room: "the study of some little man" cluttered with rare but dryed-up curiosities—more like the room of El Greco referred to at the beginning of this chapter. This is in contrast to the room of Velasquez's *Las Meninas*, or of the painting of the Virgin by Cigoli, where the moon itself is indicationally appresented by the feet of the Virgin (whose "room" is a festive hall if ever there was one: the whole universe).

[63]For a discussion of these issues in Tasso's *Gerusalemme Liberata* and Ariosto's *Orlando Furioso*, see Doran, *Endeavors of Art*, pp. 265ff. Of course, the other unities, of time and place, were at issue as well.

[64]Galileo's discussions of Tasso and Ariosto are published in *Opere*, Vol. IX, pp. 10ff.; for a review of Galileo's views, see Panofsky, *op. cit.* , pp. 16ff.; see also Maniates, *Mannerism* , p. 83, and Chapter V for a survey of the chief characteristics of mannerist poetry. In general I have relied on Ernest Hatch Wilkins, *A History of Italian Literature*, Chapters 21 and 29. See Mario Biagioli, *Galileo Courtier. The Practice of Science in the Culture of Absolutism*, pp. 116ff., who notes that the questions raised about Tasso and Ariosto, likewise those concerning painting and sculpture "were routinely discussed in the Florentine Accademia del Disegno and in other artistic academic circles." This, of course, does not alter the significance of Galileo's views, as developed by Panosky (to whom Baglioni refers, fn 52, p. 118) and Hauser.

[65]*Opere*, Vol. IX, p. 87; the translation is by Panofsky, and I have altered the order of the sentences slightly for the purpose of emphasizing the comparison of Tasso and Ariosto.

In short, there is "right" and "wrong" indicational appresentation, and there is likewise a genuine and pseudo room. In terms of the phenomenology of Baroque appresentation that we have been developing, what is the criticism of Tasso? It is this: the "increase of sensibility" produced by Tasso's use of conceits, for instance, allows the "substantiality of sense impressions,"[66] even of "sensory evidence," to evaporate instead of being indicative of their opposite. To put the matter another way, what *seems* small *is made large*. It would be like the case where parallel lines apparently meeting are made to actually meet. But precisely their seeming to meet appresents indicationally their being parallel, not meeting— just the opposite. Just this makes me believe that the idea that least resembles the object is the "true" idea. So in the case, e.g., of large and small: in effect, what Tasso does is, as it were, make the object resemble what least resembles it by means of the assonance of antithetical conceits.[67]

The examples we have mentioned are not just examples from Galileo's earlier to his latest work, but they all exhibit a consistency in employing the self-same principle of indicational appresentation. In noting, in particular, that Galileo held the views about Tasso and Ariosto until his dying day,[68] Panofsky goes on to say that we cannot therefore dismiss the earlier or the later either as the "sins of youth" or the senility of old age; if "Galileo's scientific attitude is held to have influenced his aesthetic judgment, his aesthetic attitude may just as well be held to have influenced his scientific convictions; to be more precise: both as a scientist and as a critic of the arts he may be said to have obeyed the same controlling tendency."[69] To this we have to add that it is precisely the nature of the Baroque formulation of consciousness to allow for the same "controlling tendency"—although I would certainly want to say that it is much more than a "controlling tendency." Or if it is a tendency, it is only so because of the compossibility of concepts in the case of indicational appresentation. In addition to verisimilitude and the rules of decorum, in addition to the use of fantastic as opposed to other images, and in addition to the "right" room, there is

[66]Hauser's comment on Galileo's criticism of Tasso is interesting, although I cannot agree with it: Galileo, he says, "fails to appreciate the significance of the stylistic revolution represented by Tasso; he fails to see that Ariosto's plastic method of representation is yielding a more fleeting, more impressional, more emotional as well as more musical, more poetical, and more differentiated description of experiences." Galileo "objects to anything so insubstantial as an echo, dream, or shadow being scattered by the wind like smoke or mist, but underrates the poetical gain that lies in the increase of sensibility that allows the substantiality of sense impressions to evaporate, though without losing anything of their sharpness and wealth," Hauser, *Mannerism*, p. 305. Hauser makes his judgment about Galileo in connection with the passages cited in the text. It is my belief that Galileo does appreciate Tasso for what he does, and employs precisely the same principle of appresentation that emerges from his comparison of painting and sculpture: the "farther removed the means of imitation are from the thing imitated, the more marvelous the imitation will be." In these terms, Tasso makes the imitation and imitated as close as possible.

[67]For examples, see Hauser's examples from Tasso, *ibid*.

[68]Panofsky refers to Galileo's letters to Francesco Rinuccini of 5/11/1639 and 19/5/1640 (*Opere*, XVIII, pp. 120f., 192f.).

[69]Panofsky, p. 20.

something else involved which we have to investigate here: the marvelous and the fabulous.

The Mimetic Epoché

Perhaps it is best at this juncture to express the idea of the Baroque formulation of consciousness, as far as developed here, by saying that Galileo consistently exercises a limited version of what Husserl called a "phenomenological epoché" with respect to what does not allow us to believe the idea which least resembles. Across the board the epoché is consistently exercised with respect to resemblance, similarity, in short, with respect to any actual or possible "imitation of Nature" in the attempt to reproduce Nature. For our purposes in this book we shall call this epoché the "*mimetic epoché*" in consequence of which the verisimilar appresents the true, what seems right appresents the right. In other words, the mimetic epoché is essential to the mutual determination of room-milieu and indicational appresentation; it is the "condition for the possibility" of the "right" room-milieu.

To introduce, let alone speak of, a phenomenological epoché leaves us with an excess of conceptual baggage imported into the seventeenth from the twentieth century, thus over-loading an already weakened Baroque beam. Even so, we cannot dismiss this aspect of the Baroque formulation of consciousness as an actual and essentially possible formulation of the phenomenology of consciousness. What, after all, is at issue?

What is at issue on the Baroque formulation of consciousness is precisely *what fits and does not fit* into the extrapolation and indicational appresentation of the "real" and for which fitting (non-icastic) images, expressions and ideas must be found.[70] The "fit" is determined by the room-milieu, and one of its determinations is precisely the "putting out of action" or "bracketing" of any actual or possible making of copies, resemblances, images—in short—imitation on the Classical formulation of consciousness.[71] It is "transcendental" in at least the Husserlian sense by being founded on consciousness of the world and things in it precisely and just as "objects" of and

[70] See above, pp.65f..

[71] There is yet another question that arises here, but with which we cannot deal at the moment: the question of the "validity" of the Baroque formulation of consciousness today. Perhaps the most significant argument against its validity in recent times is to be found in Eric Auerbach's *Mimesis. The Representation of Reality in Western Literature* (1946). To be sure, it is interesting in this connection that Auerbach has become the favorite target of attack in the development of structuralism as much, if not more, as of deconstructionism, both of which develop semiological theories of consciousness. In this light, the observation is suggested that the whole controversy concerning "mimesis" and the representation of reality, with its Saussurian critique by Derrida, Barthes, and others, is strikingly foreshadowed by very similar controversies at the beginning of the seventeenth century, i.e., they are Mannerist controversies. For an attempt to revive the Baroque ideas of the fantastic and its verisimilitude, see Milan Kundera, *Testaments Betrayed,* Part One.

for consciousness of them. Whether experience is "transcendental" in any other sense is an open question here, and of no immediate interest. In Galileo's criticism of Tasso one thing at issue in the "fit" is the marvelous, the miraculous, the fantastic image and imagery taken to its extreme as much in the epics of Tasso and Ariosto as in Mannerist painting, sculpture and architecture[72]—the verisimilar "stretched about as wide as it needs to be to allow for all the fantasies an imaginative age liked to entertain itself with."[73]

Here too credibility requires a set of rules for the use of the marvelous and supernatural so that, for instance, even if "two things are equally credible, one of which was more marvelous than the other, though it was false, so long as it was not impossible, the poet ought to take it over and give up the less marvelous" (Mazzoni).[74] With the criterion of the "not impossible even if false," the same principle of representation is at work: the principle of representation by least resemblance, indeed by its opposite and therefore the "most marvelous," is the superior idea as well: the "means of imitation" are the "farthest removed from the thing being imitated," therefore is the "most marvelous"—to apply Galileo's aesthetics, not all that different from Mazzoni's. And, again, this is a just the rule of organization that generates the contexture, the room-milieu, or as we expressed it in an earlier chapter, the "view from the window."[75] The criteria of Alberti are nothing else but what we have discussed under the headings of the verisimilar and decorum in the Baroque formulation of consciousness.

The room-milieu is, to be sure, broader in conception than Alberti's idea of *istoria*. Or we might also say that its criteria of inclusion and exclusion are conceptually compossible with those of the room-milieu which involves as well "imitation in figurative language reduced to verse, of human actions" (poetry, in Giacomini's definition)[76] and the sequence of (non-mimetically) imitated human actions with respect to their passions and affections make up a *favola* (Guarini[77]). In sort, we may redefine the room-milieu as "fable." In the very broadest sense, the room-milieu constitutes the *"parlare favoloso"* with the caveat that we understand by "imitation," not *mimesis*, but non-mimetic appresentation.

But what, then, is the "fable"? One has to look to the development both of pastoral poetry and drama for the roots of tragedy and comedy and tragicomedy in the early Renaissance, first in Italy and then certainly in England.[78] Moreover, it is there as well that one must look for the beginnings of what later

[72] See the discussion of Maniates, pp. 26ff. and Tesauro's comparison of the poet's conceits, fusing "*maniera*" and "*meraviglia*" with the illusionism of art.

[73] Doran, p. 83.

[74] Cited by Doran, p. 82.

[75] Above, p. 71.

[76] Above, p.96.

[77] Above, p. 120. For a thorough and brilliant discussion of Guarini, see Doran, pp. 202 and 203ff.

[78] See Foss, *op. cit.*, Chapter One.

comes to be opera[79] as much as one must look to the Florentine Camarata[80] with its revival or re-invention of Greek tragedy through the work especially of Girolamo Mei and Vincenzo Galileo, just to name two who had a go at it.[81] The idea of "fable" has its origin in poetry, drama and music, but not only there. Nor do I believe that the term "fable" (along with "history" or *istoria*) is quite as "noncommittal" as Doran believes. Monteverdi's *Orfeo*, usually put at the head of the table so far as the beginning of opera goes, is (in the printed score of 1609) called "*La favola d'Orfeo*" and also referred to as a "*favola in musica*" (later on also a "*dramma per musica*"). The terms certainly are common and prevalent at the end of the Sixteenth and beginning of Seventeenth Centuries. And whatever else the terms may signify, it is not so much a case of music accompanying words (as in Mysteries, Moralities, Sacred Dramas), or as making up an "*intermedio,*" as it is of drama through music just as the true idea of the sun or the moon is based on the presentation of the sun or moon through the telescope. The *favola in musica*, in other words, is the twin and compossible concept of the "sensory evidence" through the telescope; in short, it is the idea that least resembles its object. The reason for this assertion is this:

Regardless of what variety of meanings we can attach to "fable," or allied expressions, and regardless of how and to what extent we can trace their

[79] See the discussions, for instance, of Poliziano by Katz, *op. cit.*., pp. 116ff. (especially of Poliziano's *Favola di Orfeo*), of the *favola* by Sommi, Poliziano, Giraldi, especially of Rinuccini, by Hanning, *op. cit.*, pp. 2ff. See also the discussion by John D. Drummond, *Opera in Perspective*, pp. 105ff.

[80] See Drummond, pp. 110f., who distinguishes three "Camerata groups," and who notes the obvious, namely that "Literally a *camerata* is a room shared by a number of people, in artistic terminology a *salon*. In fact, there were several groups of like-minded artists and scholars who met in different nobles' houses in Florence..." (p. 108). This is one of the few cases where a "room" is called just that, a "room;" we might even say that it is a room aware of itself as a room! Their "like-mindedness," to be sure, is as much a determination of the room-milieu as the specifics of the discussions, the polemics, the production of works of theatre and music. As it were, they carried their "room-milieu" with them, whether they were in Florence, Rome, Frostbite Falls, or wherever.

[81] There is, of course, the received tradition that opera emerged from an attempt to reinvent Greek tragedy, of course within the specific literary tradition at a specific time and place. This is obviously both too simple and too complex a view. If there is any merit whatever in the view, however, then it is necessary to single out a defining feature of that reinvention. In comparing Handel's operas with those of his Italian predecessors using the libretti of Metastasio, Reinhard Strom makes the point that "the Italian public regarded the singer more as a kind of acoustic instrument for reciting poetry, distinct from his or her role" than is found in Handel where singers "were more closely identified with the historical characters whom they represented," Reinhard Strom, *Essays on Handel & Italian Opera*, p. 234. The comparison is instructive because it signifies that for the Italians, inventors of opera and reinventors of Greek tragedy, the singers take on the function of the chorus (cf. Bukofzer, *op. cit.*, p. 59) in Greek tragedy rather than that of the actors; thus the Prologues of Rinuccini, as Hanning notes, are like the chorus at the beginning of the Greek tragedy (pp. 2f., 5, 31ff.). See, in contrast, Leo Schrade, *Tragedy in the Art of Music*, p. 58; and F. W. Sternfeld, "The Orpheus myth and the libretto of 'Orfeo'," in *Claudio Monteverdi, Orfeo*, pp. 26f.; Lippman, *A History of Western Musical Aesthetics*, pp. 32ff.

"origins," regardless of to what extent such terms are commital or noncommital, the new meaning of *favola in musica* is as radical as Galileo's "sensory evidence." It is not that Galileo saw better than others or that his sensory evidence was in some way superior to others. It is rather that under the mimetic epoché there is, phenomenologically expressed, what we may also call a *new means of access* per experimentum *or* per musica *to the "true," the "real."* This is the novelty of the Galileii and Monteverdi and others who practised what is called here the mimetic epoché. It is quite a different thing to consider music *not only as the opposite* of what is presented in a spoken or written text, *but also as the means of access to what is so presented.* The mimetic epoché, then, is the other side of the coin of the self-conscious exercise of self-interpretation of social action.[82] *In this consists the uniqueness of the invention of opera as well as of science, painting, sculpture, architecture on the Baroque formulation of consciousness.* In still other words, music neither supports a narrative, nor expresses something transcendent to it. It is rather the paradox described by Auden "that emotions and situations which in real life would be sad or painful are on the stage a source of pleasure" and which, if we add Guarini, make up the *favola.*

Our question now concerns not so much how certain terms were used and or with what sailed forth under their flags,[83] as it is with the mode of appresentational representation which is also the means of access to what is appresented and expressed by the term, *"favola,"* "fable," as the name for the room-milieu. The fable becomes, moreover, a name for the whole world, for the universe. Room and universe become one. And it is when they become one, when the whole universe is the room-milieu, that the Baroque formulation of consciousness embraces, with its compossibility of concepts, both opera, but also theatre, poetry, painting, architecture, sculpture, and science but also mathematics, mechanics, kinematics.

The Fable of the World

The novelty of the concept expressed by the word *"favola"* in the late sixteenth and seventeenth Centuries was detailed by Jean Beaufret in one of his magical essays called *"Le Fable du Monde."*[84] He is, to be sure, mainly concerned with Leibniz, but that is perhaps to our advantage here because we have already shaken hands with Leibniz in developing the Baroque formulation of consciousness.[85] More particularly, Beaufret is concerned with Leibniz's idea

[82]Above, pp.91f..

[83]See Schrade, *op. cit..*, pp. 55f. who collates the many and various uses of *"favola"* as well as other allied terms such as *"dramma musicale," "opera rappresentata in musica;"* and Franco Rello, *"Fabula,"* pp. 147f., 150f. for an account from the side of Vico.

[84]Jean Beaufret, "La Fable du Monde," in *Martin Heidegger zum Siebzigsten Geburtstag*, pp. 11ff.; cf. Gurwitsch, "Compossibility and Incompossibility in Leibniz," pp. 11ff.

[85]Above, pp. 101f.; see below, pp. 199f.

consciousness.[85] More particularly, Beaufret is concerned with Leibniz's idea that mathematics and the mathematical series, as expression of necessary truth, presents the opposite, contingency—specifically, the contingency of the world. The novelty of Leibniz's view may be expressed by an analogy: Just as we can determine mathematically an infinite series, so we can conceive that the indeterminate series of contingent truths for us can, however, terminate in God. Beaufret notes that the analogy is less a question of applying a mathematical series to contingency than it is of seeing darkly into the intelligibility of that series and finding the higher calculus of God by which the possibilities and compossibilities are distributed into worlds.[86] And just this is the broadest meaning of "fable," which has its roots in the VIth Book of Aristotle's *Poetics* (where Aristotle designates as *"mythos"* what later comes to be called *"fabula," "fable"*). Moreover, in at least one meaning, "fable" designates the "argument," e.g., of a literary work and, by extension, that organized action and planification of its parts making up a given situation (such as the "production" of the best of all possible worlds).[87]

In other words, Leibniz, drawing on Descartes (and the sort of distinction Descartes makes between the two ideas of the sun), establishes a new correspondence between "man" and "being" which Beaufret characterizes as entering into "total planification" of the "best of all possible worlds," or as we expressed it before, a formulation of consciousness compossible with every other to which it is reciprocally related in a contexture, subsisting in and of themselves and for each other out of the internal necessity of organization. Precisely this is a fable in its broadest, yet most conventional meaning. Being or the "real" is always being or the "real" decreed and ratified. As a result, the means of access to what is presented, the opposite of necessity in this case—the best possible—is at the same time the ordering principle of what is presented (and appresented). Beaufret goes on to say that "Between monotony and cacophony order is the richest possible polyphony. But this serial polyphony, however, is not unforeseen because everything is calculated from the beginning."[88] And it is here that the novel meaning of *favola* is to be found: the "creation" of the world is a *favola*.

In this connection Beaufret refers to a portrait of Descartes by Jean-Baptiste Weenyx. It shows Descartes standing, with head inclined and slightly turned toward the back as though coming out of a dream; he is holding an open book, on which are the words: *Mundus est Fabula:*

[85] Above, pp. 101f.; see below, pp. 199f.

[86] Beaufret, p. 16.

[87] For this more conventional meaning of "fable" as argument and organized structure and action, see Wolfgang Kayser, *Interpretacion y Analisis de la Obra Literaria,* Chapter II, §4.

[88] *Ibid.* (the translation is mine).

"The World is a Fable." A fable, *favola*, is a "story," a "history," that generates its own means of access to, and non-mimetic representation of, that story, that history. We might even say, looking ahead to Leibniz, that the fable reduces the form of the story or history to the principle of its generation. At the very beginning of the fifth part of his anonymously published *Discours de la méthode,* Descartes seeks an account of the "laws which God has so established in nature" and which "we cannot doubt that they are exactly observed in all which exists or which happens in the world."[89] However, Descartes says, he cannot at the moment publish his explanation of those laws; still he can summarize the results. But to do so confronts one with the sort of difficulty met by painters "who cannot equally well represent in a two-dimensional painting all the various faces of a solid body, and so choose one to bring to the light and leave the others in shadow, so that they can be seen only while viewing the selected side." Descartes' subject for summary is the topic of light, and he will also have to say something about the sun and the fixed stars because they are sources of light, add a few things about the sky which reflects light, a tad more

[89]*Oeuvres de Descartes*, publiées par Charles Adam et Paul Tannery, VI: *Discours de la Méthode & Essais* (Paris: Vrin, 1968), pp.41ff. The English translation is by Laurence J. LaFleur, René Descartes, *Philosophical Essays*, p. 31, 31ff.

about the earth and the planets and the comets because they too reflect light, followed, of course, by a short spiel about us humans because we observe it all.

That is pretty much the order of creation, and rather than state it in theological terms, of which he modestly disclaims any expertise, Descartes resorts to doing as "a painter might do, to place my object somewhat in the shadow, so that I could express my opinions more freely without being obliged to accept or to refute the opinions commonly held by the learned." But if he does that, operates like the painter, starting with light and sky and ending up with the observer of light, then, like the painter, he is not speaking of the old world, but rather of what would happen "in a new one, if God should now create, somewhere in imaginary space, enough matter to make one; and if he agitated the various parts of this matter without order, making a chaos as confused as the poets could imagine, but that afterward he did nothing but lend his usual support to nature, allowing it to behave according to the laws he had established."[90]

In this delightfully outrageous Mannerist passage, Descartes describes the primordial case of push come to shove, from out of which emerges the very lawfulness recognized in nature by mechanics and physics. In terms of the painter whose procedure he follows, we would have to say that the "creation of the world" is a fable, certainly, but a *costruzzione legittima* produced by the "painter's" *prospectiva pingendi* or *artificialis* in contrast to the *prospectiva naturalis* of which Descartes disclaims any knowledge. And just as the content of the "artifactual" (or: "artificial") perspective is the *"istoria,"* so the content of the "new creation" is the fable of the world and that, Descartes adds, is just the world that is "similar" to ours anyway—just as the view from the window, is, after all, a view of the "real" world, not a different one.[91] If we take some matter in imaginary space, or any line of sight you please, no matter how fantastic and marvelous, shake it up, or grid it, and cast it in motion, then the verisimilar, the new creation, the fabulous and marvelous, appresents the "real" and indeed is the means of access to the "real." The room with a view, the milieu or context, is now the whole cosmos.

And the same holds for other fables, including the *"favola d'Orfeo"* which, likemany other such works of the period both before and after 1637, is also called a *"tragedia."*

[90]See above, p. 69f. for a very similar notion of "god" by Alberti. See also above, pp. 93f. for a further specification of the Albertian deity. There is also a striking similarity with another mid-fifteenth century account of the "creation of the world," Cusa's *De Ludo Globi*, the frontispiece of the Paris edition of 1514 showing a hand casting dice which generates the cosmos and the (circular) order of things: it is a game, he says, practiced as much in the sciences as in music and "arithmetic," and no different from gaming or even chess.

[91]See above, pp.64f., 69

The Imaginary Space of the Room

The "fable of the world" is the story of a "new creation" of the world in an "imagined space," just as the *istoria* is a "new creation" reproducing Nature by means of the *prospectiva artificialis*. Both are examples, moreover, of the planification, of the organization of action, of motion and of emotion, of setting into action a sequence of motions and emotions which generate their own lawfulness. Moreover, it is action which is manipulated, managed, and negotiated: action at the center. Perhaps (but only perhaps) the most singular Baroque expression of this fable is that of Orpheus, but the *Baroque* Orpheus which is a "tragedy" in the Baroque but not the Classical sense. We have already discussed the meaning of "tragedy" on the Baroque formulation of consciousness,[92] with its "*fin lieto*" and the "sweeter affections" which awaken, not pity and terror, but a "nameless melancholy" while "delighting" and "moving" the affections of the soul. In other words, a *favola* which is a tragedy deals with the answerable rather than the unanswerable, the center of action rather than the periphery and is then, as Schrade suggests, a characteristic of the human condition rather than a literary genre.[93] It is a set of internally organized actions which, though they may lead to suffering and violence, can be resolved, that is, are answerable, hence lie within the manipulatory zone of the world within reach.

Within that context, "whatever errors the characters make and whatever they suffer, they are doing exactly what they wish. Hence the feeling that *opera seria*, Auden says, "should not employ a contemporary subject, but confine itself to mythical situations...which, as human beings, we are all of us necessarily in and must, therefore, accept, however tragic they may be."[94] And it is equally characteristic of the fable-tragedy, perhaps we should also say, tragicomedy, that the suffering and violence are resolved "erotically," Monteverdi's *L'Incoronazione di Poppea* no doubt being the paradigmatic example. Yet it rests upon and presupposes what is perhaps the much more obvious, and certainly more favored among the critics, *La favola d'Orfeo*—and not just that of Monteverdi, where the rescue of Eurydice is a good example of push coming to shove, but also of its archetype, that of Poliziano. With the latter *Orfeo*, the Arcadian dimension is introduced into the *favola-tragedia* fulfilling the fantastic images of dreams and aspirations. And *Orfeo* is really a Baroque invention, because even the underworld and death are within the manipulatory zone of the world with reach. "In this world of fulfillment," Katz says, "gods no longer manipulate the fate of man; on the contrary, man posesses the power to manipulate the gods"—the Far, the gods, is not just read off the Near, but managed and manipulated in the near-sphere.[95]

[92] Above, pp. 96f..

[93] Schrade, *op. cit..*, p. 57. For further on the idea of melancholy in the Baroque, see Judith Butler, "Thresholds of Melancholy," pp. 6f

[94] Auden, *The Dyers Hand*, p. 468.

[95] Ruth Katz, *Divining the Powers of Music*, p. 118; see especially, pp. 113ff.; for the

In any case, the passage and resolution of actions presuppose the very idea of the Baroque theatre, the newly invented room-milieu of non-mimetic indicational appresentation of "situations which, as human beings, we are all of us necessarily in and must, therefore, accept, however tragic they may be," and where divine and human orders of events and actions mutually work themselves out. Thus Bacon's notion that the theatre is the "mirror of life," or the *"Espejo de Caballeria"* that names the Carolingan cycles of stories of knighthood leading to the great Baroque invention, the novel, or the notion of the life as a theatrical spectacle, or Calderon's idea of the world as a great theatre in which are actors performing our lives before god. To be sure, it is the Baroque mirror, rather than the Classical or Euclidean one, and the room-milieu peculiar to music (the "camerata") or to theatre itself or to the painter (even if the curtains are drawn over the windows).[96] Perhaps the theatre itself becomes the true idea of human life because it least resembles the divine "authorization" or decree of the "real," the best of all possible worlds.

Most obviously, the human order of things appresents its opposite, the "natural" and non-spectacular order of divinity—if we go this route. It would hardly seem an accident that the Baroque prince, who believed that he ruled by means of incorporation into the divine order, saw himself glorified in opera. Perhaps it would not be too great an exaggeration to say that under the mimetic epoché indicational appresentation is especially suited to such glorification. Thus operatic libretti, as Schrade points out, were a *"dramma musicale regio e politica."*[97] Phenomenologically, the less the resemblance, the truer the representation of divine incorporation into human affairs and the world within actual and potential reach. Thus political action is transformed from a form of service into a commodity and subject to "rationalization" or "planification." And to that extent the characters represented on stage are favored by fortune.[98] However, with respect to the same principle, the spectacles of great kings and princes, great architecture, exotic lands, gigantic land and sea battles, magnificently displayed events, do not involve so much the play of the real over against the unreal, or of *memento vivere* over against *memento mori* (Schrade) as they do the play of opposites, one of which is the least resembling but true idea of the other. And the play of opposites centers around the ways in which eros is at work equally at the beginning of the drama penetrating and disrupting glory and honor (the deceits of love) such that a *commozione d'affetti* is produced but only then to be resolved by love whereby the characters end "doing exactly as they wish" (thus the otherwise incomprehensible last scene of *L'Incoronazione di Poppea*).

The room-milieu is where push comes to shove. But this is not to say that it is the context of some sort of "causality," at least in an ordinary sense because they all are antithetical to the Scholastic formula, *operare sequitur esse*.

Baroque idea of Arcadia, see Panofsky, "Et in Arcadia Ego: On the Conception of Transience in Poussin and Watteau," pp. 229-232.

[96]See above, pp. 113f..

[97]Schrade, *op. cit., loc. cit.;* Hammond, *Music & Spectacle in Baroque Rome*, pp. 240, 243f. and Chapter 13, passim.

[98]See above, p. 130.

And this is the case with the very measure taken of motion. The compossible fable-tragedy in the case of motion too requires its room-milieu, or perhaps better, a certain specification of the room-milieu. Descartes, we may say, provides us with the genesis of matter in imaginary space, the painter (and by extension, musicians, sculptors and architects) the fable-tragedy, the *istoria*, of the "new creation"—its "perspective" under the mimetic epoché, and Galileo the thingness of the things that fit into the fable of the world-room. Here we have to return to Galileo's room with its telescope and pendulum, water glass and copper plate.

Galileo's Fitting Room

We have referred before to Galileo's account of motion on several occasions.[99] If we try to boil down that account, and set aside for the moment the vast literature critically examining his account, and just stick with my attic textbook, we can take the risk of beginning with the simplest case of velocity, namely the motion of a body on a plane moving at uniform velocity ($s = ct^2$). Owing to friction, of course, no body is perceived as moving uniformly along a horizontal plane. What is it, then, that I perceive as my glass of beer slides down toward me on the bar? Certainly what I perceive is not the standard case. What I perceive is not obvious, and therefore must be analyzed. Watching the glass of beer approach, suppose I consider velocity not as constant but as changing. I have the next simplest case. On the wet surface of the bar with my finger I now write: $v = s/t$, and represent changing velocity by "gt" so that, for instance, after one second there is an increase of one degree of velocity and after 5 seconds an increase of 5 degrees. Thus I scratch in the wet surface of the bar: 1) $v = s/t$; and solving for s, $s = vt$; and, 2) $v = gt$. The biker on the bar stool to my right now asks the obvious question: Does that mean that the distance, s, then, $= gt$ (the changing velocity) x t? Is there a simple substitution of velocity by changing velocity? And the biker on my left gives the obvious answer: No, because the velocity starts out at 0 and reaches the maximum. The question really is: what is the mean between 0 and the maximum? Just as obviously the answer is that the mean is 1/2 the maximum. And it must be because the simple substitution of changing velocity for velocity would signify that velocity is at the maximum at the beginning. Thus with Galileo I "imagine" that 1/2 is the mean, and hence s $=1/2\ gt^2$.

The example is as intructive as any other in Galileo: to disclose the mathematical structure of Nature it is necessary to employ "imagination," a fantastic image or "mathematical hypothesis." First the "imagining," then the icastic image, the "empirical observation" which provides a verification. Of course that is not what I experience as I grab the glass of beer as it slides along, gradually coming to stop in front of me. What I experience is a complex phenomenon that involves friction of the wet bar surface, not the standard case of motion, so that I have to analyze the perceived phenomenon, "resolve" it.

[99] Above, pp. 26f., 76f., 116.

(And we have had to wait almost two hundred years for George Stokes to provide us with a formula for the glass of beer sliding down the wet bar.) Of course, not too long after Galileo's demise the vacuum pump is invented and then it was possible to "experience" free fall. Still, so far as I know, no bar has ever served beer in a vacuum.

There are two possibilities: either velocity is constant: $v = c$; $v = s/t$, hence $s = ct$. This is the case of inertia, and even though we express the formula biting into Newton's apple, Galileo is not that different. An objection to the formula is that at best it only holds for what is imperishable, for matter which cannot be destroyed or which cannot go out of being. Otherwise what moves could not do so on a plane at uniform velocity for all eternity. The Baroque answer to the objection is interesting: the objection implies that if I am to explain motion then I have to explain something real, that only icastic images and representations will do and are admissable. But icastic images are irrelevant; to explain motion I do not have to explain something real. Fantastic images, the marvelous, are sufficient, it suffices to "imagine" (or "reason"): the verisimilar can appresent the "real" just as much as, or even better than, the "factual." Yet this is not quite correct. Indeed, on the Baroque formulation of consciousness, after all, Nature is no longer to be accounted for in its own terms as either real or ideal, but instead in mathematical (geometrical and exponential) terms.[100] But the same is the case with painting or architecture or tragicomedy: The geometrical and exponential is as much a fable as anything else-- be it the grid of controlled coordinates, equal temperament or the mythic past. Yet another way of expressing the same thing would be to say that, on the Baroque formulation of consciousness, the verismilar *indifferently* appresents reality or ideality or phantasy. For this reason whatever may come to count as "real" is always decreed.[101]

The second case concerns changing velocity rather than constant velocity (where $s = 1/2gt^2$). Here velocity increases as the time increases, and this is "realized" in the case of free fall in a vacuum. If there is resistance then there is no longer the standard case of motion indicationally appresented by the formula but instead the complex, non-standard case, which is what I perceive as the glass of beer slows down. And here, again, Nature is no longer explained in its own terms. But what, then, is the difference between standard and non-standard or complex cases of motion? One of the ways it was expressed at the end of the Baroque was the way Samuel Clarke expressed it: "miracles" are things which happen only very rarely; in contrast, "natural" things can happen frequently.[102] Now, whether something in nature is simple or complex, standard or non-standard, cannot be established from the case itself: if one fantastic image, or mathematical hypothesis, is required to account for it, then it is a simple or standard case. But if several fantastic images, or hypotheses, are

[100]Or, we expressed it before, in Auden's terms, time and space are "purified" of every historical singularity, above, pp. 6f.

[101]Above, pp. 101f., 113f.

[102]It was a distinction that greatly offended Leibniz; see Alexandre Koyré, *From the Closed World to the Infinite Universe*, pp. 300f., note 3 for Clarke and Leibniz, and Chapter XI; see also Ernst Cassirer, "Newton and Leibniz," pp. 366ff.

required then it is a complex one,[103] then it must be resolved into the simple or standard case. And we have to ask, where? That is to say, where are we allowed to create the conditions under which only one factor is operative?

The room-milieu where conditions are created for a unitary fantastic image, where factors can be varied or persuaded to remain constant, or where factors can be eliminated, is the "laboratory."[104] Like the theatre, or the room with a window, or the camerata, the laboratory is a milieu of a manipulatory zone where push comes to shove, where the far is read off the near, yet which has no expressive unity of its own—no matter if it is a room with sides of beef hanging from the ceiling (Descartes), a telescope on the table (Galileo), a veil over a canvas (Alberti), or whatever. To the extent that it is a milieu indifferent to affectivity, it is a milieu within which the fantastic but versimilar indifferently appresents the real or ideal, the beautiful or ugly, the sorrowful or the joyful. Moreover, while the room-milieu does not exclude actual or possible peripheries, or the mutual exchange of center and periphery, it does not admit of them. Even though the accent of reality, as we expressed it before, is shifted to the center of the world within actual and potential reach, where push comes to shove, it is an accent of reality which is indifferently real or ideal—or neither. That is to say, action is serious, and serious in just the way in which are the mythical situations in which we necessarily find ourselves and "must, therefore, accept, however tragic they may be" (Auden).

So far as the room-milieu is concerned, the ontic conviction of ordinary life is neither a conviction nor a non-conviction: its very ungroundedness is recognized as such. Another way of saying this is that the room-milieu is indifferent to the eccentricity of life; it is neither answerable or unanswerable but always only answerable, always only centric. The compossibility of sensory evidence is the evidence of the room-mileu. On the Baroque formulation of consciousness, a further problem is that of circumscribing the limits of the room milieu, precisely where the compossible becomes the incompossible.

[103] Whether the concept of the fantastic image, of the marvelous, is sufficiently broad to include the hypothesis as it figures in Baroque science requires a special study. It may be objected that, after all, with Newton, we do not "feign" hypotheses but we do indeed "feign" fantastic images (in contradistinction to icastic ones). On the other hand, fantastic images, subject to the rules of decorum and the other rhetorical devices favored in the Baroque—even the aesthetic rules of Mannerism—constitute verisimilitude as much as do the hypotheses of mathematics or geometry and, unlike the Classical formulation of consciousness, require some sort of verification by icastic images, i.e., in the actual practice of ruling, or of behavior of people toward each other, or of actual architectual construction, etc. Finally, fantastic images generally are constituted in "imaginings" which, if specifically different in painting or theatre, like hypotheses in mathematics "*rendere ragione*," render Nature.

[104] The phenomenology and history of the laboratory have yet to be written, or at least given the attention received by the painter's windowed room. Moreover, there is a close relationship between the Baroque invention of the "scientific society" and the legal and political warranting of the laboratory as a specification of the room-milieu. A fragment of this phenomenology and history has been studied in a late 18th century development of the laboratory, the clinic, by Michel Foucault, *The Birth of the Clinic. An Archaeology of Medical Perception.*

Nonetheless, to the extent that, for example, imaginary space and matter in motion are possible and compossible, to that extent the room-milieu includes all of "creation." It is the room where everything fits and is fittable.

The painter does not go into room with the window to discover the "true" shape of things, nor does the astronomer or the physicist go into the laboratory to discover the standard case of motion: the discoveries are already accomplished in the "imagination." The task is to "render" what is already discovered. Of course, if, for example, we begin with the standard case of motion, and we were to regard it not only as standard but as privileged over all other cases of motion, then the laboratory, the room-milieu, would not be required. And just this realization is at least one motive for exercising the mimetic epoché: we never begin with what we observe, we never begin with that or those aspects of ordinary experience from which we extrapolate the "real." Even those the Baroque formulation shares with the basic assumption of the Classical formulation, unlike the latter it never begins with it. The Classical formulation requires no room-milieu, no laboratory, because it starts with what we observe at night, desires only the known and observable. *The desire for the center, however, is the desire for the unobservable, the unknown and therefore requires a room-milieu, a laboratory, a permanent day.*

In the room-milieu push comes to shove. But that is not a causal relation as we shall suggest in the next chapter. In the room-milieu, action is serious but not causal. Nor is the laboratory, or generally the room-milieu, at all like the little room in which Nikolai Kusmitch was confined. In that room, push and shove are causally related; that room is hardly indifferent to the real or the ideal—neither are decreed but instead taken for granted. The two rooms are indeed separate, unrelated to one another: the room of Nikolai Kusmitch, or of the enclave of ordinary life, on the one hand, and, on the other hand, the painter's studio, the music room, the laboratory, the theatre, have nothing whatever in common. Nor do they stand in relation to each other as mutually exchangeable periphery to center. To be sure, both are characterized by the desire for the center. But only the former is truly eccentric, only the former takes the ontic conviction of ordinary life for granted. To be sure, there is the relation of extrapolating to extrapolated, but that is of no concern to Galileo's fitting room. *In ordinary life labor is still a form of service, and only in Galileo's fitting room does it get determined as a form of commodity: the market place of capitalism belongs to the room-milieu that is the studio, music room, laboratory. Indifferently appresenting reality or ideality, the room-milieu is indifferent to tradition, to the singularity of time and place, to security or insecurity.*[105] *Nor is the room-milieu a substitute for ordinary life, or its ground.*

In short, we have rounded the bend only to arrive at the gap between ordinary life and the room-milieu on the Baroque formulation of consciousness, and it is, moreover, a gap essential to the room-milieu. Galileo's fitting room, extrapolated from action in ordinary experience of the world within actual and potential reach is the universe "created anew" determined and further determinable "mathematically." It is the "fable of the world." Into that gap we must throw ourselves again, with special concern for the fate of Nikolai

[105] Above, pp. 119ff.

Kusmitch, Bartelby and even ourselves. The fate is Cartesian because "fabulous," and the gap which finally comes into view portrays things to come. Coming around the bend is like Weenyx's portrait of Descartes, where, like Descartes, we slowly awaken from a dream. But we must not forget the quite different (and perhaps more famous) portrait of Descartes by Franz Hals where we see a somewhat puffy face turned toward us with a mildly questioning smile on lips slightly curving upwards, but eyes now wide open as though suddenly surprised, like Nikolai Kusmitch, that actual time was passing by and the earth moving under his feet—it is a portrait from the gap. There is yet another supposed portrait of Descartes by Sebastien Bourdon where we see him facing us, staring down upon us with a slightly amused smile, the precursor of the "dead-wall revery" of Bartelby—the last stand before the gap.

CHAPTER SIX

Life at the Gap

Before throwing ourselves into the gap to explore in more detail Galileo's idea of motion and its operatic compossibles, we need to take a deep breath and take stock of where we have arrived around the bend.

On the Baroque formulation of consciousness the verisimilar indicationally appresents by way of least resemblance the "true idea" of Nature and Soul in the room-milieu which is indifferent to the real or the ideal, to joy or sorrow, to love or hate, hence which allows for the conceptual and sensory compossibility of all facets of the "recreation" and "fable" of the world. The verisimilar is self-interpretatively extrapolated from those aspects of ordinary experience of social action at the center of daily life where push always comes to shove. Under the *mimetic epoché*, as an essential ingredient of the self-interpretation of ordinary life, social action at the center of the world within actual and potential reach has no privileged status, and indeed is considered the non-standard case of motion and emotion. Precisely the non-standard, the underprivileged, or non-privileged, is the appresenting vehicle, the verisimilar, of the the indicationally appresented opposite, the standard, the measure—the certain (the "real"). Because what is so appresented by the versimilar which least resembles the appresented, the appresented is *not obvious* and therefore must be "rendered," "resolved." Because the context of indicational appresentation, the room-milieu, is indifferent to reality and ideality, and because the appresenting vehicle least resembles what is indicated, "mathematics," among other things, is employed to render and resolve the appresented.[1]

Because ordinary experience under the mimetic epoché is not privileged, non-standard, because what is indicated by the verisimilar is not obvious and must be "rendered" mathematically ("geometrized" as we said before), and because the verisimilar rests ultimately upon the ungrounded ontic conviction of eccentric daily life, there is, we said, a gap between daily life in so far as it is an appresenting vehicle and means of access on the one hand, and the appresented (the "true idea," the clear and distinct, the certain and valid) on the other hand. To the extent that ordinary, common-sensical social action least resembles what it indicates, to the extent it is farthest and opposite in privilege from what it appresents, it is verisimilar and to that extent it counts as sensory evidence of the "true," the "clear and distinct." The images of those aspects of ordinary experience to the the "real" is accessible in the room-milieu are *fantastic* rather than icastic ones,[2] and the systematic sequence of fantastic

[1] See below, pp. 163f., 183.

[2] Obviously this distinction presupposes the distinction between mimetic and non-

images makes up a "fable" of what is appresented, an *istoria*. The most marvelous of the fantastic images are those of "mathematics," of the geometrical-exponential rendering of the indicationally appresented by the versimilar, and its compossible "poetics of wonder" (Celletti) in opera. It is in this context that we have to set our discussion of motion and music.

There is a large and impressive literature discussing the concept of motion in Galileo, assessing its importance for the development of mechanics and physics, especially as that concept is redefined, refined and redeveloped at the end of the seventeenth century in Newton. This is hardly the place to rehearse and reconsider Galileo in this respect, nor would anyone believe me were I to try. What is necessary, however, is an attempt to formulate Galileo's concept of motion as a *compossible* concept in connection with other compossible concepts in music and painting, but always under the sway of the desire for the center. In turn this will provide us with the basis for developing the center-piece of the Baroque formulation of consciousness: the gap between ordinary experience in action at the center of the common-sensical common world and the scientific and aesthetic construction of the fable of the world.

The gist of what we shall find is not a secret: the Baroque formulation of consciousness, exhibited as much in the laws of motion as in those of operatic composition or in painting, sculpture, architecture and politics, "transcends" the very eccentricity of ordinary experience from which it is extrapolated in the first place. In its final shape, the Baroque formulation involves not so much as a shift from periphery to center but instead a relinquishment of eccentric ordinary experience all together—a relinguishment to which the taken-for-granted ontic conviction is, after all, indifferent in its ungroundedness.

Of course it is not unusual for that ungroundedness to surface in ordinary, common-sensical life itself. The very common-sense of the ungrounded ontic conviction, on occasion, itself allows for its own relinguishment. And that in turn allows for extrapolation of the "real" which transcends the eccentricity of ordinary life. Thus it was that I met the famous biker Harbinger P. Breakwater for the first and last time on an extremely dark and foggy, cold night. On his way home that night he stopped on the highway to put his leather jacket on backwards in order to ward off damp and cold, soared off again on the Harley and saw ahead of him a set of lights set wide apart. At 110 mph he rode straight through them. It turned out that they were attached to each side to the rear of a semi stalled on the highway. When we arrived at the scene of carnage we found the Harley in bits and pieces and Harbinger in the ditch, apparently still breathing. Not realizing that Harbinger's jacket was on backwards, the attending physician, in the confusion of the moment, decided to save him by turning his helmeted head back around the way he thought it should go by alligning it with the front of the jacket. The appearances, we may say, were saved. Harbinger was not (below, pp. 176f.)

Here, too, even in this most common-sensical of situations, where front of jacket and face should be aligned, the ungroundedness of the ontic conviction made itself felt with dire consequences. The eccentricity of ordinary experience

mimetic or indicational appresentation. The distinctions are not quite the same as the antique distinction between *Phantasia* and *Mimesis*. See Janson, op. cit., loc. cit., pp. 258f, 265f. See below, pp. 176f.

came to nought with the fatal turn of Harbinger's head, with what seemed right appresenting its opposite, what is right: face alligned with jacket zipper. As Aristotle would say, we shape the rules of appearance, i.e., what seems right, to the result: the construction of what is right.

From Architectonics to Kinematics

But when Galileo noted that "Aristotle shapes the rules of architecture to the construction of the universe, not the construction to the rules"[3] he does not add that the rules too have changed. Aristotle indeed provides "an excellent rule for never understanding either motions or bodies."[4] And no matter whether the rules of architecture are applied to the construction of the universe, or the construction of the universe to the rules, the result will be the same: only space is a condition of motion, and certainly not velocity or anything else. Not just the rules, but the whole cosmic ballgame is different. And if Aristotle is suspect on which rules to apply, tied up in turn with the ostensible construction and perfection of the universe, then the rest of what he says is also suspect. As Descartes too saw some seven years later, at the very beginning of the First Meditation, the architecture of the universe is falling into irreparable ruins and requires wholly new foundations and likewise rules.[5] The business of applying rules emerges rather late in The First Day when Sagredo admits that they are on the moon: "Please, now that we are on the moon, let us go on with things that pertain to it, so that we shall not have to make another trip over so long a road."[6] In other words, at issue is the comparison of the moon to the earth *from the standpoint of the moon.*[7] By the Third Day Salviati will even venture to explain the Copernican system as well as make the "learning of it very much less obscure" by "utilizing explanations other than those resorted to by Copernicus." To do that he has put himself on the moon, so that "the earth being spherical in shape and its material being opaque, half its surface is continually lighted and the rest is dark"—something seen only when off the earth. Moreover, both day and night are determined by the "boundary which separates the lighted part from the dark" (the "boundary circle of light"), and the arcs cut by the boundary determine the lengths of day and night. In short, day and night are observed together, just as,

[3]Galileo Galilei, *Dialogue Concerning the Two Chief World Systems—Ptolemaic & Copernican*, p. 16.

[4]*Ibid.*, p. 17. See above, pp. 24f.

[5]Galileo, *ibid..*, pp. 56f.; cf. Descartes, *The Meditations Concerning First Philosophy*, pp. 75f. Cf. also Jean Dietz Moss, *Novelties in the Heavens*, pp. 273ff. From what has been said so far, it is obvious that much more than an "architectual metaphor" (p. 275) is involved here.

[6]Galileo, *ibid..*, p. 63.

[7]See above, p.10.

e.g., "when the earth is in Capricorn the sun will appear in Cancer; the earth moving along the arc from Capricorn to Aries..."[8]

From the moon the rules certainly are not those of architecture and architectonics. They are rather the rules of kinematics. The similitude of *moon to earth and of day and night of the earth observed together* is a *veri*similitude as well, a fantastic image in a fable of the universe told not just from the moon or even from the earth, but from anywhere. To be sure, the "from anywhere" does have an architecture, not of Aristotle but of Alberti. It is an "anywhere" appresented from "somewhere," and the ubiquitous somewhere, in this case, proves to be not just the "palace of the illustrious Sagredo" in Venice, but more specifically a room with a window from which not just the overdue approach of Salviati is observed, but the very ebb and flow of the seas and the whimsicality of nature.[9] It is the room of a Venetian palace.

The room from which all the cosmos is appresented, and the window from which it is seen, gets illustrated by the frontispiece to Galileo's *Dialogue*: the background reveals that it is none other than a version of the Arsenal of Venice, the model of the theatres in Venice, where the first public theatres are built for the performance of operas (from 1637 on)[10] and of the Venetian palace in which the dialogue takes place (the frontispiece clearly shows that it is the operatic theatre, the operatic room, and not that of the spoken drama).[11] The lower part of the background of the frontispiece, especially the lower right, shows the dockside and one of the two towers of the Venetian port. The paradigm of this symbol of Venetian power and glory is illustrated for our purposes in a contemporary engraving reproduced in Leclerc, p. 415, where both towers can be seen—the ship's mast in the far lower right shows that it is the second tower that is seen, the first being hidden by the figure of Copernicus, and the large gateway hidden by the figures of Aristotle and Ptolemy. A background precisely similar to that of the frontispiece and the engraving can be found in Giuseppe Torelli's design of the operatic stage for acts II and IV of Sacrati's *Venere Gelosa*, performed in Venice in 1643 (reproduced in Leclerc, p. 418). Although the three figures on the stage in Torelli's design are farther apart than the three in Galileo's frontispiece, perspectively they are in the same position with respect to the "vanishing point" and construction of the image.

[8]Galileo, *Dialogue*, pp. 389f. And by also describing the orbit of the earth in the plane of the ecliptic, Salviati even relates the earth seen from the standpoint of the moon to the skies seen from the standpoint of the earth, *ibid.*, p. 390.

[9]Galileo, *Dialogue*, pp. 7, 416.

[10]Leclerc, *op. cit.*, pp. 414ff.

[11]See Maniates, p. 466. It is a difference which "stems from the incontrovertible fact that early operas still manifest an interest in *la meriviglia, ohimé, degli intermedi*." The chief reason for the difference would seem to be the fact that the central focus of early opera is on narrative and lyrical recitative and the mannerist devices for involving the listener in the "lyric core" of the narrative by means of affective appresentation. See also Bukofzer, pp. 394ff. and the discussion of the different kinds of opera (likewise Maniates, p. 467) and the sorts of theatres required. For the essential elements of "*meriviglia*" in connection with the invention of the theatre, see Celletti, *A History of Bel Canto*, pp. 20ff.

Judging from the examples provided by LeClerc in her thorough study of the Baroque Venetian stage and its architechture, the room is that of a tragic rather than comic scene if one presumes serious use of the types provided by the 1545 edition of Vitruvius (a good example is reproduced in LeClerc, p. 250); the types of design for comic scenes would apparently lack the background of the Arsenal (see the example on p. 248 of Leclerc). Whether this entitles us to read Galileo's *Dialogue* as a "tragedy" in the sense discussed in Chapter Four is an open question. The last pages of the fourth day of the dialogue do suggest the *fin lieto* of the Baroque tragedy with the impatient waiting for the return of Salviati to explain the elements of natural and constrained [*violento*] local motions but tempered by the expected pleasure of an hour of refreshments in the waiting gondola—rather like the bite tempered by the gentle kiss. However we may decide such a speculation, the *fin lieto* allows for Salviati to masquerade in the "comic guise" of Copernicus. And this points to other elements of the room *cum* operatic stage important for understanding the non-mimetic appresentation of motion in Galileo's *Dialogue*.

Frontispiece,
Opere, VII

What is important in the present context is that all the theatres, whether courtly or public, whether for spoken or musical drama, presuppose the invention of the stage with *proscenium* so that the action on stage is seen through the "grid" or "picture frame;" in other words, the proscenium serves the same function as the grid or veil in painting, and indeed the stage scenery is determined in its perspective by the picture-frame structure of the proscenium (this is shared by the spoken theatre as well.)[12] Thus when the auditorium eventually becomes an amphitheatre in style, with semi-circular rows of seats facing the stage with its proscenium, and, of course with the royal boxes arranged over the sides of the stage, then, as it were, the semi-circular rows provide a multiplicity of equal sight-lines of the grid or picture-frame.[13] Phenomenologically, the proscenium has the same function as does the window in painting in its role in the constituting of the appresentational verisimiltude within the special features of the room-milieu—and that included the development of the whole art of the stage and its effects, including "scenic perspective 'reaching to infinity,'" and all of the stage machinery for the elaborate scenic affects, of the "poetics of wonder," the "meraviglia, the lighting necessary produced by chandeliers hung from the proscenium arch along with candles and oil lamps placed in the wings."[14] As a matter of fact, the *Dialogue Concerning the Chief World Systems*, for instance, is itself nothing but a play in which Salviati is in the "comic guise" "masquerading" as Copernicus ("*a guisa di comico mi maschero da Copernico in queste rappresentazioni nostre*").[15] Perhaps more than a "tragedy" in the Baroque sense, the *Dialogue* is a "tragicomedy," even a *dramma giacoso*.

But what is it in this case that is appresented, non-mimetically, by means of the stage that is the palatial room-milieu? Under the mimetic epoché what are the specific characteristics of the *"meriviglia,"* the "poetics of wonder"? In short, what are the compossibles of the representation by what least resembles? The answer is not just the motion of the planets, of the moon around the earth, but of motion itself, appresented as neither real nor ideal from the room milieu that, like the stage with proscenium, renders the "real."[16]

What, then, moves? What, then, is motion? And what compossible concepts does it exhibit? From the room-milieu of the palace-stage reality is, after all, not obvious and must be rendered as a result. The room of the palace is just where the Medieval formula, we do not desire the unknown or unobservable, is reversed. We desire, *with Salviate*, precisely the unknown and unobservable in principle. The verisimilar indicationally appresents by least

[12]Cf. Maniates, p. 465. Supposedly the first Italian Renaissance theatre to use the proscenium was the Teatro Farneses at Parma, but I seem unable to confirm this piece of "incidental intelligence." See also Hammond, *Music & Spectacle*, pp. 186f.

[13]See Drummond, *op. cit.*, pp. 144ff.

[14]See Celletti, pp. 20f.; Bukofzer, pp. 393ff.; and LeClerc, pp. 419ff.

[15]*Dialogo sopra i due massimi sistemi del mondo*, Opere, VII, p. 281 (*Dialogue Concerning the Two Chief Systems*, p. 256). The translation has been altered slightly to make it more literal.

[16]See above, pp.151f..; below, pp. 173f.

resemblance the "true idea" of, e.g., earth and moon, in a room-milieu indifferent to the real or the ideal, to joy or sorrow, to laughter or crying, and generally to the eccentric—hence the poetics of wonder, the *"meriviglia"*—and that is what makes the verisimilar "verisimilar." As expressed before, the "non-standard" case represents the "standard" case of motion, and because it is not obvious it must be "analyzed" and "resolved."

Motion Spaced Out

It is at this point that I head back to the attic for yet another physics book in the box that so injured my foot. A quick check in the index sends me to a chapter that informs me that, traditionally, the distinction has been drawn between "natural" and "accidental" happenings. Consider a natural happening: a child is born, and grows up to school age; one day the child is walking to school (which he rightfully hates), and a brick falls on his head, killing him. The latter is an accident which disturbs, we might say, in Paul Goodman's words, the natural course of events of growing up absurd. This is a crucial distinction for the Classical formulation of consciousness because only natural happenings are the objects of science (no matter what anyone might make out of Aristotle's sea battle example), and never accidents. On the Baroque formulation of consciousness, however, there is no place whatever for this distinction.

There is no place for the distinction, after all, because "quantification" is involved (recall the earlier discussion of Oresme,[17]) something immediately accessible to space and time, to being "veiled," "gridded"—the new meaning of the thingness of things. And, in turn, variation of either space or time is immediately accessible on in a quite specific room-milieu (the palace-stage with its proscenium, or, eventually, the "laboratory"). Consider another example: the formula $v = 1/2\ gt^2$ describes both upward and downward motions.

How do we account, however, for a spatio-temporally located body moving forward and falling down, such as when I throw something into the air, represented graphically in Figure 1:

Figure 1

[17]See above, pp. 37ff. For what follows, see also Finocchiaro's summary and commentary on the arguments about motion in the second day of the *Dialogo*, pp. 36ff., 54f. See Galileo, *Opere*, VIII, pp. 184ff. (English translation, pp. 156ff).

Here science on the Classical formulation of consciousness is at a loss to account for this phenomenal situation because, on the Classical formulation, motion, as a case of change, expresses the real tendencies of the agent of motion and here the tendencies are contradictory. Yet in the room-milieu of Galileo and his friends, as on the stage with the proscenium, or the veiled painting, such tendencies are irrelevant. On the Baroque formulation of consciousness we deal only with mathematical conditions and accordingly with a case of velocity where both tendencies, upward and downward, are contained. Graphically this case may be represented by Figure 2:

Figure 2

What we have done in the spirit of the Baroque formulation of consciousness is to combine the two velocities (recall the example considered before from *The Starry Messenger*[18]). Let us take an even more simple-minded example, that of shooting an arrow into the air, and it lands I know not where, i.e., a case where something is shot into the air in some direction and it neither moves straight ahead nor does it move straight downwards—represented graphically in Figure 3:

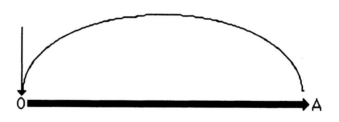

Figure 3

At every moment there is a combination of forward and downward motion, each straight line being composed of two tendencies, i.e., of "two" bodies, one of which is moving forward and one of which is moving upward and downward. Composed, then, of a manifold of straight lines the parabola is but

[18]See above, pp.108f. and 149f.

the limiting condition. This signifies that we "decompose" the arrows in Figures 1 and 2 so that the two mathematical conditions combine, yielding the composite hypothesis which, fortunately describes the parabola of something thrown or shot into the air (represented graphically in Figure 4). [19]

Figure 4

What, now is the significance of all of this? What are the new "rules"? Of what does the verismilitude consist with the "decomposition" and "combining" of mathematical conditions? We have the non-mimetic representation of something moving in contrary directions at the same time, appresenting an arrow shot into the air and landing I know not where.

Mathematical Realism and the Rendering of Reality

Appresented indicationally from the Baroque room-milieu, "nature" is a manifold of an appresented set of an appresented set of "ideal existences" rather than "real existences." Phenomenologically, the "mathematization of nature" rests on the "idealization of nature,"[20] and the mathematization of motion is a wholly new appresentational representation so far as Euclidean geometry is concerned where, after all, geometrical figures are "ideas" in the sense of Plato or Aristotle on the Classical formulation of consciousness, hence are the objects of contemplation. But now motion involves time, whereas before timelessness stamped the geometrical figures on the Classical formulation which regarded the parabola and the ellipse as inferior figures.[21] For the study of motion to be possible and indicationally appresented, motion must be a mathematical concept, and what the Baroque formulation really implies, despite the "spell of the circle," is that there is a special physics apart from mathematics. Of course, Galileo and the whole gang in the various rooms from which motion is

[19] See Stillman Drake, "Mathematics, Astronomy, and Physic in the Work of Galileo," pp. 311ff. Drake does not seem to realize the nature of the composite hypothesis here; see below, pp. 164f., and above, 111f.

[20] See Fred Kersten, "The Life Concept and Life Conviction," pp. 109-115.

[21] See above, pp. 89f.

appresented did not consider the application of mathematics to nature as a merely practical affair. Even in the Venice of Galileo's *Dialogue,* that application was not just something to facilitate navigation and thereby enhance the glory that was the Venetian Republic. As Hall points out,[22] Galileo preferred an axiomatic "to an inductive exposition: he does not tell us how he found things out by experiment, but only explains how he used experiment to confirm the truth of what he already knew." And the new stock of knowledge at hand that he communicates is that *Nature is not only of a mathematical structure but it is equally the simplest theory. Mathematics "renders" reality (rendere ragione) because there is not a divorce between what things are and the simplest theory of Nature.* Mathematics, as we have said, is the new meaning of the thingness of things, and rests on their conceptual compossibility.

Simplicity, rather than appearance, is now part of the new meaning of the thingness of "things" because it signifies a greater rationality. And greater rationality signifies the greater number of phenomena derived from a single principle. Even though it may be customary to speak here of "mathematical realism," it is neither a case of realism or of idealism. This is because it is no longer a case of "what seems right" appresenting "what is right," of life at the center appresenting motion. "Rationality" is then but another version of the "fable of the world," the "new creation" with which we are already familiar.[23] It is a rationality compossible not only with painting and the *prospectiva pingendi*, as Descartes himself noted,[24] but also with music. The compossibility in all cases concerns the mathematical "rendering" of reality which is otherwise not obvious to us, not "pre-given." Perhaps it will be better to speak of a "mathematical rendering" rather than a "mathematical realism" of Nature.

For the starting point of Galileo's discussion of motion is not the agent of motion, no more in the *Discourses* than in the *Dialogue*—and despite any conceptual limitation to constant force and constant acceleration, to what is "natural," to the verisimilar, even when variable on an inclined plane.[25] Rather than following the Scholastic formula of *operare sequitur esse* in his axiomatic exposition, he starts from the mathematical conception of motion, from change as position in time. Thus not only is exposition of the agent of motion irrelevant, but likewise the goal of motion is irrelevant. In other words, precisely what is relevant in ordinary life for action at the center, is mathematically irrelevant. Moreover, mathematics accounts for or renders a multitudinous variety of heterogeneous cases of action and motion, even the boundary or eccentric cases, but always yielding one theoretical context which is the simplest. The centricity, where push comes to shove, and the eccentricity of daily life are utterly irrelevant[26] and constitute the non-standard case of motion and emotion. The

[22] Hall, *The Revolution in Science*, p. 103.

[23] Above, pp.143ff.

[24] Above, p. 143.

[25] See Hall, *op. cit., loc. cit.*

[26] See Hall, p. 103. It then comes as no surprise that "To the extent that Galileo's subject was always the description of motions (kinematics) rather than the action of forces in producing motion (dynamics) he never quite renounced this limitation..."

distinction between the unanswerable threatening and non-threatening has become moot. And just here there is an analogy between Galileo and Archimedes: "...just as Archimedes constructed a theory of statics, so Galileo constructs a theory of motion. Just as the former necessarily idealized the concepts of perfect equilibrium or perfect fluid, so Galileo had to geometrize (make perfect) the physical reality of inclined planes and pendulums."[27] The "accounting for," "making perfect" or "rendering of" reality means that it is necessary to set the most heterogeneous events into a single context and then generalize and justify them by experiments. The single, and simplest, context rules out and renders superfluous "unanswerableness."

The rendering of reality is the rendering of reality as to "how" it is, not "what" it is. The verisimilitude is that of "how," of the context established among the phenomena in question. The context is then a fantastic rather than an icastic representation. And the fantastic, fabled rendering of reality is not a trivial description but rather one confirmed by experiment in turn confirming the truth of the already-known fantastic image. Within this framework "how" is what limits the representation or image, establishes the parameters, so to speak, of the principle of representation by the least resemblance and by the opposite. Thus $s = 1/2gt^2$ is the representation by least resemblance of uniformity of accelerated motion.[28] Or gravity, for instance, does not denote some force in analogy with our own effort expended—an idea beyond our human capacity to understand. But we can ask how the aspects involved in gravity hang together, no matter how different their appearances.[29] The "hanging together" of the various aspects is precisely the "fabulous," the "fable of the world."

[27]Hall, *op. cit., loc. cit.*

[28]Our formula shows how change in space and time is related in the case of free fall, describing how freely falling bodies behave. In other words, the laws which are constructed must always be of the sort where one aspect, we may say, is a function of another aspect. Thus in our example a functional relationship is established between time and space: $S = F(t)$ or $t = \sqrt{\frac{2s}{g}}$. What is important here is that there is no cause or effect involved because they have "disappeared" with the introduction of functional dependency. The functional relationship expressed by the formula, $F(s, t) = 0$, effectively eliminates cause and effect, rendering irrelevant the very experiential datum of ordinary life from which it is extrapolated: push coming to shove. To be sure, not to eliminate cause and effect *as an icastic image* would mean that, for instance, a change in time causes a change in place. And this would, in turn, introduce a productive force into the picture, such as is found in the Aristotelian physics where the paradigm of the occurrence of natural events is the craftsman exerting an effort to bring about a change in the material worked upon in accord with a pre-established form and telos. Now, for Galileo, force, the "power of things," is conceived as the function of alteration of motion. The datum of extrapolation, push coming to shove, is then a *fantastic image*. For us, at the moment, the significance of the "how" is that, of necessity, the experiential datum of daily life from which it is extrapolated must be rendered irrelevant so that "reality itself" can be rendered. Grateful thanks to Andrew Kersten for help on this footnote.

[29]See Hall, *op. cit.*, pp. 102ff. for the description of the advance in Galileo's description of motion from *Treatise on the Sphere* to the *Discourses*.

Galileo, like the Greek philosophers, preferred an axiomatic rather than an inductive exposition. In short, Galileo's thought smacks of Platonism. But as we noted earlier,[30] it is an "inverse Platonism;" both his axiomatics and kinematics were "inverse." For Greek Platonism, for instance, knowledge in the genuine sense is knowledge of the permanent, the unchangeable, the invariant. And the permanent, invariant, can only be accounted for with reference to "forms," "ideas." To take a simple-minded example, such as proposed by Nikolai Kusmitch, a body grows bigger; it "participates" in the form or idea, Bigness. However, because we can always imagine a bigger body, the body always only approximates bigness and, at the same time, also participates in the form or idea, "Smallness." In short, if we speak of a body as big, we always only speak of it in a relative manner. Galileo would seem to deal with such a situation in a different, and inverted, way. In the case of motion, for instance, he deals only with change, change of time and of distance. However, our formula, the indicational appresentation by least resemblance, $s = 1/2gt^2$ is invariant and permanent. It expresses how change in time hangs together with change in distance. The invariance and permanence are found in change *when change is recognized as change according to law and when experiment confirms the truth of what one already recognizes, finds.* This is what Husserl had in mind when he spoke of Galileo's *idealization of Nature.*[31] If the laws are mathematical ones, then the idealization is a *mathematization* (or, more specifically, a geometrization).

The mathematization of Nature presupposes Euclidean geometry, thus the geometrical idealities of that geometry. However, as is known, and as was known, Euclidean geometry rests on the ideas of the straight line and the circle, and all of those figures which are constructable from them. Now, with the Baroque formulation of consciousness a new mathematics is required, something already in the works since the dark days and bright nights of Oresme.[32] What cannot be "designated" by numbers and so indicationally appresented must now be non-mimetically *appresented* by "numbers," whereby it makes no difference whether we read the higher off the lower, or the lower off the higher. Indeed, there is no "higher" or "lower," nor is there any longer a "privileged" experiential datum of ordinary life when it comes to a matter of what we previously called "exponential representation" (non-mimentic, indicational appresentation).[33] The gap between ordinary experience and scientific construction of the universe with its solar-centricity is now irrelevant

[30] See above, pp. 111f..

[31] It was a further step to assume, as Husserl and others have insisted, that this is the only genuine case of idealization, hence of objectivity. Everything else is then "subjective" because it is a non-idealization. This represents a further chapter in the history of modern thought which we cannot pursue here.

[32] See above, pp. 40f.

[33] Above, pp. 43f. For the "fate" of exponential representation, see Paul Schrecker, "On the Infinite Number of Infinite Orders," pp. 361-373, especially pp. 363ff.

and it has become superfluous that the latter is extrapolated from the former on the assumption that the "metaphysically real" is somehow experienceable. With the idealization and mathematization of Nature by means of the verisimiltude of exponential representation, there is no gap in the sense of an icastic image but rather only in the sense of a fantastic one. Ordinary experience is rather fantastic, a fable of verisimilitude. Its verisimiltude, *qua fantastic, qua meriviglia and fable*, consists, in part, of its least (and oppositive) resemblance to what it indicates and appresents.

The Harmonies of the Room-Milieu

What, then, are the fantastic images of ordinary life from which the "real" is extrapolated? Icastic images we cannot trust, our senses are suspect, we are after all stupid in judging sensible things close at hand and at the center of action; sensory evidence of the "true" and the "real" is not obvious.[34] Yet it is the very "deceptiveness" of the senses in daily life, under the four-fold ontic conviction, that serves as verisimilar datum for extrapolating the "metaphysically real:" Such is the event consisting of the "appearance to those who travel along a street by night of being followed by the moon, with steps equal to theirs, when they see it go gliding along the eaves of the roofs. There it looks to them just as would a cat really running along the tiles and putting them behind it."[35]

The cat at night running along the tiles is a fantastic image, the image that least resembles, in this case, the "true" perception of the earth's motion. The least resemblance, indeed "least" because it is an "illusion," a "deception"— Descartes' image of the sun.[36] Of course, there are many other such cases of self-interpretive experience by least resemblance: from tossing dead and live cats out the window, an upset stomach from eating fish and snails at the local raw bar to an unfortunate farmer whose harvest is destroyed by a storm or a knot in one's hair that cannot be combed out or putting one's hand in a bucket of hot water; and so forth.[37] Undoubtedly these images are at the service of Galileo's rhetorical strategies which in turn serve the persuasiveness of his arguments. But

[34] So the Latin epigram, *Dialogo*, p. 280: *Ex hac itaque opinione necesse est diffidere nostris sensibus, ut penitus fallacibus vel stupidis in sensibilibus, etiam coniunctissimis, diiudicandis; quam ergo veritatem sperare possumus, a facultate adeo fallaci ortum trahentem?* (*Dialogue*, p. 255f. "And from this opinion we must necessarily suspect our own senses as wholly fallible or stupid in judging sensible things which are very close at hand. Then what truth can we hope for, deriving its origin from so deceptive a faculty?"); for this notion of "sensory evidence," see above, pp. 105f., 135f.

[35] *Ibid.*, p. 281 (p. 256).

[36] Above, pp.103f.

[37] Finocchiaro, *op. cit.*, Chapter 3, lists and summarizes these and many other "rhetorical" —i.e., fantastic and comic—images, establishing their function in specific arguments in the text of the *Dialogo*. To be sure, he is concerned with assessing, finally, the "rhetorical force" of the images, even though they may be "pleasing and clever aesthetic" images in their own right. See also Moss, pp. 283ff.

for all that they are equally fantastic images, all of them, and, under the mimetic epoché, serve as experiences in ordinary life from which the "true" may be extrapolated by virtue of least resemblance secured, certainly in part, by the very deceptiveness of the senses. And it is the intervention of "reason" that what seems right, revealed in its *seeming*, indicationally appresents what is right.[38]

It is not only the rhetorical persuasiveness that is at issue. Essential to the indicational appresentation under the mimetic epoché is the room-milieu which makes it possible. We have already sketched the nature of the room-milieu[39] and we need to refer to a few of the characteristics we mentioned before in order to advance our discussion here to establish some of the compossibilities of the Galilean account of motion. Peculiar to any milieu in which we find ourselves is the fact that it is related to drives primarily and only secondarily to cognitive-perceptual functions; our immediate data are not physical things so much as they are unities of expression of "feelings," and those "feelings" and affections include joy and sadness as much as ridicule and contempt, scorn and anger. In other words, and with special reference to the room-milieu presupuposed throughout Galileo's writings, from the *Letters on Sunspots* and afterwards, the expressive, affective unities are pressed into the service of the rhetoric of persuasion, and the very representation of feelings in service of the "theory of affections." With respect to the latter, the former, the affections in service of rhetorical persuasion, are but one class of affections.[40]

In the sixteenth and seventeenth centuries feelings and affective experiences are divided into two general groups: energy, joy, hardness, harshness, bitterness and the bittersweet, on the one hand; and, on the philosophical other hand, softness, weakness, sweetness, pity, sadness. This division is a classification accomplished from the standpoint of the mutually exchangeable center-periphery of daily life rather than from the boundary- or limit-peripheries (unanswerable and either threatening or non-threatening). Thus feelings and affective experiences encountered in the Baroque room-milieu generally are *sentimental* rather than tragic or comic.[41] And when it comes to harmonic and melodic intervals, there are always, as Walker notes,[42] oppositions between the two sets or groups so that strength is experienced in one set, weakness in the other. In the specific case of melodic intervals, there is distribution into two classes: opposition between rising and falling intervals, or else and also between large and small intervals up and down, fat and skinny. We

[38] See above, pp.61f., 113f. For the notion of "reason" and its intervention, see above, pp. 104f..

[39] Above, pp. 105f., 113f., 137f.

[40] See Walker, Chapter V, pp. 63ff.

[41] See Plessner, *Laughing and Crying*, pp. 126, 128. This, again, is not obvious, i.e., whether the feelings are genuine or merely sentimental. The whole issue requires a separate inquiry into the criteria of "genuine" as opposed to"sentimental" feelings, and, in turn, of correct or incorrect verisimiltude. Plessner's view is that "genuine" feelings are those bound to situations, i.e., serious action at the center, and not just objects. The "cultural" difference in "genuine" feelings, i.e., relative to a time or a place, is a different issue; see above, pp. 91f.

[42] Walker, *op. cit.*, p. 63.

have already encountered something of this sort in the examination of the eccentricity of ordinary, common-sensical experience, although in its formulation peculiar to the Baroque, namely as a case of the self-conscious self-interpretation, a self-reflective and self-generating method, a "self-griding,"[43] of those feelings essential to social action.[44] Thus with Walker we may be permitted to cite a passage from Mersenne's *Harmonie Universelle* (of 1636) which expresses the peripheries from which the "self-griding" is extrapolated: "Semitones and accidentals represent tears and groans because of their small intervals, which signify weakness; for little intervals, either ascending or descending, are like children, like old people or those who have recently had a long illness, who cannot walk with big steps, and who cover a short space in a long time."[45]

Moreover, the whole scheme is set up in terms of appresentational and indicational opposites so that (following Nicola Vicentino, then Vincenzo Galilei) there is a case of weakness when there are small intervals, semitones and minor thirds when rising, and a case of vigorousness when falling; in contrast, and oppositively, in the case of large intervals (e.g., major third, fourth and fifth) which are vigorous when rising, weak when falling. Walker notes that the scheme is too neat when so expressed and that Vicentino makes more musical sense when, in the case of the minor third as both a melodic and harmonic interval Vicentino notes that its nature is "feeble" and even sad when descending, though it may appear happy if accompanied by rapid movements, and that when it descends or falls slowly it is of the "nature of a man when he is tired."[46] Still, we have not yet quite reached the nature of the motion of rising and falling. Something more is required to characterize with precision that motion, just as in the case of the Galilean law of motion where there is a combination of forward and downward motion.[47] What would be the compossible equivalent in the case of music?

The invaluable Walker notes that Vincenzo Galilei in his *Dialogo* (when criticizing modern polyphony with respect to its contrary motion of parts) takes into account not only melodic intervals but also harmonic progression of

[43]Above, pp.73f...

[44]See above, pp. 91f.. Such self-conscious exercise is certainly peculiar to the Baroque; for example, see Walker, pp. 76ff. for a case of "hardness and harshness" in a song of Vincenzo Galilei composed just to express hardness and harshness (reproduced, p. 77) and which contains "only 5_3 chords, mostly major, which, to my ear, give no impression of hardness or harshness, but produced the effect of a calm, solemn, rather mysterious hymn" (p. 77)—in other words, a case of self-conscious exercise of self-interpretations at odds with "ears" of a later century. Indeed, the self-interpretations are so at odds that one has to ask to "what extent are they *a priori* constructions, or, on the contrary, derived by induction from the practice of great composers?" (p. 76). Walker admits there is no easy answer; one may add that perhaps the self-interpretations are generically incompatible.

[45]*Ibid.*, p. 64.

[46]Walker, p. 64. Likewise the major third likes to ascend because it is of a "lively and happy nature;" or a minor tenth is weak because it likes to descend, and the major tenth rises because it is lively. See also Lippman, pp. 28f.

[47]Above, pp. 161f..

parts (upward and downward as well as forward, as in the case of something thrown into the air and landing I know not where). As in the other cases, we have to ask a more precise question: in music, which chords, which melodic and harmonic intervals, first of all, are plausible, i.e., constitute verisimilitude? Which temperaments, which keys? If we follow Walker's reading of Vincenzo Galilei, then the answer lies in harmonic progressions: "the reason why the fifth and fourth have opposite qualities when rising or falling is that, if these intervals make the bass of the harmony, the descending fifth or the ascending fourth produce a perfect cadence, and the contrary directions a plagal cadence."[48]

To shed more light on the question of the validity of theories of the expressive value of harmonic intervals Walker reverts to Kepler[49] and his account, in *Harmonice Mundi*, of why there is a tendency of minor thirds to fall and major ones to rise. The gist of Kepler's view centers around the "attractive power of the semitone" because it produces in the listener the impression that "certain melodic lines are likely to rise or to fall," thus introducing the "psychological notion of expectation" so that while listening to a piece of music one expects that the harmony will progress in a certain manner and which is either fulfilled or disappointed. It is the semitone that requires greater force: "a greater increase in the muscular tension of the vocal chords is required to ascend by a greater interval, and, on the other hand, to sing a descending interval produces a feeling of relaxation."[50] Walker reviews yet other theories, including those of Zarlino and Doni, noting the parallels in Galilei. Whatever the similarities and differences, though, the fact remains that it is chiefly the harmonic division e.g. of the fifth (15, 12, 10), i.e., the "multiples of modes," as Alberti would say,[51] an exponential representation as we would say, rather than the arithmetic division (6,5,4) which establishes the expressive values. It is the harmonic division that is "more natural."

Harmony and Motion

Zarlino divides the expressive value of major and minor modes into two classes according to whether there is a major or a minor triad on the final: "the modes on C, F, G, are 'very joyful and lively,' whereas those on D, E. A, are rather sad." In other words, it is not just that they appresent certain expressive values in rising and falling, but do so by combining melodic and harmonic intervals, i.e., "decomposing" and "combining" of musical conditions in much the same way that this was accomplished with mathematical conditions in the case of motion:[52]

[48]Walker, p. 65; examples on p. 66.
[49]See above, pp. 86f., and Walker, pp. 66ff.
[50]Walker, pp. 67f.; cf. also the discussion of Beeckman by Cohen, pp. 132f.
[51]See above, p70.
[52]See above, pp.161f.

a) "Decomposition:" Zarlino's first group of emotions consists of harshness, hardness, cruelty, bitterness and the like, and requires for expression melodic intervals "without a semitone, such as the tone and major third," and harmonic intervals such as major sixth and major thirteenth;

b) "Combination:" the second class of emotions, such as complaint, pain, lamentation, sighs, tears, which are soft and sweet in a harmony full of sadness and requires for expression melodic intervals which use "the semitone, minor third and suchlike, and as harmonic intervals minor sixths and minor thirteenths on the bass of the chord."[53]

As in the case of the parabola of motion, we have here the non-mimetic representation of emotions that either leave out or combine the semitone. As in the case of motion, the "composite hypothesis" yields the indicational appresentation of one or another emotions.[54] Granted that, still, the difficulties of plausibility are significant; Walker notes (as do Cohen and others) the "almost insurmountable" difficulties raised the by fourth no matter whether the theories were arithmetic or based on coincidence of vibrations (whether in connection with pendulum swings or new classifications of consonances).[55] Aside from musical and musicological problems as well as historical ones of understanding the Renaissance and Baroque writers on musical theory and theories of affections, of importance to the present discussion is the way the compossible music fits the Baroque formulation of consciousness in its final form. Perhaps the best way of assembling the compossibility of science and music is by illustrating it with a *favola pastorale*, Monteverdi's *Orfeo* where we find the compossibility of the verisimilar. [56]

[53]Walker, p. 69; see below, pp.198f.

[54]See *ibid.*, pp. 69f.; also Cohen's discussion of Galileo's account of the "physiological" foundations of this indicational appresentation in the *Dialogo*, pp. 90ff.; and above, pp. 128f.

[55]Walker, pp. 71ff., Cohen, pp. 91ff. (and especially the reference to the studies of Costabel and Lerner which he cites), pp. 168ff. in connection with Descartes. Moreover, the appresented emotions are not themselves always without ambiguity, as is the impression from Peter Kivy's valuable study, *Osmin's Rage. Philosophical Reflections on Opera, Drama, and Text*, pp. 216ff., perhaps leaning too heavily on the "Cartesian" compartmentalization of emotions and the "possible sequence of emotions in the human experience: that being determined, in the present instance, by the Cartesian view" (p. 217); see Walker's contrast of major and minor modes in the sixteenth and seventeenth centuries with those in the eighteenth and nineteenth centuries, and Cohen pp. 169f. (Perhaps the major disagreement I have with Kivy is his reliance on a "psychology of association" to clarify the theory of affections, and although this is of central importance, especially as concerns the Enlightenment and the use made of it in discussing the *da capo* form in Chapters IX and X, it misses the *non-mimetic* nature of appresentation of emotions even in Descartes' *Compendium musicae*. That is to say, the "association" is the result of appresentation by way of opposites, i.e., the Cartesian principle of truth by least resemblance, above, pp. 104f., 135f.—and which is entailed by Kivy's important distinction between the Baroque and contemporary interpretation of expressiveness where, on the former, music "arouses" emotions, and on the latter music possesses emotive qualities. See Kivy's discussion of Archibald Alison, pp. 207ff.)

[56]See above, pp. 145f.; for what follows, see *Claudio Monteverdi, Orfeo*; Maniates,

The room in which *Orfeo* was first performed was in all probablility a small one "'in the apartments which the Most Serene Lady of Ferrara had use of'," and which implies, with its presumably changed ending, that the opera "was devised as an intimate chamber work."[57] Still, the resemblance in the use of two stage sets for Peri's *Euridice* (as well as other resemblances[58]) suggests that the room was a "worthy one" with an arch and at least minimal scenery and machinery for the stage.[59] In the music we certainly find the (ascending and descending scalewise) melodic and harmonic intervals in a specific order determined by the juxtaposition of styles and versifications[60] along with the symmetrical and cyclical disposition of the music (with its self-generating, internal organization)[61] and thus motion. And even though this may prove nothing either for resemblance with other works, or for understanding the nature of the music of the opera, it must still be borne in mind that such motion, on the Baroque formulation of consciousness in line with the strictures of Mei, Doni and others, expresses the affective meaning of the conceits of the soul.[62]

Moreover, the librettist, Alessandro Striggio, himself refers to the work as a *"favola pastorale,"* [63] which is the most appropriate genre of drama to be set to music.[64] This, of course, while providing greater understanding of the work does not resolve the many problems of the literary or musicological nature of the work, which remain perplexing and even paradoxical:[65] "the style and structure of the libretto serve as indicators of the peculiarly hybrid nature of the opera <*Orfeo*> as a whole. A quality of artificial nobility marks the poetic conception, and this quality reminds us of Rinuccini's poems. Large static sections alternate with real dramatic depiction, a minority aspect, and with long sections of lyrical expression"— the description would just as well fit almost any section of Galileo's *Dialogo*. "<In the long sections,> Striggio writes mannerist poetry featuring conceits typical of Guarini, Tasso, and Marino.

Mannerism in Italian Music and Culture, pp. 472ff.; Kivy, *Osmin's Rage*, Chapter V. For the performance of *Orfeo*, I prefer, for the most part, that of Nikolaus Harnoncourt and Jean-Pierre Ponnelle in 1978 at the Zurich Opera House (London: CD Video 071 203-1).

[57]Iain Fenlon, in Whenham, *op. cit.*, pp. 16f. As Monteverdi himself notes in dedicatory preface to first printed edition of 1609, *L'Orfeo* was given in the large, 4000-seat Manutuan theatre as well.

[58]See Kivy, *op. cit.*, pp. 73ff.; Silke Leopold, *Monteverdi. Music in Transition*, pp. 86ff.

[59]See Whenham, *op. cit..*, p. 47.

[60]See Leopold, pp.91f.; Hanning, *Of Poetry and Music's Power*, pp. 118ff.

[61]See Maniates' careful account of, e.g., *"Possente spirto" op. cit..,* note 55, pp. 561f. and Kivy, *op. cit., ibid..;* Leopold, pp. 60, 89, 92f.

[62]See above, pp. 96f.. and Manitates' references to Guarini, *op. cit..,* pp. 472f.

[63]See Maniates, p. 472. To be sure, in a few decades this and similar terms will disappear.

[64]See Leopold, p. 85, and the citations there from Doni's *Tratto della musica scenica;* also Maniates, *op. cit..,, ibid..* For Doni, see also Lippman, pp. 42ff.

[65]Kivy wrestles these to the ground in *op. cit.*, Chapter V, centered around the question ultimately of just what sort of work, musical or dramatic, *Orfeo* is; see especially pp. 91ff.

Although the total narrative makes logical sense, each act is a separate entity, a scenic *tableau* animated by minor dramatic motion; narrative links between the acts are missing"[66]—in much the same way accounts of Galileo's experiments are missing.

Out of a hybrid of diverse instrumental forms, derived, it would seem, from the intermedio tradition, of strophic variations, ritornellos, sinfonias, deriving from strophic madrigals or arias, and the like, Monteverdi creates a "new ideal of operatic formalization unknown in earlier Florentine style." Yet at the same time, "these sections add to the static quality of his opera, a quality that renders it closer to the intermedio than to modern opera."[67] Maniates' conclusion would seem to achieve as well a middle ground among contemporary commentators on Monteverdi's first "opera" sufficient for our purposes and enables us to leave aside from further consideration whether it is the first or not, whether there is anything genuinely "melodic" or not, whether it is "drama" or not, whether Monteverdi invents something of his own or "borrows" from earlier work, or even whether Monteverdi's work makes "truth claims" which we can establish and employ to "read" his text. Our task is slightly different: from what experienced datum is the "real" extrapolated? How does it find its place in, and reveal, the Baroque formulation of consciousness in its compossibility?

The Room-Milieu of Arcadia

Under the mimetic epoché and essential to the nature of the fable of the world with its fantastic images is the appresentation of what least resembles that which is not obvious and which, therefore, must be rendered. As in the case of motion where there is no divorce between what things are and the simplest theory, so too in the case of opera: the indicational appresentation which least resembles, which renders the "real" in a room-milieu indifferent to reality and ideality, hence offsets the privileged status of the center of action, is the *stile rappresentativo*, the manner of singing, "like that of ancient tragedy, which was neither speech nor song but something in between,"[68] and which is the indicational appresenting vehicle of fantastic verisimiltude. Indicational rather than mimetic, the "speech in song" and "song in speech" allow for figurative, stylized and idealized representation.[69]

Essential to the room-milieu, as Leopold notes, is "the silent dislocation of Orpheus from Thrace to Arcadia...How else could he be brought into contact with the musically talented shepherds and nymphs?[70] Thrace was a rugged

[66]Maniates, *ibid.*

[67]*Ibid.*, and pp. 510ff. In contrast, see Drummond, pp. 122, 135.

[68]Palisca, *Humanism in Italian Renaissance Musical Thought*, p. 432.

[69]See Celletti, *op. cit.*, pp. 4ff.

[70]Thus the issue of whether the *stile rappresentativo* is in one or some other sense "melody" is hardly important; at the least, melody rides in on the back of the *stile*

region, which had only been taught some manners by his singing and his playing of the lyre; it was therefore unsuited for the setting of a pastoral opera. In order to avoid this calamity, the first librettists made short work of bestowing Thrace with Arcadian qualities."[71] Arcadia is as well the birthplace of Hermes, yielding an Orpheus-Hermes through the overcoming of the separation of Orpheus and Eurydice in the stars and the heavens. Moreover, the Arcadian landscape is appresented indicationally by the introductory ritornello in the Overture which is played at the beginning and end of the pastoral scenes in the first and second acts, and at the beginning of the pastoral scene in the last act.[72] In Harnoncourt's words, "Because <the ritornello> represents the landscape, it must not be linked emotionally with the action, i.e., it must sound exactly the same in the last grief-filled act as in the happy first act. The landscape remains the same, only the fates of the humans change; the music can change only in relation to the human fates." Arcadia is then the musical expression of the specifically Baroque room-milieu, indifferent to the affectivity of the action it circumscribes.[73]

For the moment, though, Maniates' observation is sufficient for the purpose at hand: "all dramatically and lyrically intense moments <of *L'Orfeo*> are rendered in recitative," with the exception of the third act where, in the spirit of Doni, the recitative is combined with the arioso. Maniates emphasizes the decorum[74] of recitative insisted upon by Doni: the "passionate recitative," the combining of normal recitative to "free arioso style," and which, in their turn mirror the "spiritual agony behind the poetic conceits" where "Monteverdi attains his most daring and iconoclastic use of strange harmonies and affective dissonances" comprising the *maniera* peculiar to the work.[75]

The versimilitude of the opera experienced within the Arcadian room-milieu is quite distinct from that of the dialogue of the play, which was not sung.

rappresentativo regardless of whether it itself is "melodic." See Kivy, *op. cit.*, pp. 90f.

[71]Leopold, *op. cit.*, p. 85. Maniates as well, pp. 475f. notes the strictures of Doni followed not only by Monteverdi but Peri, Rinuccini, and others as well: "We should not imagine that the shepherds depicted there were the sordid and common ones that tend the livestock today, but those of that older age when the noblest people practised this art" (Cited by Leopold, p. 85)—another case of "what seems right" in Arcadia rather than in Thrace. See also Thomas G. Rosenmeyer, *The Green Cabinet. Theocritus and the European Pastoral Lyric*, pp. 232ff., especially p. 235.

[72]Harnoncourt, *The Musical Dialogue*, pp. 127f.

[73]See above, pp. 113, 149f..

[74]See above, pp. 128ff.

[75]Maniates, p. 475. To be sure, it will not be long before Arcadia becomes the playground of the comic and ridiculous, as e.g.,in Monteverdi's next Manutuan opera, *La finta pazza licori*: "the pastoral world, which had dominated the first stage of operatic history, came to an end with the new dramas dealing with thrilling entanglements and intrigues. Only a little later stingy nymphs, sly shepherds, and vulgar gods will appear. A Narcissus who wastes away from loving his own reflection, an Echo who turns to stone because of the sorrow of love, were truly no longer part of the world." Arcadia is "reduced to an arbitrary, interchangeable background."(Leopold, p. 103.) That is to say, the arcadian room-milieu is indifferent to the comic or the tragic, and indifferently can be either.

The one exception, as noted, is "where poetry had its home, and where the shimmering gold veil of a peaceful paradise was drawn over all passions, both good and evil: the distant Arcadia of a previous Golden Age"—the compossible "poetics of wonder."[76] It is a case, as Auden says, of music declaring its own "self-consciousness," where things familiar in ordinary life do not belong there at all, where, as in the dislocation from Thrace to Arcadia, there is purification from every trace of historical singularity. The fantastic images rendered by the *stile rappresentativo* are like the cloakroom checks in the anteroom of the theatre.[77]

And like the cloakroom checks, the *stile rappresentativo*, along with its ostinato bass,[78] is the harmonic and melodic "grid" of the *favola* with its expressive feelings of the *istoria*.[79] With the push-come-to-shove of the *istoria*, Orpheus makes the unanswerable answerable (the peaceful veil of paradise); he makes the unanswerable fit by turning death into life upon rescuing Eurydice from the underworld, so that death becomes temporarily indifferent to the eccentricity of life.[80] It is the exemplary case where the center has no privileged status in the specious present (of the fable). The otherwise unanswerable boundary or limit case is exchanged for the center, the answerable. The aspect of ordinary life at the center from which the "real" is extrapolated i.e., where push comes to shove, is sudden death. The situation with Orpheus and Eurydice, even on the surface, is more complex in its simplicity when Orpheus comes up against a boundary, death, which, as Plessner says, stamps him as human with "indirectness and mediacy." Because Orpheus finds himself between himself, the agent of action, and the object of action, with the rescue of Eurydice, he can either deal with them, manipulate them, or blunder. Following Plessner we may say that Orpheus not only is attentive to relations, meaning-connections, to himself and the world, but also between the world and himself. His action takes place in conformity with the relations of meaning that prevail at the moment, the

[76]Leopold, p. 85; see above, p. 155f.

[77]Above, pp.5f..

[78]Below, p 179.

[79]Above, pp.69, 130f., 141f...

[80]See above, p. 134; see Plessner, *Laughing and Crying*, p. 152: "What is common to laughing and crying is that they are answers to a *boundary situation*. Their opposition depends on the mutually contrasted directions in which man falls into this boundary situation. Since it makes itself known as a boundary situation only in the twofold way in which every possible mode of human behavior is blocked or thwarted, there are only two crisis reactions having the character of a response to such a situation. Laughter responds to the thwarting of behavior by the irremediable ambiguity of cues to action, crying to the thwarting of behavior by the negation of the relativity of human existence." In the specious present of the fable, however, there is an ambiguity affirmed at the end of the opera as well (not in the libretto) when Orpheus and Eurydice are united in the stars. There is an ambiguous zone between laughing and crying that remains; it is a case of laughing and crying at the same time, just as with the kiss and the bite. This ambiguity of the kiss would seem to be especially Marinist in character; cf. Monteverdi's setting, in the Seventh Book of Madrigals of 1619, of Marino's "Tornate, o cari baci" and "Vorrei baciarti;" see Tomlinson, *Monteverdi*, pp. 185ff., and Leopold, *Monteverdi*, pp. 64f.

death of Eurydice, but he also confronts those relations by means of a way of dealing with them, descending into the Underworld and retrieving Eurydice, which signifies that Orpheus apprehends the organization of those relations to the world. In short, Orpheus "knows what to do"—up to a point. Thus his action is serious

On the way back from the Underworld those relations with the world and their formation get out of control; vitally all remains in order, yet suddenly everything is also out of relation the moment Orpheus looks back, and he can find no relation to them, no longer knows how to relate them to himself and to the world to such an extent that he generalizes the lack. That is to say, relations of meaning are so disturbed and disrrupted that there are no clues as to how to act, only an echo (Act V). No comparisons or distinctions can be made: all other women are of no worth, *"Quince non fia giammai che per vil femina/Amor con aureo stral il cor trafiggami."* Meaning and understanding are suppressed; there is an ambiguity of cues to action—Orpheus becomes suddenly passive and submits completely to the intervention of Apollo—and the "relativity of existence" is negated: there is no meaningful reference to anything at all. Orpheus becomes an "invalid of his own spiritual powers" (borrowing Plessner's phrase); he now lives beyond his means (as Scheler would express it).

The contrary case is Peri's *Euridice*, where Euridice returns without conditions attached. In contrast, the endings of Monteverdi's *Orfeo*, of 1607 and of 1609, and whatever was performed, still fall within the bounds of a *fin lieto*, but in an ambiguous way—like the biker whose head is turned around, and of course in the one ending, more Virgilian, where the head wrested from the torso by the Bacchantes, continues to sing. It is not so much that the room did not allow of the necessary stage machinery, but rather that the eccentricity of daily life has become quite ambiguous, all of which leads us back to that ungrounded but basic ontic belief or conviction of being alive.

Still, the most immediate question remains: *phenomenologically* the significance of the *favola in musica* consists in the Baroque formulation of consciousness under the mimetic epoché of a *new means of access per musica* to the object of the true idea. It is of course quite a different thing to consider music not only as the opposite of what is presented in a spoken or written text, *but also as the means of access to what is so presented*; in this sense, music neither supports a narrative, nor expresses something transcendent to it. It is rather that paradox described by Auden "that emotions and situations which in real life would be sad or painful are on the stage a source of pleasure." What then is the facet of experience in ordinary life from which the "reality" of Orpheus is extrapolated? It is a serious action just like that of Harbinger J. Breakwater: *Like Harbinger, Orpheus won his chance to overcome death and then lost it again.* And Orpheus did so by his own devising, his own effort, and as a result went straight to Hell. Like Harbinger, his head still sang—if we are to believe the tradition behind the ending of Striggio's libretto, or he lucked out in the apotheosis with Apollo if we believe Monteverdi's printed score.[81] And it

[81] See below, pp. 209f..; for the difference in Act V of *Orfeo* see Leopold, pp. 94f.; Maniates, pp. 472f.; Sternfeld, pp. 29ff.; Drummond, p. 133.

was, of course, "by chance" that Harbinger/Orpheus lost his chance.[82] The problem is how to achieve the decorum necessary to versimilitude for the new means of access *per musica*. An example will have to suffice, or this scene in the operatic cloakroom will go on too long. Orpheus, to win his chance, must get to the Underworld: he must persuade Caronte in song and lyre playing: "The vocal part is notated in two staves; the first presents a simple, recitative declamation, the second a virtuous, embellished version of the first, bordering on the limits of what is vocally possible. Monteverdi's own instruction here reads: 'Orfeo sings only one of the versions.' Is it imaginable that Orfeo could have made any impression with as simple notes as those of the unornamented lines?"[83]

The decorum involves the exchange of foreground and background. If the simple melodic line is performed, then the effect of the music lies with the instruments; if the embellished line is performed, the effect lies not with the instruments, which recede into the background, but with the vocal line in the foreground, forced into service of dramatic statement.[84] It is the latter which is like the "sensory evidence" of Galileo and essential to indicational appresentation of least resemblance which constitutes the "what seems right" of decorous versimilitude.

When Orpheus first addresses Caronte, the embellishments are echoed by two concerted string instruments; then in the second strophe of *"Possente spirto"* there is a mannerist pun, *slc*. Orpheus must be dead because he has been deprived of his heart which is his wife and who has been deprived of life (like Harbinger sailing through those two wide-set rear lights on the truck), and of course we get the concerted cornetts; then in the fourth strophe pride is expressed in the highly intricate ornaments, and in the fifth strophe there is a passionate recitative with only continuo accompaniment to be followed by the last strophe where Orpheus pleads with Caronte while the string accompaniment symbolizes the harp (and there is a further mannerist conceit: he arms his lyre with sweet strings, rather like Harbinger putting his jacket on backwards, above, p. 156). Here the embellished, ornamented line is precisely what is decorous, "what seems right" to appresent "what is right." "What seems right" is further established in the instrumental ritornellos: the string ritornellos at the beginning when Orpheus addresses Caronte directly, or the cornetts when death is mentioned, or the harp when the heavens are referred to.

This first "accompanied recitative in the history of opera" "is nothing more than a musical representation of Orfeo, who, while singing and playing the lyre, attempts to appease Caronte with words to the effect that his only weapon is a golden lyre."[85] It is the "shimmering gold veil of a peaceful paradise" (Leopold) gridding a chance won and then lost. Here we have the corrolary assumption of the Baroque formulation of consciousness: events in the manipulatory zone of social action, the chance won and lost, retain their size,

[82] See above, pp. 131f.
[83] Leopold, p. 94.
[84] *Ibid.*, p. 95.
[85] Leopold, p. 97; Maniates, pp. 561f.; Harnoncourt, pp. 126ff.

shape and magnitude; the golden lyre is nothing else but the "thingness of things;" a golden *lira da braccio* the playing of which involves those bones whose ends, Galileo says, "are spherical, namely those which must move in all directions as do...the joint of the shoulder and the arm."[86] As noted in an earlier chapter, while the *stile rappresentativo* is not strictly "geometrized" as in the case of the laws of motion or the *prospective artificialis* in painting, still it is fused with human proportion in its fantastic image of Orpheus playing the lyre in the Underworld as well as in the world of the living, of winning and losing the chance to overcome death.[87] Moreover, winning and then losing the chance is nothing else than the "gentle kiss with a bite."[88] It is all extrapolated from *what is common* to laughing and crying, from the prohibition of action in the world, at the center, by the "irremediable ambiguity of cues to action" (here in despair) and from the "negation of the relativity of existence" (here in self-abandonment and capitulation to Apollo or, in the other case, to Caronte). Again, the "real" extrapolated is the "real decreed" because it is a self-conscious exercise, in the case of Orpheus and Eurydice, of the self-interpretation of what is common to laughing and crying. The "real decreed," the events proceeding in the Arcadian room-milieu, the fable of Orpheus and Eurydice, are independent, self-sufficient, self-inclusive. [89]

The harmonies in motion in this case—*"sopra un aurea cetra/sol di corde soavi armo le dita"*—form the geometric parabola correlative to the circular motion of shoulder and arm. Appresented indicationally, non-mimetically, are, under the new meaning of "catharsis" and "imitation," the "conceits of the soul" in "speech in song" as much as in "song in speech."[90] The *stile rappresentativo* is the "grid" cutting the "aural pyramid" in the same way the veil cuts the visual one, but now in the way in which, by means of "decomposition" and "combination," the grid of the parabola of motion cuts the pyramid of the projectile.

The Compossibility of the Formula of Motion and the Ostinato Bass

There is yet another facet of the *stile rappresenativo* that must be considered here in connection with versimilitude under the mimetic epoché on the Baroque formulation of consciousness: the ostinato bass and harmony of the recitative. Its consideration will also locate the present study in the midst of current discussion of the work of Monteverdi. On several occasions we have referred to

[86] See above, pp.90f.

[87] Above, pp.98f.

[88] See Leopold, p. 97, for the significance of the lyre in the central scenes of Orpheus and the precedence for in the Mantuan song tradition that includes Poliziano's *Fabula d'Orfeo*. See also Celletti, *Voce di Tenore*, pp. 24ff.

[89] See above, pp.101f.

[90] See above, pp. 96f. Celletti, *A History of Bel Canto*, pp. 26f.

Tomlinson's *Music in Renaissance Magic. Toward a Historiography of Others.* In a chapter called "Monteverdi's Musical Magic," Tomlinson considers several madrigals of Monteverdi: from Book IV, of 1603, *"Sfogava con le stelle,"* and from Book VIII, of 1638, the same year as Galileo's *Dialogo, "Lamento della ninfa."* It is the latter which is of interest to us here. Eschewing a hermeneutic account of Monteverdi's practice in favor of an "archeological" one following Foucault, Tomlinson sets his sights on the "emblematics of the late Renaissance madrigal."[91] And in that context, with reference to Ellen Rosand's "The Descending Tetrachord: An Emblem of Lament,"[92] Tomlinson examines the employment of the descending tetrachord as an "ostinato emblem" connected to the lament. The connection has "no higher hypostasis" to which both refer and rely on for their meaning. "Their connection is not founded in the given similitudes of things...Instead the ostinato, in this particular usage, established for itself a new and arbitrary connection between the world and a deontologized language. It exercised the authority of language, conceived as a human devised collection of signs, to order and name the world. The ostinato is an emblem that does not resemble, in short; it *represents*."[93]

For Tomlinson, "the absence of resemblance between the ostinato emblem and what it signifies in the *Lament* calls into question the magical basis of knowledge." Seen in the light of an "ontology of similitude" of Foucault, there is a "shift to a new ordering of knowledge based on the autonomy of language from the world and its resulting representational power."[94] At the "archeological level," the ostinato in question has a "nonmagical use;" it is "Monteverdi's new type of sign" which cannot close the "chasm of representation" between it and what it signifies.[95]

Our sketch so far of the Baroque formulation of consciousness can hardly count as an ontology of similitude nor even as a hermeneutics of versimilitude (although neither are excluded by the present study).[96] As conceived here, the Baroque formulation historically roots itself in a Classical assumption that the "real" is somehow accessible to ordinary experience, but which introduces a number of other, quite distinct, assumptions peculiar to it so that, rather than a "chasm of representation" there is a non-mimetic, indicational-appresentational relation between "sign" and "signified," so that indeed the verisimilarity in its decorum is not a resemblance, but instead a *least*, or even an oppositive, resemblance.

Accordingly, the descending tetrachord—or any of the other practices mentioned of Monteverdi (and others)—is a compossible "resolution" of

[91]Tomlinson, p. 237. In the preceding pages Tomlinson makes a strong case for his "archeologies" over against other approaches.

[92]*Musical Quarterly*, pp. 346-359.

[93]Tomlinson, p. 240.

[94]*Ibid.*, pp. 240f.

[95]We have already referred in this connection to the practice of the ostinato or ground bass above, pp.88f., 105..

[96] Thus we are far removed from Lawrence Ferrara's *Philosophy and the Analysis of Music,* or Bruce Bensen's "Improvising Music: An Essay on Musical Hermeneutics."

sensory evidence—sensory evidence ("aural figure") which is the appresenting vehicle that least resembles what is indicated ("signified"). It is in this sense "mathematical" and in the same sense as are Galileo's laws of motion. Moreover, it is not so much that the use (e.g., of the descending tetrachord) is "nonmagical;" the "magic" is after all a modality of the fantastic rather than the icastic image. And the "image" remains fantastic, does not for all that become icastic because it does not rememble, or because it least resembles. Indeed, throughout the discussion of the development of the Baroque formulation of consciousness the argument has been precisely that it is of the very nature of the fantastic and marvelous that it least resembles not what it represents but what it *indicationally appresents* under the mimetic epoché, *an essential feature of self-interpretation on the part of ordinary experience*, in a room-milieu indifferent to reality or ideality. In this connection we can reconsider the "lament of the nymph" as well as yet another example, just as contemporary with Galileo's *Dialogue*, namely the duet at the end of Monteverdi's *L'Inncoronazione di Poppea*. The latter is even a better example, perhaps, although as we shall suggest, Monteverdi's sign is not really so new.

Caccini's *Le nuove musiche* of 1602[97] lists three models of the new style of composition: through-composed madrigals with an embellished vocal part above a supporting chordal bass; strophic songs based on dance-like rhythms, and virtuousic vocal variations over a strophically repeated and melodically moving bass. Leaving aside the development of the ostinato bass,[98] we can generalize its role (following Peri) in a certain way for our purposes: a bass note and chord accompany notes set to the syllables of (intoned) speech in a way that is consonant with the syllables, and the bass note and chord remain fixed while the voice moves on through the syllables that are not sustained; the bass and harmony change only when, e.g., the singer or singers reach a new and sustained syllable and then the syllable is accompanied by a consonant bass and harmony. The frequency of voice meeting with the consonances built upon the bass varies according to the affection to be expressed. Thus when there is greater frequency the notes of the bass are changed more often to meet the freshly intoned syllables, or when sorrow or grief are expressed, fewer syllables are intoned and the bass moves more slowly.[99] Accordingly the plausibility of the verisimilitude lies in the bass and its greater or lesser frequency meeting freshly intoned or sustained syllables, much like the larger or smaller segments of the visual grid or veil in painting. The "aural pyramid" is cut by the bass and its chords in much the same way that the "visual pyramid" is cut by veil or grid in function of the particular *istoria*:

"The voice is not hindered by contrapuntal obligation to other parts. So it is free[100] to declaim the text according to speechlike accents and durations,

[97] In Angelo Solerti, *Le Origini del Melodrama* (Torino: Fratelli Bocca, 1903), pp. 57ff. See also Lippman, *op. cit.,* pp. 37ff.

[98] Traced in Leopold, Chapter 3, pp. 104ff.

[99] See Palisca, *op. cit..*, pp. 431ff. ; Leopold, pp. 106ff.

[100] See Harnoncourt, *The Musical Dialogue*, pp. 29ff., who insists that the "freedom" to declaim lies in a distinction we have to make between the work itself and the

hurrying and hestitating in imitation of the character and passion. ...An almost random mixture of consonances and dissonances among the nonintoned syllables diverts the mind from constantly anticipating resolution of dissonance into sweet concordance. The listener's attention is thus directed to the messsage of the text, as it would be in hearing ordinary speech,"[101] just as the viewer's attention in painting with the *prospective artificialis* is directed to the scene of the *istoria* as it would be in ordinary seeing. Thus the style of *"recitar cantando"* emerges where the voice of ordinary speech in continuous motion is appresented by pitches chordally accompanied and the passing notes between them.[102] And this brings us to that ever intriguing tetrachord of the accompaniment. And this is, even more, a special case where the chords are apprehended as separate entities, and melody is reduced to pitches: an ostinato bass. This is quite different, compositionally, from, e.g., "walking basses" with their strict rhythmic structure prevailing over the development of the melody (as in *"Qual honor di te fia degno"* in *L'Orfeo*).[103] According to Leopold "it was only around 1625 in Venice that the clearly defined rhythmic and melodic bass patter, which had evolved from the ciccona, finally brought to the ostinato vocal compositions that feature (already seen in the 'walking' basses) which was to become their main characteristic in the centuries to come: the tension between dependence and free development, between a strict musical form and unlimited declamatory possibilities, between the plain simplicity of the fundament and the melodic exuberance of the vocal line."[104] And that "melodic exuberance" of the vocal line led to "melodic abstraction and an instrumental character" which were special traits of dance basses, and from them to very short ostinatos lacking even rhythmic definition, comprising but a few pitches and which in no way bound the vocal part so that it acquired the greatest possible freedom. Thus we go from the melodically moving bass to the rhythmic bass to the ostinato of but a few pitches.

Short ostinatos now consisted of four, at the most, eight notes; and these had to be organized such that the *"recitar cantando"* had melodic as well as declamatory freedom. Descending tetrachords were an obvious solution to the organization in major and minor forms. "Detached from any connection with a complete melody, the tetrachord could then prove its inexhaustible applicability. It became the most popular of all the ostinato basses in the seventeenth century; in comparison, cadential formulas were rare."[105] That is to say, we have arrived at a context which is the "simplest" (or the "complete abstraction," Leopold). The ostinato bass becomes a "harmonic cage" (Leopold), the sonic equivalent of the grid or veil in painting, or the formula of functional dependence of space and time.[106] And this is precisely the case with the *"Lamento della Ninfa,"*

performance. See below, pp. 209f.

[101] Palisca, p. 432.

[102] For this distinction, see Celletti, *A History of Bel Canto*, pp. 7, 15, 26, 32f.

[103] See Leopold, pp. 108f.

[104] *Ibid.*, p. 114. But see Harnoncourt, pp. 30f.

[105] *Ibid.*, p. 117.

[106] See Harnoncourt, pp. 129f., who discusses the ways in which *"the same bass* was

which Leopold puts into the same group as other compositions of Monteverdi and contemporary Venetian musicians. It is here not so much the compositional technique that is of interest to us in connection with the Baroque formulation of consciousness as it is the consequence of the tetrachord bass. In this connection we can turn to *L'incoronazione di Poppea* and several points made by Leopold which will supplement from a different angle Tomlinson's comments.

Monteverdi employs the tetrachord basses a number of times in *L'incoronazione*, but especially in the concluding duet, *"Pur ti miro,"* where the result of the tetrachord, as the sonic grid, is clear: "All three passages are based on the major tetrachord, which tends more strongly towards tonal harmony than the minor one. Whereas the 'bocca, bocca' passage in the Nerone-Lucano duet still vacillates throughout between modal and tonal sonorities, the final duet has completed the sweep towards tonal harmony."[107] And this is what is important for the compossibility of Baroque formulation of consciousness, aside from the coincidence with law of motion in the *Dialogue,* as well as aside from all "archeologies" and "ontologies." In the duet, like the arrow shot into the air and landing I know not where, "the flight of the lovers towards one another is represented in music; this passionaste drive, which could scarcely be held in check, could best be given a form by means of the seemingly unaffected ostinato. ...The return of the *da capo*, however, intervenes and the breathless ecstacy of the beginning—on the descending tetrachord—is brought back."[108] One of the further results is that the descending tetrachord is like the invariant and permanent formula of motion: just as the mathematical formula expresses how change in time hangs together with change in distance, so the ostinato tetrachord expresses how conjoint and disjoint motion of the upper voices hang together in "the completed step towards tonal harmony." We can also say, with Tomlinson, that, as in the case of *"Lamento della Ninfa,"* the ostinato bass is an emblem that orders and names the world. Even granting that, instead of calling into question the "magical basis of knowledge," however, it is precisely that "magical," or "fantastic" basis that is established, just as is the case with the formula $s = 1/2\ gt^2$. It is then rather the absence of resemblance, or least resemblance, that *establishes*, rather than questions, the basis of "knowledge," just as it does with the formula of motion. They are fantastic images that appresent indicationally and not by means of resemblance. They are therefore properly, and now in a specifically Baroque sense, "mathematical." Indeed, "mathematics" is now almost synonymous with "fantasy." Represented non-mimetically, they confirm in practice the "truth" of what is already recognized, heard, just as the *prospectiva artificialis* appresents what is confirmed by sight.

Phenomenologically, the Baroque formulation of consciousness is *neither an ontology nor a hermeneutics* of mimesis and catharsis, or of

harmonized differently"—different harmonic solutions even when the "same voices are supplied" and, we may add, just as the vanishing point can be different for the same scene depicted in a painting with a correlative change in the grid or veil.

[107] *Ibid.*, p. 119. See below, pp.162. Perhaps it would be easier to visualize—"auralize"?—this situation if one has in mind "What child this is" of Greensleves, which is built over a descending tetrachord yielding its own peculiar harmonies.

[108] *Ibid.*, p. 120.

similtude (verisimilitude). The implication is then that the ontology and hermeneutics be founded in the phenomenology of consciousness, specifically of Renaissance and Baroque consciousness. The compossible principle of truth by least resemblance (Descartes) or even by opposites (Galileo) require a very different understanding, for instance, of Tomlinson's favorite, Emanuele Tesauro whose "Aristotelian Telescope" points out a mannerist window already familiar to us.[109] Roughly speaking, our distinction between icastic and fantastic images corresponds to that between non-ingenious and ingenious speech. The latter, we might say, involves the telescope as a linguistic grid, a "calculus through which the identities and differences of the world were gauged."[110] Despite the fact that the "telescope" is Aristotelian, hence taxonomic, the formulation of consciousness underlying it is Baroque (and Mannerist) in its treatment of the *argutezze,* the conceits of the soul, which, like the *sprezzature* in singing, animate the re-creation and fable of the world. And this is true even of Tessauro's "infamous conclusion that 'the singular honor of *argutezze* consist[s] in knowing how to lie well—l'unica lode delle Argutezze, consistere nel saper ben mentire'."[111] But what is "lying well"?

The answer is perhaps obvious. Tesauro, referring to a compossible case in architecture, compares the illusion generated by the accumulation of conceits in verse to that in architecture such as the false perspective of colonnade in the courtyard of the Palazzo Spada.[112] Or we may add the "illusion" of parallel lines meeting in space & etc. In all cases, the goal is the reproduction of things in Nature by means of what least resembles them, of the "standard" by the "non-standard," the "true" by the "verisimilar," the credible by the plausible "lie." That is to say, the "lying well" is a self-interpretive experience by least resemblance extrapolated from the very "deceptiveness" of the senses.[113]

Rather than an "infamous" conclusion, Tesauro's expresses the non-mimetic representation of Baroque science and music. Thus in Tomlinson's words, "the *Lament of the Nymph,* <or we may now add, the final duet in *L'incoronazione di Poppea,*> offers the glorious untruth of dramatic representation." Because it breaks the "ontological bonds of speech and music," because the "nymph's is a song *about* the world," a "new world" is revealed by the *Lament of the Nymph* but just as it is by the earlier *L'Orfeo,* just as it is by the laws of motion or the *prospectiva artificialis.* And in the context of the present discussion, to say that the nymph's or Orfeo's song or the duet of Nero and Poppea, is *about* the world is to say that it is a fable, a version of the

[109]Tomlinson, pp. 207ff. provides a remarkably succinct and fascinating account of *Il cannocchiale aristotelico* of Tesauro. Cf. also Maniates, pp. 26ff. on Tesauro and Gracián; and Hauser, *Mannerism,* pp. 297ff. See also Tomlinson, *Monteverdi,* pp. 223ff.

[110]Tomlinson, pp. 211. The icastic images belong to the "plain, grammatical, proper, and dialectical manner," the fantastic to the "rhetorical, poetic and figurative manner" (p. 210).

[111]*Ibid.*, p. 211; see p. 242.

[112]See Hauser, p. 298.

[113]See above, p167.

Albertian *istoria* seen and heard through the grid or veil that is the appresentational window. At the same time, "lying well" points once again to the gap between the fable that is science, painting, architecture and music and ordinary experience to which, somehow, it is accessible. The formula of motion, the *prospectiva artificialis*, the ostinato bass of short, descending tetrachords, are the invariant and permanent means of access to the appresented "conceits of the soul" the medium of access to which is the *stile rappresentativo*.

Life at the Gap: Verisimilitude and Truth

"Truth by least resemblance" is the principle at the center of the appresentation of the "real." We have sought out its compossibility in the sciences and art and music, and there would seem to be nothing to preclude our seeking it in literature and theatre as well. The verisimilar is, of course, not the truth, no matter how plausible. But on the Baroque formulation of consciousness, it is not a question of *either* verisimilitude *or* truth. Instead it is a question, in science or music or poetry or painting, or what have you, of how plausible verisimilitude may appresent the truth. Yet to say that much, to distinguish between verisimilitude and truth, signifies that we already apprehend the truth appresented either mimetically or indicationally.

The chief idea at issue here is that on the Baroque formulation of consciousness, the plausible verisimilitude indicationally appresents the truth, the "real." It is not the case, I submit, that fantastic (or "magical") images appresent the plausible while icastic images the true, thus that there is necessarily the difference between science and arts, music, literature. The difference between verisimiltude and truth is not a difference because one, e.g., science, alone concerns truth, while the others, arts, music, literature, concern the verisimilar. *Each* is a case of "the real decreed" because extrapolated from ordinary experience, i.e., oriented to human behavior.[114] Indicationally, the fantastic and marvelous appresents the "true," the "real decreed" (the appresented). The "difference" between verisimiltude and truth is an appresentational one on the Baroque formulation of consciousness. Or, as we shall express it shortly,[115] the verisimilar is the means of access to the truth. Verisimiltude and truth are twins, similitude with a difference but such that one cannot tell which of them brought its similtude to the other (Paracelsus).

And therefore each, the appresenting and the appresented, is independent, self-sufficient, self-inclusive; they are "enclaves" allowed for in the first place for by the very taken-for-granted ungroundedness of the ontic conviction of ordinary life. In short, each is a case of the gap in our technical sense between ordinary experience and science and music (opera).[116] But it is also a case of the gap in the sense of Nikolai Kusmitch when the orientation to

[114] Cf. Plessner, p. 157.
[115] See below, pp. 196f.
[116] Above, pp.93, 102.

ordinary experience is precluded or lost, when but one "enclave," e.g., of science, goes bail for the others, when the principle of compossibility disappears and the verisimilar no longer appresents the truth everywhere.

The compossibility of the principle of "truth by least resemblance" holds equally for science and the arts, equally for icastic *as well as fantastic* images. What is then at issue is the principle of compossibility and not the distinction between verisimilitude and truth.[117] On the Baroque formulation of consciousness the distinction is taken for granted, and its taken-for-grantedness does indeed have a history, eventually leading to yet another formulation of consciousness.

The task is then to examine from yet other angles the compossibility of the principle of truth by least resemblance under the mimetic epoché. The place to begin is the formulation of compossibility in the late Baroque as found in Leibniz and then testing it with a set of examples not so much in the area of mathematics but instead in the continuing development of the aesthetics of opera.

But then what about Orpheus/Euryidice and Nero/Poppea? At first both Orpheus and Nero appear to be narcissus-figures, fantastic images locked into their separateness— Nero who rids himself of Ottavia, Orpheus who loses Euryidice and condemns all women. But that is not how it turns out: each overcomes the separateness: Orpheus by abandoning himself to Apollo overcomes the separateness and discovers the *"sembianze belle"* of Eurydice *"nel sole e nelle stelle"* (or, in the case of the ending of Striggio's libretto, Orpheus discovers the *"Dea che Cipro honora <i.e., Venus>"* in the Bacchic fury that descends upon him, achieving sleep and forgetfulness of all ills.[118]); Nero who gazes upon Poppea, rejoices in her, chains her to him, who suffers no more nor dies, who has ordered the sun to fit into her eyes so that it has shrunk in size and even the dawn has forsaken the sky. Both, Orpheus and Nero, are binary figures with twofold enthusiasms for being enchanted by the twinned but dissimilar.[119]

And what about Eurydice? Ottavia? These are cases, as Hauser might say, of the femininist variety of narcissistic types. Eurydice, who starts out without having a heart within her because it is beating with his in the unison of loving *("Ché non ho meco il core,/Ma teco stassi in compagnia d'amore")*, ends because of too much love such that the separateness is reasserted to the extent that she loses the power to enjoy light, the victim of Orpheus conquered by desire which, instead of overcoming separateness, creates it. Or, Ottavia, exiled, so separated that were there no "honor and no god" she would be her own god, whose heart is divided "between innocence and lamenting" *("divido il cor tra l'innocenza e'l pianto")*. In contrast, Poppea's heart is Nero's: *"l'idol mio, tu sei pur/ sì mio ben, sì mio cor, /mia vita, sì, sì."* And Nero-Hermes finds that his destiny is determined not by the gods but by the kiss of Poppea's "rubby lips;" and Poppea herself—a feminine variety of Hermes—hears the words of Nero as

[117]For a discussion of the problems inherent in the discussion of truth and verisimilitude, see A. J. Ayer, "Truth, Verification and Versimilitude," pp. 684-692.
[118]See Whenham, *op. cit.*, pp. 39ff.
[119]See above, pp.133.

though they were kisses and stamps the kisses in her heart *("Come parole le odo,/come baci io le godo;/son de'tuoi cari detti/i sensi sì soave, e si vicaci,/che, non contenti di blandir l'udio,/mi passano al stampar sul cor i baci")*. In short, they are doing exactly what they wish (which is about as obsessively Marinist and Narcissistic as one can get).[120]

So the fantastic images of Nero, Orpheus, Poppea, Eurydice. The cases of Nero/Poppea at the end of the opera, and of Orpheus/Eurydice at the apotheosis, are emblematic of the "gentle kiss and the bite." The kiss, serious action at the center, is that datum of ordinary experience accessible to the "real." Moreover, as a "deviation" from Nature, as a twinned but dissilimilar opposite of Narcissus, it is something that happens by chance—either a chance won and then lost (Orpheus/Euryidice), or a chance taken and consumated (Nero/Poppea). As we shall see, the Baroque "kiss," the serious action at the center of ordinary experience, will prove to be the limiting case of action rather than the standard case. In the case of the "kiss," what happens when push comes to shove?

[120]Above, p. 6.

CHAPTER SEVEN

Baroque Twins: Science and Opera: The *Fin Lieto* of the Baroque Formulation of Consciousness

Like other works of the period, Monteverdi's *Favola d'Orfeo* is also called a "*tragedia.*"[1] But unlike other works of this period it does not rub in this fact by opening with a Prologue sung by "tragedia." Still, the inventors of opera, like their contemporary playwrights, certainly believed they had revived or even re-invented Greek tragedy, and perhaps with good reason.[2] Of course, even though the plots of operas were drawn from the still well-stocked shelves of ancient tragedy, like other works of the theatre they were often tempered with an apotheosis comprising a *fin lieto*. Perhaps the most generalizable and favorable judgment about the revival and reinvention would be that of Schrade who insists that the term, "*tragedia,*" would now seem to denote a characteristic of the "human condition" rather than works comprising a literary genre.[3] Or we might even say that the "human condition" has itself become a new literary genre. Auden's caveat is worth repeating here because it expresses Schrade's point in yet another way: "in a sense, there can be no tragic opera because whatever errors the characters make and whatever they suffer, they are doing exactly what they wish. Hence the feeling that *opera seria* should not employ a contemporary subject, but confine itself to mythical <*slc.* fabled or fabulous> situations, that is, situations which, as human beings, we are all of us necessarily in and must, therefore, accept, however tragic they may be."[4]

After all, the theme common to Baroque opera—and to opera in later centuries as well—is that of human passion and love, indeed of unrestrained passions culminating in human suffering and violence more than likely to be resolved "erotically." The passage and resolution of such passions presuppose the very idea of the Baroque theatre in which Divine and human orders of events mutually work themselves out dramatically. Thus Bacon's notion that the theatre is the "mirror of life," that life is a theatrical spectacle, or even Calderón's idea of the world as a great theatre in which actors perform our lives before God, or Monteverdi's statement that his *Favola d'Orfeo* "is now to appear in the great

[1] See above, pp. 96f.
[2] See especially Hanning, *Of Poetry and Music's Power*, pp. 136ff., and 174ff., who finds the treatment of the chorus quite similar to that of the Greeks, a treatment that persisted even into the works of Handel; see Reinhard Strom, *Essays on Handel and Italian Opera*, pp. 233ff.; Tomlinson, *Monteverdi*, pp. 136ff.
[3] Schrade, *Tragedy in the Art of Music*, p. 57.
[4] Auden, *The Dyers Hand*, p. 468; cf. Leopold, *Monteverdi*, p. 208 (cited note 9, below.)

Teatro dell' Universo, to reveal itself to all mankind,"[5] all embody the non-mimetic principle of presentation of the Baroque formulation of consciousness: the theatre itself is the means of access, the "window," to the "true idea" of human life because what transpires through the "window" least resembles the Divine "authorization" or, as we said before, "planification."[6]

<center>*The Gentle Kiss and the Bite*
(Joy and Malice)</center>

That is to say, the human order, if we may speak that way in a post-modern era, expressed by the theatre, presents its opposite, the "natural" and non-spectacular order of Divinity. It can hardly be an accident that the Baroque ruler, who believed that she or he governed by means of incorporation into the Divine order (how "seriously" or not is another question), saw herself or himself celebrated and glorified in opera and in the theatre generally.[7] Perhaps it would not be going too far to say that the Galilean-Cartesian presentive principle under the mimetic epoché was peculiarly suited to such celebration and glorification. Thus the operatic libretti, as Schrade points out, were a *"dramma musicale regio e politica."*[8] And, phenomenologically, the less the resemblance, the truer the presentive idea of Divine incorporation.[9] So that in Baroque opera the greater the *meraviglia* and *prospectiva artificialis*, the greater the exaggeration, distortion and the like of the character, the truer the idea indicationally appresented. And to that extent the characters, for instance, are favored by fortune. But with respect to the same principle, the spectacles of great kinds and princes, great architecture, exotic lands, gigantic land and sea battles, magnificently displayed events, do not involve so much as the play of the real vs. the unreal, or of *memento vivere* vs. *memento mori* (Schrade) as they do the

[5] In the dedicatory preface to the first printed edition (1609); cf. Schrade, pp. 59f.

[6] Above, pp.143f.

[7] In this connection, see Drummond, *Opera in Perspective*, pp. 142f. The very nature of the Baroque theatre (see above, pp. 197ff.) allowed for a "similarity between life on the stage and life in the auditorium" and "the chief actor might not, indeed, be a person on the stage, but the prince or king in the audience...the designs of theatres of this kind show a deliberate intent to blur the distinction between stage and auditorium." And, of course, the proscenium arch became the "window" in and through which the *istoria* presented itself.

[8] Schrade, *op. cit.*, *ibid.*; see also Strom, *op. cit.*, pp. 235ff.; Leopold, *Monteverdi*, pp. 184ff. who provides detailed (often contemporary) descriptions of the scenarios of tourneys, ballets, operas in the context of celebration and glorification of rulers on a wide variety of occasions (with careful attention given to differences between repertory and festive court operas and ballets). This was also shared by the performance of *intermedii* decades before; see Maniates, pp. 461ff.

[9] The "historical" personages are all reworked, to be sure, in a mythological setting; see Celletti, *A History of Bel Canto*, pp. 36, 189, 190. For Celletti this is one of the characteristics of Baroque opera that distinguishes it from "Romantic" opera.

play of opposites, one of which is the (least resembling) true idea appresented indicationally by the other.

The play of opposites centers around the ways in which love (eros, amor) is at work at the beginning of the drama penetrating and disrupting glory and honor (the conceits as well as the deceits of love, such as feigned innocence, disguised depravity) producing a *commozione d'affetti* is produced but only then at the end to be resolved by love whereby the characters end up, as Auden (along with Plessner) says, "doing exactly as they wish."[10] Too, there are limitations, such as the intervention of Amore, for example, in *L'incoronazione di Poppea*: Amore is the "only god who does not merely serve as an ornament, but intervenes at a decisive moment in the action."[11] And there are other developments in *L'incoronazione:* the declamation is determined by passions independently of social status (in contrast, for instance, to *Il ritorno d'Ulisse*); the same musical form portrays servant roles, but also joys of earth and heaven, of sensuality and love, and various states in between; there are dance-like rhythms and declamations interspersed with recitatives and coloraturas. Thus in the first scene with Poppea, Poppea seduces Nero and gets him to promise to marry her. In a classic case of push come to shove, the rather hesitant Nero is forced by Poppea's questioning to complete the crucial sentence to divorce Ottavia, and "when she finally has him where she wants him, she breaks out in a dance-like song in which it is impossible to distinguish between joy and malice"[12] — or, as we may say, it becomes impossible to distinguish the kiss from the bite. "With its idea of a 'passionate' musical language <*L'incoronazione di Poppea*> was, as with so may of <Monteverdi's> late works, more of a full stop than a beginning. With opera's preference for closed musical forms, independent of the character involved and his or her social position, it soon thereafter took off in other directions"[13] and, we may add, the exemplary case of the closed musical form is at the very end of the opera, in the final duet on the tetrachord bass, *"Pur ti miro,"* which "is regarded as one of the first *da capo* compositions in the history of opera" (Leopold). The phrases are fragments of intoxicated delight, each a double or twinned, yet dissimilar, image of the other: the binary optics of the Baroque Hermes.

[10]This is especially so in Monteverdi's *L'incoronazione di Poppea*, where, even though gods intervene in the action on occasion, "they have lost their command over the course of the action" which, as Leopold goes on to note, is "one of the most important innovations of historical subject-matter, as it was equally possible to delineate characters and to portray human behavior in mythological works as in historical ones" (p. 208). In the discussion that follows, we can safely ignore the thorny question of the authenticity of the score and text (see Ellen Rosand, "Did Monteverdi write *L'Incoronazione di Poppea* and Does It Matter?" in *Opera News*, July, 1994, pp. 21ff.), because whether written by Monteverdi or Ferrari or Laurenzi or Sacrati or Cavalli, it still exemplifies the compossible aesthetics of the Baroque formulation of consciousness; see Harnoncourt, *The Musical Dialogue*, p. 35.

[11]Leopold, p. 208.

[12]*Ibid.*, pp. 208f. (example from Act I, scene 3 on p. 209).

[13]*Ibid.*, p. 215. For the "other directions," see Robert S. Freeman, *Opera Without Drama. Currents of Change in Italian Opera 1675-1725*, Chapter 1.

It is just these two features which point again to the Baroque formulation of consciousness. The "closed musical form" is compossible with the "closed mathematical form" of the expression of the law of motion which informs us of *motion itself*, apart from the agent of motion.[14] In just the same way the "closed musical form" of the da capo informs us of the "kiss and bite," of the joy and malice, independent of the social status of the character. *But this signifies that the gap has reappeared between the agent of action and of passion, i.e., between that from which the appresenting medium of the "true idea" is extrapolated and the "true idea," the "real," itself.* Passion and action, more generally, being in the world eccentrically, along with the stock of knowledge at hand have been transformed and rendered superfluous. This is because the enclave of ordinary experience itself, with all its deceptiveness, is altered such that it no longer provides a facet in its specious present from which the "real" is extrapolated and to which the "real" is accessible.[15]

The "fabled tragedy" of the Baroque formulation of consciousness takes on a shape quite distinct from antique tragedy in the Classical formulation of consciousness. Not only are the passions independent of the eccentricity of daily life and social status, but they are dominated by love and therefore forcefully conflicting or, to use a phrase of Giordano Bruno,[16] they are "heroic passions" of which the exemplary case is the marinist "gentle kiss and a bite," or "joy and malice." As it were, they are the "best possible" passions found in the on-going course of Baroque opera that "soon took off in other directions" after *L'incoronazione di Poppea* with the almost mandated "*scena di forza*," of heroic and forcefully conflicting passions yielding access to the "original" dramatic action in its agonic tragedy. But what governs and motivates all other passions, what drives the characters of Baroque opera to violence, war, is the one dominant passion: love, the "gentle kiss and the bite." In Leibnizian terms, love is that "best possible" passion which is also realized.[17] Differently expressed, with love dominant at the beginning and at the end, the war of passions rages throughout usually reinforced by the conflict of ambition, collision of desires with obstacles. The "closed musical form" is set in a *bellum musicale* that offers in musical parataxis image piled upon image of jealousy, wrath, war-like fortitude, misery, pain, suffering.

To develop this further, and the idea that the compossible "closed musical form" operates like the Cartesian cogito in "rendering reality" which is not obvious, we need to take advantage of the reference to Leibniz, and return to the "circle" and its *mezzanità* for, hurray, one last time.

[14]Above, pp. 161f. The room-milieu has become completely "disenchanted," as we expressed it before, p. 161. We shall return to the room-milieu, below, pp. 195f., and with a more precise formulation of "disenchantment." For Galileo in this connection, see Wallace, *Prelude to Galileo*, pp. 288ff.

[15]See below, pp. 204f.

[16]See Schrade, *op. cit., ibid.*; Giordano Bruno's *Degli' eroici furori* (1585) discussed by Cassirer in *The Individual and the Cosmos in Renaissance Philosophy*, pp. 185ff.; Panofsky, *Studies in Iconology*, Chapter IV; and Tomlinson, *Music in Renaissance Magic*, Chapter 6.

[17]See above, pp. 101f.

Circles and Ellipses, Push and Shove:
Correlates in the Life-World

When push comes to shove, joints but also muscles are needed at the center. "Force" or "attraction" has its place, although in ordinary experience it is not always a satisfactory explanation. For instance, when I throw a snowball or when, inspired by Myron, I throw the discus, I explain the behavior of snowball or discus by saying that they were "attracted" by the objects struck, or that they were impelled by a "force." I much prefer the "attraction" explanation because it need not impute a "cause," thus allowing me the dignity of denying that I am responsible for what happens. The experiential datum in ordinary life from which the appresentation of force is extrapolated is push come to shove, while the datum from which the appresentation of attraction (or repulsion) is extrapolated is rather push and pull. We are accordingly returned to an issue raised in an earlier chapter concerning push and shove and throwing things at someone or something else.[18]

The issue in question is precisely that of the self-interpretation of human action body, "working," at the center of the manipulatory zone of the world within actual and potential reach[19] and which will serve as a privileged datum for extrapolation of the "real," in this case, cosmic motion. Following the Keplerian view the self-interpretative datum is one of ellipses, while following the Galilean view it is of circles. With snowball or discus, I whirl around and release the projectile toward its intended target, and this example of the life of the body geared into the world within actual and potential reach becomes a datum extrapolated for appresenting the motion of the "real," whereby it is equally plausible for motion to be circular or ellipitcal. Or, in the words of Alfred Schutz, the motions of muscles and bones are "correlates in the life-world" of what transcends the life-world. With Galileo and Kepler, however, it is a case of "either/or" as Panofsky noted, even though both are characteristically Baroque examples of the far (celestial motion) read off the near (terrestrial motion, especially that at the center of the world within reach). But which is the "plausible" datum? Push come to shove? Push and pull? By what criteria do we choose either the one or the other of the equally plausible correlates of the life-world to celestial and terrestrial motion?

Yet for the final version of the Baroque formulation of consciousness, strange as it may seem, the question of the "either/or" of two equally plausible, self-interpretive privileged data of ordinary experience is moot. It is so for several reasons.

Until I knew better, as a child I was always under the impression that whenever I tried to cross the railroad track in front of the train approaching along a straight track, it seemed that the train increased its "speed" to spite me, just as the train seems to appear through varying sizes "rotating" around a continually changing "axis of sight" until the visible surface lies in a plane

[18]Above pp.90f.

[19]See above, pp52f.

roughly perpendicular to the line of sight.[20] Rescuing my physics book once thrown in the dumpster, I discovered, however, that the snowball or discus suddenly released zooms off at a tangent to the "radius vector" at the point, well, where it goes off; the motion of the snowball or discus is inertial and uniform, the acceleration in relation to the center of revolution is an illusion: there is no force to accelerate the snowball or discus (or train, unless there truly was a malicious engineer in the locomotive as some supposed). Of course we can say, with Newton, for example, that there does have to be a force which is constant, a "centripetal force," to retain the discus in the circle described, e.g. by the body in launching the discus. Yet to reach the law at work here, we really do have to employ the fantastic image, i.e., "imagine the body being constantly accelerated inwards from the tangent (where it would otherwise be) to its position in the circle."[21] In other words, it is a perfect case of that *mezzanità* with which we are familiar in the previous chapters on the Baroque formulation of consciousness.

But what is that circle? Are we back into the Kepler/Galileo dilemma of circle/ellipse? Is it the case, as it would seem—and here we can bring in the heavy armament not only of Newton but also of Huygens—that it is the "circle," i.e., the motion of the joints, which is the privileged datum of ordinary experience from which we extrapolate the "standard" case of motion, of gravity and centripetal and centrifugal force? Or is it the ellipse? But the latter seems absurd, strange, and forces an appeal to Leibniz, for whom, as we shall suggest in a moment, the circle is nothing but a limiting case of the ellipse, the joints are nothing but the limiting case of "straight muscles stretched from here to there,"[22] that is, of push and pull. *What has become absurd, strange, is the idea that the one correlate in the life-world is the limiting case of the other, that push come to shove is the* limiting *case of push and pull.* Yet, what is the "strangeness" of the life-world, the world of ordinary experience?

Because my old physics book was no help here I bought another and more recent one at a local bookstore. Looking up "strangeness" in the index, I turned to a page which informed me that the "S quark" carries one (negative) unit of a property, and that this property is properly called "strangeness." Worse was yet to come: I also learned that the strong nuclear force acting between quarks carries a property called "color." I had been in trouble over this before, and I was not about to seek a suit with a "red" or "yellow" or "blue" nuclear force. Here, more than ever, the gap between ordinary experience with its correlates of the life-world and scientific thinking is present, yet irrelevant as much to ordinary experience as to scientific thinking. Gravitational and even electromagnetic forces can be dealt with in the light of the gap with ordinary experience, but not weak and strong nuclear forces.

Kepler, after all, did not need the last two to get him elliptical orbits, extrapolated from the stretching of muscles or indeed from the very eccentricity of ordinary experience; no more than social action, with its pauses and interruptions, does the datum from which are extrapolated the appresenting

[20] See Kersten, *Phenomenological Method: Theory and Practice*, p. 204.

[21] Hall, *op. cit.* p. 298.

[22] Above, p. 90. See also Alexandre Koyré, *Metaphysics and Measurement: Essays in the Scientific Revolution*, pp. 96f., and p. 97, note 1.

medium of the planets moving around the sun need be "eccentric" to it: revolving counter-clockwise around the sun, the "attractive pole" draws the planet nearer to the sun, while the "repelling pole" draws the planet farther away in elliptical orbits. And this is based on the observation of "a numerical congruity between excess of the eccentric circle over the true orbit at the mean distances and the excess of the secant of the optical equation in the same region over the radius, so that the sun was at but one focus of the ellipse."[23] Naturally Kepler could not leave well enough alone and reverted to his geometry of polygons, revising, as Hall points out, the Archetype of regular-polyhedra which yielded not only the "just" musical scale, but the correlation between velocities of planets and musical consonances and so coming to an account of the eccentricities of planetary orbits.[24] With his third law linking velocity and distance, Kepler then had it all up his tree "and in the *Epitome* proportioned the 'masses' of each planet so that the solar spirit (or 'species') would give the right 'push' at the right distance (he supposed that if the 'push' were taken as constant, the speed conferred by it would be inversely proportional to the 'mass')."[25]

The "constant" and "right" push and excesses of eccentricity have their correlates in the push and pull of ordinary experience (e.g., laughing, crying, death, a 9-5 workday, the experience of the earth rotating on its axis, matching coat check with coat, throwing things). Not the least of Kepler's difficulties, though, was giving a "physical meaning to the elliptical orbit" of the planets, such as showing "that the celestial machine is not so much a divine organism as a piece of clockwork, with all the variety of motions carried out by means of a *very simple magnetic force in the body*, just as in a clock all the motions derive from a simple weight."[26] The clockworks are clearly accessible to ordinary experience, and the experience of the push and pull of the mechanism affords data from which to extrapolate the motion of the planets. But it is really the muscles that do so. Kepler finally discovers that push and pull as a "simple to-and-fro motion (libration) of the planet along a short straight line, while it also revolved round the sun in a circle, would generate the ellipse."[27] Here, with the help of Hall, we can see the extrapolation of the appresentation of the ellipse from muscles which stretch, as it were, to and fro, along a straight line e.g., as I throw the discus. Push and pull: stretching of muscles, magnetic attraction and repulsion, motion, velocity. Velocity?

For Leibniz, under the mimetic epoché, velocity characterizes motion, and velocity can be measured, can be given a certain numerical value.[28] Suppose that we begin with a velocity and gradually decrease it until *0*, whereby the

[23] See Hall, *The Revolution in Science*, p. 141; cf. Marie Boas, *The Scientific Renaissance 1450-1630*, pp. 302ff.

[24] See above, pp. 86f.

[25] Hall, p. 142.

[26] Cited by Hall, p. 141 (emphasis mine). For the problem of measurement and clocks, see Koyré, *Metaphysics and Measurement*, pp. 95ff.

[27] Hall, p. 142.

[28] See above, pp.165f.

velocity of zero is rest. In other words, we define velocity so that the extreme case is one falling under a "standard" case or, as we may also say, a general rule. Here rest is not the opposite of motion, but instead a special case of motion[29] rendered mathematically. What about the ellipse where two points are fixed and separated by a distance. There is a moveable point P, and it moves so that $PF_1 + PF_2$ is a constant (where F = the foci):

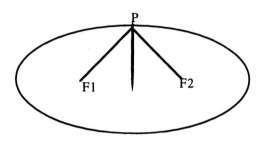

The sum of the distances from any point on the curve, to the two fixed points, F_1 and F_2 remains constant:

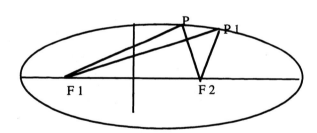

$$F_1 + F'_2 P = F_1 P^1 + F_2 P^1$$

If F_1 and F_2 are allowed to approach each other, are pushed toward each other, and if the distance becomes smaller and smaller, then with every new distance there is a new ellipse. By making the two points closer and closer together we generate not one ellipse, but a whole system of them. If they move toward one another, the limiting case will be coincidence, and if they coincide the ellipse is then a circle: a special case of the "standard" case, *slc.* the ellipse.[30]

[29] Above, pp.161, 162ff.

[30] We shall return to this special case shortly, below, pp. 204f., where it will serve to introduce us again to attempting to "live" the gap as did Nikolai Kusmitch.

Or, if the points move farther and farther apart, are pulled apart, then a parabola is generated: the discus or snowball or arrow released into the air.[31] The significance here is the same as in the previous example of the parabola, of the "standard case" and the exception: a family of ellipses is produced, having a special member, the circle. If, now, we make the radii larger or smaller, whole systems of circles will be generated. But now all systems of ellipses and of circles are interwoven and in a *certain order*, thus no ellipse or circle can be taken in isolation; in a certain order, there is nothing in isolation. The *"hantise de la circularité,"* if not broken once and for all, is only a limiting (and, now, odd) case in the Baroque "fable of the world."[32] There is nothing miraculous when, in pushing and pulling, push comes to shove.

The Last Gasp of the Gap

Certainly the "fable" does not acquire its "universality" until Newton finally universalizes the three laws of Kepler, especially the second and third.[33] The problem buried in the Baroque formulation of consciousness, however, is twofold. In the first place, we are returned to the Keplerian *mezzanità* of the circle, now a limiting case of the ellipse, shrinking into a point; the Keplerian soul becomes a potential circle: the "soulful center" which is the sun.[34] The center toward which everything tends is a limiting case. In the second place, there is the problem of reading the far off the near, in the form of accounting for action at a distance, i.e., the transmission of force at great distances.[35]

Let us turn to the first of the places. It contains, on the Baroque formulation of consciousness, the very general problem of knowledge and its place in the universe. Leibniz had already expressed this universal problem in his "monadology," where each individual monad "mirrors" the whole universe from its point of view; all monads are akin and given as originating from a variation of another monad in analogy with the variations of ellipses and circles. In metaphysical terms of the fable of the world, this is the doctrine of pre-established harmony, where, it would seem, that a) all that is needed is push and pull (variation) without shove (force), and b) that this can be extrapolated as much from the stretching of muscles as from their limiting case, the rotation of the bones in their joints. To be sure, "reality" is accessible only from the center of action and not from the boundary-periphery, as on the Classical formulation.

[31]Above, p. 161.

[32]To be sure, hurray for the "fact" that the planetary orbits turned out to be calculable in terms of the ellipses; after all, Kepler tried out the idea that they were "ovoid," egg-like, but he just did not have the mathematics to accomodate eggs. In despair, late one night he leaned back in his chair and stretched. The aching muscles at that moment gave it all away. See below, p. 205f.

[33]See Hall, pp. 314ff.

[34]Above, pp.86f.

[35]See Hall, pp. 315ff.; Toulmin/Goodfield, *The Fabric of the Heavens*, pp. 260ff.

Pre-established harmony pertains to all monads and simple substances, and signifies that each and every monad contains traces of all happenings in the universe. Thus there is no need to swallow the idea that the "force" of gravitation acts across empty space; all pushes and pulls are always already "pre-established" everywhere in the universe. The question of the transmission of gravitational force is moot with Leibniz, as is the question of privileged, experiential data in ordinary life.

Differently expressed for the Baroque formulation of consciousness: On the Classical formulation, found in Plato, for instance, using Heisenberg's expression,[36] Ideas are the "building blocks" of reality, but they are indifferent to the knowing subject, the soul. That the universe of Ideas is known at all is of no consequence whatever to Ideas.[37] For Plato, there is but one *order-form, slc.* the system of Ideas. The soul, "consciousness," has no order-form of its own; whatever order the soul discovers on the occasion of being in the world is derived from that of Ideas. The "reality" of "consciousness" on the Classical formulation is a derivative (therefore, inferior) one. The latter, the near, is read off the far, the order-form of Ideas. There is therefore no necessary reason why the knowing subject is related to the known, thus the "reality" of "consciousness" is always mortgaged, the relation of soul or "consciousness" to Ideas is always accounted for in terms of myth, i.e., a *fantastic rather than icastic* image. But the fantastic image is a true *mimetic* image, where the reality of Ideas and their order-form is set down in something else without any order-form of its own.[38]

One of the differences between the Classical and Baroque formulations lies precisely in the issue of an order-form of consciousness.[39] Descartes and Galileo, for instance, operate with a formulation of consciousness having an order-form of its own which presents, and, as we say, indicationally appresents, the order-form of the known (thus the distinction between *res cogitans* and *res extensa*). Access to the known, as we have repeatedly expressed it, is always indirect, through consciousness which appresents its opposite according to the law of presentation by least resemblance. The presentation is non-mimetic. Now, on the final formulation of Baroque consciousness, as found in Leibniz, for instance, if *res cogitans* and *res extensa* are not two substances, but more importantly, both are manifestations of one and the same substance—but also as in the case of Alberti's vanishing point, or Kepler's sun, or Monteverdi's tetrachord bass—not only is the order-form of knowing the same as the known, but, more importantly, both are manifestations of the same "substance."

Knowing about itself, consciousness knows about the whole universe; there is an absolute reflexiveness of consciousness which is mathematically but also practically and substantially a "real definition" (Leibniz) of "reality." And if

[36]See Werner Heisenberg, "Grundlegende Voraussetzungen in der Physik der Elementarteilchen," pp. 292ff., and "Platons Vorstellungen von den kleinsten Bausteinen der Materie und die Elementarteilchen der modernen Physik," pp. 137-140.

[37]See Fred Kersten, "Heidegger and the History of Platonism," §3, pp. 277-279.

[38] See above, pp.33f.

[39]Kersten, *ibid.*, §§6, 7.

we now add to Leibniz his doctrine of *petites perceptions*, we arrive at the complete "disenchantent" of the room-milieu.[40] One of Leibniz's examples is that of listening to roar of the sea against the beach, familiar to all Baroque surfers: the roar is clear and distinct only in the mass or the whole; but it is perceptually obscure in details: I do not and cannot hear every drop of water hitting the beach. Thus perceptual experience is ultimately insensible, and that means finally non-intuitable. The intensity of sound of each drop of water lies below any assignable degree, yet by no means are they nothing. They are instead purely intellectual determinations of consciousness, building up our actual consciousness from infinitesimal and continuously added elements. According to Leibniz we can distinguish qualitative degrees of insensiblity from 0 to clarity in the whole. We can construct ideal order-forms such as space and time on the basis of peceptual and apperceptual insensibility.

Suppose, adapting a Leibnizian example from the annual fireman's picnic, we break a piece of rope in half by pulling on each end; pulling harder and harder, inducing greater and greater tension in the rope, we finally pull it apart. How many tensions are there in the rope as we pull it apart? In considering the increasing tensions in the rope as we pull, every effect as each strand snaps can be conceived as the reuslt of still smaller effects, and those in turn as the result of still smaller effects. We can even consider the tensions as "infinitely small," that is, as small as we please, and if that is the case then we have what is called "intregration," a perceptual situation serving as the basis for extrapolating the construction, in Leibniz, of a mathematics of becoming. No data are privileged; they make up the insensible foundation of intellectual construction.[41]

Such is the picture of pre-established harmony, of the fable of the world in which known and knower share the self-same order-form. The gap is characterized by sensible insensibility characterizing the enclave of ordinary life which has now become a springboard for the constructibility of the "physical" world of space and time. "Sensory evidence" of the sort Galileo and Descartes introduced is no longer the means of access *per experimentum* or *per musica* to the "true," the "real."[42] It is rather insensibility of the sensory that allows the construction of the "real." The insensibility of the sensory marks a profound change in the development of the Baroque formulation of consciousness giving its final shape a *fin lieto*.[43]

[40]See above, pp.112, 161f., 188.; Leibniz, *Nouveaux Essais sur l'Intendement Humaine*, Avant-Propos, *Opera Philosophica*, pp. 197ff.

[41]And it is a "fable" in our sense distinguished earlier: the "total plannification" of the "best of all possible worlds," where each *compossible* monad "mirrors" the universe from its own point of view, where knowing and known are of the same order-form. See above, pp. 143f. It follows that the order-form or ordering principle of the appresenting is that of the (indicationally) "appresented" (or: constructed). Verisimilitude and truth share the same order form. See above, pp. 184f..

[42]See above, p. 143

[43] The change is felt perhaps even today. As is known, this idea of consciousness is taken over at the beginning of the nineteenth century by Herbart and his idea of the

198

This brings us to the second of the places: reading the far off the near rather than the near off the far. One sometimes suspects that Leibniz played tennis, for the only sort of "force" he would admit was that transmitted by direct contact, such as racket and tennis ball. (Or was he a fanatic of the pool table, as was Hume?) But how can force be transmitted across millions of miles, or even across the street? There needs to be some sort of push and pull if not push come to shove in this case, at least if we are to hold with gravitation as Newton wanted it understood. And even if Newton thought it sufficient to formulate mathematically the law of gravitation, still we must eventually tackle the problem of accounting for the mechanics of push and shove in the case of celestial motion and the seas. But even so, supposing a push and pull to be found, difficulties would remain, tied up with the whole problem of the "cohesion of bodies."[44]

Within this context there lies another factor. Crazed by the idea of flying, suppose I jump off the roof. Falling, I feel no force pressing me down, but of course down I go, faster and faster (on the way dialing 911 on my cellular phone). Earlier we noted that the standard case of motion was rectilinear motion which, if left to themselves, the planets, like me, would have followed.[45] However, what we find, and the reason why we introduce gravitation at all, and seek to find its "force," is because, like Galileo's cannonballs, we find only the exception. Owing to the action of some force or other, the planets describe an elliptical not rectilinear motion. An oddity of this force is that, however, it is not sensible, nor are data obvious from which to extrapolate its appresentation from ordinary experience. After all, there is no connecting rope, let alone Jacob's Ladder, between earth and sun so that force can be exerted just here, where I am standing at the moment. How can force reach from sun to earth, whereas nothing else can be transmitted: if I shout, the empty spaces shield the sound from being transmitted all that way. I don't feel force when I jump down from the roof. It would certainly seem that we are returned to the idea of push without shove or even pull, although, to be sure, we are no longer speaking of structures that move and of mutually constraining forms, nor are we tied to the heavens beheld at night, nor even at day, nor is rectilinear motion restricted just to terrestrial motion.[46]

Phenomenologically, how then do we take the measure of celestial as well as of terrestrial change, e.g., motion when gravity is introduced as a factor, when just push is introduced without shove? Phenomenologically, is there anything in the Baroque formulation of consciousness which provides a clue—even though the answer may not belong at all to the Baroque formulation? A possible clue lies in the fact that, some years before Einstein, W. K. Clifford suggested that all massive bodies, no matter which, might be the "centres of

"threshold" of consciousness which, in turn, at the end of the nineteenth century is transformed into the idea of the "unconscious" in Dilthey and Freud among others.

[44] Toulmin/Goodfield, pp. 258f. For some of the historical background pertaining to Galileo on this issue, see Wallace, *Prelude to Galileo,* pp. 113ff.

[45] See above, pp. 24f., 161f.

[46] Above, pp. 22f.

regions in which unforced motion <push without shove?> was *naturally* non-rectilinear, and Einstein took this idea up."[47]

Yet we still need to make Newton's assumption. We define force in terms of effort, of work; and effort involves weight and weight can be measured so that there can be a correlation between effort and the weightiness of something. While there is weight in different places, the *mass* remains invariant throughout change (the fate of most diet programs, in fact). Here Newton put Descartes back on the shelf and generalized the situation so that whenever there is force, then there is also accelleration in velocity. This is a nice idea but buried in it is the identification of two notions of mass: 1) mass of inertia, and 2) mass of gravitation. It is now another step to suggest that a mass at one place affects our measurements of magnitudes in its vicinity so that, for instance, clocks do not run at their usual rate when near centers of gravity. Newton may have been too abstract and too precise in his measurements in the sense that such measurements have to be made "using physical agencies—ideally, light signals."

On this view, we may conclude that one "body 'gravitates' toward another along a 'natural' path, and no 'force' comparable with the forces of impact again effects the geometrical shape of a body's natural track...The earth is now a centre of gravitational motion, but not because it is the centre of the universe, but simply because it is a large, massive body; and, in the new picture, *all* such bodies are centres of gravitation." That is to say, Here, in the near sphere, is any Here, any center; any mass can be any center off of which any other center can be read. There are no "fars," only "heres."[48]

What is the datum of ordinary experience at issue here? As we have said before, phenomenologically it is action, "social action" in the manipulatory, near sphere of the immediate surrounding world. "Action" at least, as we have understood it here, is purposive conduct and thus includes the "subjective" meaning that the act has for the actor, hence includes some degree or other of "spontaneity" of performance according to one or another underlying project, and, moreover, a performance that entails bodily gearing into the surrounding world: the technical subcase of action that (with Alfred Schutz and Helmut

[47]Toulmin/Goodfield, p. 260. What happens here, of course, is that "non-rectilinear" rather than "rectilinear" motion is now the standard case of motion. This is another and much later chapter in the "fable of the world." That chapter remains unnarrated here.

[48]Toulmin/Goodfield, *ibid;* see in addition, Alexandre Koyré, *Newtonian Studies,* pp. 139ff., 149f. Also, in this connection, there is the interesting comment of José Ortega y Gasset, "The Historical Significance of the Theory of Einstein," in *The Modern Theme*, pp. 139ff. We have to acknowledge, too, that what we have called the Baroque formulation of consciousness, compared to that presupposed by Einstein, is, in Ortega's words, but an "acute form of provincialism. Euclidean geometry, which is only applicable to what is close at hand," whereby in the Baroque the far is read off the near, "had been extended to the whole universe. In Germany today <*slc.* 1931> the system of Euclid is beginning to be called 'proximate geometry' in contradistinction to other collections of axioms which, like those of Riemann, are long-range geometries." (For a phenomenological statement of this problem, see Fred Kersten, *Phenomenological Method: Theory and Practice,* pp. 60ff., 122f., and p. 373, note 15.

Plessner) we called *"working."*[49] And, as we have also noted on various occasions, action in the sense of working organizes our world around our body as center together with the reciprocity of perspectives and horizons; it consitutes a "here" that is the center of a system of co-ordinates shifted along with the center whenever we move from here to there—a "there" which becomes a new "here." And unrolling, working belongs to the immediate, specious present, revealing that segment of our surrounding world relevant for the actual situation at hand and determining the scope of purpose and intention, changing and even restoring the outer world. Finally, working as bodily gearing into the world for which we are geared, and to which our purposes, motives and intentions apply, is characterized, in its spontaneity of performance, by necessity; it is "historical" in the sense that action as working is *irrevocable*. It cannot be undone, even though a previous "here" may be restored, even though an original situation may be retrieved. Working is then especially privileged for appresenting indicationally that fantastic image both of "mythical situations which, as human beings, we are all of us necessarily in and must, therefore, accept, however tragic they may be" (Auden), the *istoria, and of* a universe in which the earth is the center because it is a massive body. The *same datum* of ordinary, common-sensical experience serves as the basis for extrapolation of the fantastic image of the "real" in opera (music) or science (physics or mechanics).[50] The problem, of course, is to measure it, whether the extrapolation of its appresentation comes from push come to shove, or push and pull.

One reason why the manipulatory sphere of working is important in ordinary, common-sensical life is because it sets the "standard cases" (e.g., the sizes) of things, it takes the "measure" of things, within actual and potential reach that can be manipulated, tangibly dealt with, contacted, changed, the resistance of which can be overcome or, if not, accomodated in some way in contrast to things, for instance, visible at a distance but out of reach (the moon and the stars), thus creating a basis for the reciprocity of perspectives, hence of variability in the life-world.[51] Just such a distinction, itself crucial to the enclave of daily life is unimportant for the physical construct of the universe on the Baroque formulation of consciousness as we have described it in the preceding paragraphs. There is no distinction between things within and out of reach, or out of reach all together; there is nothing that is just visible, or hearable, or things experienced as distant just in vision. In contrast, in working we can extend the manipulatory sphere to, e.g., the far visual sphere, making a "there" a "here" by means of bodily locomotion, thus establishing a standard size of the visibly distant object: I can walk over there, convert the "there" into "here," near at hand, and confirm that what looked small at a distance is truely large, has a "true size," and solid. Whereas in the scientific construct of the universe all sizes are "standard" and bodily locomotion and the conversion of "there" into "here," and the restoration of a past "here" by returning "there," are

[49] See above, pp.47f.

[50] And when the "irrevocable" is construed as "insensible," i.e., "purified from every trace of singularity," it becomes the "framework" within which the "irreversible historicity of the notes themselves" occurs; see above, p. 10.

[51] See above, pp.76ff.

not preconditions of measurement ("physical agencies," like "light signals," hardly count as "I can move," or "I can go over there"). In other words, there are no perspectives, nor reciprocity of perspectives in the scientific construct. Bodily displacement has nothing to do with the center; the transfer of the 0 of the system of co-ordinates, essential to the eccentricity of common-sensical experience in daily life and working, is irrelevant to the idea of mass as any center you please. And, indeed, the universe conceived by the physics or mechanics of the Baroque formulation of consciousness is a universe in principle out of reach of working, out of touch, even of the cow who jumps over the moon. It is a universe that least resembles my idea of it, nor is there any supervening experience in daily life that verifies or falsifies it. Its verisimilitude as a non-mimetic, fantastic image, indicated appresentatively by the experience of working, is entirely self-contained.

Its appresentation extrapolated from the push, shove and pull of working at the center of daily life, the scientific universe is irrelevant to it; none of the distinctions and preconditions of the world of common-sensical working matter to it; it is not within reach, nor attainable as what has never been in my reach before, yet within the reach of someone—my prececessor or successor. In short, it can never be "my" world or universe, or anyone else's for that matter. *It is not so much that it is not "intersubjective" as it is that, appresented indicationally by the intersubjective experience of working, it is irrelevant to me or anyone else.* As we said before,[52] on the late Baroque or Leibnizian view, it is the appresentation by the "insensibility of the sensible" that makes possible the construction of the "real." The distinctions crucial to the sensory world of working are utterly irrelevant for the construction of the "real," thus bringing to the fore, almost as an embarrassment, ordinary life in the ungroundedness of its four-fold ontic conviction. In the previous example of the ellipses (p. 194), we employed and calculated with letters which were of indeterminate value as long as they were numbers, to express the situation in Vietta's terms. I perform an operation with letters which are numbers in such a manner that variables are expressed and not just concrete cases. Phenomenologically, I have "formalized" numbers (and by extension, geometrical figures). This formalization is both a "decrease" in intuitive content (in Descartes' sense of "intuition"[53]) and, correlatively, an "increase" in the power of the operations of systems of signs which, if correctly manipulated, will produce meaningful results which can be expressed in concepts.

In this connection, Leibniz insisted that the system of signs is "conventional," and that the best system is the one on which we can operate mechanically without having to think what the signs mean and which, in the end, can be translated again into symbols. During the operations of systems of signs we can "forget" the meaning; but because humans make mistakes, Leibniz, says, it is best that we leave the mechanical operations to a machine: the blind operations guarantee the results with respect to the way in which the operations are set up. And, for Leibniz, this holds not only in the case of scientific thought

[52]Above, p.195.
[53]See Yvon Belaval, *Leibniz critique de Descartes,* Chapter 1.

but also in the case of musical composition as well. Music is as much an algorismic system as science.[54]

It was no accident that Nikolai Kusmitch was blind; he had to be in order to avoid mistakes in matching coats and checks at the opera house. And for all the difference it would make, he could just as well have been tone deaf were he the composer as well or the performer of the music.

Tonic and Relative

Some seventy or eighty years before Leibniz set out the idea of the circle as the limiting case of the ellipse, itself a stark case of the Mannerist dimension of the Baroque formulation of consciousness, Monteverdi had trod a similar path in *La favola d'Orfeo*. And although it may seem to be stretching things a bit, it is worth recalling Leibniz's definition of music because it makes a minimal case for Monteverdi: *musica est exercitium arithmeticae occultum nescientis se numerare animi* ("Music is that hidden arithmetical operation which does not know that it is counting").[55] This definition may also serve us now as a caveat (both emptor and venditor) for taking one last look at the compossible algorismic (and aesthetic) principle of the Baroque formulation of consciousness. From the end of the seventeenth century we take a step backwards to its gigantic beginning.[56]

One problem faced by Monteverdi was a new one for Western music: "how to give shape to developing narrative drama."[57] The reason for the problem is that in cases where dramatic action continually develops, as in the case of opera, the devices of creating musical shape in post-Renaissance music, such as repetition of remembered sounds, were ineffective; what Monteverdi contributed, among other things, was the idea of "varied repetition"—ultimately to lead to the development of "such forms as the *da capo aria*, the sonata-form ensemble, and Wagner's symphonic structures."[58] To be sure, it is still a long way from Monteverdi to Wagner (thank goodness!), and Monteverdi's solution to varied repetition and development of dramatic action remains with the Baroque. If we are to accept the persuasive account of Drummond, taking *La*

[54]Leibniz's "music machine" consisted of tables of logarithms to establish pure ratios of tones and mean tone temperament; see Leibniz, *Der Briefwechsel zwishcen Leibniz und Conrad Henfling, Ein Beitrag zur Musiktheorie des 17 Jahrhunderts,* and especially the tables reproduced pp. 63ff., as well as Haase's Einleitung, pp. 7ff. 34ff.

[55]Leibniz, letter to Christian Goldbach of April, 1712 (In Leibniz, *Epistolae ad diversos*, ed. Chr. Kortholt, Leipzig, 1734, Vol. 1, pp. 240f.) The letter is cited, in a different context, by Alfred Schutz, "Mozart and the Philosophers," *Collected Papers*, Vol. II, p. 199. Leibniz's definition is the basis for the pun of Schopenhauer: "musica est exercitium metaphysices occultum nescientis se philosophari animi" (*Die Welt als Wille und Vorstellung*, III, §52.) But perhaps that would also be appropriate for Monteverdi as well.

[56]See above, pp.173f.

[57]Drummond, *Opera in Perspective* , p. 122.

[58]*Ibid.* and pp. 134ff. See above, pp.187f.

Favola d'Orfeo as an example, keys such as A minor and A major represent suffering and sighing, F major, D major and G major celebrations, tenderness, happiness. Of interest to us here is that such keys can be located within a tonal cycle of fifths in which A minor/major "is on the sharp side of D major/minor...; G major/minor, C major/minor and F major/minor are on the flat side of that key...We may therefore deduce that Monteverdi, while using only a portion of the cycle, is basically equating sharper keys with suffering and flatter keys with celebration." The cycle of fifths is precisely a case of consciousness knowing about itself[59] and the "closed musical form" of the Monteverdian, like the Leibnizian, pre-established harmony producing these associations is in no way odd: "to sharpen tonally is to increase tension; to flatten tonally is reduce tension. Monteverdi therefore uses more tense keys to represent emotional tension in Orfeo's previous state of mind, and more relaxed keys to represent the present situation."[60] Related at the tonic, in the cycle or circle of fifths major and minor are shown in the same position[61] and what differentiates them is the major third (f sharp) or minor third (f natural).

But there is yet another way to relate them, even though they share a common key signature: "D minor is the tonic of D major, but it is also the relative minor of F major, which has an identical key signature of one flat, and has, moreover, more notes in common with D minor than has D major."[62] And if we connect the keys relatively, then set them together with the first version of the cycle of fifths, the musical *mezzanità*, we have a set of associations which serves as the "standard case" as well as the simplest (despite its complexity) as in the case of motion so that "each of the following keys is equidistantly one step away from D minor: A minor, A major (in the sharp direction), G minor, G major (in the flat direction; D major (as the tonic major), and F major (as the relative major) are particularly close." And, Drummond adds, Monteverdi "does not stray outside the field of D minor."[63] Tonics and relatives are like the moving foci of the ellipses, and where the foci coincide is the cycle of fifths, the equivalent of the circle. *In other words, the first classification is but a special case of the second.*

The scale-wise motion in the shape of tonics, relatives, harmonic intervals combined form a "system" of self-interpretive associations, a musical grid of the cycle of fifths as a special case of the plannification of the tonics and relatives, that operates,[64] if we are to believe Drummond drawing out the implications of the musical structure of *Orfeo*, like the Leibnizian ellipses and Newtonian masses. The latter have their extrapolatory root in the reciprocity of perspectives and co-variation of push and pull in the specious present of working just as does the former. But like the former as well, all the distinctions

[59]See above, pp. 197f.

[60]Drummond, pp. 125f. See above, pp.169f..

[61]Drummond, p. 126 ingeniously represents this as a circle; see his figure 10.

[62]*Ibid.* and the figure 11 on p. 127.

[63]*Ibid.*, pp. 127 and 128.

[64]See above, pp.180f., 188f., 196f.

important to working, including vision and hearing, are irrelevant for the musical structure.

A few examples will suffice here: After Orfeo, in response to the shepherd, sings a song inspired by love, and in which he both recalls his previous suffering and his present joy, Euridice replies and "teasingly refuses to say that she shares Orfeo's joy. Monteverdi accordingly moves from D minor through an A major chord to E major in bar two, thus reflecting Euridice's teasing words"—another good example of the "gentle kiss with a bite." Then in the third bar—remaining with Drummond—there is the move "back to A minor and thence to a chord of F major and to C major, as if to reassure that celebration and union are really the issues here. As Euridice begins her second statement, with a tender reference to her emotions, Monteverdi takes us to G major; as love is mentioned, the harmony resolves into D minor (it could be D major). The two sides of D minor are recapitulated in Euridice's third statement: her teasing shift of focus from herself to 'her heart' is reflected in the shift to A minor, while her final acknowledgement of joy and love for Orfeo is set in F major, and through a chord of G minor to a final cadence in D major."[65] And so for the other examples singled out by Drummond as exemplifing the continual self-referencing and self-interpreting of the structural systems of tonics, relatives and harmonies the appresenting of which is extrapolated from the experiential datum of push and pull.

In clarifying the idea of the "fable of the world" we have already indicated the nature of the "system" as it figures in the Baroque formulation of consciousness, tied up as it is with the fantastic rather than the icastic, and in the non-mimetic sort of appresentational indication.[66] But what sort of "system" is devised by Monteverdi and drummed up by Drummond? To find out we can borrow someone else's fiction again, Homer Nearing's genial mathematician, Professor Cleanth Penn Ransom.[67] At the same time, we can gain an insight into the final Baroque picture of the "gap" between science and opera and the new idea of the thingness of things.

The Gap as "Hermeneutical Doughnut"

Usually when I think of a "gap" I think of it in horizontal terms, like the gap between the sill and the door in winter through which the chill wind blows, or vertically like the gap between the blinds through which I observe the weird behavior of my neighbors. But the gap which so disturbed and sickened Nikolas Kusmitch, the gap between science and opera and ordinary, common-sensical

[65]Drummond, pp. 129f.

[66]See above, pp.9f., 143f.

[67]Homer C. Nearing, Jr., "The Hermeneutical Doughnut," reprinted in *The Mathematical Magpie*, pp. 48-69. The specific problem dealt with in this piece of fiction concerns that of four-color topology, and it is precisely the "system" of topology that emerges from the Baroque formulation of consciousness. Topology, in other words, replaces the spatiality of things, as Leibniz was the first to demonstrate; see below, pp. 209, 212f.

life, is neither a horizontal nor a vertical gap. To be sure, like all gaps it is topological, but its topology is a special one, which is why Kusmitch got sick. The gap, in short, is more like the whole in a doughnut.[68]

And, as C. P. Ransom repeatedly insisted to his disbeliving colleague, MacTate while preparing his lecture for a night meeting of the Abnormal Psychology Society, when it comes to geometry there can be no doughnuts except those that have holes in them. "'On a sphere you can only make four-color maps, but on a doughnut you can get seven. If it's got a hole in it. ... Here's a circle divided into three parts, all touching each other. So if you're going to paint it, like a map, you need three colors.' He wrote a number in each sector. 'Now suppose you've got another region that touches all three of these.' He drew a curve from the center of the first arc to the center of the third. 'You need a fourth color. Don't you? But look what that does to number two. Completely surrounded by the others. So any new region can be colored like number two, and you never need more than four colors on this sort of a surface.'"

At this point MacTate noted that if one wanted, more colors after all could be used. "'Of course. Of course. But this is mathematics, MacTate. My God, what did you think it was? Art? The point is, you can't make a map that *requires* more than four colors. On a sphere.'" Apparently thumbing through his worn copy of Kepler, Ransom next noted the odd coincidence that the simplest polyhedron you can squeeze a sphere into is a tetrahedron.[69] All one has to do is take a ball of clay, squeeze it into a tetrahedron, give the sides a coat of paint, roll it up into a ball of clay again, and behold a sphere with a four color map on it. Now, Ransom asks, what is the simplest angular solid into which you can squeeze a doughnut? Answer: a tetrahedron with a hole in it, naturally, just like a doughnut which is really a sort of sphere with a hole in it. "'So you run a three-sided hole from one of these vortexes to another, and you've got a seven-sided solid where every side touches each of the others.' He drew the line representing the hole. 'You've got to bend the hole in toward the center of the pyramid and flare out the ends of two of its sides. But it works.' He threw the pencil down. 'You need seven colors to paint it.'"

Just here we are arriving at the gap, and it is not a gap of dimensions which everyone thinks of as being of right angles to each other. "'But if you get right down to it, that's kind of silly. For instance, how can a time dimension be at 'right angles' to a space dimension? Wouldn't it be a lot more sensible to think of them as contiguous areas on a solid? Like a graph? Let's take *you* as a solid, for instance. We could plot your four co-ordinates on a pyramidal graph. One time co-ordinate and three space. To show where you are in space-time.'" But if "'we tried to plot you on a pyramid with a hole in it, which is non-simply connected, we'd be up against seven dimensions, remember? One time and *six* space.' His eyes narrowed. 'Just suppose you suddenly found yourself in a non-simply connected space. What would you do with the extra three dimensions?' ... 'All taken care of by mathematical necessity. Your four dimensions would try

[68] See above, p. 194f.
[69] Cf. above, pp.86f.

to fill seven, and there would suddenly be four of you flipping around. The one you started with plus one for each extra dimension.'"

When we consider daily life *with respect to* the mathematical, scientific construct, the fantastic image of the "real," we have to think the gap between them as a "non-simply connected space pocket," with four dimensions flipping around the specious here in the specious present. To be sure, Ransom's lecture dealt with Ezekiel's vision of the wheel within the wheel (1:5-17), not without its cross-cultural complement in the Doom of Ixion.[70] And equally, to be sure, Ransom invented a device to show that the vision was not necessarily an hallucination: what looked like a flashlight which, instead of a lightbulb, has a transistor in it made out of germanium, with four electrons in its outside shell and to which are added a couple of molecules of gallium with only three electrons. When excited by electricity, the extra germanium atoms move into the vacancies in the gallium shells, creating vacancies in their own shells. The result is—for reasons glossed over by Ransom (and because the transistor has impurities in it)—a non-simply connected magnetic field. By way of illustration, Ransom set a stuffed owl on the floor, clicked the flashlight on, and in a few moments there were "four owls arranged about it in a square of three or four feet." The scene was keenly observed by Ransom's dog, Roland.

"Ransom took a red ball out of his pocket. 'Go get your ball, Roland.' He bowled it deftly between the nearer two owls. It turned into four balls, then back into one, and came to rest an inch from the flashlight....Roland began to snarl faintly at the owls. 'Go get your ball, Roland.' ...Roland was eying the owls from a menacing crouch. He barked hoarsely two or three times, then uprooted his legs and charged at the ball. As he approached the owls, he appeared to think better of it and straightened his legs to stop, but his momentum carried him among them. Abruptly there were four twisting, yelping Rolands, connected by a circling blur of incorporeal motion. 'There, he's got caught in the magnetic doughnut.' Ransom grinned. 'Poor Roland. And there's one of Ezekiel's wheels, on account of he's scrambling around. Since the owl just sat still—' 'I say, old boy, what happened to the other owl?' asked MacTate. 'There are only three of them now.' 'Outside the door.' Ransom pointed. 'Roland's extra mass expanded the doughnut, and since he got inside the owls his circle pushed one of them out of the room.'"

Roland The Dog trying to retrieve his ball in non-simply connected space, Nikolai Kusmitch trying to experience the rotation of the earth on its axis in its passage around the sun: both, dog and man, whose extra mass is expanding the doughnut, live the scientific constructs from within the enclave of daily life. The specious present is, in the lingo of Leibniz, the insensibility of the sensible,[71] and the privileged experiential datum here which is the "correlate" to the four-color typology is again, instead of push come to shove, *push and pull*. We must note too that, reappearing, the gap itself has undergone a drastic change[72] and brings us back once again to the cloakroom of the theatre with its

[70]Above, p. 23.

[71]Above, pp. 191, 195.

[72]See above, p. 188.

blind and tone deaf attendant, Nikolai Kusmitch.[73] The description of his behavior as cloakroom attendant was inspired by a comment of Ortega y Gasset about modern science, physics to be exact, which in turn had been inspired by an illustration of Herman Weyl:[74]

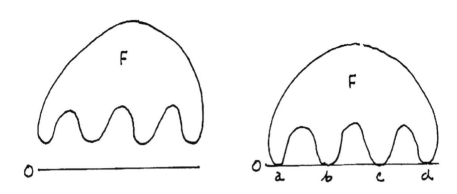

The illustrations, adapted to our discussion, suggest that the hole is bent in toward the center of the tetrahedron, squished and rolled up into an ovoid ball (shades of Kepler!). The fantastic image, F, which appresents the scientific construct of the "real," the "physical theory," is represented in the first diagram depicting the ovoid doughnut; the line O depicts ordinary, common-sensical life. If we superimpose the one on the other, that is to say, if we "live" the scientific construct, the fantastic image, "F," as did Kusmitch or Roland The Dog, we find that F does not coincide with O "except at points a, b, c, and d. These points are scientific experiments but the remaining content of physical theory—the other points of the figure, those within its area—does not coincide with the points of Reality. Hence, there is no similarity whatever." At points a, b, c, d, we experience the gap from within ordinary experience, as did Roland The Dog when he chased his ball, or as did Nikolai Kusmitch when he sought to experience the rotation of the earth on its axis, or match checks with coats, or as did I when I sought to purchase a suit in an electromagnetic field. Nor are any of the interior points of the theory, the fantastic image, identical with parts of ordinary life. There is no similarity, no mimesis, but at best "correspondence" (or: indication) which, Ortega says, is only guaranteed by scientific experiment (such as Ransom's flashlight).

The scientific experiment is an "unequivocal comparison" between the order of objects in the scientific construct and the phenomena of ordinary life, of the life-world. When the result of experimentation is positive, a correspondence obtains which is dissimilar though not unambiguous; "between the objects of

[73] Above, pp. 4f.

[74] Ortega y Gasset, *La Idea de Principio en Leibniz*, p. 40 (English translation, p. 31), which reproduces Weyl's diagrams.

one series and the other there is no likeness; therefore the correspondence is dissimilar. The only bit of similarity is the order between both of them."[75] In other words, it is like the correspondence between coat checks and coats, or being trapped in the magnetic doughnut when the extra mass expands the doughnut. But we may also say that for the scientist the scientific experiment is not unlike the "private letter" of versification and syllabic values of words for composer. To "live" the fantastic image, to occupy the gap and make it one's habitat of daily life, is like making the private letter go bail for the theory or composition, or construing the appresenting for the appresented, or sliding the signified under the signifier, or living the unobservable fact as though it were observable.[76]

It is little wonder, then, that Kusmitch became ill and took to his bed, or that I went to jail, or that the biker cum sociologist came to such a bloody end. The gap is a topological one peculiar to the "system" of the Baroque formulation of consciousness which we have been examining for so long. Trying to come to grips with the disaster of the gap expressed this way I was put in mind of an old song I heard years ago in a local bistro during the celebration of the arrival of Spring. It was called "A Very Much Married Man," and described that most ordinary of experiences of push and pull: marriage. The song begins with a man marrying a widow with a grown daughter, who becomes his stepdaughter; his father, a widower, comes to visit them, falls in love with the stepdaughter and marries her. Skipping the further interlocking branches of this new family tree, the result is that the father and stepdaughter have a daughter, who is then his son's sister and he as well as her grandfather; but that means he is also the grandfather of her brother, which is to say, of himself. He is his own grandfather.[77]

The song brought to mind Leibniz's account of genealogical lines in his 5th letter to Clarke (§47). There Leibniz says that different things may be considered as co-existing in a certain order, and that by the word, "space," we mean the order of simultaneous co-existence. If one of the co-existents changes its relation to the multiplicity of other things which otherwise retain their relations to each other, and if something else takes on the relation which the one thing had to all the others, then this change is called "motion." Space comprises all places and is, accordingly, a network of relations of co-existence. What the network looks like is explained in the letter with a comparison to genealogical lines of development. "In like manner," Leibniz says, "as the mind can fancy to itself an *order* made up of *genealogical lines,* whose bigness would consist of only the number of generations, wherein every person would have his place; and if to this one should add the fiction of a *metempsychosis*, and bring in the *same* human souls again; the persons in those lines might change place; he who was father, or a grand-father, might become a son, or a grand-son, etc. And yet those

[75]*Ibid.*, p. 41.

[76]See above, pp. 7, note 9; 9f.

[77]The first time I heard the song, or a version of it, was on an old Berliner Gramophone record, made in 1898, and narrated by one John Morton (of Morton and Burgess minstrels), no. 152 (matrix 1037X), and which recently has been dubbed onto a compact disc produced by Symposium Records (no. 1058).

geneaological places, lines, and space, though they should express real truths, would only be ideal things."[78] The experience of the gap, then, is like a topological metempsychosis, a spatial network, when it comes to experiencing in the life-world the constructs of science or art except that instead of "ideal" things they would be "real" ones, as though the "fiction of a metempsychosis" were not a fiction. There is correspondence, but no similarity, indication but no imitation.

Although far-fetched as they may be, with the disastrous results of the sort we have noted, in the one case, very much married man, the genealogical metempsychosis is entirely confined to the ordinary, common-sensical experience; while in the second, the genealogical tree, it bridges the gap. Like the experience of the hermeneutical doughnut, however, its topology is non-simply connected: the "same human souls" being in many different places at the same time proves to be the image of the experience of bridging the unbridgeable gap.

Work and Performance.
The Thingness of Things

In what way, then, does the scientific experiment stand to the theory? On this last version of the Baroque formulation of consciousness, under the mimetic epoché, what are the "correlates in the life-world" of the "real" appresented in music, scientific theory, painting, sculpture, architecture?

In *The Musical Dialogue*, Harnoncourt notes the nature of the printed edition of Monteverdi's *L'Orfeo* and goes on to speculate as to the reason why.[79] The publication of the score is "skeletal," with the result that "everything that is played on the chordal instruments above the bass, had to be improvised, i.e., freely added. One of the important innovations characterizing the transition in music from the sixteenth to the seventeenth century was that the outer voices were suddenly accorded much greater importance than the middle voices. As a result, the actual composition now consisted in the invention of the outer voices, and everything else could and had to be freely improvised by the continuo player. This necessary creative adaptation does not belong to the 'work,' but rather to performance. *This separation of work and performance* was an essential and novel feature of the music of that period."[80] The same holds true, it

[78] Leibniz, "Lettres entre Leibniz et Clarke," *Opera Philosophica*, Cinquieme Ecrit de Mr. Leibniz, pp. 768f. The translation is by Clarke.

[79] For the history of the publication of the score of *L'Orfeo*, see Nigel Fortune, "The Rediscovery of '*Orfeo*,'" in John Whenham, *Orfeo*, pp. 78-118, and Appendix 1.

[80] Harnoncourt, *The Musical Dialogue*, pp. 29f. And even when there are remarks in the score calling for violins or even all the instruments in places where only voice parts and bass are notated, "this type of writing should not be described as sketchy; it defines the *work*, the composition," p. 33. See also Harnoncourt, *Baroque Music Today: Music As Speech. Ways to a New Understanding of Music*, pp. 14ff. In this connection, see also Jane Glover, "Solving the Musical Problems," in Whenham, *op. cit.*, pp. 139ff. The

would seem, not only for printed scores in France from the mid-Seventeenth to mid-eighteenth century (where, however, orchestra parts have been preserved.) Likewise even manuscript scores require some kind of arrangement, some sort of musical adaptation.

The Baroque distinction between work and performance revived by Harnoncourt is one made by a musician whose sole purpose is a "*suitable performance*" that realizes "the intentions of the composer by using the resources and possibilities that existed during his lifetime" so as to make the "work" "understandable to us for today."[81] The distinction is rich with problems of an analytic and ontological sort, all worthy of lengthy treatment. Philosophers, musicologists and historians will want to know what a "work" is, how it can be defined or characterized, what its essential constituents are which make it a work in contradistinction to non-works and performances.[82] Still I would like to leave such issues in the bottom drawer for the moment in order to suggest that the distinction itself is a Baroque one, and that this is the reason why Harnoncourt, *as a practicing musician*, finds it necessary to make the distinction no matter what its difficulties and dangers.

Moreover, risking a new entry in the *Journal of Irreproducible Results*, I would like to suggest that the distinction rests on the compossiblility of science and painting, music, architecture and obtains as much between a scientific theory and experiments as it does, for instance, between an architectual plan and its realization in a building—or even a model of a building.[83] In this light, the question we ask is: how can the work in painting, music, science be best served using the resources and possibilities that existed in the lifetime of painter, composer, scientist, architect so that it may best be made comprehensible to us today? Or, to express the same thing phenomenologically and more broadly in terms of the Baroque formulation of consciousness: what are the "correlates in the life-world" of seventeenth century opera and science?

For our purposes here we can remain within the parameters set by Harnoncourt, the practicing musician. The question then seems relatively simple in the case of music; one can perform it, play it. But can one perform a painting? A building? In the case of a scientific theory in the form of a treatise, dialogue, or whatever rhetorical form it takes, "experimentation" is one possible answer. Still, whatever the answer here, the very distinction between work and performance is itself a Baroque one, resting on the self-interpretative nature of the Baroque formulation of consciousness according to which, we may also say, a "work" generates its own instances, if we come down on the side of Leibniz,

observation has, of course, been made, that there were no copyright laws in the seventeenth century and that therefore composers—but also artists, writers, scientists—had to protect their interests as much then as now. This is no doubt true, but hardly serves as a sufficient reason for making the distinction in the first place.

[81] *The Musical Dialogue*, p. 32.

[82] The analytic, ontological and historical problems are thoroughly discussed by Goehr, *The Imaginary Museum of Musical Works*, Chapters 1 and 2; by Peter Kivy, *Sound and Semblance. Reflections on Musical Representation*, Chapters 1 and 6.

[83] See, e.g., Joseph Connors, "The Seated Sublime," *New York Review of Books*, 16 February, 1995, pp. 24-26.

and an indefinite number of them—in the case of music, of performances; in the case of science, of experiments.[84]

And in the case of architecture? Here, too, there may be an answer, a clue to which Joseph Connors provides in his account of an exhibit of "works" of Alberti in Mantua. The exhibit was under the aegis of Olivetti, and Olivetti computers "were everywhere evident in the Alberti show. Videos showed computer-guided robots cutting the parts of wooden models with a speed and precision that would have unnerved poor Sangallo. The final projects of this process were everywhere, handsome blond wood models of impressive size showing every one of Alberti's notoriously unlucky projects completed. One could fly, virtually, around computer mock-ups of Alberti buildings in their urban contexts. ...In the words of the organizers, 'Computers and multimedia technologies will be used...[to] enable the public to take a more active, involved part in the exhibition experience.'"[85] Granted that it took Sangallo a tad longer to make his model of St. Peter's (seven years) than needed by computer, the making of models remains the precise equivalent of the "experiment," the "private letter," the "correlate in the life-world," *slc.*, *the performance*, to scientist, artist, composer, architect. Or, in Connor's words, "Beside the real Alberti, notoriously difficult to present, would stand a virtual Alberti, shaped by a new vision of what an exhibition should be like." And, conceivably, the same sort of "performance" would apply to sculpture and painting. The "virtual" Alberti becomes the "correlate in the life-world" in this case. Granted that this suggestion does not solve the analytic and ontological problems of "work" and "performance," it does lead to a final comment on the Baroque formulation of consciousness and its presence in the post-modern world.

The Olivetti computer in this case is Baroque in its application, if not design, in the sense that it operates with the Baroque idea of the thingness of things. We have considered two basic meanings of the thingness of things: on the Classical formulation of consciousness, the thingness of things consists of the shape and form of an appearance under the criterion of "beauty."[86] On the Baroque formulation, the thingness of things consists of the place of things on the grid, mathematically rendered according to the "simplest" case, viewed from the disenchanted window.[87] In the course of this book we have distinguished three ways of appresentational presentation ("representation") of the thingness of things: by way of imitation, by way of analogy, and by way of opposites. To some extent the second, but especially the third are characteristic of the Baroque formulation of consciousness but always under the mimetic epoché. We have correspondingly distinguished at least three data in ungrounded ordinary experience from which the appresentation of the metaphysically "real" is extrapolated: push without shove, push come to shove, and push and pull. The

[84]See above, pp. 86f., 127, for Walker's attempts at such "performances" of the "works" of Kepler and Galileo, both scientific and musical.

[85]*Ibid.*, p. 26. See p. 24 for the description of the exhibit of Sangallo's model in Rome.

[86]See above, pp.28f.

[87]See above, pp. 94f., 163f..And what, after all, can be a more disenchanted window than the computer screen?

last two are the privileged data on the Baroque formulation of consciousness, drawn from the center rather than the periphery of daily life and working. And it is the latter that, increasingly, becomes "the" privileged datum for extrapolating the relationship of co-variability as the mark of the "real." Moreover, it underlies the compossibility of "variation according to law" that marks not only the fantastic image of science but also music, painting, architecture, sculpture. To develop this in the necessary detail would require another and unfortunately even longer book. Here we can simply take it as a clue to our question, of how a performance stands to a work.

The answer, under the mimetic epoché, *on the Baroque formulation of consciousness,* is that the work stands to the performance as the independent variable does to the variable (its "function"). It seems to me that this is precisely the case with the glorious Olivetti computers in Mantua.[88] The Baroque distinction between work and performance proves to be the distinction between independent variable and its function. And it is a co-variability, extrapolated from the push and pull of daily life, peculiar to the Baroque algorism which purports to account for any phenomena whatever. Without developing the new ideas of geometry and of mathematics involved here, we can take a simple example to illustrate this.

Suppose that $r = 5$, $x = 3$ and that $x^2 + y^2 = (25)$; $9 + y^2 = 25$; $y^2 = 16$; thus $y = +$ or $- 4$. If we substitute for x a certain number, then y has a certain number; I am free to substitute any number for x, but there is no such freedom with respect to y. Therefore x is the independant variable, and y, we may say, is its function. Or, I can reverse the operation. The significance of this is that the independent variable and its function (push and pull) replace cause and effect in physics. Of course, strictly speaking not any values will fit; I may be half free with respect to what I substitute for x, but not at all free for what is substituted for y. That is to say, "functional dependency" of two variables signifies that at will I can consider either one or the other as variable, but not both of them. (This leads directly to the idea of space, for instance, as a network of relations as that in which relations among variables can be expressed.)

The final formulation of this is in the Leibnizian genealogy, and the first formulation we have already considered in the case of Alberti and Descartes:[89] if, under the mimetic epoché and through the window, the world is created in a "rational" way, it can only appear the way it is; if $x =$ the world, then $y =$ the way it looks. Or, if $x =$ the work, then $y =$ the way it looks and necessarily must look—if $x = L'Orfeo$, then $y =$ its performance; or if $x =$ a building of Alberti, then $y =$ the way it must look. And just for this reason the

[88] I am certainly not suggesting here that computers, and "virtual reality," are in any way necessarily the best way of serving the resources and possibilities of scientists, writers, composers, artists that existed in their lifetime, or that they are the only way to make them comprehensible to us today. I do not believe that they are, or can be. See Robert Hughes, "Take this Revolution," *Time,* Spring, 1995, p. 77 (speaking of Titian rather than Alberti: "but how many people will realize that the only way to know Titian is to study the actual, unedited physical works of his hands, in real space, not cyberspace?") See also Fred Kersten, *Phenomenological Method: Theory and Practice,* §§9, 33.

[89] See above, pp. 143f., 195f..

score or the blueprint can be a "skeletal" algorism, for given that the performance (playing of the composition, construction of the model, or carrying out of the experiment), is the way it "looks." And when the Olivetti computer sets a "virtual Alberti" next to the "real Alberti," the function becomes the independent variable and the independent variable becomes the function. And this we have already seen in Alberti: for we can grid the perceived world just as we can grid the "imaginary" world.[90] The grid, then, is a function of the central vanishing point *quasi persino in infinito*.

To be sure, as noted above, the problem is still how to measure it all. For instance, in the case of music, of the performance of the printed score of *L'Orfeo* (the independent variable), the improvisation, the "necessary creative adaptation," of chordal instruments above the bass comprise the dependent variable, are the function of the score. Their addition is "free," then, only in a relative and very special sense.[91] While the clue to the solution of "measurement" (so-called "indirect mathematization") lies within the Baroque formulation of consciousness, the solution itself does not come until a rather different formulation of consciousness emerges in the middle of the eighteenth century. We will indicate some of this in the next chapter, but its development goes beyond the scope of our book.

[90] See above, pp. 64f.f.

[91] For the specific phenomenological sense of "free" here, see Fred Kersten, *Phenomenological Method: Theory and Practice*, pp. 93f. We cannot enter into a further discussion here of "necessary creative adaptation."

CHAPTER EIGHT

The Enclave of the Eccentricity of Ordinary Life.

The principle of the compossibility[1] operative in music, science, painting, sculpture, poetry, architecture on the Baroque formulation of consciousness does not necessarily signify that, for instance, music has an extra-musical meaning, or that painting has an extra-painting meaning, or even that science has an extra-scientific meaning (although all of that may indeed be the case, e.g., technology in the case of science, moral instruction in the case of the arts[2]), or that the one must necessarily entail the other (which in no way rules our their often quite obvious mutual influence). Nor is this to deny that music, science, painting, sculpture, poetry, architecture have a reference to what is going on in theatre, church, court, society required by the listener, viewer, participant, actor on the social, political and religious scene.

The principle of compossibility signifies instead that science, music, painting, sculpture, poetry and architecture have a task in common which consists of sharing an ideal possibility or "essence." However, in its representation of that possibility the principle of compossibility is always subject to the mimetic epoché enabling indicational appresentation by opposites and truth by least resemblance within a quite specific and disenchanted room-milieu where the "real" decreed, although independent and self-sufficient, nonetheless has its own peculiar correlate in social action in the world.[3] Whether the compossibility of the arts and science rests, and can rest, on any other basis than the Classical assumption that the "real" is somehow accessible to ordinary experience is a question that must remain open.

These are not the terms or even the language of the Baroque thinkers and artists we have discussed. The principle of compossibility can neither claim to be a deductive system from which art and science are derived, nor can it be reconstrued as a sort of Hilbertian plan exhaustively establishing genuine cases of verisimilitude appresented in art and science. In a retrospective way, Gödel's Theorem applies here: there are cases of indicational appresentation which cannot be decided as to their verisimiltude or even truth and falsity, yet which are meaningful.

No one in the seventeenth century wandered around with a lantern seeking verisimiltude in the compossibility of art and science, and it is doubtful

[1] See above, pp. 94f..

[2] See Cohen, *The Scientific Revolution. A Historiographical Inquiry,* pp. 191ff., 198ff.

[3] See above, p 102. It should be added that the warrant for the "real" decreed on the Baroque formulation of consciousness is allowed for by the ungrounded ontic conviction of daily life. There is no implication here that Baroque music, is in any sense "absolute" in the meaning of the term in the nineteenth century, for which see Carl Dahlhaus, *The Idea of Absolute Music*, Chapter 2.

that, at least until Leibniz, anyone would even want to speak that way. Indeed, to speak of the "compossibility" of art and science, plausible as it may be as a speech about Being, is about as "abstract" and "obtuse" as one can get, about as baroque as one can become. Nor is it difficult to understand why, especially after the middle of the seventeenth and into the eighteenth centuries, trenchant and vituperative criticism was leveled at the marinistic labyrinth of the Baroque representation of Nature and Society in the name of "common sense" especially in art (e.g., from catering to the bad taste of the audience and populace to violating the basic principles of the received tradition of Aristotle, i.e., losing sight of plot and unity of action, as well as introducing sounds and scenes just for the sake of entertainment and the spectacle of virtuosity). "Common-sense" became the basis for the "reform" movement in opera as in science. Perhaps more than any other, the Baroque formulation of consciousness invites criticism in terms of that from which it is extrapolated, ordinary common-sense. It may be odd to consider Nikolai Kusmitch as a critic of art and science. Yet he represents the sort who common-sensically suffered most keenly the consequences of the legacy of Baroque art and science.

To go from the Baroque to what its critics envisioned is rather like leaving a waterfront bar humming a sentimental ballad. What, say, opera turned out to be, and what its critics would have liked it to be, stand in stark contrast to each other, as stark, for instance, as Berkeley's criticism of Newton. Such criticism certainly serves here to bring into relief and further clarify the taken-for-grantedness of the ontic conviction of daily life on which the Baroque, like the Classical, formulation of consciousness rests. It is for this purpose that we introduce some late seventeenth and early eighteenth century challenges of ideas in Baroque music and science.

The question central for us, however, is whether the criticisms provide a basis in common-sense for an alternative that still operates with the Baroque formulation of consciousness or whether with a new one, and if so what are the clues to that new formulation, whether the assumptions are the same, i.e., whether they still take for granted the positing of the world in the four-fold ontic conviction and whether the "metaphysically real" is still accessible to, and can be extrapolated from, certain privileged data in ordinary experience.

The examples chosen, moreover, are intended not so much as "counter examples" to the Baroque formulation[4] as they are for what they can tell us about the fate of the assumptions of that formulation and perhaps even of the gap remaining between daily life and the "real" appresented (a gap which proved to be an "enclave" of daily life set into the "non-simply connected space").[5] Perhaps most importantly, though, the examples reveal a

[4]The method of "counter examples" is so fraught with difficulties that it can be introduced only with the most elaborate conceptual apparatus; see Lydia Goehr, *The Imaginary Museum of Musical Works*, pp. 26ff. (the difficulty of counter examples in the controversy of Goodman and Ziff), and Chapter 4 for still other conceptual difficulties. The problems of analysis by "counter example" is part of a much deeper set of problems concerning the very nature of hypotheses and experiments in the rise of modern science; in this connection, see Cohen, *The Scientific Revolution*, pp. 187ff.

[5]Thus they serve the same purpose as the discussion of Zuccaro, above, pp. 121ff.

representation which is *mimetic, rather than* non-mimetic. It is, however, mimetic 1) in yet a novel sense, and 2) such that it is the appresented "metaphysically real" which determines the "similitude." The reason for introducing the examples from eighteenth-century criticism is then two-fold: 1) to bring into sharper relief the Baroque formulation of consciousness, but equally important, 2) to sketch the phenomenological clarification of the difference between constituting of the mimetic and the non-mimetic and of "fiction" generally, fabulous or otherwise, necessitated by the rejection of the mimetic epoché implicit in the eighteenth-century criticism in the arts and science.[6]

The Classical Wolf at the Baroque Door

When George Berkley, as a young man, went to London for the first time he discovered in the dens of Free Thinkers atheists and skeptics among the mathematicians and philosophers. Like his *Three Dialogues*, most of his philosophical works are written in "opposition to sceptics and atheists," and seek, like *A Treatise Concerning the Principles of Human Knowledge*, to lay bare the "chief Causes of Error and Difficulty in the *Sciences*, with the Grounds of *Scepticism, Atheism,* and *Irreligion*...inquir'd into." You just cannot predict what will happen when Free Thinkers get together. Mathematics got a jolt when Berkeley went to work on it, especially on that of Newton and others who espoused the "Method of Fluxions." Consider an arch, Berkeley says, made up of infinitesimal segments. Suppose that we substitute for those segments straight lines; when we add them up we still do not have an arch, but instead a polygon. Even so we can still define the length of the arch because the segments are as numerous and as small as we please and, eventually, we come to a limit: the length of the arch ("The Analyst," 1734).[7] Berkeley notes that "foreign" mathematicians are perhaps more intelligible because they proceed in a less accurate and geometrical way. This is because they deal with "variable finite quantities" instead of "flowing quantities and their fluxions," considering only the increments or decriments themselves, which they call "differences, and which are supposed to be infinitely small." But that does not get them off the hook anymore than indigenous mathematicians. Berkeley threw up his hands and pen in despair over them all, for to try to conceive of a quantity that is infinitely less than anything sensible or even imaginable is, he admits, beyond his capacity. Still, that is hardly his fault because "to conceive a part of such infinitely small quantity that shall be still infinitely less than it, and consequently though multiplied shall never equal the minutest finite quantity, is, I suspect, an infinite difficulty to any man whatsoever." And, in fact, anyone who thinks he

[6] Below, pp. 239ff.

[7] *The Works of George Berkeley, Bishop of Cloyne*, edited by A. A. Luce and T. E. Jessop, Volume Four, pp. 65-102. For a thorough and detailed study of Berkeley's criticisms, see Douglas M. Jesseph, *Berkeley's Philosophy of Mathematics*, especially Chapters 4 and 6.

can do that, and then proceed to "digest a second or third fluxion, a second or third difference, need not, methinks, be squeamish about any point in divinity."[8] They are not only wrong in their mathematics but in their religion as well. No wonder Berkeley was driven to his "grand scheme" of a new Empire, with its capitol in Bermuda, the Course of which is Westward.

Berkeley serves us as a touchstone for the feeling about Baroque mathematics set out by Leibniz and Newton among many others. No matter how plausible or implausible it might seem, and despite the view of some historians that Berkeley set British mathematics back a hundred years, the dangers of the Baroque ideas about mathematics and science, as well as of the arts, did not go unperceived. The non-mimetic image of the "real" and truth by least resemblance tax to the breaking point one's capacity to understand the "real world" in which one lives. We can no more comprehend what is infinitely less than anything sensible than we can the meaning of words when we give to syllables of words as many beats as notes. In short, the verisimilitude of the representation of the "real" whether in mathematics or music is rendered unintelligible, whether mathematics and music be foreign or domestic. Free Thinkers abound as much in the clubs of London as in the opera houses of Vienna, Venice, Paris or Rome.

Of course, one may say that Berkeley was just plain wrong in his views of mathematics, that after all the segments in the arch are not really said to be infinitely small, but only as small as one pleases, and that it is the segments as small as we please which converge toward a limit, and that after all, to make sense perception, limited to finite quantities, go bail for the rules of mechanics, is ridiculous and would preclude, for instance, the decomposition and combining of mathematical conditions of motion as well as mathematical realism itself.[9] But can we say that same sort of thing about criticism in the arts? If Italian opera at the middle of the eighteenth century is incomprehensible in the same way that Newton's "fluxions" are, can we say that the criticism is plain wrong?

To find out, I dug deeper into my box of books in the attic. Besides a dog-chewed edition of Berkeley's writings, the box contained not only textbooks in chemistry but also in music criticism (such as a dilapidated copy of Strunk). Of the latter many contain "textbook" examples, such as Ludovico Antonio Muratori's *On Perfect Italian Poetry* (*Della perfetta poesia italiana,* 1706),[10] which, in its marvelous (and baroque) subtitle, expresses the same Berkeleyian fears: "On the Defects That Can Be Observed in Modern Operas.

[8]*Ibid.* pp. 87ff., 67ff. See also Berkeley's "A Defense of Free-thinking in Mathematics" where he says that Newton's authority is "converting the republick of letters into an absolute monarchy...even introducing a kind of philosophic popery among a free people," *ibid.*, pp. 115f.

[9]See above, pp.163f., 206f.

[10]For the most recent textbook version, see Enrico Fubini, *Music & Culture in Eighteenth-Century Europe. A Source Book*, pp. 39-47; see also Robert S. Freeman, *Opera Without Drama. Currents of Change in Italian Opera, 1625-1725*), pp. 22 ff., who examines Muratori's ideas in the light of his correspondence with Apostolo Zeno in the context of the reform (especially of Venetian) opera as a response to French criticism. See also Edward Lippman, *A History of Western Musical Aesthetics*, pp. 139ff.

Their Music Pernicious to Morals. Criticized Also By The Ancients. Poetry Is The Servant of Music. The Purpose of Tragedy Cannot Be Realized By Means Of These Operas. Other Defects Of Poetry For The Theatre, And Various Incongruities." Muratori does not waste any time getting down to basics by tracing the music of his day back to the "time of the barbarians, and just before the year 1,000 or thereabouts," after which "it was patched up on the ancient model by Guido d'Arezzo."

One of Muratori's chief complaints is that "where once music was both a servant and minister to poetry, today poetry is a servant of music" so that poets "are constrained to lay out and embellish their operas, not as art and the particular subject matter would demand, but in accordance with the dictates of music." Among many examples of the consequence of such an idea is "diphthonged singing," which Muratori explains in a footnote is that singing in which a syllable is "given as many beats as the notes to which it is set, which draws out a passage," making it "difficult to grasp the whole word, and in those wandering and confused tremolos, trills, and passages one loses track of the words, and understanding is confounded." As with Berkeley's complaint about the "Method of Fluxions," intelligibility is zilch and one cannot make out what anyone is singing, nor even what the plot is about.[11]

Yet another consequence is the "lack of verisimilitude," so that "emotions not only languish, but are deprived of their very soul, as experience teaches us." The reason why is not hard to find: "Now, when are men ever seen singing in the midst of their activities and while engaged in serious matters? Is it humanly likely that a person beset by anger, full of sorrow or anguish, or talking seriously about his affairs can sing?[12] ...Certainly, if we consider the opera house, we are sooner moved to laughter than to any other emotion in observing those who seek to imitate and respresent serious individuals, who treat matters of state, plan betrayals, assaults, and wars, or go to their death; or who complain and bemoan some terrible mishap; or who perform other such deeds, all the while singing sweetly, warbling, and with the utmost composure producing a prolonged and sweet trill. ..."[13] Clearly verisimilitude is lacking because, in opera as in mathematics, the "imitation and respresentation" involved are non-mimetic, rather than mimetic.[14]

Muratori's contemporary, Gian Vincenzo Gravina, in *On Tragedy* (*Della tragedia*, 1715)[15] draws out a further and more dangerous implication.

[11] Fubini, pp. 42, 43.

[12] Cf. Auden, cited above, p. 5.

[13] Fubini, pp. 44, 45.

[14] And it is precisely the lack of mimetic representation which is at issue; Muratori takes as one of many examples the "arrieta:" "I say simply that it is a travesty of verisimilitude to want to imitate real people, and then interrupt their serious and heated dialogues with such ariettas: the other singer has to remain idle and silent, listening to the former's beautiful melody, when in fact the very nature of the situation and of civil conversation would have him go on with the matter at hand" (p. 45). Music, then, does not preserve the center of social action but rather is the haunt of its boundary situations, such as laughing and crying, but now become laughable and ridiculous.

[15] Fubini, pp. 37-38.

Noting that all the "imitative" arts have in common a concept which, when altered, alters all the others. For instance, music changes with changes in the poetry "just as the shadow changes with the body." When "corrupted" by excessive ornamentation, in equal measure poetry then "contaminates" music which becomes so full of figures that it loses "its natural expression, for music is born of imitation" and just because it delights the ear is no reason to judge it the delight proper to "dramatic" music. Just here we find the problem: "pleasure today, however, is produced first of all from the lack of the true idea, and then incidentally from any movement of choice capable of enticing and appeasing man's animal nature, which is sense alone, without the participation of reason...like the liveliness of variety of color of Chinese paintings, which delight without imitating truth."[16]

"Reason," then, must intervene so that there can be delight in what imitates the truth and furnishes the true idea. How? If we return to Muratori the answer to this question, perplexing even on the Baroque formulation of consciousness, consists of the realization that (citing Aristophanes) like all things and all foods music, produced to delight the senses, leads to boredom and satiation. Instead of satisfying the ear, poetry and music, "real tragedies," for instance, must aim at satisfying the soul "whose capacity is limitless."[17] The role of "reason" is no longer to decide which of two opposite ideas is true, but rather to set the poetic sight on the soul. What takes sight of the soul rather than the ear, and, we may add, the eye, is a case of verisimilitude "imitating" the truth. Otherwise the music of the "moderns" "exudes effeminacy from every pore, contaminating the theatres. Spectators thus never leave the theatres feeling high-minded and nobly inspired, but only full of feminine tenderness, unworthy both of virile spirits and of wise and valorous people." They become a herd of effeminate Berkeleyian "minute philosophers." As one might expect, the result is "tremendous damage to the cities caused by the musicians themselves, whose behavior, be they men or women, matches the lasciviousness and effeminacy of their singing, and not without the displeasure of pious men and wise citizens."[18] Muratori hastens to assure his readers that this is not the fault of music or poetry *per se*, but only when the latter is servant of the form. Still, the horrendous consequences of effeminacy, are not easily escaped. There even may be still darker reasons for it:

Johann Christoph Gottsched, contemporary of both Muratori and Gravina, famous for a rather vituperative view of Bach, and a natural favorite of anthologists, joins the polemics in his *Essay on a Critical Art of Poetry* (*Versuch einer Critischen Dichtkunst*, 1743) by insisting that opera violates all the laws of versimiltude by failing to observe the rules of drama according to (received) Aristotelian tradition, by exhibiting great improbabilities in its plots and design, and, worse yet, by being caught up in the tangled web of the marvelous. Thus opera lacks all naturalness, has no basis in nature, and therefore lacks

[16]*Ibid.*, p. 38.
[17]Fubini, p. 47.
[18]*Ibid.*, pp. 41, 42.

"reason."[19] It is the task of art, of course, to "imitate nature," and the fantastic and marvelous remove opera from nature at such a distance that there is nothing at all to imitate. Expressed in terms of a formulation of consciousness, there is nothing in experience from which to extrapolate an appresentation of the "real" in opera which can claim any sort of versimiltude. And if, then, the Baroque "poetics of wonder" goes bail for verisimilitude, the evils of seduction, corruption, contamination infect not just poetry, which becomes the servant of music, but the whole of society as well. Moreover, as with Berkeley, Muratori and Gravina, anyone who believes otherwise is morally suspect.

Among Gottsched's students, Johann Adolph Scheibe seemed especially bright, but like most students sought to take edge off his old teacher's criticism. Scheibe, after all, was an opera buff. Accordingly, he sought minimal justification of opera using a certain idea of "imitation," but still within the framework of Gottsched's rationalism. For example, in recitative (especially with enharmonic intervals) Scheibe found an imitation of passions, sentiments and emotions which adequately corresponded to the inflections and nuances of language, at the same time strengthening the analogy between music and the various devices of rhetoric.[20] However plausible, the solution is extreme because, at least until the advent of Romanticism, recitative (especially *recitativo secco*) had but one function: to express the dynamic phases of stage action. In contrast the "aria," apparently to be eliminated by both Gottsched and Scheibe, was to portray the inner feelings of the characters appresented by the emotional levels of melody.[21]

In any case, the result is that "imitation" is mimetic, a copying. As with the other critics, the mimetic epoché is no longer in operation and there is a correlative shift in the accent of reality along with a change in the warrant of reality decreed. Thus almost everything peculiar to Baroque opera, like the achievements of Baroque mathematics and science (Galileo did recant, even if we prefer not to believe him, and Newton did lock himself up with the letters of St. Paul), was blown away when the Classical wolf of the Enlightenment huffed and puffed down the Baroque door. And despite Mozart (who was a genius anyway) and Piccinni, it was Gluck and Kant who emerged as wolves in wolve's clothing.

[19] For Gottsched, see Dora J. Wilson, "Johann Adolph Scheibe's Views on Opera and Aesthetics," pp. 49-56; Lippman, *op. cit.*, pp. 180ff. As a consequence, the Baroque idea of *meraviglia* and the "poetics of wonder" take on a pejorative meaning in the eighteenth century, revived only in a positive (or "neo-Baroque") meaning at the end of the century when associated with the idea of the sublime; see Dahlhaus, *The Idea of Absolute Music*, pp. 50f.

[20] *Ibid.*, pp. 52f. Similar attempts were made elsewhere to defend opera but within the framework of rationalism, e.g., in similar controversies in France; see Verba, *Music and the French Enlightenment*, pp. 35ff. (where, in some cases, besides recitative, the aria is also defended because it appeals to reason, p. 35). See also Giorgio Pestelli, *The Age of Mozart and Beethoven*, Chapters 17, 18.

[21] See Rodolfo Celletti, *A History of Bel Canto*, pp. 17ff.

Effeminacy and Hedonism

Rodofo Celletti has not been the first, nor will he be the last, to note that "Every age is the reflection of its own poets, its own painters, its own story-tellers, its own musicians" and, we may add, its own mathematicians and scientists.[22] After the Battle of Lepanto that reflection, as in other ages, included what delighted and pleased. In the seventeenth century of the Baroque, and on the Baroque formulation of consciousness, what delighted and pleased, was a "poetics of wonder" which found its expression in the theme common to poetry and opera: human passion and love, of course, as with any self-respecting hedonism, but after a victory in war in which Europeans lucked out, also unrestrained passions leading to human suffering and violence only to be resolved "erotically" with all the sexual ambiguity of the Hermes character of Baroque music and science.[23] The passage and resolution of such passions presupposed the Baroque theatre as window onto Divine and human orders of events which work themselves out dramatically. The theatre itself becomes the "true idea" of human life which proves to be the "true idea" of human life because it least resembles the Divine "authorization" (or: "planification"). That is to say, the human order expressed by what transpires on the stage appresents its opposite, the "natural"[24] and non-spectacular order of Divinity. It can hardly be by accident that the Baroque ruler, who believed that rule is achieved by incorporation into the Divine order, was glorified as much in opera as in the patronage of science.

As we have tried to suggest, phenomenologically the less the resemblance, the truer the appresentation of Divine incorporation into the world, so that the greater the "artificiality" and complexity of character, for instance, by means of exaggeration, even distortion, and therefore the truer the idea. To that extent, the characters are favored by "fortune."[25] Accordingly, the historical and courtly spectacles of great kings and princes, great architecture, exotic lands, gigantic land and sea battles, magnificently displayed events, elaborate similes with events and things in nature, wrenching conflicts between duty and personal desires, do not involve so much the play of the "real" against the "unreal" as they do the play of opposites, one of which is the (least resembling) true idea of the other. As we have noted, too, the play of opposites centers around the ways in which eros is at work at the beginning of the drama penetrating and disrupting glory and honor (the deceits of love, such as feigned innocence, disguised depravity) resulting in a *"commozione d'affetti"* only to be resolved at the end of the drama by love so that the characters end up, as Auden says, "doing exactly as they wish."

[22]*Ibid.*, p. 198.

[23]See above, p. 129; and Celletti, pp. 7, 9, 23f.

[24] See Dahlhaus, *op. cit.*, p. 49 for the different meanings of "natural" in the eighteenth century.

[25]See above, pp. 133f., and Schrade, p. 57.

In contrast to the idea of ancient tragedy espoused by the critics of the Baroque in the eighteenth century, Baroque "fabled tragedy" has taken on a shape quite distinct from antiquity. Not only are the passions dominated by eros, but they are also among themselves forcefully conflicting. As it were, they are the "best possible" passions which would seem required by every Baroque opera and play with the mandated *"scena di forza,"* of both heroic as well as forcefully conflicting passions, thus yielding access to the "real" represented in the dramatic action in its agonic tragedy. But what governs and motivates all other passions, what drives the characters of Baroque opera and drama to violence, war, is the one dominant passion: love. With love dominant at the beginning and the end, the war of passions, usually reinforced by the conflict of ambition and duty, by the collision of desires with obstacles, rages throught the work. The musical shape this acquired was a reflection by the characters analyzing their own passions and feelings and actions in recitatives and arias of increasing length and structure (and a correlative reduction in set pieces), offering in succession image piled upon image of jealousy, wrath, warlike fortitude, misery, pain, suffering, forming an agonistic whole shaped into the rigor of a style making the passions "clear and distinct," unambiguous—the mark of a "true" idea.[26] The *stile rappresentativo* becomes the *stile concertante* of the *"bellum musicale."*

Thus in the Baroque hedonism the musical rhetoric of "fabled tragedy" operates as a compossible equivalent of the Cartesian *certitudo* peculiar to those ideas which have "objective reality." Using the term, *"stile concertante,"* as a name for this Baroque musical rhetoric, it is a mechanism of style which is the compossible equivalent of the mathematized mechanics in physics, or of algebra in mathematics. Risking the charge of audacity, hardly important in old age, the temptation remains to say that *Baroque style is nothing else than the Cartesian cogito unravelled in its compossibility.* The concerted style of eros-dominated passions is then as much the access to, as the planification of the human condition: all the elements of the work are defined by the style which demands that the expression of conflict match it. Thus the emphatic, almost explosive exaggeration in gestures and the elaborate distinctions in the modes of singing and instrumental playing. As Galileo says in his letter to Cigoli,[27] it is the *music* and the musician, not so much the libretto and the librettist, which express the fabled tragedy and the idea which least resembles. (This is a notion echoed as late as Boito (writing in 1863) who said that even though Italian opera was strengthened and developed by each successive genius it always remained formula because, from the beginning, Italian composers had confused form with formula. Boito then drew the rather extreme conclusion that one cannot write good music to a bad libretto, nor indeed to a libretto of any kind: the musician has to think in terms of tragedy rather than in terms of libretti.[28])

[26] For the specific kind of self-reflection involved here, see above, pp.195f.

[27] See above, p. 136.

[28] Cited and summarized by Julian Budden, *The Operas of Giuseppe Verdi.* Volume 2, *From Il Trovatore to La Forza del Destino,* p. 15. Budden discusses in detail Boito's solution to this problem, pp. 21ff. in terms of Boito's libretto to Faccio's *Amleto* and Boito's own *Mefistofele* of 1868.

Together the foregoing characteristics constitute an erotic hedonism of the "poetics of wonder" which in opera, with its sharp distinction in the *stile rappresentativo* between "speech in song" and "song in speech,"[29] becomes "effeminacy" for eighteenth-century critics of Italian opera.[30] With the "poetics of wonder" secular music had been cultivated in the direction of song (and the "'singing' of instruments in the execution of melody") characterized by the virtuosity (the "amazing feats of daring needed to portray the wonders of a world of fantasy") found in divisions, variations, improvisations and eventually contrapuntual skills, all of which led to a hedonism consisting of lyricism in the sense of "smoothness, tenderness and pathos." In turn, there was a correlatively closer "imitation" of nature: "Imitation of a world of magic, enchanted and superhuman...brought both voices and instruments closer to nature, and they were to outdo each other in describing bird-song, tempests...The reproduction was not to be literal, however, but figurative <i.e., in our lingo, non-mimetic>, stylized, idealized..."[31]

All of that posed a problem for the "imitation" of human feelings, first for the inventors of Florentine opera, then for subsequent composers, which gradually led to the "trend" toward expanding melody in the Roman and Venetian schools of composing opera, which ruled out the "theory of inflected speech," i.e., recitative, favored by the Florentines (Peri, da Gagliano)— inflected speech serving as the basis of various types of recitative. In a relatively short period of time vocalism followed the two different paths of "speech in song" and "song in speech"—the former a "plain, unadorned style" (but on occasion melismatic) and the latter a "'florid' style" where virtuosity "imitated" "nature, presenting a stylized, transfigured image of nature" but reproduced "certain feelings and passions, here again looking towards stylization and transfiguration."[32] Together the two styles make up *"bel canto,"* which Celletti and others insist, is entirely peculiar to the Baroque Age.

Its initial formulation, like almost everything else, is found in Monteverdi's operas— and just in case his librettist still didn't get it, in a letter to Alessandro Striggio of 9 December, 1616,[33] Monteverdi explicitly introduces the distinction of "speech in song" and "song in speech."[34] The distinction is as

[29]See above, pp. 96f., 183f..

[30]For the positive meaning of "hedonism," see Celletti, pp. 3f. For the negative or pejorative use of "hedonism," which we can equate with the charge of "effeminacy" in eighteenth-century criticism, see *ibid.,* pp. 10f., 12.

[31]*Ibid..*, pp. 4f. See pp. 116ff. for very specific examples.

[32]*Ibid.,* p. 6. See pp. 30ff. for detailed discussion of the devices of the "florid" style by different composers in various works. See also Rodolfo Celletti, *Voce di Tenore. Dal Rinascimento a oggi, storia e tecnica, ruoli e protagonisti di un mito della lirica,* pp. 13ff.

[33]*The Letters of Claudio Monteverdi,* pp. 117f. See Celletti, *A History of Bel Canto,* pp. 6f.

[34]Pier Francesco Tosi's *Opinioni d'cantori antiche e moderni* of 1723 is probably as instructive an example of the codification of the two styles as any. And it is interesting to note, as Celletti has emphasized (*ibid.,* p. 6), that one of the subtitle's of Tosi's book

much musical as theatrical and social: generally "elevated," "florid" style characterizes divinity and by extension heroic characters; "plain" style, speaking in song, characterizes instead mere mortals, often sorrow-stricken ones at that. Correspondingly, these characterizations have their life-worldly correlate in the differences in social classes and the kinds of emotions and sentiments which beset them according to the socially approved stock of knowledge at hand.

Perhaps what is at stake in the criticism of the "poetics of wonder" can best be expressed by saying that the mimetic, or a return to the mimetic (it is, after all, an issue of "re-form"), overcomes the hedonism of the non-mimetic, which, when vanquished, reveals itself as effeminacy. Another way to express the matter, using Celletti's suggestion for the distinction still present in Rossini, is to say that the mimetic is "descriptive," the non-mimetic "evocative."[35] We shall return to this distinction in the next section. For the moment, we need to pursue a somewhat different line of thought. What would seem to be the case for the mimetics of the eighteenth century is that it is the "plain" style which predominates at the expense of the "florid." That would certainly seem to be a return to the original Florentine style of recitative, or if not, at least transporting a version of it into the eighteenth century. For the Baroque formulation of consciousness, it is "reason" which makes us believe that the true idea of the "real" is the opposite, that the idea which appresents the truth is the idea that least resembles it. The gist of eighteenth-century criticism, in those terms, is that what "reason" really does is to make us "suspend rationality" so that the "real" extrapolated from the center of action and ordinary experience is "confused" with its opposite, the fantastic, the "illusion," which appresents it.[36] If that is true then surely the Baroque hedonism must be considered "effeminate" (always in the eighteenth-century meaning of the term), and what pleases and delights on the Baroque formulation of consciousness, the "poetics of wonder," is vain and frivolous illusion.

Thus, in terms of the criticism, the greatest rationality drawn from the center of planned action in the world of ordinary experience turns out to be illusory and the least rational because it releases us from the inhibitions necessary to civilization and sets us down in the boundry-situations of laughing and crying, and laughing until we cry, putting us at risk by removing us from the center of life to its eccentric limits not always exchangeable with the center. Even the "reform" librettists, such as Zeno and Metastasio, contributed to this state of affairs by increasing the development of character, and, with composers from Lotti to Handel, by increasing the use of metaphors to depict the state of mind of characters through comparison with natural phenomena such as flights

informs us that what he has to say about the "florid" style is "Useful for all Performers, *Instrumental* as well as *Vocal*." (Translation by Mr. J. E. Galliard, *Observations on the Florid Song; or Sentiments on the Ancient and Modern Singers*, London, 1743).

[35] *A History of Bel Canto*, pp. 136f.

[36] Cf. Leslie Fiedler, *What Was Literature*, pp. 136f. To be sure, Fiedler is not talking about the Baroque, but the Classical formulation of consciousness; but what he says is much more apt for the eighteenth-century criticism of the Baroque formulation; see above, pp. 181f., 188.

of birds, flooding of rivers, scents of flowers, storms, and the like,[37] and inspiring, as Celletti says, "more fanciful imitation, arising either out of the poetic text or from the bravura of the new singers—bravura here in the sense also of imagination in improvising and embellishing."

To be sure, one does not have to be a Nikolai Kusmitch to realize that in opera characters, however complex and drowned in metaphor, *still communicate by singing,* and that what delights and pleases is that "fantasy on the part of the composer and fantasy in the interpreter are communicating vessels, as are also, more than ever, instrumental virtuosity and vocal virtuosity."[38] Under the eighteenth-century criticism leading to Gluck, precisely that communication is rejected and replaced by the unity of dramatic action, to which the music is subordinate—that is, the music is not just the servant of the words, but also subject to drama. Or, to express the matter in another way, it is the sounds of language, not of music, by which persons on the stage communicate with each other and with the composer.[39] Whereas, on the Baroque formulation of consciousness, the sounds by which communication is established in opera are the sounds of music, the compossible harmonic grid, rather than the sounds of language (thus they seem detached from the reality of daily life) and their inner unity is derived, not from the drama, i.e., not from the libretto, but from the structure of music itself.

What is at issue here, finally, is the very idea of "imitation." To be sure, by reverting to recitative and the "plain" style musical forms and formulae become subordinate to the dramatic idea, placing great weight on declamatory expression. Tragedy then hinges on human emotions which are best expressed by the simplicity of ideas and by actions best respresented when not interrupted by metaphors and similes at times of crisis. The figurative, florid and fantastic only distort the human condition. What, then, is "imitation"? Is the "real" still to be extrapolated from ordinary, common-sense experience? Is the "real" still accessible at all to ordinary experience?

[37]But always through the use of the epic style of *"tertium comparationis."* See also Fred Kersten, "Phenomenology, History and Myth," *loc. cit.,* pp. 245ff.

[38]Celletti, p. 67. See p. 115: "bravura singing, which consists specifically in the execution of full-voice coloratura, as opposed to plaintive, flute-like execution known as graceful or 'mannered' agility." According to Celletti this sort of singing arose at the begining of the eighteenth century, as part of the "elegiac-pathetic" style, and was replaced at the second half of the century by overdone virtuosity ruining the expressiveness of the singing. Thus the story about the Emperor Charles VI and Farinelli, when the latter was admonished to stop trying to astonish his audience and become more expressive, engaging the emotions of his audience, returning to the "pathetic" style.

[39]See Wilhelm Dilthey, *Von deutscher Dichtung und Musik: Aus den Studien zur Geschichte des deutschen Geistes,* pp. 275-295. Cited by Alfred Schutz, "Mozart and the Philosophers," *Collected Papers,* Vol. II, pp. 190f.

The "Real" Unextrapolated

To answer those and similar questions we need to establish a rather different Archimedian point. Apparently unaffected, or even unconcerned with the controversies about Italian opera going on in France and Italy, Leonhard Euler, now half-blind, was busy pondering the nature of space and time. In 1748, having travelled from the court of Catherine the Great in St. Petersburg to the court of Frederick the Great in Berlin, he wrote a small essay of large influence: "Reflections on Space and Time" (*"Reflections sur l'espace et le tems"*).[40] The essay can serve us here as *Sturmvogel* for the course of thought about the metaphysically "real" for the rest of the eighteenth century. Euler says that "The principles of mechanics have already been so solidly established that it would be absurd for anyone to doubt their truth. Even if one is not in a position to demonstrate them by the general principles of metaphysics, the marvelous agreement of all the conclusions... would be sufficient to set their truth outside doubt...For one would be right in rejecting in metaphysics all reasonings and all ideas, no matter how well founded they might otherwise be, if they lead to conclusions contrary to those truths of mechanics. And one would also be right in admitting into metaphysics only those principles which can co-exist with these same truths of mechanics."

In other words, the metaphysically "real" is not extrapolated from ordinary experience, nor from anything else. The "real" is a construct of mechanics and therefore the sole tribunal of justification is mechanics itself—more broadly, science itself, and not sense perception as Berkeley would have it. Our philosophical, and by extension, common-sensical notions of space and time have to square with those of science. It is, say, the principles of mechancs which decide which ideas are the true ones. Only what is an indispensible precondition of mechanics or science is a true idea—and if that means that it is inaccessible to philosophy ("metaphysics") or ordinary experience, then the latter must conform to those preconditions no matter what. And it was the "no matter what" which Berkeley could not stomach and therefore he only told half the story. This is because Berkeley was also half right, for the moment one tries to "imagine" the perceiving of "flowing quantities and their "fluxions" and "differences which are supposed to be infinitely small," however unimaginable the size, the gap reappears because the unimaginable proves to be the necessary precondition of, e.g., mathematics. Thus eventually we shall be forced to distinguish between "perceiving" a "fiction" and judging that it is "real."[41] If we cross national borders, and go from court to theatre (usually only a short walk), then what is at stake concerning the criticism of Italian opera is that music must conform to whatever are the indispensable preconditions for drama, and that characters must conform to the dramatic idea. The forms of music, and especially the "florid" style, indeed *bel canto,* no matter how otherwise well-

[40] Leonhardi Euleri, *Opera Omnia,* Series Tertia, *Opera Physica,* Vol. II., pp. 376ff. (The translation is mine.) For a discussion of this essay of Euler, see Fred Kersten, *Phenomenological Method: Theory and Practice,* §40.

[41] See below, pp.235 and 237f..

founded they may be, are to rejected when they lead to ideas contrary to those indispensable preconditions.

In short, we may say that on the *Enlightenment formulation of consciousness* (horrendous phrase) the ideas of character and action in the world must square with the idea of drama and language, just as ordinary experience of space and time must square with the indispensable preconditions of mechanics. It is not so much "reason" which determines the "true idea," but rather whatever is required by mechanics, science, in the one case, drama and language in the other case. Stated in still other words, only recitative and the "plain" style are not contrary to the dramatic idea (e.g., tragedy).

Phenomenologically, the question has changed from, From which aspect of ordinary experience is the "real" extrapolated and appresented, to What makes music an "imitation" of human nature? The answer is the preconditions of the dramatic idea of tragedy or of comedy which make music an "imitation" of human nature. A brief glance at Rousseau will give us some idea of those preconditions. In the article, "Opera," in his *Dictionnaire de Musique* of 1768,[42] Rousseau traces the history of opera and notes two states of reform. The first occurred when music evolved into an independent art with its own language and expression, seeking "in the imitation of nature more interesting and truthful tableaux. Until that point, opera got on as best it could; what better use could one make in the theatre of a music which was unable to paint anything, than to use it to represent things that could never exist, and of which no one could possibly be in a position to compare the image to the object?" And as soon as music "learned to paint and to speak" opera was able to rid itself of "mythological jargon" and the "charms of feelings" took the place of "magic wands"—a "more reasonable and regular form" which, Rousseau says, is "most appropriate for <representing> illusion." This led to a "second reform," where, in cases of languages suited to taking on the laws of rhythm and melody, poetry gives itself over to the inflections of melody, and music gives itself "only to the ideas of poetry," then competition between language and music is minimized and a union is forged between them.

As for painting, it is "cold," and the painter, in revealing everything seen "with the first glance of the eye," of course cannot paint what he cannot see but only hear. The musican's art then consists of "substituting for the imperceptible image of the object, that of the movements which its presence excites in the spectator's soul: he doesn't represent the object directly; but he awakes in our soul the *same* sentiment that we we experience in *seeing* it." Even if the painter has nothing to learn from the musician, the musician, Rousseau says, "will never leave the painter's studio without having gained something."

Although subordinate to painting, music must nonetheless "learn to paint"[43] if there is to be a satisfying and non-trivial harmony and union between

[42]Translated in Verba, *op. cit.*, pp. 128-137.

[43]In this connection see Peter Kivy, *Sound and Semblance*, Chapter III, for a discussion of music learning "to paint," i.e., of "musical pictures" and music "which sounds like" what it imitates. (For the inverse operation, painting music, where painting "learns to make music," see Paul Klee, *Das bildnerische Denken. Schriften zur Form- und Gestaltungslehre*, pp. 285ff. which explains how to paint a three-voice composition of

language (poetry) and painting and music. What is the relation between music and painting? Alfred Schutz perhaps put his finger on the matter when he noted for Rousseau that, first, it is melody which makes music imitate (though not quite directly) nature: "It is melody which plays the same role in music that design plays in painting: melody creates the contour; the chords, the harmony furnish merely the color."[44] It follows that unity of melody requires 1) that in a duet or trio melody is distributed successively among the parts so that two melodies are never heard at the same time because that would be unnatural—after all, it is unnatural and quite bad manners for two people to speak at the same time (canons and fugues are therefore out, an Italian barbarism left over from the madrigal). 2) In the accompaniment all complicated harmonies must be avoided, and the orchestra serves only to fill out the contours of melody and intensify its emotional values. And, of course, the "laws of verismilitude" (Rousseau) must always be adherred to in music as in drama.

As a result, it is not a large jump in time (one year) or thought to Calzabigi (a librettist with "no sense of the theatre," who was "prolix, vain, pretentious"—Celletti) and Gluck resulting in the replacement of the *opera rappresentata in musica* with the reformist *azione teatrale per musica*. It is interesting that Calzabigi and Gluck make a very similar analogy between music and painting resembling Rousseau's.[45] "I determined to restrict music to its true function," Gluck/Calzabigi say, "namely to enhance poetry in terms of expression and the situations it relates, without interrupting the action or numbing it with useless and superfluous ornaments. And I thought music ought to do for the poetry what lively colors and the contrast of light and shadow do for a correct and well-ordered drawing, animating the figures without modifying their contours." It is, of course, as with Rousseau, an *analogy*, not a

Bach.)

[44] Alfred Schutz, "Mozart and the Philosophers," *loc. cit.*, p. 182. Reading Rousseau's article of 1768 one wonders if, by chance, he had not already read Francesco Algarotti's *Saggio sopra l'opera in musica* of 1755, which traces the history of opera from the Greeks in a similar way, deplors the usurpation of authority by music rather than content itself with disposing "the minds of the audience for receiving the impression to be excited by the poet's verse, to infuse such a general tendency in their affections as to make them analogous with those particular ideas which the poet means to inspire," and then draws the same analogy between music and painting (see Oliver Strunk, *Source Readings in Music History. The Classic Era*, p. 90. See also Drummond, *op. cit.*, pp. 164ff. It could well be that Algarotti was acquainted with Euler in Berlin at the court of Frederick the Great, where Algarotti resided until 1750 (where he was between then and 1755, when he returned to Italy, is not known, although the story is that he was in Vienna where he could well have hung out with Gluck and Gluck's librettist for *Iphigénie en Aulide,* du Roullet, then attaché at the French Embassy in Vienna. Gluck was in Vienna from 1752 as Konzertmeister, then Kappelmeister, for the Prince of Saxe-Hildburghausen's orchestra). See Pestelli, *op. cit.*, pp. 71ff., especially p. 78.

[45] In, e.g., the Preface to *Alceste* of 1769. (Translated in *Music and Culture in Eighteenth-Century Europe*, pp. 364-366.) See Pestelli, *op. cit.*, who notes that in Gluck's music timbre "assumed crucial importance for the first time and, rightly or wrongly, it is with Gluck that one begins to speak of an orchestrator separate from the composer. But this is the case because Gluck's choices of sounds were derived not from the field of the sonata form but from theatrical considerations" (pp. 76f.)

compossibility as on the Baroque formulation of consciousness.[46] Indeed, the relation between music, poetry, painting is not any longer one of compossibles *but rather of subordination in accord with those preconditions indispensable for representing the human condition.*[47]

Imitation," then, is not a matter of extrapolation and indicational appresentation as in the Baroque. It is, rather, a case of image measured off its original. And Rousseau's criticism, as of others in the second half of the eighteenth century, is that in Italian opera there was no original whatever to compare with the image: what was depicted by the image did not exist. "Imitation" is mimetic in the original sense,[48] a copying of what exists in Nature in another medium: music, dance, painting, to be sure. Gravina, Muratori, Algarotti, Rousseau, Gluck, but also Berkeley and Euler, in their reformist yet nostalgic zeal to return to Greek drama in its origins and to the metaphysically "real" in its genuinness, returned to the Classical formulation of consciousness, but without either the neo-Platonism of Zuccaro[49] or the basic assumptions of the Classical formulation.[50]

The Last Stand of the Baroque Formulation of Consciousness: Rossini

Almost a hundred years after the "Preface" to *Alceste* by Calzabigi/Gluck, Rossini wrote from Paris to Filippo Filippi (26 August, 1868): "You will have noticed...that I have deliberately ignored the word 'imitative' in the recommendation made to you by the young composers on Italian musical art, and I have referred 'only' to melody and rhythm. I shall always be *inébranlable* [unswerving] in my contention that Italian musical art (especially the vocal aspect) is entirely 'ideal and expressive,' and never 'imitative,' as certain materialistic so-called philosophers would argue. Allow me to state my view that the feelings of the heart are expressed and not imitated."[51] And Rossini also adds that "Music is a sublime art precisely because, not possessing ways and means of imitating the truth, it rises above and beyond everyday life into an ideal world."

[46] See above, pp. 143f. for yet another analogy with "painting" in Descartes.

[47] Of course, it is possible to proceed by suggesting that precisely what comprises, or should comprise, the human condition consists of a socially derived and approved stock of knowledge at hand defining, in turn, ideas and actions at the center of the life-world appropriate for human behavior.

[48] See above, pp.33ff.

[49] See above, pp. 121f.

[50] We should hastily add that the distinction between the non-mimetic and mimetic is not invented in the eighteenth century, but in the Renaissance; see Palisca, *Humanism in Italian Renaissance Musical Thought*, Chapters 12 and 13.

[51] Cited by Celletti, *op. cit.*, p. 135f.

If, on the road to the recovery of Greek drama, Gluck returned to the "Monteverdian principles" of music (Drummond), Rossini did the same but "turned upside down the principles which applied at the time of the birth of opera...followed at the outset even by Monteverdi" (Celletti). In that same letter to Filippo Filippi, Rossini refers to the "reform" of Gluck and his contemporaries as being in a "hydrophobic style" and avoiding the "sweet Italian singing which goes straight to the heart."[52] If the hedonism of the Baroque has become effeminate for the immediate predecessors of Rossini, their masculinity has become hydrophobic, rabic, even hydrophilic, for Rossini and (by extension) for the Baroque. With Gluck and the reformists the *favola in musica* (or: *opera rappresentata in musica*) has become an *azione teatrale per musica,* and this violates Rossini's Baroque idea that, as Celletti says, "fantasy dominates everything," i.e., that while melody begins with the basic meaning of verses it frees itself from the inflections and accents of language as she is spoken and exerts a rigorously musical influence on the character and feelings of people with respect to certain situations or episodes on stage. For Rossini, opera is still the "poetics of wonder." Rossini's music, then, represents either the last attempt to make a legitimate case for opera on the Baroque formulation of consciousness, or it represents its end—or both.

If we take Rossini at his retrospective word toward the end of his life, what melody does is to give a form to a "state of mind or a sentiment" which is "evocative, not descriptive," appealing to human feelings "by means of the stimulus and allusions of a stylized or actually sublimated (or 'idealized') type of language. In order to arouse emotions in the audience, this language follows laws of its own and uses words merely as sign-posts, or still better, as guidelines."[53] The melody gives a meaning even to the words which they otherwise would not have, and provides a reference to what is happening on the stage, the *istoria,* required by the emotions of the listener evoked by the melody in the first place.

But how is this an "answer" to the "reform" of Gluck and that gang? Is not Rossini just another name-calling reactionary returning to the discredited Baroque, despite his undoubted harmonic and melismatic abilities? Rossini's explicit denial of imitation in the sense of copying the "real" rather than indicationally appresenting it, of "evoking" rather than "describing" human passions,[54] his preservation of the distinction between the two styles of singing, his increasing tendency to write out in his own hand the florid song (although, as Celletti notes, this does not by any means eliminate the need for improvisation among the singers[55]), all point to a possible answer and will help us cast into even sharper relief opera on the Baroque formulation of consciousness.

In the first place, Rossini's reflection on, and rejection of, imitation as copy points to his idea that the floridity of song (of song in speech), is, as

[52]Cited *ibid.,* p. 139.

[53]*Ibid.,* p. 137.

[54]And it is when a melody becomes merely "descriptive" rather than "evocative" that the dreaded hydrophobia sets in.

[55]*Ibid.,* pp. 140f.

Celletti sums it up, an "emanation of music understood as an ideal art; melody was "born ornate and florid; the vocalise was an integral part of the expression and not a mere fringe adornment," thus intensively reinforcing passions no matter what they may be—idealized or carnal love, nostalgia, anger, despair or joy. The words of the poet become means to that end, and, for example, one of the devices of this, the fragmentation of words into syllables separated from one another by fioriture, as Celletti notes, almost eliminates the very meaning of the term "fioriture" but has the effect of sublimating the singing and the action on the stage with the "impulse, grace, the lightness, and even the fantasy, of a melody which is *born* ornate and of which the coluratura is an intimate part and not an ornamenth applied mechanically."[56] Celletti provides a plausible case for his judgment with plenty of detailed examples of Rossini's development as a composer (reaching its peak in *Semiramide*[57]—the use of fermatas with trills and scales with their groups of hemidemisemiquavers[58] in an Andantino of Arsace in *Aureliano in Palmira,* or the four-note groups in the duet between Isabella and Mustafà in *L'italiana in Algeri*, the replacement of long vocalise by "runs," the variations in strophic arias, but of course always with a clear reference to the action on stage, be it comic or courtly).[59] Rossini obviously is not just a throw-back to the Baroque, and the claim to indicational imitation is as plausible as copy-imitation.

In the second place, however, Celletti mentions something else which suggests that Rossini is not just a throw-back to the Baroque after all. Despite maintaining and even developing the distinctions of Baroque composition and performance, Rossini does something wholly unbaroque: he overcomes the separation between *opera seria* and *opera giacosa* by introducing into the comic the same florid style of *opera seria*.[60] And, at least in the case of *La Cenerentola*, according to Tullio Serafin, the result is the creation of a new genre which is neither *opera seria* nor *opera giacosa* [61] nor, as was commonly the case with the latter, a parody of the former. Rossini then fullfills the inner

[56]*Ibid.,* pp. 141, 145, 151f. In this connection, for the idea of "melody born ornate" see the report of a conversation of Bellini with Agostino Gallo in 1832, cited by Celletti, pp. 191f. (also mentioned in Friedrich Lippmann, *Vincenzo Bellini,* in *The New Grove Masters of Italian Opera,* pp. 168f.)

[57]*Ibid.,* pp. 144, 210.

[58] In the seventeenth century, 64th notes.

[59]*Ibid.,* pp. 142f., 144, 145, 152, 155.

[60]*Ibid.,* pp. 135, 145. A familiar example is the music of the Overture to *Il barbiere di Siviglia* which was first used in *Aureliano in Palmira* then in *L'Elisabetta,* each time shaped and reshaped stylistically and rhythmically for the individual character and idiom of each opera; the elaboration of the music in each case is differently developed—for example, the violin figure in the duet between Zenobia and Arsace in prison in *Aureliano* is so developed as to express a lamentation, while in *Il barbiere* it is developed to have a comic effect at the beginning of the calumny aria. See also Richard Osborne, *Rossini,* pp. 129, 156f.

[61]Tullio Serafin. Alceo Toni, *Stile, Tradizioni e Convenzioni del Melodramma Italiano del Settecento e dell'Ottocento,* pp. 111, 113f. For Italian "comic opera" in the second half of the eighteenth century, see Pestelli, *op. cit.,* pp. 45ff., 86ff., 187f.

telos of Baroque opera by transforming it into something new rather than subordinating it to the drama. The last gasp of the Baroque formulation of consciousness is a swallow of fresh air. Of course, that will open the door to the new social classes and the bourgeois wolves of the domestic epics of Romanticism and Realism in the nineteenth century.[62] Predators abound where novelty prevails.

It is not our task to trace, or even suggest, this development further here.[63] However, we have gone far enough around the bend to make a final attempt to clarify mimetic and non-mimetic representation, an attempt which has been the springboard of our discussions of the formulations of consciousness throughout, both by day and by night.

[62]The Baroque distinction between the icastic and the fantastic does not immediately disappear with the new formulation of consciousness, such as Romanticism. One example which comes to mind is the recent study of the role of narration in Romantic opera which proves to be a "self-reflexivity of narration" (Abbate) closely resembling the Baroque idea of self-interpretation (see above, pp. 195ff.); see Abbate, *Unsung Voices. Opera and Musical Narrative in the Nineteenth Century*, Chapter Three (examples of which are found as much in Marschner's *Der Vampyr* as in Mozart's *Le Nozze di Figaro*). What marks the transition from the Baroque to the Romantic fomulation of consciousness would seem to lie rather in the merging of the fictive into the "real world" (see Abbate, p. 76).

[63]Celletti traces the course of the fate of opera through Romanticism and its final "demise" at the end of the nineteenth century in *verismo*, which, in a strange way, is similar to the "reform" of the eighteenth-century when music becomes the servant of language, but now of the "natural" language of "Plebeian tragedy:" the "adoption of vocal patterns derived from the spoken language such as imprecations, invectic, blasphemous interjections, tavern slang" leading to "amateur" singing as much as "amateur" music (pp. 199, 201f.), ultimately losing sight of the fact that "opera is theatre in music and that theatrical values are just as important as musical values" (p. 202). In short, the *dramma musicale regio e politico*, along with the Graeco-Roman world, has disappeared in veristic Plebeian tragedy and "conversational singing" (pp. 189f.) See also Schrade, *op. cit.* pp. 61ff.; Pestelli, *op. cit.,* pp. 254ff.; Dahlhaus, Chapter 4.

CHAPTER NINE

The Baroque Formulation of Consciousness In The Domain Of Phenomenological Clarification

Both the Classical and Baroque formulations of consciousness, as well as their criticism in the eighteenth century, presuppose and take for granted, the fourfold, ungrounded ontic conviction of daily life as positing the "metaphysically real," the indicational appresentation of which is extrapolated from ordinary, common-sensical experience founded on the ungrounded ontic conviction (in Husserl's lingo, the general positing of the "natural attitude"). As long as the presupposition is in full force, the result of these formulations entails the distinction between the non-simply connected space of the gap rather than the "simply" connected space of daily life. Their confusion, or the attempt to substitute the former for the latter, lead to death, madness, prison.

Certainly the thinkers and critics of the eighteenth century spilled as much ink as those of the seventeenth century on the problem of "imitation." The problem, and the differences in the ideas of "imitation," still haunt us and they are often discussed under the perhaps more contemporary headings of "medium" and "representation." Thus we find them, for instance, in Kivy's *Sound and Semblance*. Important for his discussion of the problem are eighteenth-century thinkers, some of whom we have mentioned, but also Adam Smith, an "unexpected source" (in his essay, "Of the Nature of that Imitation which takes place in the Imitative Arts").[1] Like Galileo before him, Smith compares painting, sculpture, and music both as media of imitation as well as kinds of representation of emotions.[2] Smith makes the point, in Kivy's words to be sure, that "musical imitation, like the painterly and sculptural kind, thrives not just on the exactness of the imitation achieved, but on the dissmilarity between medium and object of imitation," and that music, however, has a much greater "imitational deficit" than either painting or sculpture which music overcomes "with the extraordinary disanalogy of its representational medium to the objects of its imitation."[3] In turn, this observation will enable Kivy to reconstruct Smith's idea of musical imitation "to suit contemporary needs" and "accommodate contemporary philosophical sensibilities."[4]

How? The "charge brought against the claims of musical illustration, in Smith's day as in ours," is that the "aesthetic recalcitrance of the sound medium

[1] Peter Kivy, *Sound and Semblance*, pp. 86ff.; the posthumously published essay of Adam Smith is found in Adam Smith, *Essays on Philosophical Subjects*, edited by W. P. D. Wightman, J.C. Bryce & I.S. Ross, pp. 176-209.

[2] See above, pp. 135f.

[3] Kivy, pp. 94, 95. See above, pp. 35f.

[4] Kivy, pp. 96, 98.

for the illustration of any object or event, is too great to allow the degree of minimal success necessary for artistic appreciation of the illustration, even if it should recognized as such." In the context of our discussion,[5] this is not just a contemporary criticism, but also one of the eighteenth century itself: thus even the grudging admission only of recitative if there is to be opera at all, and the insistence that music be subordinate to dramatic unity and above all to "natural" language.[6] The criticism does have an answer, however, Kivy believes, in the very nature of musical imitation or illustration: "The answer is that the propounder of the objection has clearly overlooked the part that that very recalcitrance plays in making musical illustrations of artistic interest. He is hoist with his own petard, for the very aesthetic recalcitrance of medium that limits the success of musical illustrations, as compared to painting and sculpture, makes that limited success larger than life. The appreciation of musical illustration, like so much else in art, is the appreciation of obstacles overcome, difficulties circumvented, success over external or self-imposed constraints."[7] And, in the case of music, we might add, the "imitation" borders on the non-mimetic because of the peculiar nature of recalcitrance and "disanalogy of its imitational medium to the objects of its imitation." It is almost an eighteenth-century version of truth by least resemblance, and the recalcitrance itself an opposite of those ideas it represents. In this respect it is more "evocative" than "expressive" of the emotions and sentiments it is to arouse. In this sense, too, the aesthetic recalcitrance is aesthetically enhancing.[8]

It is not our purpose here to develop Kivy's very plausible and important, but almost Baroque, rather than Enlightenment, view of musical imitation, certainly for me the best contemporary account we have. I have indicated some of this thoughts on imitation, however, because first, with Adam Smith as reconstructed by Kivy, we have an answer to eighteenth-century criticism by an eighteenth-century writer which, while not Baroque in theory, nonetheless rescues the Baroque idea in criticism in the same way Rossini does in music, in opera; and second, because it provides a focus for the direction of inquiry into the phenomenology of the formulations of consciousness. Our interest after all is not directly the aesthetics of music and its criticism (be it of Baroque or the Enlightenment or of Romanticism) but rather in the formulation of consciousness they presuppose. Indeed, Kivy's restatement of the charge, and his Smithic response, points to a phenomenological distinction of importance to us already presupposed by Berkeley as well as Euler and returns us as well to what is granted to phenomenological clarification pertaining to the enclave of daily life.

[5]*Ibid.*, p. 100.

[6]See above, pp. 218f. and Kivy, pp. 127, and especially 128ff.

[7]Kivy, *ibid.*; Kivy develops his view pp. 101ff., and especially in Chapter VII with illustrations from Handel, Bach to Beethoven, Honeger and Varèse.

[8]*Ibid.*, pp. 99, 101.

Predications of Reality and Existential Predications

What, after all, is a "musical illustration" or "representation" or "picture" or "imitation"?[9] Moreover, the distinction between "medium and object of imitation" points not just to its own clarification, but to the ideas of "predications of reality" and "existential predications." Although the terms themselves were first introduced in Husserl's *Experience and Judgment*,[10] the distinction itself was already made in the Sixth Logical Investigation and further developed in *Ideas, First Book*, §§19-23. The context there is the discussion of common assumptions underlying empiricism, idealism and Platonism. Among those assumptions is that all science must proceed from "experience," that is, from that consciousness in which an individual object is given. All sciences are "experiential" sciences of "matters of fact" in the sense of being comprised of founding cognitive acts of experiencing that posit something "real" individually. Such cognitive acts are acts of "immediate experience" and restricted to "matters of fact" which, in turn, are identified with the subject matter of "genuine" science. Yet, Husserl asks, what justifies this restriction? How does that restriction make experiential science "genuine" science? It is here that Husserl makes the further observation that it is assumed without doubt that the opposite of "reality," of the positing of something real individually, is "imagination." It is to further clarify this assumption that the distinction between predications of reality and existential predications is introduced. And the reason for clarifying the assumption is Husserl's attempt to show that it is not at all the case that all valid judgings are only about real individuals, and that real individuals are the only objects of such judgings (*slc.* immediately valid judgings). Here what Husserl later calls an "existential predication" is thought of chiefly as a modality of a predication of reality, and his criticism will be that empiricism as well as idealism both confuse a predication of reality with its modality.

In *Experience and Judgment*, however, Husserl further clarified what he had in mind by developing the much broader idea in a much more general context, and not just a critical, philosophical one, that existential predications are not just modalities of predications of reality, but more specifically "phantasy modifications." For example, I perceive the real typewriter in front of me, and now instead I phantasy or feign the perceiving of the real typewriter in front of me. The latter, the existential predication, is then said to be a quasi-perceiving," a modification of the original perceiving. As Husserl already suggests in *Ideas, First Book* (§5), all processes of consciousness are subject to such modifications. Here we propose to introduce the distinction in a somewhat different way, and to develop it further in order to clarify the process of consciousness basic to its Baroque formulation in the light of an example of Aron Gurwitsch.[11]

[9] *Ibid..*, p. 96.

[10] Edmund Husserl, *Erfahrung und Urteil*, §§74ff. (English translation by James S. Churchill, *Experience and Judgment*, pp. 298ff.)

[11] Aron Gurwitsch, *The Field of Consciousness*, pp. 411ff.

238

The example is that of attending a new play in the theatre. "At a certain phase of the play," Gurwitsch says, "we may foresee, and thus posit, events we must cancel at a later phase because of complications occurring in the interim." Cancellation of posited existence is possible as much in the case of real as it is of phantasied, imagined or feigned things. Thus when a "certain object has been posited as existing within the world of reality, and when later experience motivates cancellation of that object, it is thereby not declared an object of a 'world of imagination'" or of phantasy. "Rather that object remains a mundane object which, if it existed, would have its place within the world of reality. Denying the existence of the object within the world of reality, hence does not mean referring it to a different order of existence. Opposition between existence and non-existence does not coincide with that between reality and fiction or imagination" or phantasy.

There are a number of things to be learned from this example. The first is that positing things as existing, as probable, or as not existing, is not the same as subsuming them under a concept of reality. The same holds for objects of the imagination or phantasy; to feign something as existent, or as probable, or to cancel it out, is not the same as subsuming it under a concept of imaginational reality. Similarly, in the case of positing an essence as existing, or cancelling it out, is not the same as subsuming it under a concept of "essential reality." To believe that it is the same would be to fall into the trap of Berkeley referred to earlier:[12] to posit the existence of the "flowing quantities and their fluxions" is not the same as subsuming them under a concept of reality, just as to posit perceived things is not the same as subsuming them under a concept of reality (only if it were would *esse be percipi*). Concepts, such as those of reality, imagination or phantasy, or essence, Gurwitsch says, paraphrasing Husserl, "arise only if the subject, while living in the world of reality, reaches over into a world of imagination" and "reflects upon the experience of confrontation and contrast between real and imagined objects and events" or seen essences, each seized upon as exemplifying possible realities or possible phantasyings, or possible seeings of essences.

The second lesson to be learned from the example is that prior to any explicit seizing upon real objects as real, phantasied objects as "fictions," essential objects as "ideal," "real objects still appear within the context of reality from which" phantasied objects or "essences" are "excluded as eventually forming a context of their own."[13] To use Gurwitsch's term, each object presents itself as itself with its own respective "existential index" or, to use terms earlier employed, its own warrant and decree with respect to the shift in its "accent of reality." The existential index, Gurwitsch adds, is "only silently effective...experienced in a rather implicit form."[14] And *predications of reality* make explicit or thematic the silent, implicit and, ultimately, ungrounded existential belief tagged by is index. In short, positing something as existent must not be made to go bail for the concept of reality. Or, to put the matter still

[12] Above, pp.217f., 227ff.

[13] Gurwitsch, p. 412. See also Kersten, "The Occasion and Novelty of Husserl's Phenomenology of Essence," pp. 73ff.

[14] See Gurwitsch, *op. cit.*, pp. 391ff.

another way, the presentivness or appresentiveness of something is not the same as subsuming that something under a concept of reality.

Some Moments Basic To The Phenomenology of the Formulations of Consciousness

For our purposes let us now reformulate the phenomenological distinction of Husserl and Gurwitsch. The first moment implicit in and essential to any formulation of consciousness is the distinction between predications of reality and existential predications. Predications of reality assert that something belongs to the world, to what is "given," to the "real" presented in and through consciousness of it. In the case of a negative predication of reality something is relegated to the domain of phantasy, perhaps even of the "fantastic," even of "fiction." But a predication of reality is also a modification of reality in the sense of referring an object to its own "order of existence." Such predications are not to be confused with existential predications which rather express modalities of existence, of positing something as existent, or non-existent, doubtful, presumptive, and the like, whether things be marvelous, fictive, depictive, or simply presentive. It is important, too, that when something has been posited as existent in the presentive world and when later experience cancels out that something, it does not mean that the something in question is therefore to be declared an object in the world of the imagination; it is not thereby referred to a different order of existence. The something in question remains an object of the presentive world and would have a place in it were it to exist.

Existential predications, modalities, do not refer anything to its order of existence and rather presuppose the referral. Now, Husserl notes that when we live straightforwardly we do not subsume things with which we are busied, perceptually or imaginatively, under any concept of reality. *It is only when we confront and contrast things with which we are busied which are fantastic (wonderous, marvelous), for instance, with those that are presentive that we subsume some things under one or another concept of reality.* The concepts of reality arise when we reflect upon the *contrastive experience* of things of the experienced world and fantastic things appresented in the experienced world and apprehend them as exemplifying, respectively, actual or possible presentive or (e.g., indicationally) appresented fantastic (or fictive or ideal) realities. Yet whether or not we make the contrast and reflect, presentive real things still appear as real, fantastic or fictive or ideal things still appear as real fantastic things, or as real fictive things, or as real ideal things, within their mutually exclusive connections and contexts.

To express the matter in yet another way we may say with Maurice Natanson that because my being in the experienced world always bears within it the possibility of its negation, its nihilation, it follows that "the imaginary [*slc.* the fictive or fantastic] is the implicit margin surrounding the horizon of the real." Thus, as an order of existence in its own right, the "world" of the imagination is nonetheless the "margin" surrounding that order of reality which is the "paramount reality of worldly existence," and because, as Natanson

expressed it, "the imaginary is unreal...it can be deciphered. The decoding presupposes the natural language from which it was translated and transposed [*slc.* extrapolated]. Without the real the unreal is unthinkable"[15]—and this would seem to hold as well for all other orders of existence.

Thus it is only in a reflective attitude that the existential index of their order of reality is made thematic. And this is the second moment esssential to any formulation of consciousness: the reflective contrast between things presented and appresented and subsuming them under different concepts of reality, under one or another of what Alfred Schutz called "multiple realities."

What then distinguishes one formulation of consciousness from another depends on which existential index is reflectively and respectively made thematic and assigned the warrant and decree of "the" concept of reality. Truth by least resemblance, representation by opposites, the difference between the fantastic and the icastic, all presuppose the contrast in reflection between what is presented, given, in the experienced world of ordinary life and what is indicationally appresented, given, in the world of the fantastic or the fictive or the ideal.

This requires further exploration and clarification, because, after all, the preceding distinctions, however abstract and obtuse, are drawn from either the center or the periphery of ungrounded ordinary, common-sensical experience in the world and from which the "existential index" is extrapolated in the first place.

*The Multiple Realities of the Enclave
of Daily Life*

Alfred Schutz went to some pains to distinguish "finite provinces of meaning" from "multiple realities" (or "subuniverses" or "worlds" as he also called them).[16] By "finite provinces of meaning" he meant very specific cases of experien*cing,* e.g. of "realities" such as dreams, practical affairs of daily life, phantasies, fictions, realms of scientific discourse. By "multiple realities" he understood what is experien*ced,* precisely and only as I or anyone else discovers and experiences them in reading, listening and attending performances in the theatre, or deal with in social actions, direct or indirect, or in thinking. In the case of fantastic and fictive "worlds," such as set forth in a "poetics of wonder," for example and in particular, even though experienced and present in daily life, they are "experienced worlds" only in a most unusual sense: I am neither born into such a "world," nor do I grow older and die in it, and unless I choose to entertain it the "world" so discovered subsists only in a ubiquitous limbo of the imagination.

[15] Maurice Natanson, "Existentialism and the Theory of Literature," in Maurice Natanson, *Literature, Philosophy and the Social,* p. 112.

[16] A typical example may be found in "On Multiple Realities," *Collected Papers,* Volume I, p. 230.

Both "worlds," generally, the "world" of the *meraviglia* (the "fable of the world") or, say, the world of the novel, or of the poem or the drama, and of the ordinary, experienced world as we have sketched it in previous chapters, may be said to be singular. The latter is singular in the sense of being single; the former are singular rather in the sense of being singular: their presence in the ordinary common-sensical world can be accomodated neither to the on-going business of daily life nor to the domain of ideas. Of course it is in the experienced world of daily life that I encounter novels, dramas, poems, operas, scientific theories, and in each case I confront a world possessed of a structure, a time and a space of its own, created out of words, symbols, sounds, paint, stone and even actions. Moreover, each of the worlds I confront is populated with people, events, things, actions, often participating in a sociality but certainly not that which otherwise we share in daily life; and finally I confront events perhaps free, but also perhaps determined in which people are *really* involved, events which *really* happen, words which undergo twists and turns, stand in unusual, even marinist, relations to each other, sounds which bear melodic, melismatic and strophic meanings all their own; I confront laughing and crying, suffering and grieving, joy and despair, reversals of fortunes, even happy endings of affairs. All are real, yet imaginary, marvelous and fantastic, yet always fictional despite everything conjured up by the words "really" and "real."

The result is that as reader or theatre-goer or beholder of paintings and sculptures or architecture I confront in daily life "imaginational worlds" made up of systems of interpretation, attitudes, information. Even so, they are "worlds" which I cannot enter and change; even so, they all depend on me and my willingness to entertain them. Each in their own way are "enclaves" issuing their own passports and visas.

But what do "world" and "worlds," "multiple realities," signify on a formulation of consciousness? Suppose I use the word, "world," such as when I say, "experienced world of daily life into which I am born, grow older and die," or "world of ordinary, common-sensical life," as the name for whatever exists and which is presumably self-identical. I say, "presumably self-identical," because there is no other actual individual from which it is different. It is quite single, a "region" as Husserl would say.[17] Nor is "world" in this sense individuated by having a place in time and space as are other actual or real individuals and which are thus self-identities different from each other, like the things on my desk or Gingrich, Dole and Clinton. Accordingly, "self-identity" of other individuals in this case is rather a question of "regional categories" (Husserl) than "regions."[18] But what about a phantasied or imagined "world" of the "poetics of wonder," of a drama, a novel, a poem, an opera, a painting, a sculpture? What about a feigned, let alone a fictional "world"?

Such a "world" is an imitation—be it in Art or Science—but not necessarily an "image" depicting the universe of whatever exists, the presumptively self-identical experienced world of daily life. On the Baroque formulation of consciousness, the imitation is an *indication* rather than an image. And, if we take Adam Smith as representing the Enlightenment

[17] See below, pp. 250f., and Husserl, *Ideas, Book One*, §§ 9ff.

[18] See Kersten, *Phenomenological Method: Theory and Practice*, §§90f.

formulation of consciousness, then imitation is a copy that is always less than an image.[19] Or, as we shall say shortly, *imitation on either formulation, be it mimetic or non-mimetic, is never a case of "image awareness" but always only of "feigning awarenes."* Before even touching that distinction with a long pole of an over-beamed barge, we must note several things.

In the first place, feigned worlds, if we may use that as a shorthand expression for the moment for a variety of "worlds," have a self-identity quite distinct from that of the world of daily life so that, it would seem, a feigned world rather behaves like a regional category instead of a region. Is there, then, but *one* experienced world of daily life as region and many, multiple feigned worlds as regional categories? Are painting, sculpture, scientific theory, mathematics, opera, separate regional categories? Certainly it would seem that, on the basis of contrastive reflection peculiar to any formulation of consciousness, that to be "one world" the feigned world must not contain any deliberate inconsistencies or gross contradictions and it must exhibit events and acitons in an orderly sequence so that, whether contriving such a world in our own imaginations or following that contrived by painter, sculptor, musician, poet or thinker, or even by characters in search of an author, we proceed from phase to phase of events or features in that "world" each of which is connected like links in a chain. (All of that is, of course, distinguished phenomenologically from the multiplicity of acts of consciousness of feigning, phantasying, imagining, events and people which may be separated from one another by greater or lesser intervals such as when I put down a poem and only start reading again much later, or when I spend the intermission in the crush bar of the theatre. The self-identity of the feigned fictional world is in no way affected by the discontinuity of acts of feigning; the distinction remains between acts of consciousness on the one hand, and the "spatial-temporal" structures appresented on the other hand.)

Yet, we would have to say, for instance, that Orpheus' world is the "all of whatever exists" just as the "world" of Poppea or Hermes is the "all of whatever exists"—the indicationally *appresented*, feigned fictional worlds of Arcadia and Ancient Rome. Yet by virtue of the room with the window those feigned worlds "behave" like regional categories, *yet operate as though they were regions.* Here we have to note also that, phenomenologically, my appresentational experiencing of the phantasied or feigned "world" of Orpheus, or whomever or whatever, is, strictly speaking, *non-presentive,* whereas my experiencing of the world of daily life is *presentive.* To be sure, when I feign a character such as Orpheus I feign that character's experiencing of a presentive world as well as of his dreams and nightmares. And Orpheus is self-identical and different from other feigned real individuals just as, and only so far as, Orpheus is concerned. But just that I cannot say for my experienced world of daily life; I am self-identical *not at all* just so far as I am concerned, and to be sure my experienced world is also seriously presentive and only incidentally non-presentive. Although needed here, the terms "presentive" and "non-presentive" require some clarification. It is again, like the distinction between

[19]See above, pp. 35f.

predications of reality and existential predications, a distinction which arises in contrastive reflection.

Presentive and Non-Presentive Orders of Reality

We can distinguish some obvious manners of experiencing: perception, remembrance, expectation, for example. Perception, such as sense perception, is a manner of awareness of real individuals, given or presented here and now—in their most original way, given here and now as just they, themselves. Perception is a way of making present of experiencing in the present indicative. Remembrance is the way of making present by memory of the experiencing of a real individual in the past indicative. Expectation is the experiencing of something real as yet to come or happen, but in the subjunctive. The imagination, or feigning awareness, phantasy, like the other three manners of experiencing, makes something present too, but always in the "negative" rather than in the subjunctive or the indicative (to borrow an expression from Maurice Natanson[20]). And experiencing involves not just presentation and making present, but also appresentation as well. I see two pencils in front of me; I perceive them "paired" (Husserl) both as each self-identical and different from each other; the seeing is a seriously presentive seeing. Or I see smoke bellowing from my house as a sign of fire; the smoke appresents fire; here there is a seriously presentive or indicative seeing of smoke and a seriously expectant seeing of fire made present subjunctively (merely appresented). Or I remember having seen two pencils on the desk; remembering makes the seeing of the pencils present but in the past tense. Or, finally, I see a photo of the house now in smoking ruins; the image, the photo, makes present in an even more complex way: a serious mnemonic making present of serious past seeings of the house upon which is founded a present, indicative seeing of the depictive photo.[21] These are all cases of something *presentive* or even *appresentive* made present in the present or past indicative, or the subjunctive.

In contrast, that experiencing we have variously called imagining, feigning, phantasying, makes present something *non-presentive*. The idea, drawn from Husserl,[22] is that every genus or species of "serious" experiencing, awareness, has as its counterpart a genus or species of feigning awareness, of a "phantasy modification." A perceiving has a quasi-perceiving, a remembering a quasi-remembering, as their counterparts. Even an image-awareness includes as its counterpart a quasi-perceiving (e.g., the quasi-perceiving of the face on the barroom floor as an image of my father). In contrast to seeing a black dog enter my room, I feign to myself seeing a black dog enter my room, and I feign to myself the odor of sulphur. This is a feigning awareness of a sulphurous black

[20]See Maurice Natanson, "Man as Actor," pp. 333, 340 and 341.
[21]See Dorion Cairns, "Perceiving, Remembering, Image-Awareness, Feigning Awareness," pp. 259ff. for the intentive complexity of image-awareness in contradistinction to feigning-awareness. See above, pp. 35ff., 51ff.
[22]See above, p. 237.

dog, presented as itself in person in the feigning seeing of it. Here I am not seeing something else and taking it as an image of a black dog (as in the case of the face on the barroom floor). It is not a case of image awareness but instead is a case of a modification of a serious black-dog-seeing-and-smelling.[23] It would be no more right to say that the black dog is unpresented than it would be to say that, in feigning it, it is not believed in as existing. I feign not an imaginary black dog, but a real black dog with the real odor of sulphur. Nevertheless, feigning the seeing of a real black dog is not equivalent to feigning to myself believing in the existence of the real black dog. *An existential predication is not* ipso facto *a predication of reality.*

To say that the dog is non-presentive is to say that a certain sort of thing is "made present" in a very specific, correlative act which is a modification of a quite different, but very specific act of awareness. To distinguish terminologically this making present from the other cases of making present of something presentive, I would to use a term in English fashioned after a similar one in Husserl: "presentation."[24] To be sure, not every phantasy modification, not every feigning awareness of something non-presentive is *ipso facto* a feigning awareness of something non-presentive *as fictional*. Our example in a previous chapter of Galileo's "imagining" motion of something on a straight line at uniform accelleration is a phantasy modification of perceiving cannon balls rolling down a chute from the top of the tower of Pisa; or mathematical ratios and analogies discussed in connection with Oresme and Bradwardine are phantasy modifications of perceiving motion of celestial bodies. However, the standard case of motion is not a fiction, nor are the mathematical ratios. Even so, my old physics book gets a lot of mileage out of Newton's *"non fingo hypotheses,"* i.e., he does not feign hypotheses but rather extrapolates them from the "phenomena" themselves. But the "hypotheses" are, for all that, still non-presentive rather than presentive, and are thus yet another case of the phantasy modification of the perception of the "phenomena" (wet feet when the tide comes in).

How then are those feignings to be distinguished from those of the strictly *fictively* non-presentive? And how can we even suggest such a distinction without writing an epistemology and metaphysics of scientific theory, fiction and works of art?

[23]There are still other and non-feigning cases of the awareness of the non-presentive; for example, the awareness of something symbolized by a symbol, the awareness of embarrassment expressed by a blush or of a judgment merely expressed by a sentence. Cf. Cairns, *op. cit.*, p. 261.

[24]Making present of the non-presentive is at least one meaning of the admittedly equivocal term in Husserl, *Vergegenwärtigung*. Here we can only note that a feigned "world" is not *ipso facto* a feigned *fictive* "world"—a distinction as Baroque as that of the idea of the compossibility of Art and Science. Moreoever, it is a distinction that lies at the core of the idea of the "fable of the world." As a result, the "poetics of wonder" is not *ipso facto* a "poetics of fiction." Thus whether Mannerist prose works, such as Cervantes' *Don Quijote*, can be regarded as "fiction" in terms of the Baroque formulation of consciousness is an open question which cannot be investigated here. Fantastic verisimiltude appresenting the "real" is not necessarily "fiction."

The Enclave of Daily Life and the Mimetic Epoché

The distinction between predications of reality and existential predications, between presentiveness and non-presentiveness on the one hand, and their existential modalities on the other hand, provide us with some important clues. For it follows just from these distinctions that not only are feigned worlds or quasi-worlds, as we may also call them, completely divorced from the one experienced world of daily life, but also from each other—they are utterly heterogeneous. We shall return to this idea shortly. For the moment we have to note that the one experienced world and the quasi-worlds are all characterized by time, temporality. Suppose we take the temporality of something feigned and fictional, such as a novel. That temporality must not be confused with other temporalities such as that of presentive things let alone of so-called "objective time." Strictly speaking, to ask whether the life-time of Molly Bloom is contemporary with mine or Clinton's or anyone else's is absurd and meaningless. Of course I can make thematic the temporality of the novel so far as concerns the duration and order of events in Molly's life, but then I am really concerned with a "quasi-temporality," a "quasi-life-time," a fictional and non-presentive world. For anything to belong to the real, presentive (and "objective") world, it has to be inserted into *presentive space and time*, not their modifications in phantasy.[25] Thus quasi-worlds, multiple realities, such as fictional worlds or feigned worlds, with their quasi-temporalities and quasi-spaces (Arcadia, the Roman Empire, Dublin at the turn of the century) are not sub-orders of reality but instead must be considered as *orders of existence in their own right* even though they are non-presentive.[26]

It also follows as a corollary that there is no question, then, concerning the consistency or inconsistency between different feigned quasi-worlds; each quasi-world, for instance, each feigned fictional world, is autonomous precisely and only as an order of existence in its own right, remaining completely separate from every other one. And even though I can go back and forth between the paramount reality of daily life and quasi-worlds, other orders of existence, I cannot cross the boundaries of quasi-worlds.

Granted that, it also follows that all events in their quasi-times and quasi-spaces are unified into one quasi-time and space encompassing the feigned world but without being inserted into a wider context than that of the feigned, non-presentive world in question. The phrase, "wider context," is an important qualification because, for instance, I can read a novel, entertain a feigned fictional world, then stop and do things other than read. The horizon of my daily world includes entertaining other quasi-worlds, such as the fictional ones, and then proceeding to do other things in daily life. Just that horizon of expectations is not included in quasi-worlds for doing things in the experienced world of

[25] See Gurwitsch, *op. cit.*, p. 393.

[26] See Husserl, *Erfahrung und Urteil*, §39 (English translation, pp, 167ff.); Gurwitsch, *The Field of Consciousness*, pp. 389, 411f.; Natanson, "Existentialism and the Theory of Literature," *loc. cit.*, pp. 111f.

daily life, nor for doing things in yet another feigned quasi-world (e.g., that of the symphony).

This is one reason for speaking of the "priority" of the experienced world of daily life and which marks daily life off as an enclave over against quasi-worlds such as that of fiction, or of real individuals over against characters in the novel or the drama. Another reason, of course, is that the appresenting component of any quasi-world you please is always an event or action or artifact of daily life, and by virtue of its priority, its status as paramount, daily life and its experiential data are privileged: everything else is a phantasy modification (in a quite broad sense, to be sure) of daily life. Moreover, as more than one writer on formulations of consciousness from Sartre to Natanson has noted,[27] although I can go back and forth between them, I cannot entertain at once the experienced world of daily life and, e.g., the quasi-world of fiction or of scientific hypotheses (witness the disaster of Nikolai Kusmitch). The presentiating and appresenting of the one always requires the "suspension" of the other. And this points to yet another aspect of the nature of the enclave of the daily world of common sense.

In the case of a performance of a drama, for instance, I cannot rush onto the stage, warn Macbeth, counsel him to avoid witches at all cost and get his wife into marriage counseling. If I do so people in strange uniforms will come to take me away. I am rather condemned to be a spectator of his fate which unrolls before me in the quasi-future perfect tense. In other words, what happens occurs apart from the rest of my experience and on the basis of a tacit agreement with the author that the audience and the players can communicate only in one way: through the literary *form* in question, the drama. And in the case of the specifically Baroque formulation of consciousness, that communication by form, requires the "mimetic epoché." The same holds for opera, painting, sculpture, architecture but also science—only through the form, say, of an hypothesis expressed mathematically can I communicate with Copernicus or Kepler.

To express the matter in somewhat Sartrian terms, from the standpoint of the feigned quasi-world the world of ordinary experience is like a "nothing." Were it not "nothing," it would then get in the way, block the emergence of the meaning of the events and characters in novel or drama or even scientific theory. Only when the experienced world is as "nothing" can we "play along" with the play, or the painting, or the scientific theory. In still other words, the appresenting component of my experience is treated as a "nothing" in appresenting *presentiationally* the appresented, the drama, music (i.e., the physical sounds are as "nothing" in appresenting the music), theory. But to treat the appresenting as "nothing" is not to annihilate it. Conversely, from the standpoint of daily life the feigned quasi-worlds are treated as "nothings." It is when the quotations marks are removed from "nothing" that the trouble begins, and a predication of reality is confused with an existential predication.

[27]See Maurice Natanson, "Phenomenology of the Aesthetic Object," pp. 82ff.; "Phenomenology and Theory of Literature," pp. 91f.; "Existentialism and Theory of Literature," p.109. See also Jean Hering, "Concerning Image, Idea, and Dream. Phenomenological Notes," pp. 188ff.

The appresenting component in daily life, words or sounds, sets of marks, are "nothing" only temporarily, just for the time being. Author and audience, or listener, or reader, or beholder, temporarily agree for the time being to "play along" with the drama, to entertain the theory and let it prevail, to allow the quasi-time and space of the quasi-world to take precedence over the time and space of the place where the drama or opera is performed, where the novel is read, the poem recited, the theory discussed. For the time being, the "paramount" of "paramount reality of daily life" is set aside so that the feigned, quasi-world can prevail and be made present, be presentiated. But this means that a very special relationship obtains between the enclave of daily life in its character of enclave—it can be set aside, but not annihilated, it can be subject to phantasy modifications but only for the time being—and appresented, feigned quasi-worlds. To wrench further clarification we need to return to our earlier example of the theatre.[28]

The Mimetic Epoché and the Phenomenological Epoché

"It is self-evident," Sartre says, "that the novelist, the poet and the dramatist constitutes an irreal object [*object irréel*]<i.e., something non-presentive> by means of verbal analogue; it is also self-evident that the actor who plays Hamlet makes use of himself, of his whole body, as an analogue of the imaginary person.... The actor does not actually consider himself to be Hamlet. But this does not mean that the does not 'mobilize' all his powers to make Hamlet real. He uses all his feelings, all his strength, all his gestures as analogues of the feelings and conduct of Hamlet. But by this very fact he irrealizes them [*les irrealise*].[29] *He lives completely in an irreal way.* And it matters little that he is *actually* weeping in enacting the role. These tears...he himself experiences—and so does the audience—as the tears of Hamlet, that is as the analogue of real tears...The actor is completely caught up, inspired, by the irreal. It is not the character who *becomes real* in the actor, it is the actor who *becomes irreal* in his character."[30]

There are, accordingly, "serious" presentive modes of making present, of making the actual or real present and, moreoever, it is peculiar to experience that what is so made present is what is imposed upon me: if I open my eyes, I cannot help but see, make present something visibly real; or putting my hand on the table, I cannot help but touch, but make present, the tangible; or if I expect, I cannot help but expect something or other. In contrast, imagining, or phantasying, or feigning, too makes present, but now the non-presentive rather than the presentive, and in an entirely different way: it does so in a negative way, but always with a "correlate in the life-world" (Schutz), with an

[28] Above, p.238.

[29] In the terms used here, the actor makes present, presentiates, the non-presentive feelings and conduct of Hamlet.

[30] Jean-Paul Sartre, *L'Imaginaire. Psychologie phénoménologique de l'imagination*, p. 242. (The translation is mine.)

"analogue" (Sartre) in the real world. There is, as we said, a "suspension" of the one in favor of the other, something Alfred Schutz called "the epoché of the practical attitude"[31] of everyday, eccentric life. In the case of drama or poetry, language is subject to this "suspension" or epoché just as as are, for instance, specific sound-patterns determined by the logarithms of sound intervals and relationships ("temperament")[32] in the case of music, or patterns of paint on a canvas in the case of painting. As a consequence, as appresenting elements in daily life they presentiate, are the basis for feigning, the quasi-worlds of drama, music, painting. The correlates in the life-world are analogous to our own existence in daily life, but, as Sartre says, "imaginational" [*imaginaire*], "irreal," or as we would say, presentational. The room with a window, paint on canvas, stone, sounds, gestures, actions: all are analogues or correlates essential to presentation of utterly heterogeneous quasi-worlds. And for the Baroque formulation of consciousness, they are for all that compossible. The question remains whether has a dominant meaning of one or another quasi-world, whether one order of existence takes precedence; whether analogues or correlates can equally presentiate by way of appresentation several quasi-worlds at the same time (drama, opera, painting, architecture etc.). Are some analogues incidental, others essential for presentation of a given quasi-world? On the Baroque formulation, the answer has to be in the affirmative. Still, what justifies that answer? Of what does its complexity consist?[33] One would need to develop an "ontology" of the analogues to find out—a task clearly beyond the scope of this book.

In the specific case of music, "our auditory consciousness...goes from a realizing auditory attitude to a feigning attitude [*attitude imageante*]" in which the "melodic image" emerges and transcends the purely auditory one[34]—although almost "mechanically" and always cadentially related to and entwined with it.[35] To be sure, the "musical image is a pure spatio-temporal structure which bears only those determinations bestowed by the musical consciousness," by the "act of musical feigning [*imageant musical*]" which itself is an "affective consciousness" so that the presentiated "musical image" always appears in the world endowed with affective meaning.

What then about the "text" in the case of music? The "text," the score, is a "'prescription' for realization by performing the *analogon*, and it is performing by way of realizing the analogon in such a way that the musical image implied by the text is presentiated [*qu'il fasse apparaître l'image musicale*]."[36] To be sure, an "interpreter" is required to transform a "static scheme" into a flow of melody "animated by internal dynamism and by a qualified tempo;" the interpreter "creates music which he himself has not

[31]See e.g. Schutz, *op. cit.*, p. 234.

[32] Ernst Ansermet, *Les Fondements de la musique dans la conscience,* Chapter One; and pp. 142f. (The translations are mine.)

[33]See above, pp. 222f.

[34]Ansermet,. p. 143.

[35]*Ibid.,* pp. 149f. (examples pp. 145ff.).

[36] See above, pp. 209ff.

known…after a schematizing text of the music he creates music already feigned [*imaginé*]." The feigning, or imagining, is creative in this case "by mandate," by decree, and "should be dedicated entirely to discovering in the text the music feigned [*rêvée*] by the composer" which, on Ansermet's Sartrian view, proves to be in the end an "existential road" leading toward fulfillment of the ontic project of a work of music.[37] But what Ansermet says about music may also be applied generally to other arts and to the sciences, at least on the Baroque formulation of consciousness.

To express this whole situation in yet another way, we may say that in consequence of the "epoché of the practical attitude," and on condition that we communicate only through the "form" mimetically or non-mimetically (the already feigned quasi-world), the presentiated order of existence (keeping with our example) appearing on the stage is allowed to be an independent variable, a feigned order of existence not dependent on, yet present in, actual experience with quite recognizable and specific "analogues" or "correlates" and social relationships.[38] With respect to the one order of existence, the other order is always an independent variable. This means that a drama, an opera, a novel, a painting, makes a statement not about an actual but rather about an ideally possible quasi-human life, about a possible presentified and therefore possible quasi-world of daily life. "Possible" and "possibility" are used in an odd sense here: they name something prevailing apart from the actual and which is an independent variable of the actual, yet not concretely apart from it because allowed for by the actual in the first place. To regard the "actually real" as purely possible, as but one (ideal) possibility among others, after all, is not the same as feigning the "real" as imaginary or even as fictional. Rather we are dealing with a presentified "possible" quasi-world of which the actual is no possibility at all but, as Sartre says, an "analogue," hence a "world" in which we cannot act. Feigning or co-feigning to ourselves a drama, an opera, a novel, a painting, presentifies the possible in which we cannot act, into which we cannot go, but always from the standpoint of the actual: the feigned non-presentive.

Perhaps it is best to speak here with Maurice Natanson about a "disjunctive convergence" of reality and imagination, of the icastic and the fantastic, of the "real" and the "fable of the world," or *istoria*. It is a "convergence" which is a "clue to their disjunction."[39] The independent variable is such always only from a standpoint, e.g., the reading of a novel, listening to a poem read, beholding a painting, watching a drama, mathematically constructing motion. This "convergence" is an "achievement of fictive consciousness"

[37]*Ibid.*, pp. 163f., 165. The project itself is one of expression, dictating to the consciousness of music a "closed" melodic road and a completed "form." Because of, or perhaps in spite of, the Sartrian framework in which Ansermet casts his examination of the consciousness of music and the imagining or feigning of the musical image, his detailed analyses of a very wide spectrum of examples remains valuable and worth concentrated study.

[38]And these "analogues" or "correlates" in the life-world undergo real historical change, e.g., changes in styles of acting, singing, declamation, significations of words, punctuation, grammar, vocabulary, colors, perspectives, and the like.

[39]Natanson, "Phenomenology and Theory of Literature," *loc. cit.*, p. 96.

(Natanson), disclosing the "transcendental structure of daily life," the mutual illumination of daily life of itself and of other orders of existence. The actuality of daily life allows for a point of view outside itself. The presentified, the quasi-possible, is a point of view outside the actual allowed for by the actual: it is a "quasi-posible" actual, its materials are the same, in a way, but, for instance, the space and time of Orpheus and the space and time of the audience converge as two independent variables, one of which, by tacit agreement of the exercise of the "mimetic epoché" and the equally silent "epoché of the practical attitude" prevails "for a time" in place of the other. This, it seems to me, is one of the major features of the Baroque formulation of consciousness.

In other words, feigned quasi-worlds of essential necessity remain obscure because they do not allow for their own elucidation as does the enclave comprising the paramount reality of the world of daily life. Thus they always involve an appeal to the self-interpretation of daily for their elucidation which, like the case of music mentioned above, "creates" what is always already feigned according to its mandate, i.e., the "real decreed" and extrapolated from the experiencing of daily life in the first place. Thus to understand the feigned "worlds" of opera or drama, of philosophy or of science, we always have to return to common-sensical daily life but which, because it rests on the ungrounded ontic conviction, allows of other interpretations, self-interpretations, and phantasy modifications.

In addition, the quasi-time of a feigned world, a fictional world, for instance, and events in it is rather like the past: it is irrevocable and cannot be changed. To be sure, events and actions are projected, planned, are quasi-future-like, with their "real" possibilities which, if not realized, is because of the characters and not because of the reader. That Orpheus does not successfully extricate Eurydice from Hades is his fault, not mine or even Monteverdi's. Perhaps instead of saying that the quasi-time of a novel, a drama, a poem or an opera has as its cardinal dimension the past, we might say that it is rather the quasi-future perfect subjunctive. The non-realization of "real" possibilities remains irrevocable too but even in a more peculiar way: we may say that while free choices are made in such quasi-worlds, they are always foregone, always already feigned. The "project" is closed, finished, the "form" final.

Compossibility and the "Fable of the World."

At this point it is necessary to state for the record some irrepressibly phenomenological distinctions: time and quasi-time distinguish the paramount reality of daily life and feigned quasi-worlds, phantasies, from each other; atemporality of "essences" (or ideal possibilities) of formal and material universals and concepts (as well as eidetic singularities) and eidetic domains in Husserl's sense, distinguishes them from both the paramount reality of daily life and feigned quasi-worlds (though probably not from all multiple realities recognized by Schutz). Whereas the experiencing of the paramount temporal reality of daily life is presentive, whereas that of the quasi-temporal worlds of the imagination are non-presentive, the experiencing of the atemporal eidetic world is indifferently presentive or non-presentive. To develop these distinctions

further, as well as the status, epistemic, ontic and aesthetic, of the feigned quasi-worlds of science and art, are outside the scope of this book. The distinctions, however, lead us to some general conclusions which will introduce the final sections of this book.

As I understand it, the gist of Husserl's phenomenology of consciousness is that the "reality" of objects of whatever sort point back to their experiencing and positing by consciousness in which they are presented and made present in original or genuine ways peculiar to them.[40] For every sort of object, there is a corresponding mode of original experiencing of it. The set of such objects of a possible (eidetic) science is called a "region," and what the objects have "in common" as essential to them is called a "category" (or: fundamental regional concept). Because such categories comprise the structure of being peculiar to objects, Husserl calls them (eidetic) regional ontologies. And because regional ontologies state what must belong to objects in unconditional universality and necessity, so that they can be the subject matters of specific sciences, such ontologies are said to be eidetic sciences in contrast to so-called sciences of matters of fact. Formal ontology may then be defined as that eidetic science which cuts across all regional ontologies by disregarding, through formalization, all regional differences and therefore considers any object whatever of consciousness in the natural attitude.

There is but one formal ontology in contrast to many regional ontologies which, when viewed with respect to the one formal ontology, are called "material ontologies." Now, in the case of feigned quasi-worlds, including fictional ones, we are clearly concerned with a material ontology because our task at hand is to show and legitimate the "distribution" of objects into their corresponding regions. To accomplish that task, we consider the objects with respect to their most original modes in which they are made present or presentiated in the natural attitude. In these terms, any feigned quasi-world, any order of existence you please, whether it be drama, poetry, opera, music, painting, sculpture, or whether it be scientific theory (e.g., the "Copernican universe," the "Keplerian cosmology") or the "Cartesian cogito," is a phantasy modification of a region and not of a regional category. *That certain regional categories on the Baroque formulation of consciousness* "behave" *like regions is allowed for by the idea of their compossibility entailed by the "fable of the world" feigned in the "poetics of wonder."* The "poetics of wonder" is the principle of organization of compossible "mutliple realities," of many ostensible regions.

But that idea of compossibility hinges in turn on a dual epoché: the mimetic epoché and the epoché of the practical attitude. Without them the Baroque formulation of consciousness *qua* formulation would not be possible, nor would it be possible to compare that formulation with others such as the Classical formulation or the Enlightenment formulation. That is to say, instead of speaking of a "common ground," or of "parallel ideas," or of a "mutual influence" of science and art, it is more appropriate to say that Nature is an ideal

[40] Thus phenomenology is not a Platonism because every object is understood as the correlate of an act or group of acts (in the broadest sense) of consciousness, and this holds as much for material things as "essences," "eidetic domains," ideal possibilities.

possibility which lends itself to fantastic, non-mimetic "images" comprising the "fable of the world." The "fable of the world" it, itself, does not necessarily mean the disclosure of a pregiven, yet hidden reality. Rather it means that the Baroque formulation of consciousness is an "accomplishment" yet to be achieved, self-generative of compossible "worlds" yet to be accomplished. Taken over as a task by physics, painting, music, sculpture, drama, poetry, each under the guidance of its own methodological norms under the mimetic epoché with its principle of truth by least resemblance, each constructs its universe by means of a continuing process of feigning awareness (including idealization and mathematization). The resulting unitary "fable of the world" is, as Husserl might say, a "tissue of ideas" which must never be confused with the "real" itself and the "empirical extension" of which is never exhausted by its purely possible exemplifications which happen to be actualized. For all that, however, despite the Baroque shift in the accent of reality, despite the decree that priviliges the appresented and slides it under, or makes it go bail for, the appresenting, *phenomenologically and common-sensically* the "real" remains just the world of ordinary, everyday experience from which the quasi-world is extrapolated and to which it is accessible, no matter what may be the compossibilities of systematization and even predications opened up by Renaissance and Baroque formulations of consciousness in science and art.

Because of the largely silent rôle of the world of ungrounded ordinary, common-sense experience as the *abiding presupposition* of the Classical, Renaissance and Baroque formulations of consciousness, despite their quite distinct forms and construction, the problems to be clarified *first* are those of the world of ordinary, common-sense experience, even though those problems are arrived at last. The end of this book is therefore only its beginning. Only at the end of this book is what is granted to phenomenological clarification circumscribed.

To clarify the formulations of consciousness it was therefore necessary to at least implicitly exercise a much broader and quite different epoché: the (transcendental) phenomenological epoché in order to make explicit, thematic the silently effective presupposition of any formulation of consciousness you please.[41] Neither exercise of the mimetic epoché nor of the practical attitude in any way entails the exercise of the *phenomenological* epoché—no more than does, for instance, their rejection (which is also the case with the rejection of the "constancy hypothesis" in the sciences[42]). The reason is that the mimetic epoché as well as the epoché of the practical attitude still take for granted the ungrounded ontic conviction or "existential index" (Gurwitsch) underlying the eccentricity of daily life. It is for this reason, and for this reason alone, that the various formulations of consciousness studied in this book require phenomenological clarification: they establish with precision just what is granted to such clarification.

[41] For the idea of the transcendental phenomenological epoché as used here, see Fred Kersten, *Phenomenological Method: Theory and Practice*, pp. 25ff.

[42] See Fred Kersten, "The Constancy Hypothesis in the Social Sciences," pp. 524ff. 532f., 538f, 546ff., 552f.

That very ontic conviction in its very taken-for-grantedness, the general positing of the natural attitude, as we may call it with Husserl, must now be "put out of operation"— something we have had to do implicitly all along to develop the thought in this book so as to interpret Galileo, Monteverdi, Alberti, Kepler and others as empirical examples of the "essences" or ideal possibilities of various sorts of thinking, composing, painting. In other words, the eccentricity of ordinary life in the natural attitude is presupposed by and underpins the Classical as much as the Baroque formulation of consciousness on the traditional assumption that it is that to which the metaphysically "real" is accessible by night and by day. But that very assumption itself is also included in the range and extent of exercise of the phenomenological epoché.[43] Accordingly, the Classical assumption and its underpinning in the ontic conviction of daily life as it figures in the Baroque formulation of consciousness acquires a partial ratification by the phenomenological epoché even though *its formulation does not,* because to seize upon the ontic conviction as it, itself, we have to make it thematic by subjecting it to the phenomenological epoché.

One result of the phenomenology of consciousness is the discovery that the *compossibility* of the Baroque formulation of consciousness is allowed for in the first place precisely by leaving the ungrounded ontic conviction in operation in the exercise of the mimetic epoché and of the epoché of the practical attitude. Only when the ungrounded ontic conviction is left in operation can the assumption be made that the "real" can be extrapolated from experience, so that regional categories go bail for a region, behave like regions, so that regional categories behave like compossible multiple realities.

Two central problems arise, then, on the Baroque formulation of consciousness. First, how are multiple realities constituted and organized, and how can compossible regional categories going bail for a region be phenomenologically legitimated? (The "poetics of wonder" can only be an organizing principle if regional categories can indeed go bail for a region, and that can only be the case if existential predications can go bail for the predication of reality.) Second, on the phenomenology of consciousness are "multiple realities," orders of existence generally, twinned, even compossible? Is the "poetics of wonder," the *meraviglia,* the only principle of their organization? Is there any other basis for the compossibility of science and art on the phenomenology of consciousness?

The End of the Road Across the Street.
"Minding the Gap"

We began this book in the room of a biker bar and at its conclusion we have to return to the biker-bar, located amidst mounds of dirt and sawdust at the end of the road down by the old planing mill. The discussion there was about the "real," certainly, but also about whether one can leave the room at all. We have been locked into that room from the beginning and explored two basic ideas of

[43] See Kersten, *Phenomenological Method: Theory and Practice,* §§6, 7.

its representation, the one mimetic and analogical ("copy," "image"), the other non-mimetic and proportional ("indication") with respect to their appresentational ways. Their difference proved to lie not so much in their powers of representation as in their being drawn from the periphery (push without shove) and center of social action (push come to shove) in the enclave of daily life on the assumption in common that the metaphysically "real" is somehow accessible to daily life from which representation of the "real" is extrapolated. In the one case, there is the complementary assumption that the near is to be read off the far, and in the other case the converse assumption, that the far is to be read off the near.

Both assumptions give rise to a gap between ordinary experience and the representation of the "real" in science and art: in the one case, the specious present of the enclave to daily life is simply unconnected with the space and time of science and art; in the other case, the specious present of the enclave of daily life is non-simply connected with science and art. In the one case, "true" representation of the "real" by most resemblance prevails; in the other case it is "true" representation by least resemblance which prevails and which "reason" makes us believe. In the one case, the room, the "cabin" in the garden on the Isles of the Blessed, is enchanted, in the other case the room is disenchanted. The latter is excluded by the former, the former included by the latter. In the one case, the "real" is obvious, in the other case it is not obvious and must be interpreted and "rendered." The whole discussion of the two basic ideas of representation was set down historically in the "coincidence" of the "Galilean style" of science and opera and systematically with respect to two, well, three, contrasting formulations of consciousness.

But what about the room-milieu itself in which the ideas in this book transpired? Can one leave or even escape from the room-milieu, operatic or scientific, no matter how disenchanted? Can one open the door to reality otherwise only viewed in the mirror or from the window? In short, can one, as Virgina Woolf suggested, worry out the meaning of the "real"? Are we any different from the blind cloakroom attendant, Nikolai Kusmitch? Nikolai went home to his room to worry it out and, caught up in the gap, was never able to return to work. In a fit of Protestant Ethics, the manager fired him. The enclave of daily life closed over Nikolai Kusmitch and for some time I thought I had put him to rest. Recently, however, while travelling on the London underground, I was put in mind of him again. The train had stopped at Marble Arch, and as the doors opened onto the platform a voice from nowhere said over the loudspeakers, "Mind the gap!" As I stumbled out onto the platform, it occurred to me that Nikolas had failed to mind the gap.

And what about Nikolai's room itself? Seeking refuge in daily life, Nikolai headed out, but not back to work. Sartre's Roquetin was, very much like Rilke's Nikolai Kusmitch, sensitive to his room. "A little while ago, just as I was coming into my room, I stopped short because I felt in my hand a cold object which held my attention through a sort of personality. I opened my hand, looked: I was simply holding the door-knob... Objects should not *touch* because they are not alive. You use them, put them back in place, you live among them: they are useful, nothing more. But they touch me, it is unbearable. I am afraid of

being in contact with them as though they were living beasts."[44] The rooms of Roquetin and Kusmitch have undergone a transformation, a de-disenchantment, such as represented in the BEK cartoon:

I'M TIRED OF BEING TREATED LIKE AN OBJECT!

The cartoon fulfills most of the requirements of the push-come-to-shove and gridding of the Baroque formulation of consciousness. Can we we escape the room? Can it be disenchanted? The disenchanted room, after all, is a "neutrality-modification" (Husserl),[45] hence, which like a "phantasy-modification," presupposes and bespeaks that of which it is a modification. By what right, by what warranted decree, does the disenchanted room become a privileged room? By what shift in the "accent of reality" does it replace the enchanted room-milieu it presupposes? The room come alive, the "living" room, is the opposite extreme of the disenchanted room.

But is it not, after all, just another "fiction"? Is not speaking of the rooms of Roquetin, Nikolai Kusmitch, Bartelby, the Pub des Artistes, of Barsotti and BEK in the same breath as the rooms of Alberti, Galileo, Dürer, Monteverdi, of Venetian theatres and even of Descartes' "laboratory," nothing else but introducing more baroque conceits into the "fable of the world"? Why the further "fictions" even if perfectly consistent with the Baroque or Mannerist traditions? They are not intended, however, as "comic guises" which serve as

[44] Sartre, *Nausea,* pp. 4, 10.
[45] Husserl, *Ideas,* Book One, pp. 22f., 242f.

"masquerades."[46] Following the admonitions of Maurice Natanson,[47] they are not intended as illustrations of philosophical ideas, nor are they meant as comic relief from the dark and heavy conceptual baroque furniture of the book, nor as such are they ec-centric interruptions of the discussion for they are its central part. As with the Baroque, they should not be regarded simply as a means for achieving what "demonstration," "experimentation" or "performance" cannot accomplish. (Natanson: "for those in philosophy who would reduce style to ornamentation, despair is a neurological frailty and Gregor Samsa someone with a peridontal problem.") They are intended rather, as Natanson suggests, I believe, to be "transcendental clues" to the constituting of the Baroque formulation of consciousness as ideal possibility of the "natural twinship" of Baroque science and opera rather than as a finished accomplishment of the past. It was the purpose of this book to follow up those "clues" wherever they led and may still lead by circumscribing what is granted to the domain of phenomenological clarification of science and opera.

[46] Above, p. 160.

[47] Natanson, *Anonymity. A Study in the Philosophy of Alfred Schutz*, p. 138.

Bibliography

Abbate, Carolyn, *Unsung Voices. Opera and Musical Narrative in the Nineteenth Century,* Princeton: Princeton University Press, 1991.
Agucchi, Giovanni Battista, *Nel Mezzo. Discorso Academica,* 1611
Alberti, Leon Battista, *On Painting,* translated with Introduction and Notes by John R. Spencer. New Haven: Yale University Press, 1966.
Alberti, Leon Battista, *On Architecture,* in *A Documentary History of Art,* edited by Elizabeth G. Holt, Volume 1. New York: Doubleday Anchor Book, 1957.
Algarotti, Francesco, *Saggio sopra l'opera in musica,* 1755.
Alonso-Misol, José-Luis, "En Torno al Concepto de Barroco," *Revista de la Universidad de Madrid,* Vol. XI (nos. 42-43), 1962, pp. 321-347.
Ansermet, Ernest, *Les Fondements de la musique dans la conscience humaine.* Neuchâtel (Suisse): Editions de la Baconnière, 1961.
Arendt, Hannah, *Between Past and Future.* New York: Viking Press, 1961.
Arendt, Hannah, *The Human Condition.* New York: Doubleday Anchor Books, 1959.
Ariosto, Ludovico, *Orlando Furioso,* translated with an Introduction by Barbara Reynolds, Harmondsworth, Middelsex: Penquin Books, 1981.
Aristotle, *De Caelo,* with an English translation by W. K. C. Guthrie. Cambridge, MA: Harvard University Press, 1986.
Aristotle, *Metaphysics,* with an English translation by Hugh Tredennick. Cambridge, MA: Harvard University Press, 1980.
Aristotle, *Nicomachean Ethics,* with an English translation by H. Rackham. Cambridge, MA: Harvard University Press, 1975.
Auden, W. H., *The Dyer's Hand and Other Essays.* New York: Vintage Books, 1968.
Auerbach, Eric, *Mimesis. The Representation of Reality in Western Literature,* translated by Willard Trask, Princeton: Princeton University Press, 1968.
Ayer, Alfred J., "Truth, Verification and Verisimilitude," *The Philosophy of Karl Popper,* Part II (Volume 14, *The Library of Living Philosophers*), edited by Paul Arthur Schilpp. La Salle, Il.: Open Court, 1974), pp. 684-692.

Baltrusaitis, Jurgis, *Aberrations, quatre essais sur la légende des forms,* Paris, 1957.
Beaufret, Jean, "La Fable du Monde," in *Martin Heidegger zum Siebzigsten Geburtstag,* herausgegeben von Günter Neske, Pfullingen: Neske, 1959, pp. 11-18.
Belaval, Yvon, *Leibniz critique de Descartes.* Paris: Gallimard, 1960.
Benson, Bruce. "Improvising Music: An Essay in Musical Hermeneutics." Diss. Louvain, 1993.
Berkeley, George, *The Works of George Berkeley, Bishop of Cloyne,* edited by A.A. Luce and T. E. Jessop. Nendeln: Kraus Reprint, 1979.
Biagioli, Mario, *Galileo Courtier. The Practice of Science in the Culture of Absolutism,* Chicago: The University of Chicago Press, 1993.
Blaukopf, Kurt, *Musical Life in a Changing Society,* translated by David Marinelli, Portland, Or.: Amadeus Press, 1992.
Boas, Marie, *The Scientific Renaissance: 1450-1630.* New York: Harper Torchbooks, 1966.
Bruno, Giordano, *Degli'eroici furori* (1585)
Budden, Julian, *The Operas of Giuseppe Verdi.* Volume 2: *From Il Trovatore to La Forza del Destino.* London: Cassell & Company Limited, 1978.
Bukofzer, Manfred F., *Music in the Baroque Era,* New York: W. W. Norton & Company, 1947.
Butler, Judith, "Thresholds of Melancholy," in *The Prism of the Self. Philosophical Essays in Honor of Maurice Natanson,* edited by Steven Galt Crowell. Dordrecht/Boston/London, 1995, pp. 3-12,

Cairns, Dorion, "Perceiving, Remembering, Image-Awareness, Feigning Awareness," in *Phenomenology: Continuation and Criticism. Essays in Memory of Dorion Cairns,* edited by Fred Kersten and Richard Zaner. Den Haag: Martinus Nijhoff, 1973, pp. 251-262.
Casalduero, Joaquín, *Sentido y Forma del Quijote (1605-1615).* Madrid: Ediciones Insula, 1949.
Cassirer, Ernst, *Determinism and Indeterminism in Modern Physics. Historical and Systematic Studies of the Problem of Causality,* translated by O.Theodor Benfy with a Preface by Henry Margenau. New Haven: Yale University Press, 1956.

Cassirer, Ernst, *The Philosophy of Symbolic Forms*, Vol. III, translated by Ralph Mannheim. New Haven: Yale University Press, 1957.
Cassirer, Ernst, "Galileo's Platonism," in *Studies and Essays in the History of Science and Learning*, edited by M. F. Ashley Montague, New York: Henry Schuman, 1944, pp. 279-297.
Cassirer, Ernst, *The Logic of the Humanities*, translated by Clarence Smith Howe. New Haven: Yale University Press, 1960.
Cassirer, Ernst, "Newton and Leibniz," *The Philosophical Review*, LII (No. 4), July, 1943, pp. 366-387.
Cassirer, Ernst, *The Individual and the Cosmos in Renaissance Philosophy*, translated with an Introduction by Mario Domandi. New York: Harper Torchbooks, 1963
Casey, Edward S., *Imagining. A Phenomenological Study*. Indianapolis: Indiana University Press, 1976.
Celletti, Rodolfo, *A History of Bel Canto*, translated by Frederick Fuller, Oxford: Clarendon Press, 1991.
Celletti, Rodolfo, *Voce di Tenore. Dal Rinascimento a oggi, storia e tecnica, ruoli e protagonisti di un mito della lirica*. Milano: Idealibri, 1989.

Clagett, Marshall, "Some Novel Trends in the Science of the Fourteenth Century," in *Art, Science and History in the Renaissance*, edited by Charles S. Singleton. Baltimore: Johns Hopkins Press, 1967, pp. 275-304.
Clark, Kenneth, *The Art of Humanism*. London: John Murray, 1983.
Clavelin, Maurice, *The Natural Philosophy of Galileo*. Cambridge, MA: MIT Press, 1974.
Clément, Catherine, *Opera, or the Undoing of Women*, translated by Betsy Wing, Foreword by Susan McClary, London: Virago Press, 1989.
Cohen, H. F., *Quantifying Music. The Science of Music at the First Stage of the Scientific Revolution 1580-1650*, Dordrecht: Reidel, 1984.
Cohen, H. F., *The Scientific Revolution. A Historiographical Inquiry*. Chicago & London: The University of Chicago Press, 1994.
Comotti, Giovanni, *Music in Greek and Roman Culture*, translated by Munson. Baltimore: Johns Hopkins University Press, 1989.
Cone, Edward T. , "The Old Man's Toys: Verdi's Last Operas," *Perspectives* 6, Winter, 1964, pp. 114-133.
Connors, Joseph, "The Seated Sublime," *New York Review of Books*, 16 February, 1995, pp. 24-26.
Copernicus, Nicholas, *Complete Works*, Volume II: *On the Revolutions*, translation and commentary by Edward Rosen. Baltimore and London: The Johns Hopkins University Press, 1992 [1978].
Cusa, Nicholas, *De Ludo Globi*, 1464.
Cusa, Nicholas, *De Visione Dei*, 1514

Dahlhaus, Carl, *Foundations of Music History*, translated by J. B. Robinson. Cambridge: Cambridge University Press, 1983.
Dahlhaus, Carl, *The Idea of Absolute Music*, translated by Roger Lustig. Chicago: The University of Chicago Press, 1991.
Dante Alighieri, *The Divine Comedy: Inferno*, translated with a Commentary by Charles S. Singleton, Princeton: Princeton University Press, 1970.
Descartes, René, *Meditations Concerning First Philosophy*, translated with an Introduction and Notes by Laurence J. Lafleur, in Descartes, *Philosophical Essays*, Indianaopolis: The Bobbs Merrill Company, Inc., 1964.
Descartes, René, *Les Meditations Metaphysique de René Descartes touchant la Premiere Philosophie ...*, in *Oeuvres de Descartes* publiées par Charles Adam & Paul Tannery, Paris: J. Vrin, 1964, vol. IX-1.
Dijksterhuis, E. J., *The Mechanization of the World Picture*. Oxford: Oxford University Press, 1961.
Dilthey, Wilhelm, *Weltanschauung und Analyse des Menschen seit Renaissance und Reformation*. Leipzig: Teubner Verlag, 1914.
Dilthey, Wilhelm, *Von deutscher Dichtung und Musik: Aus den Studien zur Geschichte des deutschen Geistes*, edited by Herman Nohl and Georg Misch. Leipzig: Teubner, 1933.
Doni, Giovanni B., *Trattato della musica scenica*, 1635.
Doran, Madeleine, *Endeavors of Art: A Study of Form in Elizabethan Drama*. Madison: University of Wisconsin Press, 1954.

Drake, Stillman, *Cause, Experiment and Science*, Chicago: University of Chicago Press, 1981.
Drake, Stillman, "Mathematics, Astronomy, and Physics in the Work of Galileo," in *Art, Science and History in the Renaissance*, edited by Charles S. Singleton. Baltimore: The Johns Hopkins Press, 1967, pp. 305-330.
Drummond, John D., *Opera in Perspective*. Minneapolis: The University of Minnesota Press, 1980.
Dürer, Albrecht, *The Complete Woodcuts of Albrecht Dürer*, edited by Dr. Willi Kurth. New York: Dover Publications, Inc., 1963.
Dürer, Albrecht, *Underweysung der Messung*, 1525.

Euler, Leonhardi, *"Reflections sur l'espace et le tems,"* in *Opera Omnia*, ediderunt E. Hoppe, K. Matter, J.J. Burkhardt. Series Tertia, *Opera Physica*, Vol. II., pp. 376-392.

Fauvel, John, and Gray, Jeremy, *The History of Mathematics. A Reader*. Houndmills: MacMillan Press, Ltd., 1988.
Fenlon, Iain, "The Mantuan *Orfeo*," in *Claudio Monteverdi, Orfeo*, edited by John Whenham, Cambridge: Cambridge University Press, pp. 1-19.
Ferrara, Lawrence. *Philosophy and the Analysis of Music. Bridges to Musical Sound. Form and Reference*. Bryn Mawr: Excelsior Music Pub. Co., 1991
Fiedler, Leslie, *What Was Literature*. New York: Simon and Schuster, 1982.
Finocchiaro, Maurice A., *Galileo and the Art of Reasoning. Rhetorical Foundations of Logic and Scientific Method*. Dordrecht: D. Reidel, 1980.
Flaubert, Gustave, *Madame Bovary*. Translated by Mildred Marmur, with a Foreword by Mary McCarthy. New York: The New American Library, 1964.
Fortune, Nigel, "The Rediscovery of *'Orfeo'*," in John Whenham, *Orfeo*. Cambridge: Cambridge University Press, 1986, pp. 78-118.
Foss, Vivian, *Massinger's Tragicomedies: The Politics of Courtship*. Unpublished Doctoral Dissertation, University of Wisconsin, Madison, 1994
Foucault, Michel, *The Birth of the Clinic. An Archaeology of Medical Perception*, translated by A. M. Sheridan Smith. New York: Vintage Books, 1975.
Foucault, Michel, *The Order of Things*. New York: Vintage Books, 1994.
Fracasttoro, Girolamo, *Naugerius sive de Poetica Dialogus*, 1584.
Freeman, Robert S. *Opera Without Drama. Currents of Change in Italian Opera 1675-1725*. Ann Arbor: UMI Research Press, 1981.
Friedrich, Carl J., *The Age of the Baroque*.New York: Harper Torchbook, 1952.
Fubini, Enrico, *Music & Culture in Eighteenth-Century Europe. A Source Book*, translated from the original sources by Wolfgang Freis, Lisa Gasbarrone, Michael Louis Leone, translation edited by Bonnie J. Blackburn. Chicago: The University of Chicago Press, 1994.
Fulcher, Jane, *The Nation's Image. French Grand Opera As Politics and Politicized Art*. Cambridge: Cambridge University Press, 1987

Gadamer, Hans-Georg, *Truth and Method*. New York: Continuum Books, 1975.
Galilei, Galileo, *Dialogo sopra i due Massimi Sistemi del Mondo*, in *Le Opere di Galileo Galilei*. Firenze: G. Barbera Editore, 1933, Vol. VII.
Galilei, Galileo, *Dialogue Concerning the Two Chief World Systems*, translated by Stillman Drake. Berkeley: The University of California Press, 1967.
Galilei, Galileo, *Dialogues Concerning the Two New Sciences*, translated by Henry Crew and Alfonso de Salvio, with an Introduction by Antonio Favaro. New York: Dover Publications, n.d.
Galilei, Galileo, *Discorsi e dimostrazioni matematiche intorno a due nuove scienze*, *Le Opere di Galileo Galilei*. Firenze: G. Barbera Editore, 1933, Volume VIII.
Galilei, Galileo, *Discoveries and Opinions of Galileo*, translated with an Introduction and Notes by Stillman Drake.New York: Double Day Anchor Books, 1957.
Galilei, Galileo, *Le Opere di Galileo Galilei*. Firenze: G. Barbera Editore, 1929 ff. : Volume XI (1934), *Carteggio*, 1611-1613; Volume XII (1934), *Carteggio*, 1614-1619; XVIII (1937), *Carteggio*, 1639-1642.
Garin, Eugenio, *Italian Humanism. Philosophy and Civic Life in the Renaissance*. New York: Harper & Row, 1965.
Glover, Jane, "Solving the Musical Problems," in John Whenham, *Orfeo*. Cambridge: Cambridge University Press, 1986, pp. 138-155.
Gluck, Christoph Willibald, *Preface to Alceste*, 1769.

Goehr, Lydia, *The Imaginary Museum of Musical Works. An Essay in the Philosophy of Music.* Oxford: Oxford University Press, 1992.
Gottsched, Johann Christoph, *Versuch einer Critischen Dichtkunst,* 1743.
Gravina, Gian Vincenzo, *Della tragedia,* 1715.
Griffiths, Paul,"Rattle and Sellars: Hearing Debussy," *New Yorker,* 28 June, 1993, pp. 85-87.
Gurarini, Alessandro, *Lezioni nell'Accademia degli'Invaghiti,* Naples, 1599.
Guazzo, Stefano, *La civile conversazione,* 1586
Güldenstern, Gustav, "Beiträge zu einer Phänomenologie der Musik," in *Schweizerische Musikzeitung und Sängerblatt,* 1931.
Güldenstern, Gustav, *Theorie der Tonart.* Stuttgart: Verlag Ernst Klett, 1928.
Gurwitsch, Aron, *Human Encounters in the Social World,* translated by Fred Kersten with an Introduction by Alexandre Métraux. Pittsburgh: Duquesne University Press, 1979.
Gurwitsch, Aron, *Phenomenology and the Theory of Science,* edited by Lester E. Embree. Evanston: Northwestern University Press, 1974.
Gurwitsch, Aron, *Studies in Phenomenology and Psychology.* Evanston: Northwestern University Press, 1966.
Gurwitsch, Aron, *Leibniz. Philosophie des Panlogismus.* Berlin:Walter de Gruyter, 1974.
Gurwitisch, Aron. "Compossibility and Incompossibility in Leibniz," in *Phenomenological Perspectives Historical and Systematic. Essays in Honor of Herbert Spiegelberg.* ed. Philip Bossert. The Hague: Martinus Nijhoff, 1975, pp. 3-13.

Hall, Rupert, *The Revolution in Science 1500-1750.* London and New York: Longman, 1983.
Hammond, Frederick, *Music & Spectacle in Baroque Rome. Barberini Patronage under Urban VIII.* New Haven and London: Yale University Press, 1994.
Hanning, Barbara Russano, *Of Poetry and Music's Power. Humanism and the Creation of Opera.* Ann Arbor: UMI Press, 1980.
Harnoncourt, Nikolaus, *The Musical Dialogue. Thoughts on Monteverdi, Bach and Mozart,* translated by Mary O'Neill. Portland, Oregon: Amadeus Press, 1989
Harnoncourt, Nikolaus, *Baroque Music Today: Music as Speech. Ways to a New Understanding of Music,* translated by Mary O'Neill. Portland, Or.: Amadeus Press, 1988.
Hauser, Arnold, *Mannerism. The Crisis of the Renaissance & the Origin of Modern Art,* translated in collaboration with the author by Eric Mosbacher. New York: Alfred A. Knopf, 1965.
Heath, Thomas, *A Manual of Greek Mathematics.* New York: Dover Publications, 1963 [1931].
Heelan, Patrick A., "Husserl's Phenomenology of Science," in *Husserl's Phenomenology: A Textbook,* edited by J. N. Mohanty and William R. McKenna. Washington, D.C.: University Press of America, 1989, pp. 387-427.
Heidegger, Martin, *Der Satz vom Grund,* Pfullingen: Neske, 1957.
Heisenberg, Werner, "Grundlegende Voraussetzungen in der Physik der Elementarteilchen," in *Martin Heidegger zum Siebzigsten Geburtstag,* herausgegeben von Günther Neske. Pfullingen: Verlag Günther Neske, 1959, pp. 291-297.
Heisenberg, Werner, "Platons Vorstellungen von den kleinsten Bausteinen der Materie und die elementarteilchen der modernen Physik," in *Im Umkreis der Kunst. Eine Festschrift für Emil Preetorius,* herausgegeben von Fritz Hollwich. Stuttgart: Insel-Verlag, 1953, pp. 137-140.
Heller, Eric, *Thomas Mann. The Ironic German.* Cleveland: Meridian Books, 1961.
Hering, Jean, "Concerning Image, Idea, and Dream. Phenomenological Notes," *Philosophy and Phenomenological Research,* 8 (Sept. 1947- June, 1948), pp. 188-205.
Hibbard, Howard, *Caravaggio.* New York: Harper & Row, 1983.
Hofstadter, Douglas, *Gödel, Escher, Bach: An Eternal Golden Braid. A Metaphorical Fugue on Minds and Machines in the Spirit of Lewis Carroll.* New York: Vintage Books, 1980.
Holt, Elizabeth G., editor, *A Documentary History of Art.* New York: Doubleday Anchor Book, 1958, Vol. II.
Hughes, Robert, "Take this Revolution," *Time,* Spring, 1995, pp. 75-78.
Husserl, Edmund, *Cartesian Meditations,* translated by Dorion Cairns. The Hague: Martinus Nijhoff, 1960.
Husserl, Edmund, *Die Krisis der europäischen Wissenschaften und die transzendentale Phänomenologie,* herausgegeben von Walter Biemel. Den Haag: Martinus Nijhoff, 1954.
Husserl, Edmund, *Erfahrung und Urteil,* redigiert und herausgegeben von Ludwig Landgrebe. Hamburg: Classen Verlag, 1954 [1939].

Husserl, Edmund, *Experience and Judgment*, translated by James S. Churchill. Evanston:Northwestern Press, 1973.

Husserl, Edmund, *Ideas Pertaining to a Pure Phenomenology and to a Phenomenological Philosopy. First Book: General Introduction to a Pure Phenomenology*, translated by Fred Kersten. The Hague/Boston/London: Martinus Nijhoff, 1982.

Husserl, Edmund, *Ideen zu einer reinen Phänomenologie und phänomenologischen Philosophie*, neu herausgegeben von Karl Schuhmann. 1 Halbband. Text der 1.-3. Auflage. Den Haag: Martinus Nijhoff, 1976.

Husserl, Edmund, *Logische Untersuchungen, Zweiter Band, II Teil* Halle: Max Niemeyer, 1922, dritte Auflage.

Jaeger, Werner, *Aristotle. Fundamentals of the History of His Development*, translated with the Author's Corrections and Additions by Richard Robinson. Oxford: Oxford University Press, 1948, 2nd. Ed.

Janson, H. W., "The 'Image Made by Chance' in Renaissance Thought," in *Essays in Honor of Erwin Panofsky*, edited by Millard Meiss. New York: New York University Press, 1961, pp. 254-266.

Jesseph, Douglas, *Berkeley's Philosophy of Mathematics*. Chicago and London: University of Chicago Press, 1993.

Jonas, Hans, "Homo Pictor and the Differentia of Man," *Social Research*, 29, No. 2 (Summer, 1962), pp. 201-220.

Jonas, Hans, "The Practical Uses of Theory," in Jonas, Hans, *The Phenomenon of Life*. New York: Harper & Row, 1966, pp. 188-210.

Jonas, Hans, "Plotin über Ewigkeit und Zeit," *Politische Ordnung und Menschliche Existenz. Festgabe für Eric Voegelin zum 60. Geburtstag,* herausgegeben von Alois Dempf, Hannah Arendt, Friedrich Engel- Janosi. München: C.H. Beck, 1962, pp. 295-319.

Katz, Ruth, *Diving the Powers of Music. Aesthetic Theory and the Origins of Opera*. New York: Pendragon Press, 1986.

Kaufmann, Walter, *Tragedy and Philosophy*, New York: Anchor Books, 1969.

Kayser, Wolfgang, *Interpretación y Análisis de la Obra Literaria*, traducción de D. Mouton y V. G. Yebra. Madrid: Editorial Gredos, 1958.

Kearny, R., *Dialogues with Contemporary Thinkers*. Manchester: Manchester University Press, 1984.

Kenner, Hugh, *Samuel Beckett*. Los Angeles and Berkeley: The University of California Press, 1968.

Kepler, Johannes, *Harmonia Mundi*, 1619

Kepler, Johannes, *Mysterium Cosmographicum*, 1621

Kersten, Fred, "Heidegger and Transcendental Phenomenology," *The Southern Journal of Philosophy*, 11, No. 3, Fall, 1973, pp. 202-215.

Kersten, Fred, "The Life Concept and the Life Conviction: A Phenomenological Sketch," *The Journal of Medicine and Philosophy*, Volume 3, No. 2, June, 1978, pp. 107-128.

Kersten, Fred, "The Line in the Middle (The Middle of the Line)," *Research in Phenomenology*, IX,1978,pp. 87-107.

Kersten, Fred, *Phenomenological Method: Theory and Practice*. Dordrecht: Kluwer Academic Publications, 1989.

Kersten, Fred, "Baroque Twins: Science and Opera," in *Essays in Memory of Aron Gurwitsch*, edited by Lester E. Embree. Washington, D.C.: University Press of America, 1984.

Kersten, Fred, "The Constancy Hypothesis in the Social Sciences," in *Life-World and Consciousness. Essays for Aron Gurwitsch*, edited by Lester E. Embree. Evanston: Northwestern University Press, 1972, pp. 521-564.

Kersten, Fred, "The Philosophy of Aron Gurwitsch," *To Work at the Foundations*, edited by E. Claude Evans and R. O. Stufflebeam. Dordrecht: Kluwer Academic Publishers, 1997, pp. 21-30.

Kersten, Fred, "Phenomenology, History and Myth," in *Phenomenology and Social Reality. Essays in Memory of Alfred Schutz*, edited by Maurice Natanson. Den Haag: Martinus Nijhoff, 1970, pp. 234-269.

Kersten, Fred, "Heidegger and the History of Platonism," in *Der Idealismus und seine Gegenwart*. Hamburg: Felix Meiner, 1975, pp. 272-296.

Kersten, Fred, "Loneliness and Solitude," *Humanitas*, X (No. 3), 1974, pp. 301-312.

Kersten, Fred, "Private Faces," in *Research in Phenomenology*, XII, 1982, pp. 167-177.
Kivy, Peter, *Osmin's Rage. Philosophical Reflections on Opera, Drama and Text*. Princeton: Princeton University Press, 1988.
Kivy, Peter, *Sound and Semblance. Reflections on Musical Representation*. With a New Afterword by the Author. Ithaca and London: Cornell University Press, 1984.
Klee, Paul, *Das bildnerische Denken. Schriften zur Form- und Gestaltungslehre*. Herausgegeben und bearbeitet von Jürg Spiller. Basel/Stuttgart: Benno Schwabe & Co. Verlag, 1956.
Klein, Jacob, *Greek Mathematical Thought and the Origin of Algebra*, translated by Eva Brann. Boston: MIT Press, 1968.
Koyré, Alexandre, *From the Closed World to the Infinite Universe*. New York: Harper Torchbooks, 1957.
Koyré, Alexandre, *Newtonian Studies*. Chicago: The University of Chicago Press, 1968.
Koyré, Alexandre, *Metaphysics and Measurement: Essays in the Scientific Revolution*. Cambridge, Mass.: Harvard University Press, 1969.
Koyré, Alexandre, *Études Galiléennes*. Paris: Hermann, 1966.
Kristeller, Paul Otto, *Renaissance Thought II*. New York: Harper Torchbook, 1965.
Kuhn, Thomas S., *The Copernican Revolution. Planetary Astronomy in the Development of Western Thought*. Cambridge, Mass. and London: Harvard University Press, 1957.
Kundera, Milan. *Testaments Betrayed. An Essay in Nine Parts.* Translated from the French by Linda Asher. New York: Harper/Collins Publishers, 1995.

Leclerc, Hélène, *Venise Baroque et l'Opéra*. Paris: Armand Colin, 1987.
Leclerc, Hélène, *Les Origines italiennes de l'Architecture théâtrale Moderne*. Paris: Droz, 1946.
Leibniz, W. G., *Der Briefwechsel zwischen Leibniz und Conrad Henfling*, herausgegeben von Rudolf Haase. Frankfurt am Main: Vittorio Klosterman, 1982.
Leibniz, God. Guil., *Opera Philosophica*, instruxit Joannes Eduardus Erdmann. Berolini: Sumtibus G. Eichleri, 1840.
Leibniz, W. G., *Epistolae ad diversos*, ed. Chr. Kortholt. Leipzig, 1734, Vol. 1.
Leopold, Silke, *Monteverdi. Music in Transition*, translated by Anne Smith. Oxford: Clarendon Press, 1991.
Levi, Albert William, *Philosophy as Social Expression*, Chicago: The University of Chicago Press, 1974.
Leyendecker, Herbert, *Zur Phänomenologie der Täuschungen*. Halle: Waisenhautes, 1913.
Lindberg, David C., *The Beginnings of Western Science*. Chicago: The University of Chicago Press, 1992.
Lionardi, Alessandro, *Dialogi... della inventione poetica*, 1554
Lippman, Edward, "Aesthetics in Theoretical Treatises on Music," in *Music Theory and the Exploration of the Past*, edited by Christopher Hatch and David W. Berstein. Chicago and London: The University of Chicago Press, 1993, pp. 217-232.
Lippman, Edward, *A History of Western Musical Aesthetics*. Lincoln & London: University of Nebraska Press, 1994 [1992].
Lippmann, Friedrich, "Vincenzo Bellini," in *The New Grove Masters of Italian Opera*. New York/London: W. W. Norton, 1983, pp. 155-192.
Lowinsky, Edward, "Music in the Culture of the Renaissance," in *Renaissance Essays*, edited by Paul O. Kristeller and Philip P. Wiener. New York: Harper Torchbooks, 1968, pp. 337-381.

Maniates, Maria Rika, *Mannerism in Italian Music and Culture 1530-1630*. Chapel Hill: University of North Carolina Press, 1979.
Màrgani, Margherita, "Sull'autenticità di una lettera attribuita a G. Galilei," *Atti della Reale Accademia delle Scienze di Torino*, LVII, 1921-1922, pp. 556-561.
Mazzoni, Jacopo, *Della difesa della "Commedia" di Dante*, 1587.
Melville, Herman, *Billy Budd, Sailor & Other Stories*, Selected and Edited with an Introduction by Harold Beaver. Harmondsworth, Milddelsex: Penguin Books Ltd., 1977.
Merleau-Ponty, Maurice, *Phénoménologie de la perception*. Paris: Librairie Gallimard, 1945.
Merleau-Ponty, Maurice, *Phenomenology of Perception*, translated by Colin Smith. New York: The Humanities Press, 1962.
Mersenne, Marin, *Harmonie Universelle*, 1636
Monteverdi, Claudio, *The Letters of Claudio Monteverdi*, translated and introduced by Denis Stevens. Cambridge: Cambridge University Press, 1980.

Monteverdi, Claudio, *L'Orfeo*. Soloists, Ballett und Chor des Opernhauses, Zürich, conducted by Nikolaus Harnoncourt, Directed by Jean-Pierre Ponnelle, 1978. London O71 203-1.
Moss, Jean Dietz, *Novelties in the Heavens. Rhetoric and Science in the Copernican Controversy*. Chicago: The University of Chicago Press, 1993.
Muratori, Antonio, *Della perfetta poesia italiana*, 1706.

Natanson, Maurice, *Anonymity. A Study in the Philosophy of Alfred Schutz*. Bloomington: Indiana University Press, 1986.
Natanson, Maurice, *Literature, Philosophy and the Social Sciences*. The Hague: Martinus Nijhoff, 1962: "Phenomenology and the Theory of Literature," pp. 86-100; "Existentialism and the Theory of Literature," pp. 101-115.
Natanson, Maurice, "Man as Actor," *Philosophy and Phenomenological Research*, Vol. XXVI (March, 1966), pp. 327-341.
Nearing, Homer C. Jr., "The Hermeneutical Doughnut," in *The Mathematical Magpie*, edited by Clifton Fadiman. New York: Simon and Schuster, 1962, pp. 48-69.

Olson, Elder, *The Theory of Comedy*, Bloomington: Indiana University Press, 1968.
Oresme, Nicole, *Le Livre du ciel et du monde*, 1377
Ortega y Gasset, José, *The Idea of Principle in Leibniz and the Evolution of Deductive Theory*, translated by Mildred Adams. New York: W. W. Norton & Company, 1971.
Ortega y Gasset, *La Idea de Principio en Leibniz y la Evolución de la Teoría*. Madrid: Emecé Editores, 1958.
Ortega y Gasset, José, *Papeles sobre Velázquez y Goya*. Madrid: Revista de Occidente, 1950.
Ortega y Gasset, José, *The Modern Theme*, translated by James Cleugh, Introduction by José Ferrater Mora. New York: Harmper Torchbooks, 1961.
Osborne, Richard, *Rossini*. Boston: Northeastern University Press, 1986.

Palisca, Claude V., *Humanism in Italian Rensissance Musical Thought*. New Haven: Yale University Press, 1985.
Panofsky, Erwin, *Galileo as a Critic of the Arts*. The Hague: Martinus Nijhoff, 1954.
Panofsky, Erwin, "Et in Arcadia Ego: On the Conception of Transience in Poussin and Watteau," *Philosophy and History. The Ernst Cassirer Festschrift*, edited by Raymond Klibansky and H. J. Paton. New York: Harper Torchbooks, 1963, pp. 223-254.
Panofsky, Erwin, "The History of the Theory of Human Proportions as a Reflection of the History of Styles," in Panofsky, Erwin, *Meaning in the Visual Arts*. New York: Doubleday Anchor Book, 1955, pp. 55-107.
Panofsky, Erwin, *Idea. A Concept in Art Theory*, translated by Joseph J. S. Peake. Columbia: University of South Carolina Press, 1968.
Panofsky, Erwin, *The Life and Art of Albrecht Dürer*. Princeton: Princeton University Press, 1971
Panofsky, Erwin, *Renaissance and Renascences in Western Art*. New York: Harper Torchbooks, 1969.
Panofsky, Erwin, *Studies in Iconology. Humanistic Themes in the Art of the Renaissance*. New York: Harper Torchbook, 1962.
Panofsky, Erwin, *Three Essays on Style*. Edited by Irving Lavin. With a Memoir by William S. Hecksher. Cambridge, Massachusetts; London, England: The MIT Press, 1995. "What is Baroque?" pp. 19-88; "Style and Medium in the Motion Pictures," pp. 91-126.
Pestelli, Giorgio, *The Age of Mozart and Beethoven*, translated by Eric Cross. Cambridge: Cambridge University Press, 1984.
Plato, *The Collected Dialogues, Including the Letters*, edited by Edith Hamilton and Huntington Cairns, with Introduction and Prefatory Notes. New York: Pantheon Books, 1961.
Plato, *Phaedo*, translated by Harold North Fowler, *Euthyphro, Apology, Crito, Phaedo, Phaedrus*. Cambridge, Mass.: Harvard University Press, 1960.
Plessner, Helmut, *Laughing and Crying*, translated by James Spencer Churchill and Majorie Grene. Evanston: Northwestern University Press, 1970.
Proclus, *A Commentary on the First Book of Euclid's Elements*, translated with an Introduction and Notes by Glenn R. Morrow. Princeton: Princeton University Press, 1970.

Ray, Stefano, *Lo Specchio del Cosmo. Da Brunelleschi a Palladio: Itinerari nell'architettura del Rinascimento*. Roma: NIS, 1991.

Redondi, Pietro, *Galileo Heretic,* translated by Raymond Rosenthal, Princeton: Princeton University Press, 1987.
Rella, Franco, "Fabula," in *Recoding Metaphysics. The New Italian Philosophy.* Edited by Giovanna Borradori. Evanston: Northwestern University Press, 1988, pp. 147-154.
Ricoeur, Paul, *Husserl. An Analysis of His Phenomenology,* translated by Lester E. Embree and Edward G. Ballard. Evanston: Northwestern University Press, 1967.
Rilke, Rainer Maria, *The Notebooks of Malte Laurids Brigge,* translated by M. D. Herter Norton. New York: Capricorn Books, 1958.
Rosand, Ellen, "The Descending Tetrachord: An Emblem of Lament," *Musical Quarterly,* 65 (1979), pp. 346-359.
Rosand, Ellen, "Did Monteverdi write *L'Incoronazione di Poppea* and Does It Matter?" *Opera News,* July, 1994, pp. 21-38.
Rosenmeyer, Thomas G., *The Green Cabinet. Theocritus and the European Pastorial Lyric.* Berkeley, Los Angeles, London: University of California Press, 1969.
Rousseau, Jean-Jacques, *Dictionnaire de Musique,* 1768.
Rowland, Ingrid D., Letter, *The New York Review of Books,* 12 January, 1995.

Santillana, Giorgio de, *The Crime of Galileo.* Chicago: The University of Chicago Press, 1955.
Santayana, George, *Scepticism and Animal Faith. Introduction to a System of Philosophy.* New York: Dover Publications, 1955.
Sartre, Jean-Paul, *Nausea,* translated by Lloyd Alexander. New York: New Directions, 1964.
Sartre, Jean-Paul, *L'Imaginaire. Psychologie phénoménologie de l'imagination.* Paris: Librairie Galimard, 1948.

Scheler, Max, *Formalismus in der Ethik und die materiale Wertethik. Neuer Versuch der Grundlegung einer ethischen Personalismus.* Vierte durchgesehene Auflage herausgeben mit einem neuen Sachregister von Maria Scheler. Bern: Francke Verlag, 1954.
Scheler, Max, *Formalism in Ethics and Non-formal Ethics of Values,* translated by Manfred S. Frings and Roger L. Funk, Evanston: Northwestern University Press, 1973.
Schmitt, Charles B., "Experience and Experiment: A Comparison of Zabarella's View with Galileo's in *De Motu,*" *Studies in the Renaissance,* Vol. XVI, 1969, pp. 80-138.
Schopenhauer, Arthur, *Die Welt als Wille und Vorstellung.* Wiesbaden: Eberhard Brockhaus Verlag, 1949.
Schrade, Leo, *Tragedy in the Art of Music.* Cambridge, Mass.: Harvard University Press, 1964.
Schrecker, Paul, "On the Infinite Number of Infinite Orders. A Chapter in the Pre-history of Transfinite Numbers. In *Studies and Essays in the History of Science and Learning.* Offered in Homage to George Sarton on the Occasion of His 60th Birthday, 31 august, 1944. Edited by M. F. Ashley-Montagu. New York: Henry Schuman, 1944, pp. 361-373.
Schutz, Alfred, "Fragments on the Phenomenology of Music," edited with an Introduction by Fred Kersten, *In Searth of Musical Method,* edited by F. J. Smith. New York: Gordon and Breach Publishers, 1976, pp. 5-72.
Schutz, Alfred, *Life Forms and Meaning Structure,* translated, introduced and annotated by Helmut Wagner. London: Routledg e & Kegan Paul, 1982.
Schutz, Alfred, *Collected Papers,* Volume 1, edited by Maurice Natanson. Den Haag: Martinus Nijhoff, 1962: "Symbol, Reality and Society,", pp. 287-356; "Common-sense and Scientific Interpretation of Human Action," , pp. 3-47; "Choosing Among Projects of Action," pp. 67-97.
Schutz, Alfred, *Collected Papers,* Volume 2, edited and introduced by Arvid Broderson. The Hague: Martinus Nijhoff, 1964: "Mozart and the Philosophers," pp. 179-200; "Tiresias, or Our Knowledge of Future Events," pp. 277-294
Schutz, Alfred, , *Collected Papers,* Volume 3, edited by I. Schutz, with an Introduction by Aron Gurwitsch. The Hague: Martinus Nijhoff, 1966: "The Problem of Transcendental Intersubjectivity in Husserl," pp. 51-83.
Schutz, Alfred, *The Phenomenology of the Social World,* translated by George Walsh and Frederick Lehnert, with an Introduction by George Walsh. Evanston: Northwestern University Press, 1967.
Schutz, Alfred and Luckmann, Thomas, *Strukturen der Lebenswelt.* Frankfurt am Main: Suhrkamp Verlag, Volume 1, 1979, Volume 2, 1984.
Schutz, Alfred, and Luckmann, Thomas, *The Structures of the Life-World,* translated by Richard Zaner and H. Tristram Engelhardt, Jr. Evanston: Northwestern University Press, 1973.

Schutz, Alfred, *Reflections on the Problem of Relevance*, edited by Richard Zaner. New Haven: Yale University Press, 1970.
Schutz, Alfred, "Husserl and the Social Sciences," in *Edmund Husserl 1859-1959*. The Hague: Martinus Nijhoff, 1959, 86-98.
Serafin, Tullio e Toni, Alceo, *Stile, Tradizioni e Convenzioni del Melodramma Italiano del Settecento e dell'Ottocento*. Milan: G. Ricordi & C., 1958.
Smith, Adam, *Essays on Philosophical Subjects*. Edited by W.P.D. Wightman, J.C. Bryce & I.S. Ross. With Dugald Stewart's Account of Adam Smith. Oxford: Clarendon Press, 1980.
Solerti, Angelo, *Le Origini del Melodrama*. Torino: Fratelli Bocca, 1903.
Sternfeld, F. W., "The Orpheus Myth and the Libretto of 'Orfeo'," in *Claudio Monteverdi, Orfeo*, edied by John Whenham, Cambridge: Cambridge University Press, 1986.
Strauss, Erwin, "The Expression of Thinking," *An Invitation to Phenomenology*, edited by James Edie. Chicago: Quadrangle Books, 1966, pp.266-283
Strom, Reinhard, *Essays on Handel & Italian Opera*. Cambridge: Cambridge University Press, 1985.
Strunk, Oliver, *Source Readings in Music History. The Classic Era*. New York: W. W. Norton & Company, 1965.

Tasso, Torquato, *Gerusalemme Liberata*, translated by Edward Fairfax with an Introduction by John Charles Nelson.New York: Capricorn Books, 1963.
Tesauro, Emanuele, *Il cannocchiale aristotelico o sia idea dell'arguta et ingeniosa elocutione*, Torino, 1670.
Tomlinson, Gary, *Music in Renaissance Magic. Toward A Historiography of Others*. Chicago: The University of Chicago Press, 1993.
Tomlinson, Gary, *Monteverdi and the End of the Renaissance*. Berkeley and Los Angeles: The University of California Press, 1990.
Tosi, Pier Francesco, *Observations on the Florid Song; or Sentiments on the Ancient and Modern Singers*, translated by Mr. J. E. Galliard. 1743. London: William Reeves, Bookseller Ltd, 1967.
Toulmin, Stephen, and Goodfield, June, *The Fabric of the Heavens. The Development of Astronomy and Dynamics*. New York: Harper Torchbooks, 1961.

Verba, Cynthia, *Music and the French Enlightenment. Reconstruction of a Dialogue 1750-1764*. Oxford:Clarendon Press, 1993.
Vesalius, Andreas, *From the Works of Andreas Vesalius*. With annotations and translations by J. B. de G. M. Saunders and Charles D. O'Malley. New York: Dover Publications, 1973.
Vicentino, Nicola, *L'antica music ridotta della moderna prattica*, 1555.
Vickers, Brian, "Epideictic Rhetoric in Galileo's *Dialogo*." *Annali dell'Istituto e Museo de Storia della Scienza*, 8 (1983), pp. 69-102.
Voegelin, Eric, *The New Science of Politics*. Chicago & London: The University of Chicago Press, 1952.

Walker, D. P. , *Studies in Musical Science in the Late Renaissance*. London/The Warburg Institute/University of London, Leiden: E. J. Brill, 1978.
Wallace, William, *Prelude to Galileo*. Dordrecht: Reidel, 1981.
Whenham, John, "*Orfeo*, Act V: Alessandro Striggio's Original Ending," in John Whenham, editor, *Claudio Monteverdi's Orfeo*. Cambridge: Cambridge University Press, 1986, pp. 35-41.
White, John, "Paragone: Aspects of the Relationship Between Sculpture and Painting," in *Art, Science, and History in the Renaissance*, edited by Charles S. Singleton. Baltimore: The Johns Hopkins Press, 1967, pp. 43-110.
Wilkins, Ernest Hatch, *A History of Italian Literature*, revised by Thomas Bergin. Cambridge, Mass.: Harvard University Press, 1974.
Wilson, Dora J., "Johann Adolph Scheibe's Views on Opera and Aesthetics," *Opera Quarterly*, II (no. 2), 1984, pp. 49-56.
Winternitz, Emanuel, "The Role of Music in Leonardo's Paragone," in *Phenomenology and Social Reality*, edited by Maurice Natanson. The Hague: Martinus Nijhoff, 1970, pp. 270-296.

Zuccaro, Federico, *L'Idea dei scultori, pittori e architetti* (1607).

Index

Abbate, Carolyn 6, 233
Absolutism 85
Accidentals 169
Action, social 17ff., 21, 31, 46ff., 49f., 54, 60, 75, 80, 82, 91, 92, 94f., 102, 111ff., 120, 123, 125, 135, 141, 143, 147, 148, 155, 164, 169, 173, 176, 186, 190, 199, 200, 215, 219, 240, 241 v. Working
Aeschylus 61
Affections 64ff., 92, 93, 95, 96ff., 99, 114, 115, 131, 137, 141, 147, 148, 160, 168f., 171, 180, 187, 188ff., 220f., 222, 223, 231
Agucchi, Giovanni Battista 56, 73f., 117
Alberti, Leon Battista 57, 58, 64ff., 67, 69, 70f., 72, 75, 78, 79, 80, 91, 94, 97, 103, 105, 115, 124, 128, 131, 132, 141, 146, 151, 158, 170, 196, 211f., 213, 253
Algarotti, Francesco 229, 230
Algorism 202f., 212, 213
Alienation 131, 133
Alison, Archibald 171
Alonso-Misol, José-Luis ix
Analogue 247, 248f.
Analogy 37ff., 39f., 40ff., 42, 80, 88, 95, 100, 236 v. Appresentation, Representation
Ansermet, Ernst 248f.
Apollo 176 177, 178
Appearance 29ff., 58ff., 64, 72, 156 v. Beauty, Thingness of things
Appresentation 33ff., 38, 41, 108, 116, 246, 248; indicational appresentation, 51ff., 57, 58ff., 60, 68, 76, 80, 82, 89, 95, 102, 134, 139, 140, 155, 159, 166, 171, 173, 177, 184, 192f., 197, 204, 239, 242
Aquinas, Thomas 76
Arcadia 147, 173ff., 178, 242
Archimedes 165
Architecture 143, 158, 184, 210ff.
Architectonics 24, 26, 39, 42f.
Arendt, Hannah 29ff., 32, 34, 36, 39, 96, 117
Ariosto, Ludovico 135, 137, 138f.
Aristotle 9ff., 22ff., 25, 29, 31, 32, 39, 74, 94, 97, 107, 137f., 144, 156, 158, 161, 163, 165
Aristoxenos 86
Arithmetic 31, 43, 65, 66, 76, 80f,, 89, 171 v. Ratio
Arm 68, 177, 178
Arrow 65, 161f.
Arsenal of Venice 158
Art 75, 78, 84, 85, 99, 244, 253
Artes liberales 76
Artes mechanicae 76
Astronomy 3, 9
Auerbach, Eric 140
Auden, W. H. 5f., 7, 83, 143, 147, 150, 175, 176, 187, 222
Axiomatization 166f.
Ayer, A. J. 185

Bach, J. S. xiii, 88, 220, 228f.
Bacon, Francis 148, 187
Baltrusaitis, Jurgis 132
Baroque: meanings of, ixf., xi, 94, 120
Barsotti, C. 81
Barthes, Roland 140
Bass 105, 179ff., 182, 184, 196
Beaufret, Jean 143ff.
Beauty 28f., 30, 31, 38, 43, 45, 72, 91, 93, 95, 134, 211

Beckett, Samuel 10
Beeckman, Isacc 170
Beeton, Isabella 55
Behnke, Elizabeth xv
Bel canto 224, 227
Belief 12ff. v. Conviction
Bellini, Vincenzo 6, 232
Benedetti, Giovanni Battista 83
Bensen, Bruce 180
Bergson, Henri 46
Berkeley, George 216, 217f., 219, 220, 221, 227, 230, 236, 238
Bernini, Gianlorenzo x
Biagioli, Mario 45, 138
Bios theoretike 25
Bjoerling, Jussi 83
Blaukopf, Kurt 100
Boas, Marie 193
Boito, Arrigo 223
Bones 58, 72, 90ff., 191, 195
Bourdon, Sebastien 153
Breakwater, Harbinger P. 156f., 176, 177
Bradwardine, Thomas 43, 44, 95, 244
Brahe, Tycho 73, 116f.
Bravura 226
Brecht, Bertold 10
Brunelleschi, Filipo di Ser 66, 115
Bruno, Giordano 190
Budden, Julian 223
Bukofzer, Manfred xiii, 8, 86, 92, 105, 158, 160
Buridan, Johannes 25, 161
Butler, Judith 147

Caccini, Giulio 98, 105, 180
Cadence 170
Cairns, Dorion 34, 101, 243
Calculus 128
Calderón de la Barca, Pedro 148, 187
Calzabigi, Raniero 229, 230
Camerata, Florentine 142
Capitalism 120f.
Caravaggio, Michelangelo Merisi da 102
Casalduero, Joaquin 133
Casey, Edward 34
Cassirer, Ernst x, 4, 80, 84f., 91, 95, 100, 108f., 128, 150, 190
Castiglione, Baldassare 55
Cat 167
Category, regional 241, 242, 251, 253
Catharsis 96ff., 100, 178
Catoptics 61, 64
Cause 26f., 95, 148f., 165, 191
Cellini, Benvenuto 133
Celletti, Rodolfo 83, 137, 158, 160, 173, 178, 181, 188, 221, 222, 224, 225, 226, 229, 230, 231, 233
Center 14, 17, 26, 29f., 31, 38, 42, 44, 49ff., 56ff., 64, 71, 73, 75, 79, 82, 87, 88, 89, 90, 94, 101f., 106, 110, 113, 116f, 124, 147, 151, 156, 164, 168, 175, 186,195, 198ff., 201, 219, 225, 240 v. Periphery, Eccentricity
Cervantes, Miguel 133, 244
Chance 132 v. *Fortuna*
Change v. Motion
Character 130f.. 133, 134
Charles VI 226

Cicero 39, 97
Cigoli, Ludovico 135ff., 138, 223
Circle 72, 87f., 90, 110, 163, 191ff., 194ff., 203 v. Center, Sun
Clagett, Marshall 24, 25, 26, 27, 42, 43, 58
Clark, Kenneth 58
Clarke, Samuel 150, 208f.
Clavelin, Maurice 22, 104, 107. 109
Clément, Catherine 7
Clifford, W. K. 198f.
Clocks 193
Cogito v. *Res cogitans*
Cohen, H. Floris x, xiii, 8, 31, 79, 80, 81, 83, 84, 87, 99, 107, 109, 127, 128, 171, 215, 216
Combining. 163, 171, 178, 218
Comedy 31, 125, 131, 134, 135, 141f., 159, 168, 228
Common-sense 11, 29, 46, 56, 92, 102, 156f., 169, 215, 216, 240, 246, 250, 252
Communication 226
Compossibility 100, 101ff., 105, 109, 110, 116, 124, 128, 130, 135, 139, 144, 156, 160, 164, 169, 171, 180, 183, 185, 197, 202, 210, 212, 215, 216, 223, 229f., 235, 244, 250, 251, 252, 253
Comotti, Giovanni 31
Computer 210f., 213
Conceits 97f., 99, 139, 183, 184
Cone, Edward T. 6
Connors, Joseph 210, 211
Consciousness 196f.; formulation of xi, 19, 20 103, 221; phenomenology of, xi, xii, 183, 216, 236, 239, 240, 241, 251, 252., 253; Classical formulation of consciousness, 22ff., 26, 27, 30, 31, 32, 35, 38ff. 42f.., 44, 45 ,46, 53, 61, 62f., 71, 74, 75, 76f., 78, 80, 93, 94, 121, 124, 140,161,162,163, 196 , 230, 235, 251, 253; Baroque formulation of consciousness, 27, 32, 34, 51, 57, 67, 74, 75, 76f., 78, 84f., 92, 94ff., 103ff., 124, 135, 140, 143, 161, 162, 163, 173, 176, 185, 195, 204, 216, 222, 225, 226, 230, 235, 237, 251, 252, 253;
Enlightenment formulation of consciousness 228, 230, 242, 251; Romantic formulation of consciousness, 233
Consonance 31, 86,87, 88, 89, 109, 127f., 132, 135, 171, 193
Constancy 65f., 69, 96, 111
Contemplation 22ff., 25, 123
Contingent apriori 102
Conversation 126, 132, 134, 135
Conviction, ontic 11ff., 28, 25, 31, 46, 52, 57, 96, 102, 103, 115, 116, 155f., 176, 185, 201, 211f., 235, 253
Copernicus, Nikolus 9, 10f., 42, 116f., 137, 157, 159, 246
Copper plate 126ff., 129, 132, 149
Copy v. Mimesis, Resemblance
Costruzzione legittima 69, 76 , 77, 146
Counter-examples 216
Creation 144, 145f., 149, 164, 183, 212, 250
Crying 16, 31, 63, 71, 94, 160, 175, 178, 219, 225
Cusa, Nicholas 70, 146

Da Gagliano, Marco 224
Daily life 3, 8, 11f., 14ff., 21, 29f., 31, 37, 38, 42, 43,45, 49ff., 53,75, 81, 91, 101, 110, 116, 134, 165, 166, 167, 169, 176, 184, 186, 191, 192, 200, 207, 210, 216, 225, 226, 235, 236, 245, 246, 247, 250, 252 v. World Within Reach, Enclave, Paramount Reality, Working, Action
Dahlhaus, Carl xiii, 73, 215, 221, 222, 233
Dante 131
D'Arezzo, Guido 219
Da Vinci, Leonardo 57, 58f., 65, 67, 75, 108, 137
Day 10, 23, 104f., 126, 156, 157f.
Death 32, 50, 175, 176, 178
Debussy, Claude 48

Decomposition 163, 170f., 178, 218
Decorum 97, 98, 129, 130f., 134f., 139, 174, 177
Depiction 243
Derrida, Jacques 49, 55, 140
Descartes, René 8, 42, 57, 65, 70, 87, 104ff., 107, 115, 126, 144ff., 151, 153 157, 167, 171, 183, 190, 199, 201, 212, 230
Dialogue 134 v. Conversation
Disegno interno 121f., 123, 133
Dijksterhuis, E. J. 87
Dilthey, Wilhelm 79, 197, 226
Diophantus 75
Di Santillana, Giorgio 10
Dissonance 86, 88, 89, 90, 105, 109, 137, 174, 225
Divine 25, 222 v. Planification, God
Dog 206
Doni, Giovanni 170, 172, 174
Doran, Madeleine 34, 45, 80, 96, 129, 130, 131, 133, 134, 138, 141, 142
Doughnut 206 v. Space, Gap
Drake, Stillman 7, 22, 163
Drama 148, 224, 226, 227 , 230, 231, 246, 247, 248, 251 v. Theatre, Tragedy, Comedy, Poetry
Dramma giacoso 160
Dramma per musica 142
Drummond, John D. 142, 173, 188, 202, 203, 204, 229, 231
Drummond, John J. xv
Dürer, Albrecht 57, 58, 64, 72, 75, 77, 114, 119

Earth 2f., 24ff., 91, 158, 160, 198, 199
Eccentricity 8, 14ff., 21, 30, 44, 56 , 71 , 114, 115, 134, 151, 155, 156f., 164, 166, 175, 190, 192 , 201, 248, 252 v. Center, Periphery
Echo 174f.
Effeminacy 220f., 225
Eidos 28, 95
Einstein, Albert 198
Ellipse 72, 87, 110, 163, 191ff., 194ff., 201, 203
Emblem 179f.
Embree, Lester xv
Emotions v. Affections
Empathy 52
Empirical meaning, 36f
Enclave 3, 8, 18f., 33, 44, 45f., 93, 102, 152, 185f., 190, 216, 236, 241, 246, 247, 254 v. Daily life, Paramount Reality, Eccentricity
Enlightenment 221, 236
Episteme theologike (to theiotaton) 25
Epoché mimetic 140ff., 152, 155, 160, 183, 188, 209, 211, 215, 246, 247, 251, 252; of the practical attitude, 248, 250, 252; phenomenological, 140, 252f.
Eros 187, 189, 190, 222 , 223 v. Affections
Espejo de Caballeria 148
Essence v. Possibility
Eternity 21, 62ff., 70, 80
Euclid 61ff.
Euler, Leonhardt 227f., 230, 236
Eurydice 133, 147, 175, 176
Existence 237ff.
Existential index 238, 240, 252
Existential predications 237ff., 244, 245, 253 v. Predications of Reality
Experiments 7, 109, 126ff., 132, 134, 143, 164, 166, 173, 207, 208, 210, 211, 213
Eye 65, 66, 67, 68, 70, 72, 76, 77
Ezekiel 206

Fable v. *Favola*

Fabula v. *Favola*
Fabulous 140
Face to face relationship 53 v. Other
Fantastic, Fantasy 129, 134, 135, 139. 141, 155, 165, 180, 183, 184, 192, 196, 200, 217, 226, 239, 240
Far 23ff., 27, 30, 59, 60, 84, 104, 110, 113, 195, 199, 254 v. Near
Farinelli [Broschi, Carlo] 226
Farrady, Michael 3
Favola 131, 141 , 142, 143ff.. 147ff., 156, 164, 167, 175, 183, 184, 195, 204, 244, 249, 251, 252 v. Fabulous, World
Favola in musica 142, 143, 176, 231
Favola pastorale 172
Feigning (-awareness) 151, 237, 242, 243, 244, 245, 247, 248f. , 250 v. Phantasy
Fenlon, Iain 172
Ferrara, Lawrence 180
Fiction, Fictive 217, 227, 233, 238, 239, 242, 244, 246
Fiedler, Leslie 225
Fifth 331, 83, 127f., 132, 133, 170, 203f.
Filippi, Filippo 230
Finocchiaro, Maurice 45, 99, 107, 161, 167
Flaubert, Gustav 18
Fluxions 217f., 219, 227
Fontana, Carlo x
Force 27, 30, 31, 39, 165, 191, 192, 193, 196, 198, 199
Foreshortening 60f., 69
Form 24f., 80, 84, 246
Formalization 201f., 251
Formulation of consciousness, v. Consciousness
Fortuna 133ff., 222
Fortune, Nigel 209
Foss, Vivian xv, 97, 141
Foucault, Michel x, 34, 125, 151, 179
Fourth 31, 83, 127, 170
Fracastoro, Girolamo 130
Free fall 150
Freedom 29, 36f., 213
Freeman, Robert S. 189, 218
Freud, Sigmund 198
Friedrich, Carl J. 115, 120
Fulcher, Jane 8

Galilei, Galileo x, xii, 7, 10, 11, 27, 57, 72, 83, 84, 90ff., 94, 99, 104ff., 108ff., 115, 116f., 126ff., 131, 133, 134, 135ff., 143, 149ff., 156ff., 159, 161, 163, 164, 165, 166, 167, 171, 180, 183, 190, 191, 221, 223, 235, 244, 253
Galilei, Vincenzo 9, 88, 137, 142, 169f.
Gadamer, Hans-Georg 38
Gap 2f.; 4, 5ff., 9f., 18, 30, 43, 76f., 102, 152, 155, 166, 167, 185, 190, 194, 204ff., 208, 216, 235
Garin, Eugenio 45, 70, 126, 130
Geometry 24, 27, 31, 64, 65, 66, 68, 74, 81, 86f., 89, 95, 96, 99, 130, 163, 199, 212 v. Self-interpretation
Gestalt 70
Giacomini, Lorenzo 96f., 141
Giraldi, Cintho 142
Glover, Jane 209
Gluck, Christoph Willibald 221, 226, 229, 230, 231
God 70, 79, 88, 103, 144, 146. 148 v. Planification, Divine
Gödel's Theorem 215
Goehr, Lydia xiii, 5, 55, 75, 98, 210, 216
Goldbach, Christian 202
Goodfield, June 84

Goodman, Nelson 98
Goodman, Paul 161
Gottsched, Johann Christoph 220f.
Gramophone 126
Graticola v. Grid
Gravina, Gian Vincenzo 219f., 230
Gravity 165, 196, 198, 199
Greco, El 115, 119, 138
Grid, visual 65, 82, 92, 98, 146, 160, 175, 178, 181. 211, 213, 255; aural (harmonic) 92, 95, 98, 99, 169, 175, 178, 181, 182, 203, 226; linguistic. 183
Griffiths, Paul 48
Guarini, Alessandro 131, 141, 143, 172, 173
Guazo, Stefano 126, 132
Güldenstern, Gustav xii
Gurwitsch, Aron xi, xii, 14, 24, 32, 34, 37, 101, 103, 111, 143, 237ff., 245, 252

Hall, A. Rupert 7, 22, 24, 27, 42, 86, 116, 164, 165, 193, 195
Hals, Franz 153
Hammond, Frederick ix, 115, 148, 160
Handel, G. F. 142, 225
Hanning, Barbara Russo 7, 86, 92, 93, 96, 97, 98, 142, 172, 187
Harmony 89, 90, 95, 170ff., 174
Harnoncourt, Nicholas 7, 105, 172, 174, 178, 181, 182, 209, 210
Hauser, Arnold x, 57, 79, 94, 115, 120f., 124, 131, 133, 138, 139, 183
Heath, Thomas 62
Heavens 23, 86ff.
Hedonism 222ff., 225, 231
Heelan, Patrick xii
Heidegger, Martin 128
Heisenberg, Werner 196
Heller, Eric 134
Herbart, Johannes 197
Here and There 48f., 49ff., 52, 60, 69, 72, 67ff., 77f., 81, 90, 96,102, 110, 120, 199, 200 v. Near, Far
Here and Where 77f.
Hering, Jean 246
Hermes 133ff., 174, 185f., 189, 222, 242
Hibbart, Howard 102
Hilbert, David 215
Hofstadter, Douglas x
Holt, Elizabeth G. 119
Homer 55
Hughes, Robert 212
Hume, David 198
Husserl, Edmund xi, xii, 48, 100ff., 140, 166, 237ff., 241, 244, 245, 250, 251, 255
Hypothesis 149ff., 162f. , 171, 244, 246

Idealism 164
Idealization 166f., 252
Image awareness 242, 244
Image icastic and fantastic 129, 180, 242 v. Mimesis, Resemblance, Representation, Mirror
Imagining, Imagination 104f., 108, 129 , 149, 150, 236, 237, 239 v. Reason
Imitation v. Mimesis, Resemblance, Representation
Impetus 24, 25f., 27, 106
Incompossibility 103
Individuality, Individualizing 133, 251, 253
Induction 166
Inertia 199f.
Infinity 65f., 77, 197, 213 v. Vanishing Point
Integration 197
Intermedio 142, 158, 188

Intersubjectivity v. Other, Working
Intervals 31, 137, 168ff., 170f., 248 v. Ratio
Intonation 83
Intuition 4, 201
Invisible 77
Irreality 247f.
Istoria 70f., 76, 97, 131, 141, 142, 146, 149, 156, 175, 181, 184, 188, 200, 249
Ixion 23, 24, 206

Jaeger, Werner 32
Janson, W. H. 132, 137, 156
Jesseph, Douglas M. 217
Jonas, Hans 22, 34f., 75
Jupiter 73

Kafka, Franz 103, 256
Kant, Immanuel 221
Kaplan, Bruce Eric 255
Katz, Ruth 75, 81, 84, 85, 92, 94, 99, 142, 147
Kaufmann, Walter 10
Kayser, Wolfgang 144
Kearny, R. 55
Kenner, Hugh 134
Kepler, Johannes 10, 11, 57, 72, 79, 80, 86ff., 90ff,, 92, 116f., 170, 191, 192, 193, 195, 196, 211, 246, 253
Kersten, Andrew xv, 165
Kersten, Fred xi, 12, 13, 14, 18, 28, 30, 32, 36, 37, 47, 52, 71, 95, 101, 131, 163, 192, 196, 199, 212, 213, 226, 252, 253
Kersten, Karen xv
Kersten, Stephen xv
Keys 203f.
Kinematics 143, 158
Kinetics 24, 26, 143
Kiss 128, 129ff., 131. 134, 159, 175, 186, 189, 190
Kivy, Peter xiii, 98, 137, 171, 172, 174, 210, 228, 235ff.
Klee, Paul 228
Klein, Jacob 73, 74f.
Knowledge 10, 52, 54, 55, 85, 92, 183f. , 195 socially derived and socially approved 54f., 75, 93
Koyré, Alexandre 109, 110, 127, 150, 192, 193, 199
Kristeller, Paul Otto 75, 100
Kuhn, Thomas S. 93, 117
Kundera, Milan 140
Kusmitch, Nikolai 2f.,, 8, 9, 18, 22, 32, 33, 42, 81, 90, 115, 116, 117, 152, 166, 185, 202, 204, 207, 208, 216, 226, 254

Labor 120, 123, 152
Laboratory 151f., 161
Language 226, 229, 231, 233, 236
Laughing 16, 25, 29, 31, 63, 70, 94, 175, 178, 219, 225
Leclerc, Hélène 115, 158, 159
Leibniz, Gottfried Wilhelm 8, 21, 66, 71, 87, 90, 100, 102, 103, 128, 143f., 150, 185, 190, 192, 195f., 197, 198, 201, 202, 206, 208, 210, 218
Leopold, Silke 172, 174, 175, 177, 178, 180, 181, 187, 188, 189
Levi, William Albert 115
Leyendecker, Herbert 35
Libretto 7, 97, 148, 188, 223
Liceti, Fortunato 10
Life-world v. Daily life
Light 2f.
Lindberg, David 26, 42

Lionardi, Alessandro 129
Lippman, Edward 61, 70, 97, 100, 142, 180, 218, 221
Lippmann, Friedrich 232
Locomotion 199ff.
Lotti, Antonio 225
Love 148, 220, 223
Lyre 177, 178 v. Arm, Muscle

Madness 116, 119
Madrigal 179f.
Magic 180, 182, 184
Magnitude 66, 82, 95
Maniates, Maria Rika 34, 83, 86, 92, 93, 94, 97, 98, 99, 119, 121, 122, 129, 131, 133, 138, 141, 158, 172, 177, 178, 183, 188
Maniera 92, 96, 141 v. Self-interpretation
Manifold, mathematical 10
Manipulative zone of action 49ff., 53, 199, 200 v. World within reach
Mannerism 133 ,151v. Baroque
Màrgani, Margherita 136
Marschner, Heinrich 233
Marino, Giambattista 173, 175
Maritormes 133, 134
Marvelous, v. *Meriviglia*
Mass 198ff., 201, 203
Mathematics 10f., 75, 84, 143, 144, 150, 152, 155, 163, 164, 183, 190, 212, 217f., 223
Mathematization 27, 163ff., 166, 252
Mazzoni, Jacopo 141
Maxwell, James 3
Meade, G. H. 49
Measure 49, 77, 193, 199, 200, 213
Mechanics 3f., 74, 99, 143, 201, 218, 227f.
Mei, Girolamo 97, 142, 172
Melancholy 116, 119, 124, 147
Melody 231f.
Melville, Herman 123
Mente concipio 104
Meraviglia 131, 140, 141, 158, 167, 188, 221, 239, 241, 253
Merleau-Ponty, Maurice 65, 81
Mersenne, Marin 169
Metastasio, Pietro 225
Metempsychosis 208f.
Methexis 109
Method v. Self-interpretation
Mezzanità 73, 74, 89, 91, 92, 109, 116, 124, 190, 192, 195, 203
Middle Ages 120,
Milieu 82, 110ff. , 115, 129, 130, 131, 134, 168, 173, 180 v. Room
Mimesis 30, 32, 33ff., 37ff., 41, 44, 60, 76, 80, 89, 95, 96ff., 100, 122, 131, 136, 137, 141, 156, 183, 216, 220f., 225, 226, 229, 230, 235, 241f. v. Representation, Resemblance, Appresentation
Mirror 61ff., 70, 71, 80, 95, 133, 148, 254
Modes, multiple of 70, 170
Monadology 102, 110, 195f., 197
Moneta, Pina xv
Monody 83, 88, 90, 91
Monteverdi, Claudio x, xiii, 7, 133, 175, 179f,, 182, 184, 196, 202, 204, 224, 231, 250, 253; *Orfeo* 142, 146, 172, 174, 176, 177, 184, 185f., 187, 202, 203f., 209, 213; *L'Incoronazione di Poppea* 147, 148, 173, 180ff., 184, 185f., 189; *La finta pazza licori* 174
Monteverdi, Giulio Cesare 98
Moon 157. 158, 160, 167

Morton, John 208
Moss, Jean Dietz 83, 93, 99f,, 107, 157, 167
Motion, 22ff., 24f., 26ff., 31, 38f., 40, 43, 57, 72, 86ff., 91, 99, 104f., 144, 146, 149ff., 155, 156, 159, 161ff., 163, 165, 166, 169, 170f., 178, 190, 191ff., 194ff., 198, 199, 244
Mozart, W. A. xiii, 6, 221, 233
Muratori, Antonio 218f., 220, 221, 230
Muscles 58, 72, 90ff., 178, 191, 192f., 195 v. Bones, Arm
Music 7, 87f.; 95, 99, 169, 184, 190. 202, 215, 216, 222, 223, 226, 229, 235f., 248f.
Myron 25, 28, 191
Mythos 144

Narcissus 133ff., 174, 186
Natanson, Maurice xv, 3, 11, 239, 240, 243, 245, 246, 249, 250, 255
Nature 58ff., 67, 71, 77, 81, 95, 108, 140, 164, 166, 216, 222, 230, 251f.
Near 23ff., 59, 60, 69, 84, 104, 113, 195, 254 v. Far, Here
Nearing, Homer C 204ff.
Neo-Platonism 121ff.
Nero 133
New York Public Library 122f.
Newton, Isaac 151, 156, 192, 195, 198, 199, 203, 216, 217, 221, 244
Night 23f., 27f., 45, 61f., 63, 64, 157f.
Non-mimetic v. Mimesis; Epoché, mimetic; Appresentation, indicational
Non-presentiveness 242, 243f., 245 , 247, 249, 250f. v. Presentiveness, Phantasy, Feigning
"Nothing" 246f.
Now 63, 80 v. Specious Present, Time
Number 26, 31, 32, 39, 42, 91, 92, 166, 201 v. Ratio

Objectivity 49, 82
Octave 127, 129, 132
Olson, Elder 134
Ontology regional and formal 251
Opera and science, xi, xii; 6ff., 8, 9, 131, 142, 143, 158, 173, 218, 219, 251; Baroque, 188, 190, 218, 220f., 223, 226; Romantic, 188; Florentine, 224; Roman, 224; Venetian, 224
Opera giacosa 232
Opera seria 187, 188, 232
Opera house 115, 158 v. Room
Optics 61ff., 64
Order-form of consciousness 196f.
Ordinary life, experience v. Daily life, Common-sense
Oresme, Nicol 26, 40ff., 42, 43, 72, 94, 161, 166, 244
Orpheus 133, 146, 147f., 174, 175, 176, 177, 178, 185f., 242, 250
Ortega y Gasset, José 4, 112, 125, 199, 207
Osborn, Richard 232
Othello 131
Other , Other Minds 51, 53f., 55, 68, 99 v. Reciprocity of Perspectives, Intersubjectivity

Painting 132, 136, 137, 184, 228f., 230, 235, 248, 251
Palisca, Claude V. 98, 126, 127, 173, 181, 230
Panofsky, Erwin x, 56, 57, 58, 59, 60f., 62, 64, 65, 69, 70, 71, 72, 73, 77, 82, 85, 86, 91, 95, 100, 110, 121, 122, 124, 128, 135, 137, 138, 147, 190, 191
Paracelsus x, 185
Paradigm shift 93, 99
Paramount reality 239f., 245, 246, 247, 250 v. Daily Life, Working
Parmigianino, Francesco 122, 133
Pedal-note 88
Peithein 29, 30, 75, 93, 168
Penduluum 127f., 129, 132, 135, 171
Peneolope 133
Perception 243f.
Performance 181, 209ff., 212, 213, 232, 246, 248f.

Peri, Jacopo 98, 105, 172, 224
Periphery 14, 18, 28ff., 31, 40, 41, 42, 50 , 63, 80, 92, 103, 113, 124 , 147, 168, 195, 212, 225, 240 v. Center
Perspective 61, 64ff., 68, 69, 77, 108, 119
Perspectivism 61
Pestilli, Giorgio 221, 229, 232, 233
Petites perceptions 197
Phantasy 129, 156, 236, 237, 238, 244, 245, 250 v. Feigning
Phenomenology xi v. Consciousness
Physics 3f.,, 27, 163, 201, 252
Piccinni, Niccolò 221
Picture 36ff. v. Image awareness
Planets 23f., 88, 89f., 90ff., 110, 160, 193, 195, 198
Planification 144f., 148, 188, 197, 222, 223
Plato 30, 32, 39, 61, 63, 78, 93, 107, 108f., 196
Platonism 59, 108, 109, 119ff., 130, 166, 230, 251
Plessner, Helmut 15f., 82, 112, 168, 175, 176, 184, 189, 199
Poetics of wonder 156, 160, 161, 175, 221, 222, 225, 224, 225, 231, 240, 244, 251, 253
Poetry 7f., 130, 131, 141, 143, 175, 208, 219, 220, 222, 229f., 251
Polemos 93
Polis 29, 30, 31, 39, 52, 93
Poliziano, Angelo 142, 178
Polyclitus 61
Polygon 86f., 193
Polyphony 83, 88, 89, 90, 91, 144
Ponnelle, Jean-Pierre 172
Possibility xi, 77, 94, 215, 238, 249, 250, 251, 252
Pre-established harmony 195f., 197
Predications of reality 237ff., 244, 245, 253 v. Existential Predication
Present, specious 49, 54ff.
Presentation 33f.
Presentiation 244, 246, 248 v. Non-pesentiveness
Presentiveness 239, 242, 243f., 247, 250f. v. Non-presentiveness
Proclus 61, 84
Proportion 31, 57 , 60, 65f. 69, 70, 71, 72, 75, 77, 79, 87, 99 v. Ratio
Proscenium 160, 161, 188
Prospectiva artificialis 65, 77, 79, 81, 89, 99, 107f., 146, 178, 181, 183, 184, 188
Prospectiva naturalis 65, 81
Prospectiva pingendi 65, 67, 68, 72, 76, 77, 79, 146, 164
Ptolemy 9f., 158
Pull v. Push
Push 25ff., 28f., 40ff., 49, 61, 80, 103, 106, 116, 146, 148f., 164, 175, 191, 192, 193, 195, 198, 203, 206, 211f., 254 v. Shove, Velocity
Pyramid, visual 61f., 65f., 67, 76, 77
Pythagoras 86, 99

Quadrangulo 65 v. Window
Quantification, Quanta 43f., 79f., 109, 113, 161
Quark 192
Quality 80

Ransom, Cleanth Penn 204ff.
Ratio 26, 31, 36f., 39, 40ff., 42, 43,66, 80, 87, 104, 127, 129, 244 v. Representation
Ray, Stefano 58
Real, reality xiii, 4, 15f.., 44, 82, 92, 103, 134, 173, 178, 222, 227, 238, 239, 240, 241, 245, 249, 252; accessible to experience, 21f., 25, 27, 31f., 39, 40, 46, 49, 57, 61, 63, 67, 74, 85, 94f, 102, 116, 117, 135, 151f., 167, 176, 178, 184f., 190, 192, 197, 200, 209, 211, 215, 216, 221, 226, 253 v. Woolf, Virginia
Realism, mathematical 164
Realities, multiple 3, 8, 240f., 245, 250, 251, 253

Reality, concept of 239, 240 v. Paramount Reality, Action, Working, Daily Life
Reason 104, 105, 108,129, 137, 149, 150, 168,220f., 225, 228 v. *Rendere ragione*
Reciprocity of perspectives 52ff., 68, 77, 101, 200, 203
Recitar cantando 181f,
Recitative 220, 221, 224, 225, 227, 236
Redondi, Pietro 10, 93
Referentialism 85
Reform 216, 225, 228, 231
Region 241, 242, 251, 253
Relative 203f.
Remembering 243
Renaissance xi, xii v. Baroque
Rendere ragione 67, 151, 152, 155, 164, 190 v. Reason
Repetition 202f.
Representation 30ff., 58ff., 70, 79f., 121, 179, 235; by way of mimesis, 33ff., 38ff., 42, 45, 68, 70, 76, 216, 254; by way of analogy 37ff. 40ff., 45, 229, 254; non-mimetic and exponential representation 43, 44, 125f., 135, 137, 139, 150, 163ff., 166, 171, 211, 215, 216, 233, 240, 250, 254 v. Appresentation, Resemblance, Epoché
Res bina 134, 185f., 189
Res cogitans 67, 71, 87, 103, 190, 196, 223
Res extensa 196
Resemblance 34ff., 45, 104ff., 113, 135, 137, 139, 142, 148, 160, 167, 180. 183, 188, 196, 215, 222, 223, 236 v. Representation, Mimesis
Rhetoric 109, 129, 134, 167
Ricoeur, Paul 101
Rilke, Rainer Maria 2, 103 v. Kusmitch
Rinuccini, Francesco 139
Rinuccini, Ottavio 96, 142, 172
Romanticism 221, 232, 233
Room 8, 77f., 103, 106, 107, 110, 113ff., 129, 130, 134, 136, 138, 139, 140, 142, 147ff., 151, 152, 158, 160f, 173, 174, 178, 180, 190., 254, 255 v. Milieu, Window
Roquetin, Antoine 254f.
Rosand, Ellen 179, 189
Rosen, Edward 10
Rosenmeyer, Thomas G. 174
Rossini, Gioachino xiii, 83, 225, 230ff., 236
Rotation 23ff., 191f.
Rousseau, Jean-Jacques 228ff.
Rowland, Ingrid D 70

Sacrati, Francesco 158
Salinas, Francisco 83
Sangallo, Antonio da 211f.
Santayana, George 13
Satie, Eric 88
Sartre, Jean-Paul 35, 246, 247, 254
Scenery 61f.
Scepticism 119f., 124
Scheibe, Johann Adolph 221
Scheler, Max 82, 111ff., 114, 176
Schmidt, Charles B 109
Schopenhauer, Artur 202
Schrade, Leo 142, 147, 148, 187, 188, 233
Schrecker, Paul 166
Schutz, Alfred xii, 12, 33, 46, 48, 49, 52, 55, 64, 82, 101, 124, 191, 199, 202, 229, 240, 247, 248, 250
Science 9ff., 19, 74, 75, 78, 84, 95, 99, 108, 161, 184, 202, 216, 222, 237f., 244, 251, 253
Sculpture 133, 136f., 143, 235, 251
Self-generation 67, 68, 71 v. Compossibilty, Self-interpretation, Method, Order-form

Self-interpretation 45, 46ff., 67, 68, 92, 93, 102, 112, 129 , 143, 169, 178, 180, 190, 191,196, 204, 210, 233, 250 v. Enclave, Consciousness, Order-form
Semitones 169, 171
Senses 167f
Sensory evidence 107, 108ff., 110, 128,129, 134, 136, 139, 142, 143, 151, 177, 180, 197, 201, 206
Sentimentality 168
Serafin, Tullio 232
Shakespeare, William 131, 245
Shove 26ff., 40ff., 49, 80, 103, 106, 116, 117, 148f., 164, 175, 191, 195, 198, 211, 254 v. Push
Sign 52, 201f.
Similitude x, 185, 217; ontology of 179, 183 v. Hermes, Verisimilitude
Simplicity 164, 165
Singer, dilemma of 83 v. Temperament
Singing 219, 223, 224, 226, 232, 233
Sixth 89, 90, 171
Skolé 32
Smiles, Samuel 55
Smith, Adam 235f., 241f.
Sociality 8
Socrates 108,
Solerti, Angelo 180
Sommi, Leone 142
Sonenfield, Irwin xv
Song 31, 137, 173
Song in speech , 235173, 178, 224f., 231 v. Sppech
Space 49ff., 59, 69, 180, 208, 245, 250 v. Topology, Working, World within Reach, Here, Zero-point, Doughnut
Specious present 45, 52, 77, 102, 116, 190, 203, 206 v. Working
Speech 39f., 180, 224, 233; speech in song, 173, 178, 183, 224f. v. Song in Speech
Spencer, John 66, 67, 68, 70, 71
Sprezzatura 92, 183
Sternfeld, F. W. 142, 177
Stevin, Simon 8
Stile rappresentativo 99, 173, 174, 175, 178, 184, 223, 224
Stock of knowledge at hand 12, 47f., 57, 58, 63, 66, 68, 71, 75, 131, 132, 134, 164, 190, 225, 230
Strauss, Erwin 10, 28
Striggio, Alessandro 172, 177, 185, 224
Strom, Reinhard 142, 187, 188
Strunk, Oliver 229
Style 92, 223, 224f., 226, 227, 231f., 249
Subjectivity 82
Subjunctive 243
Substitution, mimetic likeness by 122, 123
Sun 88f., 90, 104f., 193, 195, 196 v. Circle, Center
Sunspots 106f., 110, 135f., 137, 138
Surveying 68f.
Suspension v. Epoché
Symbol 52, 76

Taken-for-grantedness 12f., 14, 18, 48, 84, 102, 116, 117, 185, 253 v. Conviction, Daily life, Common-sense
Tasso, Torquato 135, 137, 138f., 173
Teasuro, Emanuele 141, 183f.
Telescope 84, 106, 107, 108, 142, 183
Temperament 60, 83ff., 89, 91, 248
Tetrachord 179, 180, 182, 184, 196
Thales 32
Thaumazein v. Wonder
Theatre 148, 151, 159f., 187f., 222, 226, 227, 229
Thingness of things 29, 31, 36, 43, 92, 96, 124, 161, 164, 178, 204, 211

Third 89, 90, 171
Thucydides 46
Timbre 229
Time 21, 48ff., 52, 80, 245, 250 v. Specious present, Now
Titian 212
Tomlinson, Gary xiii, 84, 86, 175, 179f., 183, 187, 190
Tonic 203f.
Tönnies, Ferdinand 113
Topology 204ff.
Torelli, Giuseppe 158
Tosi, Pier Francesco 224f.
Toulmin, Stephen 84, 195, 199
Tragedy 31, 96ff., 125, 131, 134, 135, 141f., 146, 147, 149, 159, 160,168, 187, 190, 220, 223, 226, 228, 233
Tragicomedy 97, 147, 160
Transcendental 140, 253
Transformation formula 100, 102
Triad 83, 170
Truth 85, 98, 105, 129, 134f., 166, 183, 184ff., 201, 215, 220, 223, 240

Universal 133, 135, 250f.
Use, usefulness 36f. , 92f., 94, 123

Vanishing point 65, 66, 68ff., 77, 89, 109, 158, 160, 196, 213
Variable 212, 213
Vasari, Giorgio 129
Veil v. Grid
Vela Bueno, Carlos xv
Velázquez, Diego 125, 138
Velocity 26ff., 31, 38, 40, 43, 149ff.
Venice 158ff,, 164
Venus 133
Verba, Cynthia 221, 228
Verdi, Giuseppe 6, 83
Verification 151
Verisimiltude 97, 128, 129, 130f., 132, 134f., 136, 139, 150, 151, 155, 158, 160, 161, 166, 173, 175, 177, 183, 184ff., 197, 215, 219, 220, 221; hermeneutics of 179, 183, 201, 218, 229, 244
 v. Similitude, Hermes
Verismo 233
Veronese, Paolo 125
Vesalius, Andreas 58
Vicentino, Nicola 83, 169
Vickers, Brian 99f.
Vision 61ff., 65ff., 77
Vitruvius Pollio 62, 66, 70
Voegelin, Eric 1, 21

Wagner, Richard 137, 202
Walker, D. P. 80, 83, 84, 86, 87, 127, 137, 168, 169f., 171, 211
Wallace, William 22, 190
Water glass 127, 129, 132
Weber, Max 113
Weenyx, Jean Baptiste 144f.
Weidner, Edward xv
Weyle, Herman
Whenham, John 185
White, John 58
Wilkins, Ernest Hatch 138
Wilson, Dora J. 221

Window 64ff., 67, 69ff., 75, 77, 105, 107, 110, 113ff., 141, 158, 160, 183, 184, 188, 211, 254 kv. Room
Winternitz, Emanuel 137
Wonder 25, 31, 94f.
Woolf, Virginia xiii, 254
Work 209ff., 212, 213, 249
Working 14, 29, 45, 47f., 51, 55., 72 , 77, 81, 82, 94, 199f., 201, 212 v, 245f.., 248, 249 Action, social
World, worlds 52, 239, 240, 241, 242, 244, 246, 250, 250f., 252 v. Enclave, *Favola,* Realities
World within reach 12, 49f., 52, 69, 72, 75, 76, 77, 81, 91, 95, 102, 110, 114, 151, 152, 201

Zarlino, Gioseffo 83, 170
Zeno, Apostolo 218, 225
Zero-coordinates 48f., 50, 67f., 72, 77, 80, 102, 113 v. Here, Action, World within reach
Zuccaro, Federico 119ff., 216, 230

Contributions to Phenomenology

IN COOPERATION WITH

THE CENTER FOR ADVANCED RESEARCH IN PHENOMENOLOGY

1. F. Kersten: *Phenomenological Method.* Theory and Practice. 1989
 ISBN 0-7923-0094-7
2. E. G. Ballard: *Philosophy and the Liberal Arts.* 1989 ISBN 0-7923-0241-9
3. H. A. Durfee and D.F.T. Rodier (eds.): *Phenomenology and Beyond.* The Self and Its Language. 1989 ISBN 0-7923-0511-6
4. J. J. Drummond: *Husserlian Intentionality and Non-Foundational Realism.* Noema and Object. 1990 ISBN 0-7923-0651-1
5. A. Gurwitsch: *Kants Theorie des Verstandes.* Herausgegeben von T.M. Seebohm. 1990 ISBN 0-7923-0696-1
6. D. Jervolino: *The Cogito and Hermeneutics.* The Question of the Subject in Ricœur. 1990 ISBN 0-7923-0824-7
7. B.P. Dauenhauer: *Elements of Responsible Politics.* 1991
 ISBN 0-7923-1329-1
8. T.M. Seebohm, D. Føllesdal and J.N. Mohanty (eds.): *Phenomenology and the Formal Sciences.* 1991 ISBN 0-7923-1499-9
9. L. Hardy and L. Embree (eds.): *Phenomenology of Natural Science.* 1992
 ISBN 0-7923-1541-3
10. J.J. Drummond and L. Embree (eds.): *The Phenomenology of the Noema.* 1992
 ISBN 0-7923-1980-X
11. B. C. Hopkins: *Intentionality in Husserl and Heidegger.* The Problem of the Original Method and Phenomenon of Phenomenology. 1993
 ISBN 0-7923-2074-3
12. P. Blosser, E. Shimomissé, L. Embree and H. Kojima (eds.): *Japanese and Western Phenomenology.* 1993 ISBN 0-7923-2075-1
13. F. M. Kirkland and P. D. Chattopadhyaya (eds.): *Phenomenology: East and West.* Essays in Honor of J. N. Mohanty. 1993 ISBN 0-7923-2087-5
14. E. Marbach: *Mental Representation and Consciousness.* Towards a Phenomenological Theory of Representation and Reference. 1993
 ISBN 0-7923-2101-4
15. J.J. Kockelmans: *Ideas for a Hermeneutic Phenomenology of the Natural Sciences.* 1993 ISBN 0-7923-2364-5
16. M. Daniel and L. Embree (eds.): *Phenomenology of the Cultural Disciplines.* 1994 ISBN 0-7923-2792-6

Contributions to Phenomenology

IN COOPERATION WITH
THE CENTER FOR ADVANCED RESEARCH IN PHENOMENOLOGY

17. T.J. Stapleton (ed.): *The Question of Hermeneutics*. Essays in Honor of Joseph J. Kockelmans. 1994 ISBN 0-7923-2911-2; Pb 0-7923-2964-3
18. L. Embree, E. Behnke, D. Carr, J.C. Evans, J. Huertas-Jourda, J.J. Kockelmans, W.R. McKenna, A. Mickunas, J.N. Mohanty, T.M. Seebohm and R.M. Zaner (eds.): *Encyclopedia of Phenomenology*. 1997
ISBN 0-7923-2956-2
19. S.G. Crowell (ed.): *The Prism of the Self*. Philosophical Essays in Honor of Maurice Natanson. 1995 ISBN 0-7923-3546-5
20. W.R. McKenna and J.C. Evans (eds.): *Derrida and Phenomenology*. 1995
ISBN 0-7923-3730-1
21. S.B. Mallin: *Art Line Thought*. 1996 ISBN 0-7923-3774-3
22. R.D. Ellis: *Eros in a Narcissistic Culture*. An Analysis Anchored in the Life-World. 1996 ISBN 0-7923-3982-7
23. J.J. Drummond and J.G. Hart (eds.): *The Truthful and The Good*. Essays in Honor of Robert Sokolowski. 1996 ISBN 0-7923-4134-1
24. T. Nenon and L. Embree (eds.): *Issues in Husserl's* Ideas II. 1996
ISBN 0-7923-4216-X
25. J.C. Evans and R.S. Stufflebeam (eds.): *To Work at the Foundations*. Essays in Memory of Aron Gurwitsch. 1997 ISBN 0-7923-4317-4
26. B.C. Hopkins (ed.): *Husserl in Contemporary Context*. Prospects and Projects for Phenomenology. 1997 ISBN 0-7923-4469-3
27. M.C. Baseheart, S.C.N.: *Person in the World*. Introduction to the Philosophy of Edith Stein. 1997 ISBN 0-7923-4490-1
28. J.G. Hart and L. Embree (eds.): *Phenomenology of Values and Valuing*. 1997
ISBN 0-7923-4491-X
29. F. Kersten: *Galileo and the 'Invention' of Opera*. A Study in the Phenomenology of Consciousness. 1997 ISBN 0-7923-4536-3

Further information about our publications on *Phenomenology* is available on request.

Kluwer Academic Publishers – Dordrecht / Boston / London

Printed by Books on Demand, Germany